The Geographies of Englishness

Studies in British Art 10

The Geographies of Englishness: Landscape and the National Past 1880–1940

Edited by

David Peters Corbett, Ysanne Holt and Fiona Russell

Published for
The Paul Mellon Centre for Studies in British Art
The Yale Center for British Art

Yale University Press, New Haven & London

Typeset in Adobe Garamond
Printed in Great Britain by BAS Printers Limited, Over Wallop, Hampshire

Library of Congress Control Number 2001098546
ISBN 0-300-09488-4

A catalogue record for this book is available from the British Library.

Contents

Acknowledgements

During the preparation of this book we have incurred, individually and collectively, many debts. Many of the chapters in this book began life as papers at the conference 'Rethinking Englishness: English Art 1880–1940'. We are grateful to the University of York, where the conference was held in 1997, and to the Faculty of Arts at the University of Northumbria and the Henry Moore Foundation, who supported it, as well as to all those, too numerous to mention individually, who attended or gave papers and who helped to push the conversation forward. Lara Perry made an important contribution in discussing the form of the book during its preliminary stages. At Northumbria, Barbara Sweet provided crucial help with an early draft. Our biggest debt there is to Laura Newton, who has acted as a businesslike editorial assistant during the completion of the project. Brian Allen was enthusiastic and supportive when we first took the project to him, and has remained so during its several travails. Also at the Paul Mellon Centre in London, Guilland Sutherland has proved an exemplary and sympathetic editor throughout its concluding moments.

David Peters Corbett
Ysanne Holt
Fiona Russell

Introduction

David Peters Corbett, Ysanne Holt and Fiona Russell

THE ORIGINS OF THIS BOOK lie in a conference held at the University of York in 1997. 'Rethinking Englishness: English Art, 1880–1940' aimed to bring new insights from inter-disciplinary debates about the formation and perpetuation of national identity to the visual arts of the late nineteenth and early twentieth centuries.[1] Although recent scholarship in history, cultural geography, literary studies and elsewhere had addressed the role of nationality and landscape in cultural representation, 'Rethinking Englishness' provided the opportunity for a sustained examination of the interaction of modernisation, landscape and national identity in English art for the first time.[2] We had initially envisaged a conference reviewing the art-historical field in the fifteen years since the publication of Charles Harrison's *English Art and Modernism: 1900–1939*, which had recently been reprinted by Yale University Press.[3] We asked ourselves to what extent 'modernism' continued to be an issue and how new historical and theoretical perspectives could usefully be applied to the period. A number of central concerns emerged from the event, but questions of artistic and other identities, gender, nationalism, modernisation and the urban/rural relationship dominated. *The Geographies of Englishness* deals with the last three of these.[4]

An investigation of Englishness is central to consideration of the visual arts in this collection of essays. The characteristics of Englishness which Pevsner derived from the eighteenth century at the beginning of the Second World War provide a helpful means of access to the late Victorian and inter-war period. The years following 1880 were a time when the rediscovery of national identity and native traditions prevailed throughout the western world, in some places precipitating broader political realignments, for example in the Celtic revival. Ideals of Englishness, of a national and cultural unity, either disregarded or sought to subsume all other identities within the British Isles by the end of the nineteenth century.[5] Englishness, rethought, remained of profound importance up to the time in which Pevsner was writing. This volume examines the ways in which changing ideals of national identity were variously situated and reconstructed in English art historically and geographically throughout the period. We are concerned

to explore the different ways in which concepts of Englishness are made to signify place and time, implying a consensus about qualities, a series of intangible attitudes and formal traits, which have been variously interpreted as embodying national and racial attributes.

The late nineteenth century marks a turning point in the rise of a modern sensibility and modern modes of representation in England. In part, this moment can be discerned in the modernisation of the institutions of British culture, including those which governed the fine arts. English art became increasingly professionalised. The Slade School of Art was founded at University College London in 1871 as a response to the widely perceived stagnation of the Royal Academy Schools and the orientation towards applied art of the National Art Training School. Young English artists' persistent desire to train abroad, at the ateliers of Paris, Antwerp and Munich, provoked a particular anxiety, as P. H. Calderon's warning of 1884 reveals: 'Your English feelings and reticences imperceptibly fall away. — you find you have lost touch, as it were, with the intellect of your country, and you are a stranger in your own land'.[6] The sense that there was a specifically native tendency in art which needed to be preserved had already preoccupied John Ruskin who, in 1869, had been elected to the Slade Professorship at Oxford, where he initiated his discussion of the nature of English art by considering how the English character might be defined. By 1885 this consideration appeared all the more urgent, and the British schools were in danger, he argued, of losing their national character 'in their endeavour to become sentimentally German, dramatically Parisian or decoratively Asiatic'.[7]

Anxieties about the Englishness of English art and the reshaping of art institutions were inextricably bound together by the late 1880s.[8] Artists, and later art historians, were drawn to national institutions in the capital city. This reflected a larger picture of developing centralisation as London, dominating the ever-expanding hinterland, accrued greater cultural as well as economic authority. The emergence of calls for a distinctively English art was therefore intimately related to wider perceptions of modernisation in the national culture. One reaction to the accelerated pace of change was recoil, a revulsion from modern life and its symbols. Social and economic transformations to do with industry, empire, and neighbouring states in Europe contributed to growing unease and crisis. Such anxieties were exacerbated by experiences like the agricultural depression of the 1880s and the growing realisation that Britain's status as a major international power was seriously under challenge by the end of the century, particularly from Germany and the United States.[9]

The realisation that progress was not inevitable, perhaps not even desirable, was associated in many cases with the rejection of modernity. For earlier groups like the Pre-Raphaelites repudiation had taken the form of an imaginary past; it now took the form of geographical not temporal difference, an imagined space not an imagined time. This geographical retreat, however, was highly selective and the search was for sites which either were, or could appear to be, pre-industrial and anti-urban. By the end of the nineteenth century the north was imagined as entirely overrun by industrialisation and consequently ceased to be available as a representative image at a time when England and therefore Englishness was popularly conceived as profoundly anti-industrial and anti-modern. Such an ideal was perpetuated by new cultural institutions like the National Trust, founded in 1895, and by the veritable industry surrounding pastoralism and anti-urbanist discourse.[10] The nation, redefined culturally and geographically, shrank to southern sites and to isolated, supposedly more authentic, locations like Cornwall.[11] All of these versions of Englishness, pursuing a symbolic heart of nationhood, were in fact mediated through metropolitan ideals, just as the artists considered in these essays remained tied to metropolitan exhibition societies, critics and spectators. Whilst England shrank, it also seemed increasingly under siege from international conflict without and politically organised conflict within.[12] The displacement of these threats in visual terms is a central concern of this book.

Despite claims both for and against a native insularity or parochialism there were continuous attempts to integrate English painting into developments in Europe, particularly in France. French painting had been an important model for modern English artists from the foundation of the New English Art Club in 1886, associated first with the assimilation of Rustic Naturalism and latterly with Impressionism, to the Post-Impressionist exhibitions organised in 1910 and 1912 by Roger Fry. Awareness of wider European developments followed the advent of Vorticism, a self-consciously modern and international movement, up to the arrival of the European émigrés and the establishment of an international style of modernism in Britain at the beginning of the thirties. Many of the essays collected here are concerned with those artists and theorists who considered how international techniques and aesthetics could be incorporated within English art in a period of escalating national and international crisis.

At specific points fears of foreign invasion preceded assimilation. As imperial power declined and the threat from Germany increased, even the most convinced of English artists could be ambivalent. Each potential onslaught seemed to require a return to the central question of what constituted 'English' art and

ultimately to the question of Englishness itself. Was it most evident in England's status as part of an island, or in a national story unbroken by revolution? Could its essence be found in the Home Counties, the garden suburbs or in the prehistoric monuments of Stonehenge and Avebury? Each new crisis precipitated a new selection from the art of the past. In the latter part of the period, particularly the early thirties, a number of theorists, notably Fry, Stokes, Read and Nash, attempted to re-situate English art historically and geographically by redrawing the map of art history, reorientating English art and re-mapping its history to connect it to the early Renaissance, the northern tribes of Europe, even the paleolithic builders of stone circles. The nineteenth century and the industrial revolution were seen by both conservative writers and by the artists and theorists of thirties modernism as the point when the English character and its art had been blown off course. Increasingly ancient antecedents were explored — the medieval period, the Saxons, Neolithic man.

Thus the title of our book, *The Geographies of Englishness*, signals a central dilemma for these artists and theorists, whether to think Englishness laterally or horizontally, as geography or history, as a European future or an English past. Our subtitle, *Landscape and the National Past*, highlights our concern to examine the two central themes around which the notion of Englishness was debated by critics from the left and right, progressive as well as conservative: the first a sense that there is a specifically English landscape and an English concern with, and way of representing, that landscape; the second that there is a unique history of the nation, a particular and resilient national character. A number of debates encircled these two concerns, revolving around the rural and the urban, the traditional and the modern. For the most radical thinkers of the period, the question was how to be both modern and English, local and international, informed by the past and open to the future.

The first four chapters of the collection examine landscape painting before the First World War. Each of these considers the assimilation of French styles in the continual process of aestheticising the countryside and depicting ideal fantasies of rural life, primarily for urban spectators. Economic depression, rural depopulation and progressive mechanisation are on the whole not registered in these paintings and the countryside remains impervious to the vicissitudes of modern culture. Anna Gruetzner Robins examines George Clausen's decision to establish himself in a rural community near St Albans and the implications of his adoption of plein-air naturalist techniques for initially controversial representations of rural female labour. In the context of contemporary fears about shifting

class and gender relationships in rural areas and racial decay and degeneracy in the metropolis, the representation of a native 'peasantry' becomes an especially contentious issue by the end of the 1880s; this raises the possibility of seeing rural Hertfordshire as a kind of *banlieue*, housing the equivalent of *classes dangereuses*.

Gradually, through specific aesthetic and cultural tendencies, the 'peasant' became idealised as a 'type', as the nostalgic embodiment of noble, Anglo-Saxon virtues and an exemplary figure in an authentic and stable golden age entirely unaffected by change. This idealisation could only be achieved through a process of sanitisation, or purification, by ignoring actual circumstances in effect. Nina Lübbren's essay extends the discussion of rural workers to fisherfolk in Cornwall. She argues that the interest in fisherfolk forms part of a wider European interest in marginal and pre-modern lives. Like other primitive Europeans, English fisherfolk are perceived as even more heroic than the land-locked peasant. They embody perfect patriarchal and domestic relationships in sites far removed from metropolitan centres and the signs of contemporary turmoil. Although modern technological progress is disregarded in these paintings, for Lübbren they nevertheless engage with modern experience on other levels, most clearly with the phenomenon of tourism. She discusses particular works not simply as regressive evasions of modern life, but as active engagements with developing patterns of leisure which form one crucial aspect of the modern experience. Rural areas, increasingly empty as a result of internal emigration to the cities, now became repopulated by the tourist and the suburbanite. Lübbren's essay, like several of those included here, resists the established contrasts between Englishness and the modern.

Stephen Daniels has argued that landscapes can stand as 'examples of moral order and aesthetic harmony,'[13] and it is striking that in the period surveyed by the first essays order can only be achieved through the elimination of disturbing particularities. Englishness is asserted through the fictive landscape of an art in which conflict and the environment of modernity is smoothed away. These processes are most clearly achieved in the generally popular, pure landscapes which are the subject of Kenneth McConkey's essay. In his discussion of the works of Alfred East, McConkey considers the landscape as a site of contemplation, of memory and archetype, where trained observation was filtered through the distorting lens provided by respected antecedents like Corot and Constable. The result was a seductive nostalgia and a savoured melancholy. Ysanne Holt's essay addresses the reshaping of this increasingly anodyne vision. Young painters like Spencer Gore, when they left the urban milieu for the countryside, directly experienced a sense of disjuncture. The depiction of contemporary realities con-

veyed through Post-Impressionist techniques was not discarded, although as in Impressionist accounts of the city the achievement of order and harmony emerged as significant impulses. By exploring Gore's representations of the Garden City of Letchworth in 1912, Holt's essay, like Lübbren's, seeks to question conventional polarities. She is concerned with the early modernists' striving towards metaphorical and pictorial stability. In a series of works, Gore attempts a reconciliation of Englishness and modernity, the traditional and the modern, in ways which resonate with contemporary anxieties about cultural and economic change in the city and the country.

Involvement with Continental traditions in modern art was deeply ambivalent, at once fascinated and fearful. Belligerent reaffirmation of 'English' values co-existed, throughout the period, with curiosity about and a tentative acceptance of change. The second group of essays examines these tensions. David Peters Corbett's essay on landscape begins by arguing for a connection between Vorticism and its English antecedents. The work of Spencer Gore and others provided the Vorticists with a pre-history of attempts to deal with the circumstances of modern life by deploying new modes of representation. Corbett examines *Blast*'s preoccupation with Englishness, with the mapping of national artistic identity and with the creation of a new visual idiom, all of which feature both in *Blast* and in the more general rhetorics of Vorticism and its proponents.

That moment of potential, when 'English' and 'modern' might finally have ceased to seem to be antithetical terms, when Wadsworth looked down from an aeroplane and saw a landscape which had never been seen in this way before and when the Vorticists strove to develop a new visual language, was short-lived. Corbett's essay considers the later history of this impulse when, in the 1920s, Post-Vorticists and other artists tackled the negative connotations of mechanised war. Paul Edwards's examination of Wyndham Lewis in the 1920s takes up the intertwining inheritances of Englishness and the European avant-garde, itself undergoing a period of reassessment and retrenchment after the war. Edwards concentrates on Lewis's engagement with the recall to order seen across Europe after 1918. Preoccupied with that development, he found himself also re-working the native tradition. His version of the recall to order involves a wholesale rethinking of the principles which had been exemplified by Bloomsbury and *Blast*, a return to a self-consciously national inheritance of political and satirical art, with roots stretching back to Hogarth.

That deliberate reaffirmation of Englishness, the desperate urge to find and revitalise the essential character of a national school, is a common theme after

1918. Those Continental developments which had provoked a reassessment of the modernist ambitions of the early twentieth century clearly provoked regressive as well as progressive responses. Brandon Taylor's essay on anti-Semitism and English art criticism investigates the ways in which the assertion of Englishness and a national tradition was bound up with small-mindedness, xenophobia and an all too familiar political violence. There is a continuous spectrum of interest linking the proponents of racial stereotyping and a mean, narrow, Englishness of the sort Taylor's subjects prescribed with the interests in English traditions revealed by internationally aware modernist artists in the 1930s.

Andrew Causey's essay bridges the post-war period and the 1930s, demonstrating that the concerns preoccupying Brandon Taylor's conservative critics were equally important for the establishment and the institutional construction of English traditions in modern art. Parochialism and little Englandism were implicit, on the national stage as on the level of individual obsession. As a group, the essays which deal with the 1930s describe a renewed attempt to situate English art within a continuous, imagined tradition. But now the focus becomes the national past at its deepest and most remote. The geographical decisions which dominated the pre-war art of Spencer Gore or the Vorticists are still present, artists are still fascinated by the landscapes of the south of England, by the sites of earlier habitation and development, by the coasts and seaports, but these geographies are now radically historicised. Andrew Causey's essay points to a renewed interest in the medieval, but other periods were raided just as enthusiastically. Sam Smiles's essay shows how Britain's Neolithic past was imagined as a homologue for the modern, comfortably collapsing the distance which separated antiquity from the rootless, mechanical and disordered present. Significant southern sites now become important because of their neolithic, Anglo-Saxon or pre-historic antecedents, which evoke continuity, island status (as in *Blast*), and primeval national origins. These are attempts to introduce a set of traditions and histories across the centuries at a time of national anxiety, of depression and the triumph of National Socialism in Germany. Englishness at this moment becomes both a reactionary reading and a progressive metaphor.

In the later essays of the volume, then, an imagined chronological remoteness stages a return. But this is a practical interest in the past, deemed relevant only in so far as it can illuminate or be made use of in the present. Chris Stephens demonstrates this tendency in his essay on Ben Nicholson, taking issue with what has become a rather hackneyed story of the arrival and triumph of international modernism in the early thirties. He considers Nicholson's *White*

Reliefs, viewed by Charles Harrison as the acme of international modernism, and traces their relation to the craft movement and the cult of the handmade in the twenties. Simple binary oppositions between the traditional and the modern are inadequate here, and Alan Powers discovers similar failings in his essay, refuting cliched historical observations that neo-romanticism and modern abstraction were somehow diametrically opposed. Artists like John Piper and writers like Geoffrey Grigson struggled against what they perceived as a blind faith in logical advancement and rigid Bloomsbury formalism. But this was not a purely anti-modernist position. Their belief was that the tyranny of categories or, for Read, living too long at the level of rational consciousness, stifled creativity and the instinctive life force. Through a reconfiguration of past achievements, through study of nature alongside the medium of modernism, an affirmative art might result. Englishness, Powers argues, seemed therefore double-coded, capable of incorporating modernity, its other.

The attempts of artists and theorists in the thirties to imagine connections with the past were fundamentally speculative and unsustainable. Traditions were invariably evoked at the expense of actual histories and concocted through a series of disconnected observations. Fiona Russell's essay examines the part Ruskin plays in Herbert Read's story of art and the nation. She demonstrates the potential attractiveness of Ruskin's critique of the nineteenth century — in particular of its obsession with landscape and the national past — to the most important spokesman for 'the modern' in the nineteen thirties. But Read's use of Ruskin was highly selective and occasional and he failed to produce an intellectually sustainable reading. Whereas Ruskin, and his disciple Morris, figured as English precursors in contemporaneous European accounts of the modern, in an increasingly biographical reading the figure of Ruskin emerged in Read's work as a modern English type — eternally bound to his childhood (and in particular the landscape of his childhood), essentially preoccupied with the past and permanently fearful of a seemingly inevitable European War. Russell's essay underlines the strategic manipulation of history described by Chris Stephens and Sam Smiles.

These thirties narratives long for constancy and integration, they struggle, against all the odds, to envisage a nation, an 'imagined community',[14] effortlessly spanning the past and present. Ramsay Burt addresses the significance of this imagined community in his comparison between *Façade* and *Dark Elegies*, two modernist ballets of the 1930s, each of which evoke different sensibilities and different responses to changing class, gender and national identities. The

performance of *Façade*, described in terms of a Bloomsbury-based upper-class modernism, Burt sees as underpinned by a particular mourning for traditional, social and national differences and a resolute disavowal of change. The technical composition of *Dark Elegies* also demonstrates a tension provoked by a sense of loss, but in terms of a universal internationalism, transcending specific class and national identity.

At the end of our period, the notion that a discrete entity and stylistic category called Englishness could actually be scientifically identified was, as Will Vaughan discusses in the final essay, asserted in Pevsner in relation to the German art historian Dagobert Frey's use of continental methods of formal analysis. Drawing on Wölfflin's use of binary opposition and investigations developed in the post-Darwinian natural sciences, Pevsner and Frey discerned what they believed to be the essential characteristics of the national, racial style — naturalistic, linear, earthy and moderate. At a moment of utmost national urgency these assertions seemed, as Vaughan shows, almost a message of reassurance about England's native resilience and permanence.

The sixty years up to the Second World War were marked by repeated attempts to imagine a way out of modernity through national identity. Whether by stressing historical continuities or the elemental power of ancient geographical sites, the idea of something determinedly and identifiably English is central. That decision to define nationality as a counter to modern conditions brought with it possibilities but also, as this book has shown, negative developments, racial violence and exclusions. *The Geographies of Englishness* seeks to begin to recount the consequences for English art of the invention of nation in the midst of specific social and cultural contexts.

This conclusion raises other questions. We have described Englishness as in important ways fictional and speculative, the consequence of modern necessities rather than realities or natural inheritances which could simply be recovered. So do we actually need a notion of Englishness? Charles Harrison has recently questioned the whole idea of English art as a reasonable field of study, denying its value aesthetically or as an enquiry into modernity.[15] Is 'English art' a fiction we can do without? This book has shown that Englishness, in art as elsewhere, is deeply complex and unresolved. To name a particular body of art peculiarly English risks making an absolute and impossible act of definition. The whole thrust of this book has been against any idea that Englishness is some ahistorical and absolute category. Our claim rather, is that at this particular historical juncture, Englishness, ideas of nationhood and national identity are especially important

and influential. English art is a category which artists and theorists struggle to define and develop, and an ideal of nation is a primary focus for that struggle. 'English art' between 1880 and 1940 is in this sense a period of sufficient historical integrity to make it worth our attention. In the wake of the social history of art, it is our hope that future writers on this period will advance discussion of the themes we have identified here, will continue to question the relationships between art and national identity, the history and geography of Englishness.

1 The conference was co-organised by the History of Art Department at the University of York and the Henry Moore Institute, Leeds. We are very grateful to the latter for their support.

2 See for example, Robert Colls and Philip Dodd (eds.), *Englishness, Politics and Culture 1880–1920* (London, Croom Helm, 1984); David Matless, *Landscape and Englishness* (London, Reaktion Books, 1998); Brian Doyle, *English and Englishness* (London, Routledge, 1989); David Lowenthall, 'British National Identity and the English Landscape', *Rural History* 2 (1991): 205–30; Patrick Wright, *On Living in an Old Country: The National Past in Contemporary Britain* (London, Verso, 1985).

3 First published, Indiana, Allen Lane, 1981.

4 Other themes explored in the conference have been published in David Peters Corbett and Lara Perry (eds.), *English Art 1860–1914: Modern Artists and Identity* (Manchester, Manchester University Press, 2000).

5 An extremely useful discussion of the construction of Englishness as a focus for national identity at this moment was provided by Will Vaughan in 'The Englishness of British Art', *Oxford Art Journal* 13.2 (1990): 11–23.

6 *Art Journal,* 1884, 58–59.

7 Ruskin's comments appeared in his introduction to Ernest Chesneau's survey of *The English School of Painting,* 1885, cited in Kenneth McConkey, *Impressionism in Britain* (London, Yale University Press and Barbican Art Gallery, 1995), 30.

8 This is not to suggest that artists had been unconcerned with national character before this date. The Pre-Raphaelites in the mid-nineteenth century had explicitly imagined the renovation of modern art through the creation of an English school which would draw on elements of a national tradition commonly imagined to begin with Hogarth. But this ambition was tangential to their main aims.

9 For general historical discussion of this period see, for example, Richard Shannon, *The Crisis of Imperialism, 1865–1914* (St Albans, Paladin, 1976); Keith Robbins, *The Eclipse of a Great Power, 1870–1992* (London, Longmans, 1994); Martin Weiner, *English Culture and the Decline of the Industrial Spirit* (Cambridge, Cambridge University Press, 1981). For specific discussion of the effects of agricultural decline see Alun Howkins, *Reshaping Rural England, A Social History* (London, Harper Collins, 1991).

10 For discussion of the cultural significance of the Trust, see Robert Hewison, *The Heritage Industry; Britain in a Climate of Decline* (London, Methuen, 1987).

11 There were extensive discussions about the processes of Cornwall's accommodation to these novel requirements at David Cottington's 1996 conference at Falmouth School of Art, Imagining Cornwall.

12 See Karl Beckson, *London in the 1890s: A Cultural History* (New York & London, Norton, 1992).

13 Stephen Daniels, *Fields of Vision: Landscape Imagery and National Identity in England and the United States* (London, Polity Press, 1993), 5.

14 See Benedict Anderson, *Imagined Communities: Reflections on the Origin and Spread of Nationalism*, revised edition (London, Verso, 1996).

15 Charles Harrison, '"Englishness" and "Modernism" Revisited', *Modernism/Modernity* 6:1 (1999), 75–90.

Colour Plates

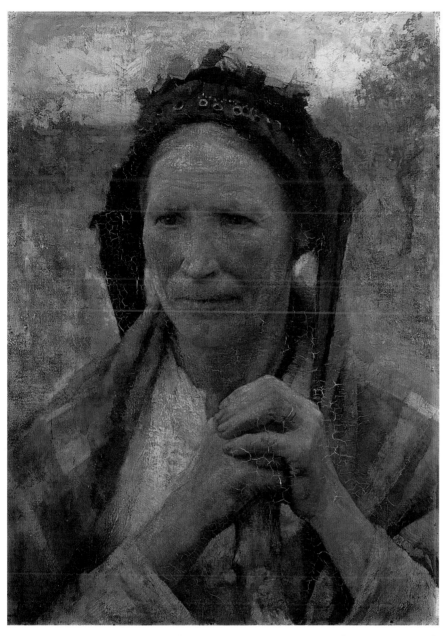

I George Clausen, *A Woman of the Fields*, 1882, oil on canvas (55.5 x 40.5 cm). Photograph courtesy of Sotheby's.

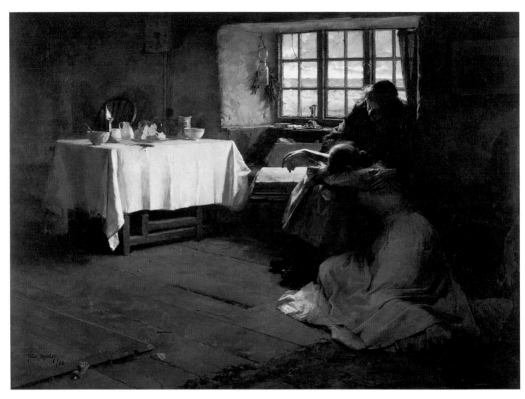

II Frank Bramley, *A Hopeless Dawn*, 1888, oil on canvas (122.6 x 167.6 cm). © Tate, London 2001.

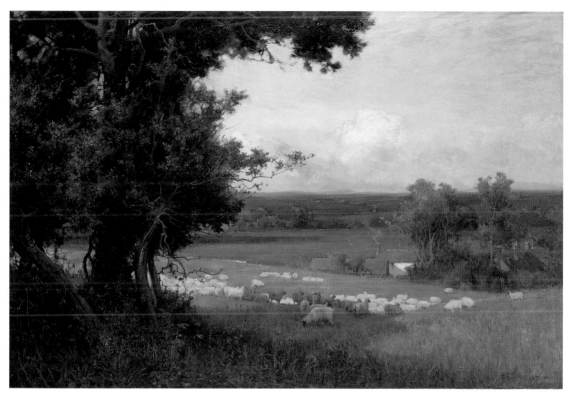

III Alfred East, *The Golden Valley*, 1893, oil on canvas (147.3 x 223.5 cm). Leeds Museums & Galleries (City Art Gallery) UK / Bridgeman Art Library.

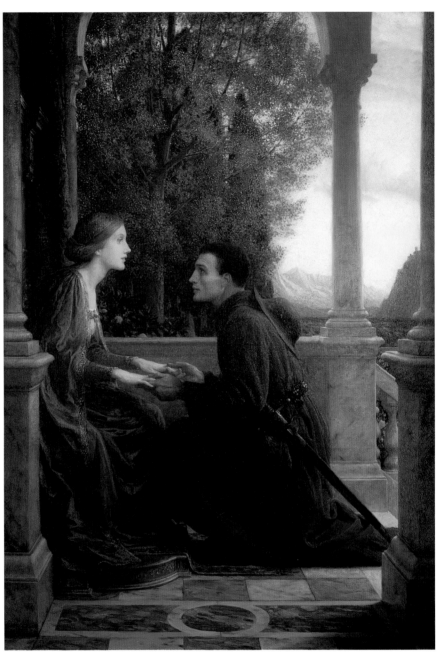

IV F. Dicksee, *The End of the Quest*, 1921, oil on canvas (144.7 x 106.7 cm). Leighton House Museum, London.

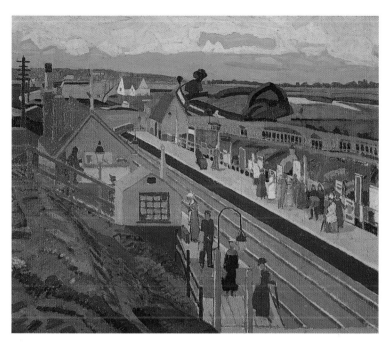

V Spencer Gore, *Letchworth Station*, 1912, oil on canvas (63.2 x 76.2 cm). National Railway Museum / Science and Society Picture Library.

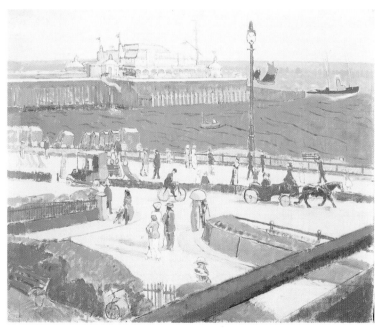

VI Spencer Gore, *Brighton Pier*, 1913, oil on canvas (63.5 x.76.3 cm). Southampton City Art Gallery, Hampshire UK / Bridgeman Art Library.

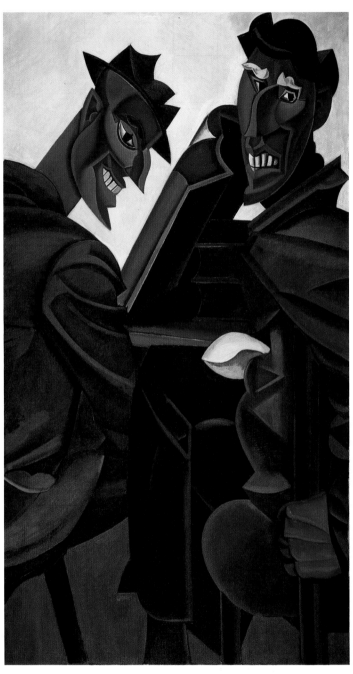

VII Wyndham Lewis, *A Reading of Ovid*, 1920–21, oil on canvas (165 x 89 cm).
Scottish Gallery of Modern Art, Edinburgh, UK / Bridgeman Art Library.

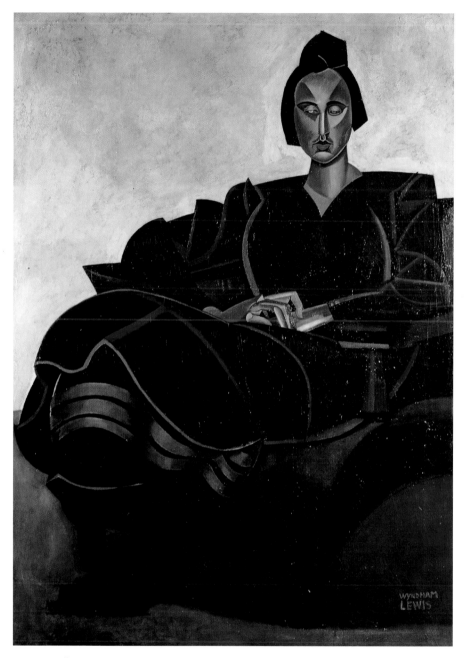

VIII Wyndham Lewis, *Praxitella*, 1920–21, oil on canvas (142.2 x 101.6 cm). Leeds Museums & Galleries (City Art Gallery) UK / Bridgeman Art Library.

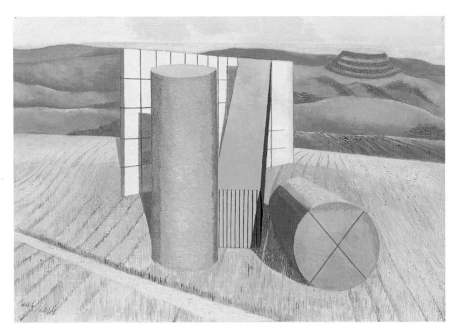

IX Paul Nash, *Equivalents for Megaliths*, 1935, oil on canvas (45.7 x 66 cm). © Tate, London 2001.

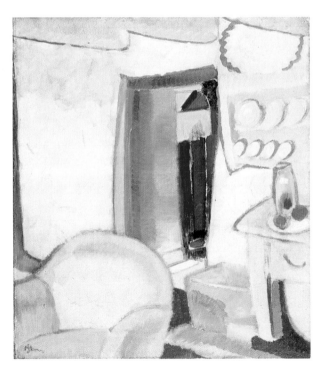

X Ivon Hitchens,
Cottage Interior, 1925, oil
on canvas (50.8 x 45.8 cm).
Private Collection.

Living the Simple Life:
George Clausen at Childwick Green, St Albans

Anna Gruetzner Robins

G EORGE CLAUSEN was establishing a reputation as a skilful painter of London street scenes when he moved, in 1881, with his new wife Agnes to Childwick Green on the outskirts of St Albans, an ancient market town twenty-five miles north of London, in Hertfordshire. This essay looks at the circumstances surrounding Clausen's life at Childwick Green and asks questions about some of the images of rural life he produced there.

In the 1880s an idea of Englishness took shape which was closely tied to a popular image of England that gave a central place to the countryside. Artists born and bred in towns and cities moved to small English villages where they professed to live, and paint, the simple country life. Several artists of Clausen's generation who depicted English rural life came from urban backgrounds. Henry Herbert La Thangue, who came from a comfortable London middle-class background, settled at Bosham, a fishing village on the Chichester harbour in West Sussex where methods of farming were untouched by modern developments in agriculture. James Charles joined him there, originally from Warrington, an industrial town in the north of England. Edward Stott, from Rochdale, another town in the industrial north, settled at Amberley, a village in rural Sussex where he actively tried to prevent any changes that would effect its age-old appearance. These artists' exodus reflects a much wider pattern of migration whereby the professional middle classes settled in 'cottages' in southern England and savoured a landscape of thatched cottages, hedgerows, copses and green fields.[1] As Howard Newby has noted, 'as the countryside was deprived of its productive importance it became more and more an amenity to be appreciated and consumed'.[2]

There are two conflicting images of rural life in Clausen's Childwickbury pictures. The first celebrates a remote, reassuring quintessential pastoral of Englishness — nostalgic and unchanging. Consider, for example, the fictive sweetness of

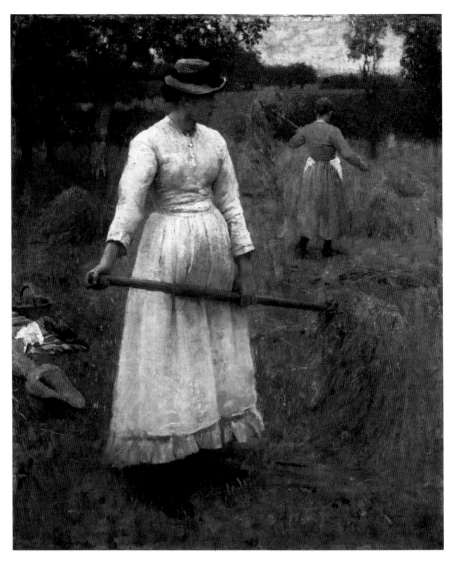

1 George Clausen, *Haying*, 1882, oil on canvas (68.6 x 60.3 cm). Art Gallery of Ontario, Toronto.

2 *Robins*

Haying or *Haytime* (fig. 1), as it was first known. Conscious of the growing appeal that English rural life had to the urban-based English middle class to which he himself belonged, Clausen conspired to fulfil the fantasies of this audience with images that sanitised the realities of rural life. Many such pictures painted by Clausen at Childwickbury play with the trope of sex, femininity and youth. Young country women alone or in pairs, ostensibly haying or tending sheep, but lost in reverie, are depicted in pictures which evoke a longing for a rustic idyll. These pictures found a ready market amongst the new manufacturing rich who were to be Clausen's chief patrons.

But Clausen had ambitions for financial reward and for critical recognition. Perhaps more than any other British artist of the period, he was attuned to ideas about the representation of rural life, and the methods for effecting them, that were current in French Naturalist circles. What counted for these French artists — Jules Bastien-Lepage, Pascal Adolphe Jean Dagnan-Bouveret and others — was the creation of an utterly convincing visual image that could be tied in the viewer's imagination to rural life. The elderly, with their bent and deformed bodies and their wrinkles visible and exaggerated, were a favourite subject of the French Naturalists. There are clear signs that Clausen sought out, and found in the depiction of the elderly, a subject that would satisfy the requirements of the French Naturalists and bring him critical recognition as an avant-garde artist.

These more ambitious pictures *Winter Work* (fig. 2) and *A Woman of the Fields* (pl. I) represented a recognisable old woman who is depicted by Clausen as an agricultural worker. It might be assumed that they are accurate records of English country life. These representations, however, as we shall see, did not sit easily with Clausen's urban viewers. They incited widespread, commonly held prejudices about female agricultural labourers and a hostile critical response that raises important issues about our assumptions about the English countryside at the end of the nineteenth century.

George Clausen was born in London in 1852, but he lived a large part of his adult life in the countryside, where he quickly established a reputation as one of the most successful English rural painters, skilfully combining art and life, reality and fiction, in his images of rural life.[3] Like many other artists of his generation Clausen declared his interest in French paintings of rural life and he made it well known that his two most important artist-heroes were Jean-François Millet and Jules Bastien-Lepage. There are many pictures painted by Clausen using English models set in an English landscape where the debt to Millet and Bastien-Lepage is blatant. 'No two men could be named whose works exercise a greater

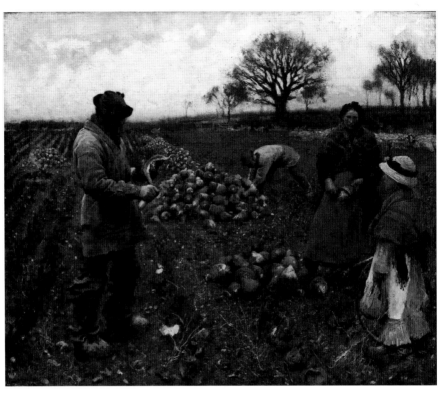

2 George Clausen, *Winter Work*, 1883–84, oil on canvas (77.5 x 92.2 cm). Tate Gallery, London.

influence on painting at the present day', Clausen said in 1888, 'than Millet and Bastien-Lepage.'[4] Clausen was not alone in his admiration.

The life-stories of Millet and Bastien-Lepage were well known. Alfred Sensier's *La vie et l'oeuvre de Jean-François Millet*,[5] which was published in French and English in 1881, encouraged the myth of the rural artist who formed a strong attachment to a particular locale.[6] Bastien-Lepage, the great publicist of the rural experience myth, drew on this when he let it be known that his attachment to his native Damvilliers contributed to the authenticity of his rural subjects. As Clausen pointed out, 'Damvilliers is . . . a small village, not more picturesque or paintable than any other French, or many an English village; and yet a few things, truly seen and recorded there, have made a considerable mark. . . . It is . . . his own home life that he paints — one feels in his work a deeper penetration, and a greater intimacy with his subject.'[7]

Interviews and his own writings suggest Clausen also consciously constructed myths about his experience of living and working in the English countryside. Forming a link to a single locale was a way of securing the illusion of an enduring past within the present, and Clausen, like so many of his generation, consciously sought an English locale to call his own. But without childhood memories, family ties and a long-established attachment, he remained an outsider in the rural communities where he lived. As Christopher Lasch observes, the outsider in a small community remains so because 'his lack of access to a common fund of memories . . . marks him as an outsider.'[8] With no rural roots of his own, Clausen had to invent an association with place.

Clausen said little about the places where he lived and painted, first Hertfordshire, later Berkshire and Essex, and he rarely used place-names when he gave titles to his pictures. The few facts about his life in the countryside that he did provide create a mystique about the simple country life. When asked why he moved to the countryside Clausen was vague about the details. It had been cheaper to live at Childwick Green, he said, and there were better opportunities for working. 'One saw people doing simple things under good conditions of lighting and there was always landscape.'[9]

Childwick Green was a real community, with its own history, when Clausen went to live there for almost three years. The local history collection at St Albans, the census and personal reminiscences, provide a great deal of information, both about the circumstances surrounding the life and the identity of individuals who appear in Clausen's pictures performing tasks of rural work.[10] Such sources reveal that in the years between 1881 and 1884 when Clausen lived at Childwick Green he must have witnessed enormous social and economic upheaval, as traditional ways of country life were destroyed and long-established families of rural labourers were displaced by newer inhabitants. Such facts, however, would have undermined the myth that he was consciously creating in the carefully tailored accounts he gave to journalists.

Clausen neglected to mention that Childwick Green was a small hamlet on the large estate of Childwickbury two miles from St Albans. To enjoy the simple country life Clausen took tenancy of a three-storey, six-bedroom house (fig. 3) which Pevsner describes as 'miniature Jacobean', nestling amongst twelve small cottages surrounded by woodland.[11] Late in 1881 Clausen leased the house from Henry Toulmin who earlier that year had leased the family home, Childwick Manor, and its estate to John Blundell Maple (1845–1903). Blundell Maple bought the house and the surrounding 850 acres outright two years later: 'I am

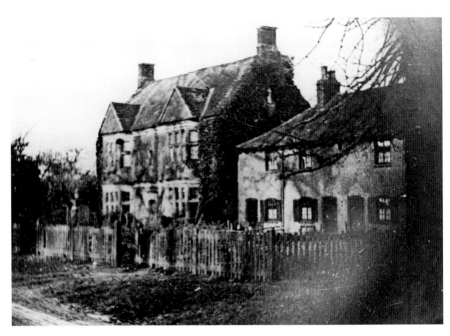

3 Modern print from an 'Academy' plate (3.9 x 3.9 cm) taken by Clausen of houses at Childwick Green. Clausen lived in the house on the left. Photograph courtesy Rural History Centre, University of Reading.

out to buy a place and if I take Childwick it will be with a view to buying it'.[12] Childwickbury's income had derived from mixed farming, but the severe and widespread depression in agriculture, which began in the 1870s, meant that its arable farmlands were no longer economically viable. Blundell Maple had no interest in reviving the tradition of mixed farming. His substantial income came from Maples, the London furniture firm on the Tottenham Court Road founded by his father in 1841.[13] Under Blundell Maple's directorship Maples expanded rapidly in the 1880s and its profits increased dramatically as the firm secured contracts to supply furniture to the new 'monster' hotels, as they were known, that were being built in and around Trafalgar Square. For example, in 1885 Maples furnished the Constitutional Club, Northumberland Avenue, and the Grand Hotel, Trafalgar Square, and the First Avenue Hotel, Holborn. Blundell Maple was 'proud of his connection with the extensive furniture factory in London,' but he had no intention of living above the firm's premises as his parents John and Emily Maple (nee Blundell) had done at first.[14] His newly acquired wealth

brought with it social ambitions.[15] Like many of the other newly rich of his generation, he mingled with the social set that converged around the Prince of Wales. The purchase of a country estate was a necessary acquisition and followed the typical pattern of the rich manufacturing urban-based class in England who bought estates within easy reach of London: 'For a busy man no more convenient place than Childwickbury could have been selected as a country residence which is no more than 40 minutes to London.'[16] St Albans was, in fact, in the throes of changing from an ancient market town to one increasingly attractive to commuters. This reflected a larger pattern of middle-class migration to the counties surrounding London, as the image of London became more and more tainted. The train that Blundell Maple took, from St Albans to St Pancras Station and the firm's factories and shop premises on the Tottenham Court Road, soon became known as the Blundell Maple express.

Sixty years after Henry Toulmin leased Childwickbury to John Blundell Maple, Mary Carbery, Toulmin's daughter, published her reminiscences about growing up at Childwickbury. Published at a moment when the horrors of war made the English countryside even more appealing to the English imagination, *Happy World: The Story of a Victorian Childhood*, is an account of her childhood on the estate. The book is sentimental, as its saccharine title suggests. Nevertheless, it provides a unique glimpse into what could have been a forgotten history. Childwick Green was, according to Carbery, 'a world in itself, made up of the chapel-school, a dozen old-fashioned cottages, the Pig and Whistle, a well with its snudgel[17] coiled above it, and a company of great elms strayed from the green wood across the road'.[18] Mary Carbery was only twelve years old when the family left Childwickbury, and her memoirs are tinged with nostalgia for country life — the quaint country ways of the estate's tenants, the women and girls who made 'a cheerful picture, sitting and standing at their doors among honeysuckle and pinks, chatting together'.[19] She recalls the gardeners, who would have been better known to her than the other estate workers, 'in their white neckerchiefs and white socks, the steel lips of their boots shining'.[20] In Mary Carbery's account it is the enduring aspect of life at Childwickbury that appeals: 'For a thousand years men have been caring for the land, ploughing, sowing, [and] reaping'.

However, this method of farming disappeared after the departure of the Toulmin family from Childwickbury. The estate, which had been devoted to mixed farming, arable crops, some sheep and dairy cows, changed rapidly under John Blundell Maple's ownership. Childwickbury was of course only one of many estates that underwent enormous transformations as a shift in the disposition of

wealth and in cultural and social practices took effect in England at the end of the nineteenth century. What is pertinent is that Clausen lived and worked there during this process of change. He did not witness all of these changes, which continued after he left, but he must have been aware of the momentous significance of the plans that Blundell Maple had for Childwickbury. According to Mary Carbery, as the Toulmin family departed, the tenant farmers and estate workers feared the worst: 'The farmers are shaking in their shoes lest someone should take the farms who would make them pay their rents. The men who work for us are bewildered. Munt was heard to mutter, I just can't leave goo of 'em, and Lee cried openly.'[21]

Clausen's paintings depict several of the agricultural labourers who lived and worked at Childwickbury at the moment when the Toulmin family was living there. To what extent are Clausen's depictions accurate and to what extent do they conform to stereotypical ideas about the English peasant, as Clausen insisted on calling agricultural labourers?[22] By the end of the nineteenth century the peasantry had long since ceased to exist in England. Indeed, the idea of the peasant was an anachronism harking back to feudal times. During Clausen's lifetime the English agricultural economy was based on a three-tier system of landlord, tenant farmers and labourers, who were employed on a seasonal or daily basis. Nevertheless, the term peasant was widely used by commentators on English country life, notably in the writings of the great populariser of the English countryside Richard Jeffries, but also by Francis George Heath, whose first study, *The English Peasantry*, was published in 1874. Almost without exception Clausen's first critics described the agricultural labourers in Clausen's paintings as 'peasants'. 'Few painters have painted the truth about the English peasant as Mr. George Clausen' wrote the critic in the *Magazine of Art*, which was strongly partisan in its support of Clausen's first pictures of English rural life, and *The Graphic* described another picture, *Daydreams*, as depicting 'an old and young peasant-woman'.[23]

The insistence that English agricultural labourers were peasants was far more than a collusion between Clausen and his critics. The belief that a quasi-feudal society still existed, and that English rural labourers were still peasants protected and contained by the old paternalistic system, resembles the operation of folklore as Raphael Samuel has defined it:[24] 'The procedures of the folklorists parallel those of the psychoanalysts in encouraging us to take an essential first step to relate the myths we find not to reality but rather to other myths and to the imaginative complexities which sustain them.'[25]

Clausen's view that the English 'peasant' came from 'the bottom crust of society' and 'was slow to understand, and distrustful of all that lies outside his own experience', reflects, as K. D. M. Snell has shown, a commonly-held middle-class stereotype of the English labourer as a stupid, brutish, lower order of humanity. Few nineteenth-century authors discarded their prejudices when writing about the agricultural labourer. Even Thomas Hardy, to whom Clausen has been compared, drew upon this common image for his rural characters, Snell shows.[26] By referring to English agricultural labourers as peasants Clausen created a social and psychological space between himself and those he depicted. It was convenient to transform the English agricultural worker of the late nineteenth century into the timeless peasant of folklore, and thereby ignore the poor housing, the low incomes, the inadequate diet, and the misery of their daily lives.

Many of the Childwickbury pictures, as I have already mentioned, are idealised images of country life. For example, Clausen probably witnessed the Childwickbury labourers carrying bundles of brushwood, but his representation of this activity in *The Return from the Fields* (fig. 4) draws heavily on the theme of youth and old age—a popular theme in Naturalist painting—and a range of images of work in pictures by Millet, Bastien-Lepage and others. Indeed Clausen's ideas about the representation of rural life were largely acquired from a pool of images gathered from a wide number of sources that had been available to him in London. The Grosvenor Gallery, the French Gallery, and the Continental Gallery regularly showed works by Millet, Bastien-Lepage and other Salon Naturalists: 'At the galleries of two dealers (Deschamps and Cottier) we used to see Barbizon pictures and paintings by Millet, before the Millet boom came on. I remember we went down in a body to see *The Sower* (1850, Philadelphia Museum of Art) by Millet, before it went off to America. These pictures expressed our ideals'.[27] Books and illustrated articles in the newly-founded *Magazine of Art*, which acquired W. E. Henley, an early enthusiast in England for the work of Millet, as its editor in 1882, were another source. In 1881 the Fine Art Society issued *Jean-François Millet's Twenty Etchings and Woodcuts Reproduced in Fac-simile with an introduction by W. E. Henley*, and at some point in the 1880s Clausen acquired six etchings by Millet for his own collection which he lent to the dealer D. C. Thomson to reproduce in his book *The Barbizon School of Painters* (1890). Clausen frequently borrowed from Millet's compositions even in his most Naturalist pictures. Kenneth McConkey has pointed out that the poses of the male and female agricultural labourers in a small oil known as *December, 1883* (fig. 5), which was used as a 'plein air' study for *Winter Work*,

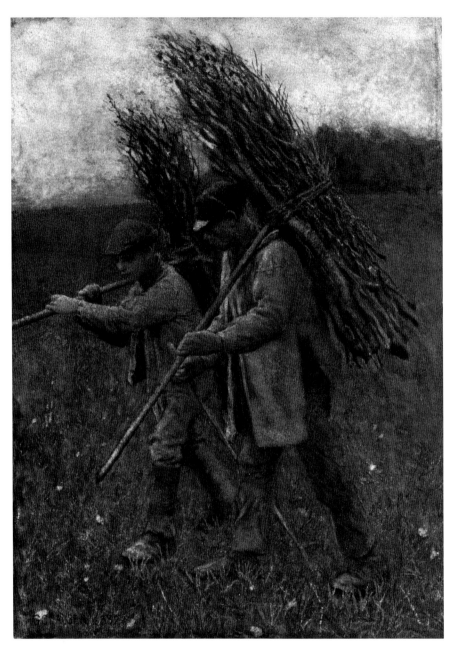

4 George Clausen, *The Return from the Fields*, 1882, watercolour (36.2 x 26 cm). Photograph courtesy of the Fine Art Society.

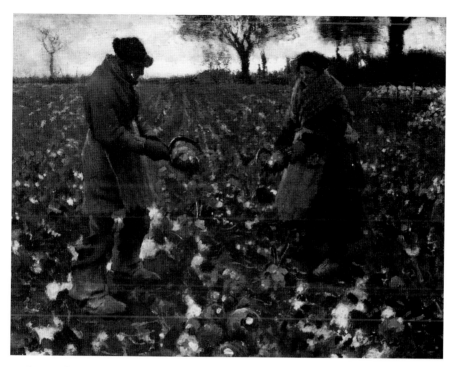

5 George Clausen, *December 1883*, 1883, oil on panel (23.5 x 31.1 cm). Photograph courtesy of the Fine Art Society.

compare to those in Millet's *The Angelus* (1855–57, Musée du Louvre, Paris), which the *Magazine of Art* reproduced in 1882.[28] More pictures were seen on trips to Paris and Quimperlé, Brittany, in 1882 and again in 1884, and there were trips back to London on a train journey which took forty minutes. The world of art sent Clausen to the English countryside in search of rural imagery and the world of art frequently determined what he represented there.[29]

We can establish the identity of some of the people who appear in the Childwickbury pictures, since Mary Carbery's reminiscences and the 1881 census match the names on some annotated sketches by Clausen.[30] Mary Carbery recalled the following people: 'Gibbons and his sons'[31] were George Gibbons, aged 52, the bailiff, and his sons John, aged 18, a farm keeper, Thomas, aged 14, a gardener and Henry, aged 12, a schoolboy; 'Impey' was Thomas Impey, aged 36, the publican, who was married to Elizabeth, aged 30, the chapel school governess who had six children; 'Sharp' was Edward Sharp, aged 36, who had two sons living at home, William, aged 17, an undergardener and Ernest, aged 14, an agricultural

6 George Clausen, *St. Albans Peasant Figures*, 1883 (21 x 13 cm), inscr. t.r. 'William Smith Wednesday [indistinct], agricultural labourer 36 son John Smith 11 agricultural boy', Royal Academy of Arts.

labourer; Hunt was William Hunt, aged 19, an undergardener; 'Weatherly'[sic] the highland shepherd, who Mary Carbery remembered meeting at the Harpenden fair 'looking Londony in a collar and tie, his serious sheep-like face under a brown billycock'[32] was John Wetherby, aged 45, the only shepherd living at Childwick Green. Clausen depicted Wetherby in several pictures including *A Shepherd and a Lamb*, 1883 (Cecil Higgins Art Gallery, Bedford). Other identities can be determined by comparing the annotations on Clausen's sketches with the census. An annotated sketch (fig. 6) for *Labourers after Dinner* identifies William Smith, aged 36, an agricultural labourer, as the man on the right in the picture. His son, John, aged 11, described in the census as an 'agricultural boy', is probably the lad who appears in a number of Childwickbury pictures.

I want now to look again at the pictures that I mentioned at the beginning of the essay. Clausen tested his audience's reactions with two different kinds of painting. For example, both *Haying* and *Winter Work* were sent to the summer exhibition of the Grosvenor Gallery in 1883, where the same audience swooned with delight at the sight of the 'sweet country maids' in *Haying* and backed away

with distaste from *Winter Work. Haying,* I suggested, has a fictive sweetness. Two young women, wearing clean pastel-coloured frocks stand poised with hayforks. There is no suggestion here of the harsh conditions endured by harvesters. Their bodies are eroticised: the delicate profile and tight bodice of the young woman who poses with a hayfork pressed tightly against the top of her thighs, invites and entices; the discarded bonnet of her companion lies amongst a casual array of blankets and cast-off items, including a wicker lunch basket, suggesting a relaxed frolic in the countryside. The two female labourers lift the lush swirls of hay entangled in their forks, effortlessly; their bodies barely register the effort of work. *Haying* was snapped-up by Sharpley Bainbridge the owner of a department store and one of Clausen's new-rich collectors.

Mary Carbery's memoir, however, tells a different story. According to her, haying was an exclusively male occupation: 'When in summer I hear the sound of whetting scythes, and watch the mowers, each on his straight line and spaced so perfectly that there is never a tuft of standing grass between one man's swathe and the next man's, I think this perfection must come from generations of fathers and sons working together, teaching and learning, following one another in a thousand Junes'.[33] There are no men in *Haying,* and certainly there is no allusion to the excessive drinking, quarrels, fights, serious physical injuries and indeed tragedies that represented the historical reality of haying.[34] Moreover, even before the enormous disruptions to life which occurred there after the estate changed hands, full-time employment for young people, especially young women, was rare at Childwick. Many of the younger residents found work elsewhere: several of the young men living at Childwick Green, for example, were railway labourers. There was a far higher proportion of men than women in the village—44 as opposed to 17—and this reflects a pattern of migration that had become commonplace: by the 1880s it was unusual to find young girls older than 13 living at home. With no local employment they took up domestic service in the towns. Traditionally women and girls in the St Albans area had found work as straw plaiters—a local craft. The most highly skilled could plait straw to create highly detailed and differentiated patterns which supplied the braid for the straw hat industry in St Albans. However, cheap imports from China threatened this traditional cottage industry, and by the 1880s straw plaiting was a dying skill. Nevertheless Clausen posed a dark-haired, attractive young woman, who bears more than a passing resemblance to his wife Agnes, in the guise of a straw plaiter (fig. 7). The straw mingles with her hair, and lightly touches her smooth skin; she is the picture of innocence. But in fact, according to the census, only two women—Mary Ann

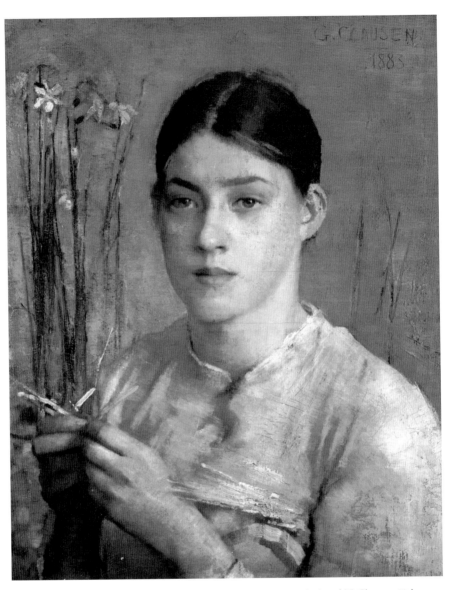

7 George Clausen, *A Straw Plaiter*, 1883, oil on canvas (49.5 x 40.5 cm), signed 'G.Clausen 1883'.
Board of Trustees the National Museums and Galleries on Merseyside, Liverpool.

8 George Clausen, *Figure studies,* 1881,
pencil on brown card (19 x 12.5 cm),
inscr. 'Mrs. Chapman, 60'.
Royal Academy of Arts.

Warren, aged 62, who was a straw hat maker, and Susan Chapman, a widow aged
60 and a tenant in one the cottages at Childwick Green who gave her occupation
as a straw plaiter — declared a connection with this dying trade.

A sketch of an old woman, annotated 'Mrs. Chapman, 60' (fig. 8), in the
Clausen archive at the Royal Academy, together with the 1881 census, enables us
to identify Susan Chapman, who lived alone at Childwick Green, as the woman
whom Clausen depicted as an agricultural labourer in *Daydreams, Winter Work,
A Woman of the Fields* and several other pictures. We cannot however, take the
census, where she is listed as a straw plaiter, as reliable guide as to Susan Chap-
man's occupation. As female field work became increasingly marginal and tem-
porary, women were often contracted on a daily basis to do the roughest and
heaviest work. In April, when the census was taken, very few women would have
been working in the fields. When employed there, however, they continued to
do the backbreaking tasks of pulling, topping and tailing mangolds or turnips,
stone picking, and hoeing and weeding.

Clausen lived in close proximity to Susan Chapman. He could have depicted
her in a variety of different contexts, at home, for example, minding her eight

9 George Clausen, *The Villager*, 1882, oil on canvas (33 x 29 cm), inscr. 'The Villager, Childwick, Herts' on the reverse. Photograph courtesy of Sotheby's.

grandchildren, who ranged in age from 25 to 3 and who lived in a cottage on the tenant farm Childwick Hedges nearby with their parents James, aged 45, a cowman and agricultural labourer, and their mother Elizabeth, aged 44.[35] Susan Chapman probably also stood in her doorway chatting with the other women, as they plaited straw 'with flying fingers, now and then measuring the strip, from nose-tip to arm's length, one yard',[36] or bought goods from the visiting 'Pots and Pans' man. But Clausen did not depict Susan Chapman in this domestic village

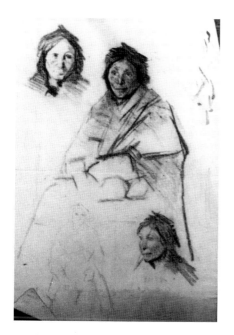

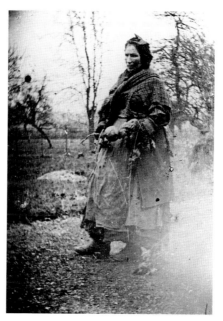

10 George Clausen, *Sketch of Susan Chapman* (21 x 13 cm). Royal Academy of Arts.

11 Susan Chapman, modern print of an 'Academy' plate (3.9 x 3.9 cm) taken by Clausen. Photograph courtesy Rural History Centre, University of Reading.

habitat. Indeed, *The Villager,* 1882 (fig. 9) which depicts an old man seated with an air of relaxed familiarity outside 'The Old Bell', the public house at Childwick Green is, as far as I know, a unique image. In a comparable setting Susan Chapman would have had little sensational value. In Clausen's pictures Susan Chapman's identity is closely connected with the field work she undertakes. After he obtained a small portable Marion Miniature 'academy' camera shortly after they were first manufactured in 1881, Clausen photographed her and the other Childwick Green inhabitants performing the tasks of field work. His photographs, which show workers in carefully selected poses that uphold stereotypical ideas about rural workers, have been referred to as some of the earliest unposed photographs of field workers.

The meticulous on-the-spot notational sketches, the more studied drawings and the photographs Clausen took are methods based on those of the French Naturalist painters whom Clausen admired for their 'wide range and great technical accomplishment'.[37] Clausen saw his commitment to Naturalist ideas as

comparable to those of the novelist and critic George Moore, the first writer in England to use Zola's methods in his novels. According to Moore, Clausen thought 'the blank realism' of Moore's *A Mummer's Wife*[38] — a novel which plots the decline and dissolution of Kate Ede with a scientific candour that omits none of the unsavoury aspects of her habits and character — was similar to his own approach to depicting the Childwickbury agricultural workers.[39] The annotated drawing of Susan Chapman, however, has an intimacy lacking in the subsequent drawings (fig. 10), photographs (fig. 11) and paintings, which depict her as an agricultural labourer standing in the open field. In each image she wears the same clothing — a whitish dress edged with violet which she topped with a man's coat in cold weather, a large apron and a brown tartan shawl — and Clausen followed the precepts of French Naturalism in recording the details of her clothing with meticulous care. The other labourers in *Winter Work* and *Hoeing Turnips* look down, bend forward or turn away, but Susan Chapman with her black widow's bonnet and distinctive clothing, is immediately recognisable. Her weather-worn face, with its broad high cheekbones, looks out at us in *Winter Work*. In *Hoeing Turnips* (fig. 12) she poses, her flat, largish nose in profile.

In spite of their claims to give a heightened sense of reality, the images in Naturalist painting still encode messages about their subjects that reflect commonly held prejudice and belief. As a female field worker Susan Chapman was an object of fascination to Clausen and her presence in these images is signed to fulfil that function. In contrast to *Haying*, *Winter Work* depicts the grimness of agricultural labour. Susan Chapman and her male companions top and tail mangolds, a kind of large turnip used as a fodder for sheep. This was one of the unskilled and unpleasant tasks that women were employed to do during the winter season, a fallow period in the agricultural year. The landscape is bleak, with bare trees silhouetted against the cold, grey, overcast sky. The muddy field, with piles of mangolds amongst the furrows, are uninviting. Susan Chapman stands, forlorn, a mangold clutched in her large swollen hands. In her coarse wool coat, her hitched-up skirt protected by a hessian apron, and her heavy mud-encrusted boots, she is the antithesis of the Victorian ideal of the dewy country maid.

But if Clausen had hoped to gain notoriety with *Winter Work* when he sent it to the Grosvenor Gallery exhibition in 1883, then his plan failed.[40] *The Times* reported that it had been ''wisely skyed'' [sic] and added that it was 'really too ugly' and that it could 'give no pleasure'. Most critics passed over *Winter Work* preferring the 'two comely girls at work' in *Haying*. And it was Clausen's depiction of Susan Chapman as a female agricultural labourer that explains this hostility.

12 George Clausen, *Hoeing Turnips*, 1883, watercolour (37.5 x 50.5 cm). Photograph courtesy of the Pyms Gallery, London.

Earlier in the century, women's field work had been seen as physically healthy and economically necessary. A major turning point in public opinion occurred after the publication of the Parliamentary Report of 1867 (The Royal Commission on the Employment of Children, Young Persons and Women in Agriculture) when clergymen, commissioners and other upholders of public propriety agreed that field work did irreparable damage to the female character. The report investigated mixed field work gangs of men, women and children who were contracted by agents and taken long distances to do field work on a daily basis. The Commissioners found suffering and deprivation and a reputed lack of sexual restraint, and blamed women for the lack of family values and stability. The Reverend James Fraser, later the Bishop of Manchester, reported to the Commission: 'Not only does [field work] almost unsex a woman in dress, gait, manners, character, making her rough, coarse, clumsy, and masculine; but it generates a further very pregnant social mischief, by unfitting her or indisposing her for a woman's proper duties at home'.[41] A changed view of labouring women, expressed by the

male middle class, restricted the opportunities not only in agriculture, but also in other employment previously given to women — for example mining.[42]

As a result of these findings, the Agriculture Gangs Act (1870) curtailed the involvement of women and children by outlawing mixed labour gangs and barring children under eight from working in them. Public opinion increasingly reflected this paternalistic middle-class attitude: a woman's role was seen as that of homemaker and mother. Field work was unsuitable and unnatural.

Winter Work does not depict 'a field gang', as has been suggested, but it does evoke memories of the earlier reporting about mixed field gangs: coarse language, immoral behaviour, dirt and unpleasant smells.[43] Alone with two male field work hands, Susan Chapman is an unpleasant and unwelcome presence. As Alun Howkins points out: 'Unlike the dairymaids of the pastoral regions hidden in the dairies and with their echoes no matter how absurd of Meissen figurines, the field woman could be seen everywhere in the huge fields and open places of the wheatlands … she was the antithesis of the ideal of the angel at the hearth and a constant reproach to those who sought an ordered paternal idyll'.[44] Today, however, the initial impact of *Winter Work* is lost. After the picture's first unsuccessful showing Clausen added the young girl in pink and blue whose satchel identifies her as a school child. Perhaps she is one of several children who attended the chapel school at Childwick Green? Literally and metaphorically, however, her presence softens this grim scene. Her physical proximity makes Susan Chapman, who may perhaps be her grandmother, more maternal, certainly a less threatening presence.

The findings of the 1867 Commission quickly became established fact. When the Naturalist writer, Richard Jeffries first published his detailed scientific reports about country life, his accounts of field women unquestioningly reflected the new prejudices. Jeffries' descriptions of field women emphasised their unnaturalness and depravity, and were clearly meant to elicit a response of pity, horror and disgust in his middle-class urban readership. He emphasised that hard work in the open field in all weather conditions marred and changed a woman's face and body. His scrutinising descriptions were anthropological in their approach: sunburn, roughened skin, dirt and wrinkles and her costume — which consisted of a practical mixture of male and female garments (a man's jacket, a shortened skirt over leather gaiters) — all increased the field woman's oddity.[45]

These texts identified field women as unnatural and depraved objects to be viewed with horror and distaste, and Clausen's representations of Susan Chapman as an agricultural worker must be framed within these English literary and

official texts about female field workers which refashioned the women's image in the public imagination.[46] But such sensationalism was far out of proportion to the number of women doing agriculture work. A recent survey by Alun Howkins suggests that only 63 per cent of women living in the country were agricultural labourers at the high point of the agricultural year (the harvest season) in 1871.[47]

Clausen flaunted the common opinion of field women when he sent another picture of Susan Chapman (pl. I) for exhibition in London in December 1884. The close-up view of her distinctive strong face and wrinkled skin suggests that it is a portrait. However, the picture was first entitled *A Woman of the Fields*, a title which defines Susan Chapman as a sociological category rather than a named individual. (Subsequently it was retitled *A Field Hand* a title that denies Susan Chapman both her identity and her gender.)[48] The critics were vicious in their condemnation. Why represent 'physical ugliness and degradation' without a moral, or a narrative element? asked *The Graphic*.[49] The *Morning Post* agreed, saying that Clausen had made a mistake by drifting into 'grim dreary realism' with his depiction of 'a terrible, old woman with her rugged weather beaten face and her filthy nails'; she was 'ugly and revolting'.[50] The painting was, The *Standard* said, 'a faithful and studious record of a hideousness better ignored'.[51] Even the *Magazine of Art*, which was still under the editorship of W. E. Henley, withdrew its support. Its sensational and horrifying description of an elderly field hand 'with little or no forehead; her cheeks, all weather-worn and coarse . . . purpled in their staring redness; her mouth a mere gash; her hands . . . brutalised with work, with fingers worn to the bone, and stubby, grubby, grimy nails' was intended to elicit a response from its aesthetic urban readers of disgust and repulsion.[52] Susan Chapman, a sixty-two year old widow, skilled straw plaiter, grandmother to eight and occasional field work worker, was a woman of 'the lowest type' with 'repulsive characteristics . . . squalidly attired and very dirty'.[53]

The critic R. A. M. Stevenson later recalled that *A Field Hand* was 'admired by some and hated by others as a piece of thoroughgoing realism, unusual in England at that time, when peasants were represented as unnaturally clean, coquettish, and simperingly pretty'.[54] The English middle-classes, who were making the English countryside their own, wanted no unsettling reminders of its less savoury aspects. This was the decade after all when the more sanitised image of Constable's Suffolk was constructed.[55] On all counts Clausen's images of Susan Chapman as a field hand represented an aspect of English rural life that failed to satisfy the idea of the Englishness of the English countryside that had emerged in the 1880s and that

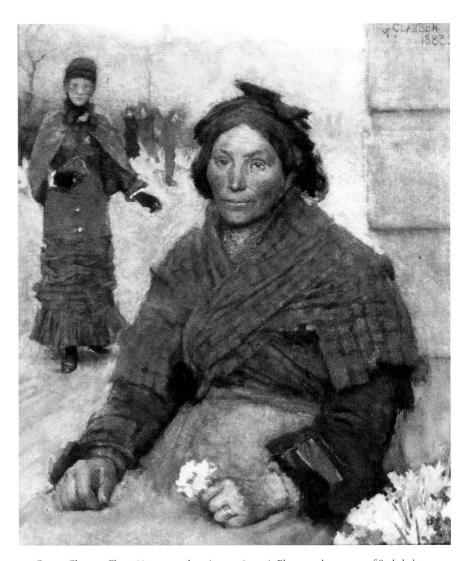

13 George Clausen, *Flora*, 1883, watercolour (32.5 x 28.5 cm). Photograph courtesy of Sotheby's.

served to counter earlier reports and findings. Above all, the abuse and hostility was provoked because Clausen's depictions of a female field work hand transgressed what Karen Sayer has called 'the myth of rural femininity'.[56]

By the 1880s, the English middle-classes associated filth, poverty and deviant sexuality with the cities from which they wanted to escape. Therefore, it is perhaps not surprising that in an urban setting the figure of Susan Chapman did

not provoke hostility as the response to *Flora* (fig. 13), a watercolour exhibited by Clausen in 1883, shows. The watercolour is close to an earlier sketch (fig. 10), but Clausen has transposed the figure to another setting. In *Flora*, Susan Chapman, wearing the same rough man's overcoat and hitched-up skirt that she wears in *Winter Work* and the other Childwickbury pictures, poses as a London flower seller. Her cut off figure is depicted seated against a wall, the harsh lines of her face are softened, she clutches a bunch of yellow primroses that contrasts with the touches of violet on her wrist and neck. The young respectably dressed woman who stops on the street to look gazes at us, inviting sympathy. The flower seller, of course, is a recognisable London type whose representation had a long history in popular illustration. Transposed to this safe and familiar context, recast as a flower seller, the figure of Susan Chapman posed few problems. In the words of the same *Magazine of Art*, which had expressed such distaste when confronted by *A Woman of the Fields*: 'In point of view of humanity it is the best thing he has done. . . . There is something very touching in the expression of the old flower-seller's face, in the ingenious contrast of her weather-beaten aspect and poverty-stricken figure with the fresh flowers'.[57]

By the time Clausen sent *A Woman of the Fields* to exhibition in 1885 many changes had taken place at Childwickbury. After Blundell Maple purchased the estate in 1883 he quickly developed it as a vast playground devoted to leisure and pleasure. I cannot list the changes in chronological sequence but I do know that they were extensive. The most significant was that much of the estate's arable land was made over to a stud farm. By 1884 Blundell Maple had acquired his own racing colours and within ten years he had over three hundred blood stock breeding over one hundred foals a year. New stables were built; a model dairy with five cows to provide milk for home consumption was erected and three hundred acres of parkland surrounding the old manor house, to which he added a conservatory and a billiards room, were landscaped as a pleasure garden with an extensive rose garden. Around 1885 twelve new model cottages were built at Childwick Green to house the grooms and stable hands, and at least some of the thatched cottages surrounding Clausen's Jacobean house, which originally housed the agricultural labourers, were torn down. By December 1884 Clausen had abandoned his initial plan to live the simple country life and was living in St Albans.[58] But country life was essential to his new identity and shortly afterwards he moved to Cookham Dene in Berkshire before settling in Essex.

Clausen was well on his way to making a reputation as a painter of rural life. When the first full-length feature about him appeared in the art press in 1890, *A*

Field Hand, as the picture was now known, was still being discussed. R. A. M. Stevenson, the author of the article, claimed that Clausen still found 'peasant life interesting, if for no other reason than it is the bottom crust of society'.[59] But Clausen was to abandon the style he formed at Childwickbury: 'I pursued the method until I found myself facing a dead wall. I could go no further, and had to retrace my steps.'[60] John Blundell Maple continued to prosper acquiring two more estates, one near Childwickbury and another at Newmarket. In 1891 he bought the common at Childwick Green for 15,000 guineas, thus depriving the local inhabitants of their age-old rite of access, and replaced feudal privilege with various kinds of philanthropy.[61] The 1891 census shows that few of the original inhabitants at Childwick Green continued to live there. Only four of the thirty-nine families from 1881 are listed as being still there in 1891. These include Susan Chapman, still living alone. No longer modelling for Clausen and without other employment she is recorded as 'living on her means'.[62]

1 I am grateful to David Peters Corbett and Fiona Russell for their comments on an earlier draft of this essay. For further discussion of the exodus by La Thangue, Charles and Stott see Anna Gruetzner Robins, 'British Impressionism: The Magic and Poetry of Life Around Them', in Norma Broude, ed., *World Impressionism: The International Movement, 1860–1920* (New York: Harry N. Abrams Inc., 1990), 85–87. For a discussion of the colonisation of the rural south of England by the intelligentsia and the professional middle classes see Alun Howkins, 'The Discovery of Rural England', in R. Colls and P. Dodd, eds., *Englishness: Culture and Politics 1880–1920* (London: Croom Helm, 1986); also Howkins, *Reshaping Rural England: A social history 1850–1925* (London: Harper Collins Academic, 1991); and Jan Marsh, *Back to the Land* (London: Quartet, 1982).

2 Howard Newby, *Country Life* (London: Weidenfeld and Nicholson, 1987), 107.

3 He was born in the London borough of St. Pancras, at 8 William Street, 18 April 1852 and attended St. Mark's School, Chelsea until 1867 when he left to work in the drawing office of Messrs. Trollope, a firm of decorators while attending evening classes at the National Art Training School, South Kensington.

4 George Clausen, 'Bastien-Lepage and Modern Realism', *The Scottish Art Review* (1888), 114.

5 Alfred Sensier, *Jean-François Millet, Peasant and Painter*, trans. Helena De Kay (Boston: J. R. Osgood, 1881).

6 For the myth-forming effect of Sensier's biography see Christopher Parsons and Neil McWilliam, '"Le Paysan de Paris": Alfred Sensier and the Myth of Rural France', *Oxford Art Journal* 6.2 (1983): 38–58. Parsons and McWilliam point out that Sensier's critical writing is an affirmation of values located in the past.

7 Clausen, 'Bastien-Lepage and Modern Realism', 114–15.

8 Christopher Lasch, *The True and Only Heaven: Progress and Its Critics* (New York: Norton, 1991), 104.

9 George Clausen, 'Autobiographical Notes', *Artwork*, no. 25 (Spring 1931), 19; cited in Kenneth McConkey, *Sir George Clausen, R.A. 1852–1944* (Bradford: Bradford Museum and Art Gallery, 1980), 29.

10 I am indebted to Harriet Perkis, St Albans Museum, who kindly allowed me access to a press cuttings file on Childwickbury in the museum's local history collection.

11 I am indebted to Stafford Mortimer who very kindly sent me a copy of his scrapbook about Childwickbury.

12 Mary Toulmin Carbery, *Happy World: The Story of a Victorian Childhood* (London: Longmans & Co., 1941), 216. The exact date of Clausen's arrival is unknown. The census was taken in April 1881 while the Toulmin family was still in residence at Childwickbury although they were to leave within a matter of weeks. When Clausen married Agnes Mary Webster, 1 June 1881, he was still living at 4, The Mall, Hampstead in north London. It is possible that Clausen had an earlier connection with Blundell Maple. In the 1870s he worked designing furniture and decorations and before leaving London he lived near John and Emily Maple, Blundell Maple's parents, who lived at Bedford Lodge, Haverstock Hill, Hampstead.

13 For a history of the firm see Hugh Barty-King, *Maples: Fine Furnishers. A Household Name for 150 Years* (London: Quiller Press, 1992).

14 *Hertfordshire Advertiser*, 1 November 1890.

15 He won a Conservative seat in the House of Commons in 1887, was knighted in 1892 and made a Baronet in 1897.

16 *Hertfordshire Advertiser*, 1 November 1890.

17 A chain with hooks for bringing up pails from the well.

18 Carbery, *Happy World*, 163.

19 Carbery, *Happy World*, 163.

20 Carbery, *Happy World*, 162.

21 Carbery, *Happy World*, 215.

22 A folder of drawings by Clausen of the Childwickbury labourers, now in the collection of the Royal Academy, is inscribed 'St Albans Peasants'.

23 *The Graphic* thought *Hoeing Turnips* depicted 'male and female peasants', 3 May 1884, 247.

24 For a discussion of the complexities of the term peasant, see Griselda Pollock, 'Revising or Reviving Realism', *Art History* (1984), 361–62.

25 Raphael Samuel and Paul Thomson, eds., *The Myths We Live By* (London: Routledge, 1990), 43.

26 See K. D. M. Snell, *Annals of the Labouring Poor. Social Change and Agrarian England 1660–1900* (Cambridge: Cambridge University Press, 1985).

27 J.M. Gibbon, 'Painters of the Light. An Interview with George Clausen, R.A.', *Black and White* (8 July 1905), 42; cited in part by McConkey, *Sir George Clausen, R.A. 1852–1944*, 57. Clausen thought this was the version of *The Sower* now in Boston; however, it is more likely to have been the version in the Philadelphia Museum of Art, as

McConkey points out, which was shown at Durand-Ruel's Gallery, London in 1872.

28 Kenneth McConkey, 'Figures in a field — *Winter Work* by Sir George Clausen, R.A.', *Art at Auction, The Year at Sotheby's 1982–83* (1983), 72–77.

29 See Christiana Payne, *Toil and Plenty. Images of the Agricultural Landscape in England 1780–1890* (New Haven and London: Yale University Press, 1993) and 'Boundless Harvests: representations of Open Fields and Gleaning in Early Nineteenth Century England', *Turner Studies*, 2.1 (Summer 1991): 7–15.

30 1881 census, St Albans, St. Michael's District.

31 Carbery, *Happy World,* 156.

32 Carbery, *Happy World,* 180.

33 Carbery, *Happy World,* 161.

34 See David Hosean Morgan, *Harvesters and Harvesting 1840–1900: A Study of the Rural Proletariat* (London: Croom Helm, 1982).

35 It is possible that James Chapman was her brother not her son.

36 Carbery, *Happy World,* 164.

37 George Clausen, 'The English School in Peril: A Reply', *Magazine of Art* (November 1887), 223. Evidence suggests that Clausen consciously pursued the underlying philosophy of Naturalism. Fred Brown, one of his close associates who accompanied him on a painting trip to France in 1882 and who later joined the London Impressionists and became Slade Professor, recalled 'At St Albans ... you were my artistic guide, philosopher and friend' (unpublished ms., 7 May 1940, Brown to Clausen, Clausen Papers, Royal Academy of Arts).

38 George Moore, *A Mummer's Wife* (London: Vizetelly & Co., 1885).

39 See George Moore, 'Exteriority', *The Speaker* (22 June 1895).

40 It could hardly have gained the approval of Joseph Comyns Carr, one of the directors of the Grosvenor Gallery, who as editor of the *English Illustrated Magazine* campaigned to preserve rural values, country lore and what he saw as an English way of life. See Kenneth McConkey, 'Rustic Naturalism at the Grosvenor Gallery', in Susan P. Casteras and Colleen Denney, eds., *The Grosvenor Gallery. A Palace of Art in Victorian England* (New Haven and London: Yale University Press, 1996), 129–46.

41 The Reverend James Fraser, 'Reports from the commissioners on the Employment of Children, Young Persons and Women in Agriculture', *Parliamentary Papers* (1867), 16, cited in Karen Sayer, *Women of the Fields. Representations of Rural Women in the Nineteenth Century* (Manchester and New York: Manchester University Press, 1995), 78.

42 For a discussion of women miners see Griselda Pollock, 'With my Own Eye: Fetishism, The Labouring Body, and the Colour of its Sex', *Art History* 17 (September 1994): 342–82.

43 Kenneth McConkey makes this observation in *British Impressionism* (Oxford: Phaidon, 1989), 26.

44 Howkins, *Reshaping Rural England,* 107.

45 [John] Richard Jeffries essays on country life which were serialised in the 1870s were published in several volumes including *Hodge and his Masters*, 2 vols. (London: Eldar & Co., 1880).

46 Moreover, Clausen must have been aware of the controversy that Bastien-Lepage's depiction of a female peasant in *Les Foins* had caused at the Grosvenor Gallery. McConkey, 'Rustic Naturalism at the Grosvenor Gallery', 134 cites the British response, which draws heavily on prejudices about class and gender, to the female labourer in *Les Foins* when it was exhibited at the Grosvenor Gallery in summer 1880. 'Her vacant, broad face looking out in an abstraction which has no thought in it, but merely the passive dreaming of an animal' ('Pictures of the Year', *Magazine of Art* (1880), 400), and 'a pure descendant of the primeval Eve as first evolved from the gorilla' (*Illustrated London News* (8 May 1880), 251).

47 Howkins, *Reshaping Rural England,* 102.

48 For other discussions of this picture see Gabriel Weisberg, *Beyond Impressionism. The Naturalist Impulse in European Art 1860–1905* (New York and London: Harry N. Abrams Inc., 1992), 111, where the picture is entitled *Head of a Peasant Woman* and Kristi Jean Holden, 'George Clausen and Henry Herbert La Thangue: The Construction of English Rural Imagery; 1800–1900', PhD diss., The University of Minnesota, 1996, 463–66. Holden usefully quotes some of the critical commentary cited in my text; however the conclusions drawn are my own.

49 *The Graphic*, 6 December 1884.

50 *The Morning Post*, 7 December 1884.

51 *The Standard*, 6 December 1884.

52 *The Magazine of Art* (1885), 134–35. The picture is reproduced as *A Field Hand*.

53 *The Morning Post*, 7 December 1884.

54 R.A.M. Stevenson, 'George Clausen', *The Art Journal* (October 1890), 292.

55 For a discussion see Stephen Daniels, 'John Constable and the Making of Constable Country', *Fields of Vision. Landscape Imagery and National Identity in England and the United States* (Cambridge: Polity Press, 1993), 200–42.

56 Karen Sayer, *Women of the Fields,* 1. I am indebted to this work for much of the background information about attitudes to field women.

57 *The Magazine of Art* (1883), 438.

58 The catalogue for the Institute of Oil Painters winter exhibition 1884–85 lists his address as 22 London Road, St Albans. In May 1885 he moved to Cookham Dene, Berkshire.

59 R.A.M. Stevenson, 'George Clausen', 292.

60 George Moore reported this conversation with Clausen in 'Exteriority', *The Speaker* (22 June 1895).

61 *Sporting Sketches*, May–June 1894. This forms part of the press cuttings file on Childwickbury, in St Albans Museum.

62 1891 census, St Albans, St. Michael's District.

'Toilers of the Sea': Fisherfolk and the Geographies of Tourism in England, 1880–1900

Nina Lübbren

IN RECENT DECADES, there have been numerous critical analyses of the representation of rural village life in nineteenth-century Europe. However, none deals with the pictorial representation of life in coastal fishing villages.[1] This is surprising, given the immense popularity of the painting of fisherfolk, particularly in the last two decades of the nineteenth century. In terms of sheer numerical presence, fisherfolk were, next to peasants, the single most popular genre subject in the Royal Academy's annual exhibitions between 1880 and 1900.[2] Between 1870 and 1910, coastal Cornwall became the most painted region of Britain outside London, followed only by another coastal place, the fishing village of Whitby in East Yorkshire.[3] This essay constitutes a first critical study of the important but hitherto neglected theme of fisherfolk in late nineteenth-century painting. While there are some justified points of comparison between fisherfolk and peasant representations, my argument here is based on the premise that paintings of fisherfolk constituted an important, popular and, above all, distinctive genre in late nineteenth-century art. I will also argue that the genre provides crucial insights into the wider developments of those cultural practices and habits of looking associated with modern tourism. I should stress that I am not so much interested in the economic or social history of fishing villages in Victorian England as in the pictorial representation of these places and their inhabitants by urban painters who were producing works for an urban audience. That is, I am concerned with the metropolitan bourgeois myth of fisherfolk as constructed and propagated through images, articles and tourist guides.

We may identify a number of constitutive ingredients of this bourgeois myth, some of which were shared with the parallel myth of the peasant. Indeed, the comparison of fisherfolk with peasants was a recurring trope within nineteenth-century texts on the subject.[4] The attributes which both stereotypes shared were those of supposedly pre-industrial communities: both peasants and

fisherfolk were imagined to be poor and hard working, and to be preserving traditional ways of life and intact social relationships. Fisherfolk were, however, distinguished by specific characteristics, arising from their contact with the sea. These can be summed up in the phrase: heroic struggle in the face of constant danger. Most of the above rhetorical tropes can be found *in nuce* in one of the rare texts on fisherfolk as subjects for art, an article written in 1886 by the critic R. J. Charleton on the popular artists' haunt of Cullercoats, a Northumbrian fishing village:

> Much has been said and written, and justly so, concerning the picturesqueness and pathos to be found in the lives and employment of the tillers of the soil. . . . Yet, take it at its noblest and best, [the labour of tilling the earth] lacks the fascination which the element of danger adds to the calling of the toilers of the sea . . . for those who seek their living in the sea, without sowing go forth to reap their harvest; and then, not in peaceful fields where safety dwells, but in the deep waters where death is ever lurking to find them unprepared.[5]

These remarks sum up the main late nineteenth-century stereotypes associated with images of fisherfolk that I will address in this essay. Fisherfolk were compared with peasants — the 'tillers of the soil' versus the 'toilers of the sea' — but in contrast to the peasant, who was seen as being tied to the soil, fisherfolk were imagined as hunters, not as farmers or husbandmen. They were further ennobled by the glow of mortal danger cast over their profession, and by the implied heroism arising from the struggle against it. Fisherfolk were located in geographical space in 'the deep waters', a liminal and, for landlocked urban art audiences, exotic location loaded with connotations of danger and death — very different to the familiar idylls of the countryside conjured up by the image of peasants.

In what follows, I will address these themes: similarity to and difference from peasants; danger and heroism; the associations of the coastal location. Crucially, I will suggest that images of fisherfolk were not about actual fisherfolk in any direct sense but were, rather, representations of the way contemporary urban bourgeois audiences were coming to terms with modernity. Images of coastal villages did not reflect or illustrate the reality of life in those villages, despite claims to the contrary by contemporary artists and critics. Instead, representations of supposedly pre-industrial fishing villages articulated specific urban concerns about modernity, in particular modernity as it manifested itself along the coastal regions of England. That modernity was experienced by art's urban audiences primarily in the form of seaside leisure tourism, and the connotations of the coast

as perilous shifted gradually, so that by the late 1890s, pictures of 'toiling' fisherfolk had largely given way to more peaceful representations of coastal life. In a world that seemed to be changing at an increasingly rapid rate, pictures of simple pre-industrial villagers, seemingly untouched by the developments of technology, industry and commerce, and plying their centuries-old trade, served as reassurance that, while life in the city centres might be changing, life in the villages went on, timelessly, as it always had. The function of providing reassuring images for the urban bourgeoisie was shared between paintings of fisherfolk and paintings of peasants. The insistence on constructing a world of pre-industrial 'primitive' labour, unencumbered by the vagaries of fashion and change prevailing in the cities, underpins paintings of inhabitants of both coastal and landlocked villages. Just as painters of agricultural labourers excluded steam threshers and telegraph poles from their canvases, so painters of fisherfolk nearly always banished steam trawlers, recently erected piers, the rail transport of fish (modernising forces within the fishing industry), and newly built hotels, pleasure yachts and urban bathers (the modernising impact of tourism) from their canvases.

In this sense, the argument about fisherfolk follows in the footsteps of Robert L. Herbert's seminal article on the rural image in late nineteenth-century French painting. Herbert argued that the sheer number of peasant paintings in this period articulates artists' nostalgic evocation of a way of life in the face of the steadily spreading effects of the urban-industrial revolution and the actual depopulation of rural areas.[6] Peasant paintings have this in common with fisherfolk paintings; both conjure up an alternative world to that of their urban-bourgeois audiences, a place that was geographically somewhat distant from the urban and semi-urban spaces of modernisation. The German ethnographer Klaus Bergmann has termed this nostalgic view of the countryside 'Agrarromantik': agrarian romanticism.[7] My contention is that there was a romanticism of the coast as well.

Painters of coastal regions were not only reacting to the effects of modernity by retreating into pre-modern subject matter; their practices and productions also actively participated in the construction of a modernity by the seaside, both in a material and an ideological sense. The principal ways that modernity was actually making itself felt in coastal areas was in the shift of sea-going vessels from wind-driven to steam-powered ships, and in the transformation of fishing villages into seaside resorts for urban tourists. The former phenomenon is significantly absent from paintings of fisherfolk. Pictures such as Stanhope Forbes' *A Fish Sale on a Cornish Beach*, G. P. Jacomb Hood's *The Fisher-Folks' Harvest* or G. S. Walters' *Toilers of the Sea* show only sailing vessels and old-fashioned fish

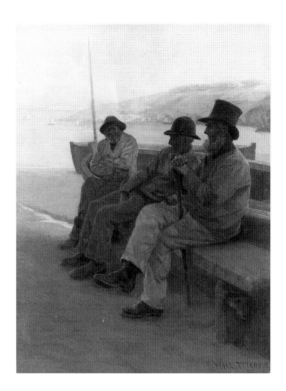

14 W.H. Titcomb, *Old Sea Dogs,*
1891. Nottingham Castle Museum
and Art Gallery.

markets, not steam trawlers and the modern mass packing of fish for long-distance transport into cities, recently made possible by the development of freezer technology.[8] However, the second manifestation of coastal modernisation, that of tourism, was closely bound up with the travels and practices of seaside painters themselves. It is through the lens of the modern phenomenon of mass tourism that coastal paintings of fisherfolk can be best understood.

Before I go on to examine the relationship of fisherfolk paintings to the contemporary expansion of the tourist industry, it is worth defusing some initial reservations concerning the modernity of fisherfolk paintings. After all, at first sight, late nineteenth-century English paintings of fishing villages would seem to have precious little to do with the representation of modernity, if modernity is taken to mean the experience of modernisation. Art historians investigating 'the painting of modern life' have focused on artists who engaged in a direct way with the manifestations of modern urban or leisure life, particularly on those who combined an interest in modern subject matter with an experimental handling, form and facture. This bias has resulted in the privileged study of the French Impressionists and their followers and in a marked neglect of anything else.[9] If

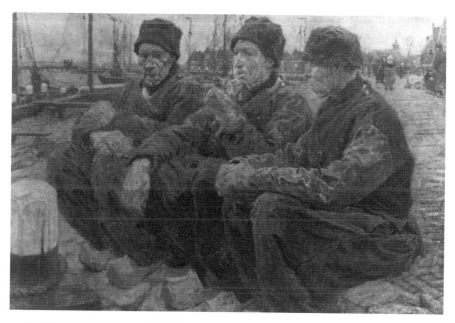

15 Paul Rink, *On the Dyke*, 1902. Volendam Museum, Volendam, The Netherlands.

we compare, for example, Stanhope Forbes' *A Fish Sale on a Cornish Beach* with paintings of the seaside by Monet, Manet, Morisot or Degas, we would have to concede that the Impressionist works, with their leisure-seekers in modern dress and steam ships on the horizon, appear to engage much more directly with the modern experience of the coast than do Forbes' anecdotal and semi-academic depictions of rugged fisherfolk. Juxtapositions of this kind only underscore yet again the supposed backwardness of late Victorian and Edwardian art, measured against developments in the avant-garde art worlds of Continental Europe and especially France. However, English art in this period was actually much less insular or retrograde than is commonly suggested. The view of English backwardness can only be upheld if we take a comparatively small group of French Impressionist and Post-Impressionist paintings as the yardstick for all other art across Europe, and indeed, the world—a profoundly ahistorical position, yet one that prevails with astonishing tenacity within Anglo-American art history and criticism. As soon as we study what was actually exhibited and discussed in contemporary art magazines, both in terms of quantity and popularity, a more complex picture of late nineteenth-century art emerges.[10]

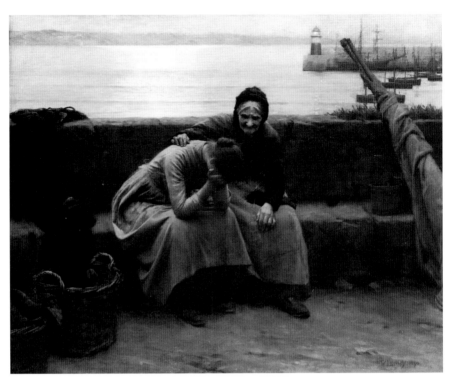

16 Walter Langley, *Never Morning Wore to Evening But Some Heart Did Break,* 1884, Birmingham Museums and Art Gallery.

At one level, fisherfolk in England can be seen to fulfil a kind of substitute function for artists recently returned from Europe and on the look-out for peasants to paint. England did not offer the picturesquely costumed peasants that Europe did, and fisherpeople were the next best alternative to European peasants for artists in England, as far as costume, regional identity and what were perceived to be traditional lifestyles were concerned. In 1889, the art critic Alice Meynell wrote of Newlyn and St. Ives: 'Both places, being fishing villages, have an always paintable population. A fisherman in a jersey is one of the few modern Englishmen not burlesqued by his garments'.[11]

Paintings of fisherfolk produced in England share basic formal and iconographic characteristics with their counterparts in continental Europe. These counterparts are today largely forgotten, at least within mainstream art history, and this has distorted our perception of English examples. Painters treating fisherfolk included the Irish Henry Jones Thaddeus, the Portuguese José Julio de

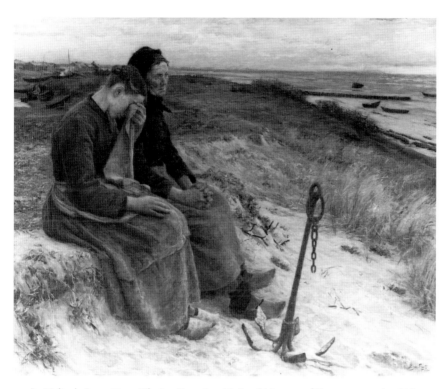

17 José Julio de Sousa Pinto, *The Lost Boat*, 1890, National Museum of Contemporary Art, Lisbon.

Sousa Pinto, the French Alfred Guillou, Jean-Charles Cazin and Emile Renouf, the German Hans von Bartels, the Dutch Paul Rink, the Danish Michael Ancher and the American Howard Russell Butler. A comparison of W. H. Titcomb's *Old Sea Dogs* with Paul Rink's *On the Dyke*, of Walter Langley's *Never Morning Wore to Evening But Some Heart Did Break* with José Julio de Sousa Pinto's *The Lost Boat*, or of Stanhope Forbes' *A Fish Sale on a Cornish Beach* with Henry Jones Thaddeus' *Market Day in Finistère* (figs. 14–18) reveals a commonality of choice of motif, of composition, treatment of figures, preference for grey-brown colour schemes, of choice of model (rustic fishing types) and poses taken from academic modelling practice (note the women leaning on their hands in Thaddeus' and Forbes' paintings). An academic style gesturing towards the Old Masters is tempered by pictorial elements signifying plein-air practice. This type of painting was produced and exhibited in huge numbers all over Europe.[12] Far from being retrograde or pursuing their own eccentric insular course, English fisherfolk

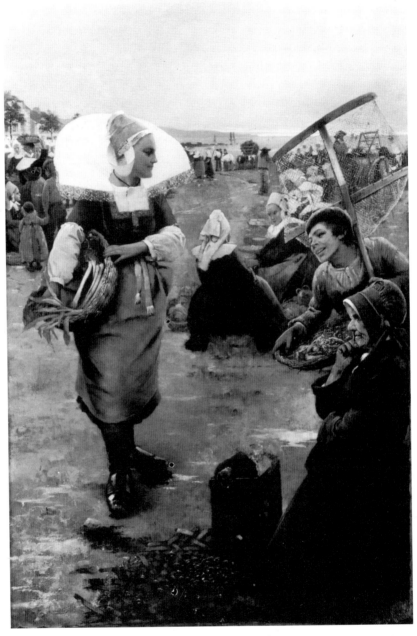

18 Henry Jones Thaddeus, *Market Day in Finistère*, 1882. National Gallery of Ireland, Dublin.

paintings of the late nineteenth century were part of an international trend in artistic plein-air practice.

In paintings of fisherfolk, fishing was seen from the artists' shorebound point of view. In other words, the fleet's voyage out to sea was figured by men's absence from the feminine domain of the fishing cottage or by indexical markers of the fishing process, such as fish being sold, shared, carried in baskets or collected from boats,[13] and anxious or bereaved women, gazing out at sea or lost in grief.[14] A very common way of signifying the peculiarity of a fishing community was to represent a domestic arrangement in which the (young and middle-aged) men were missing (fig. 19).[15] A female-dominated domestic world was set up that echoed the world of intact domestic family life represented in earlier British and contemporary Continental paintings of peasants (fig. 20).[16] This was a tamed and cleaned-up peasantry whose customs and habitus had more to do with nineteenth-century bourgeois values of family life than with actual conditions in rural areas.[17] Paintings of the interiors of fishing cottages provided similar reassurances of the alleged continuance of 'traditional' family and gender relations to urban middle-class audiences. Langley's and Burger's interiors (figs. 19 and 20) are just poor enough to be picturesque but otherwise neat and tidy, complete with scrubbed floorboards, curtains, tablecloths, wall decorations and other accoutrements of middle-class domesticity, and its inhabitants are well-groomed and respectably behaved. However, paintings of fisherfolks' domesticity such as Langley's *Memories* (fig. 19) and Bramley's *Hopeless Dawn* (pl. II) show a family structure that has been disrupted. It is troubled by the absence of the men at sea, and this absence is cast in a tragic light.

Bourgeois urban families were also sometimes painted in the breach, as in William Quiller Orchardson's *Mariage de Convenance* (1884, Glasgow Museums: Art Gallery and Museum, Kelvingrove) or Augustus Egg's earlier cycle *Past and Present* (1858, Tate Gallery). However, in fisherfolk paintings, this disruption was naturalised. Whereas the urban families are disturbed by degenerate forces from within, fishing families were afflicted by the external forces of fate. The young woman in Bramley's *A Hopeless Dawn* casts herself on the floor in an abandoned posture of sorrow not out of horror at her own moral downfall (as in the central scene of Egg's cycle) but out of grief for her husband lost at sea.[18] Both Egg's and Bramley's canvases show disrupted families but the former is disrupted by internal failure and feminine corruption, the latter by external fate and kept together by feminine faith and long-suffering.

The representation of fisherfolk was closely linked to the representation of specific places, namely of coastscapes, and the fisherfolks' natural abode was

19 Walter Langley, *Memories*, 1885. Birmingham Museums and Art Gallery.

understood to be the fishing village. This may appear to be obvious but historical studies show that fishing fleets were actually not fixed at a particular port but followed travelling shoals of fish up and down the coast. Newlyn boats, for example, were away from home for up to three months on end.[19] They fished off the coasts of East Anglia and Yorkshire, and, by the 1880s, as far away as Shetland and the Caledonian Canal.[20] Staithes fishermen sailed north to Aberdeen in the early summer and ended up in Lowestoft in the autumn, following the movements of the herring shoals.[21] Such roaming across diverse fishing grounds portended a way of life not focused, as in the agricultural sphere, on a specific spatial domain or on the ownership of land. As the vicar of Newlyn said around 1888, 'No man claims an acre of ocean as his own'.[22] The openness of the oceans to all comers constituted a problem for the fishermen of the late nineteenth century, as, indeed, it continues to do for the fishermen of the European Union today.[23] However, this is not what concerned artists. The largely nomadic and homosocial existence at sea where men and boys lived, worked, and slept together in a confined space, mending their own clothes and cooking their own

20 Anton Burger, *The Country Meal*, 1894. Stadelsches Kunstinstitut, Frankfurt am Main.

meals, was not depicted by artists. In fact, pictures of fishermen at sea were very rare, partly for the practical reason that artists could not join them on their voyages. Such a subject, however, could have been imagined on canvas (even if not observed at first hand), and fishermen willing to take on board an artist for a suitable fee could no doubt have been found. One Mr. Fryer did accompany Cornish fishermen on a vessel off Land's End.[24] Practical obstacles should not blind us to the fact that artists *chose* not to paint fishing life on the high seas. Depictions of actual fishing were confined to scenes that were observable from the shore, for example, the popular Cornish subject of 'tucking' pilchards (that is, the removal of fish from the large seine-nets into smaller, so-called tuck-nets for transport ashore).[25]

The presence of a tragic aspect is distinctive for the painting of fisherfolk, as opposed to the painting of peasants. Fisherfolk were associated with danger and death by drowning. Paintings showing dramatic episodes involving fishing boats lost at sea during a storm were very popular in late nineteenth-century England.[26] Let us examine one painting of drama at sea in more detail, namely

21 Walter Langley, *Disaster! Scene in a Cornish Fishing Village*, 1889, Birmingham Museums and Art Gallery.

Walter Langley's *Disaster! Scene in a Cornish Fishing Village* (fig. 21).[27] To convey the danger and drama of a storm at sea, Langley here employed a technique akin to that used in the depiction of battle scenes in traditional theatre: on-stage spectators describe the action which takes place off-stage.[28] We do not witness the drama of the boats at sea first-hand but must imagine it, prompted by the actions and emotions visible in the people on shore. A pier wall serves to obscure our view of the actual water. We see only white and grey streaks of paint, indicating the spray and foam of churning waves, above the parapet. The tension of the episode is conveyed by two principal figures: the young girl left of centre, facing the viewer directly with wide-open eyes, worry-lines above the nose, tensed eyebrows and drawn lips, and the man in sou'wester and oilskin, in the right middleground, lifting his hands around his opened mouth, in the attitude of someone shouting out a message to unseen personages outside the picture frame. Both of these are reinforced by secondary figures, echoing the emotion: the little girl hiding her face in the central woman's skirt and the lad at top left, who lifts his arm in a gesture of warning and alarm. The drama is divided into a masculine and a feminine camp: imperilled and active men versus shorebound, anxious women. The entry for this watercolour in the Whitechapel Art Gallery exhibition catalogue of 1902 aptly commented: 'Whether in calm or storm, the lives of the fisherfolk are never far removed from sorrow'.[29]

Such narrative dramas of anxiety, action, grief and death seem to be England's particular contribution to the fisherfolk genre. Paintings referring to turbulent conditions at sea, produced on the Continent, tended to be more muted in tone, downplaying the actual violent event and focusing perhaps on the anxious looks of some women out to sea (fig. 17) or on a grieving widow at a grave.[30] I am not entirely sure why drama-filled paintings of fisherfolk should be peculiarly English but would like to suggest two possible reasons. First, the English penchant for fisherfolk drama may have been animated by developments specific to the art world itself: it may owe much to the often remarked upon literariness of English art. Fisherfolk paintings turned specific locations into stages for stories, which can be quite complex in their narrative structure.[31] Second, we might emphasise the role of the sea in Britain as a setting for heroism. The historian Linda Colley has pointed to the ways in which definitions of British (as opposed to English, Welsh or Scottish) nationhood are connected with a particular relationship to the sea: 'Rule Britannia, Britannia Rules the Waves' (that is, nationhood is displaced from the homeland onto the oceans), and (therefore) 'Britons never will be slaves'.[32] It is tempting to draw parallels between the free

Britons of national song and the hardy fisherfolk-heroes, not 'tied to the soil'.

The projection of heroic qualities onto painted figures is rarely found in contemporary images of peasants, but it sounded the dominant note in fisherfolk paintings.[33] Charleton singled out the element of ever-present mortal danger as the defining moral characteristic of the locals of Cullercoats, that which lifted them above the common run of humanity.[34] 'It is this tragic element, underlying their [the fisherfolks'] life, which adds an interest to all its phases, deeper and more enthralling, the more you know of it . . . The companionship of the sea and its perils gives a dignity to the character of those who keep it.'[35] Alice Meynell was impressed by the Newlyn fishermen's bearing which betrayed a familiarity 'with the sky and with horizons' and concluded that 'men who have the habit of seeing something farther off than the other side of the street, certainly look the worthier human beings'.[36] Another commentator lauded Newlyn fishermen as 'a fine lot of fellows': 'no better sailors on England's coast than these'.[37] Praise of the men's sailing skills invites comparison with the Navy, although echoes of Britain's naval domination are faint, if detectable at all in images and critics' comments. The rhetoric of fisherfolk as courageous and robust runs through nineteenth-century writings, as it does through paintings: fishermen are 'hardy and adventurous',[38] exposed to 'dangers and to hardships',[39] they 'braved the dangers of the deep without the slightest prospect of being rewarded for their often successful daring'[40] and we 'admire [their] spirit of heroic self-sacrifice'.[41] Peter Howard has characterised the entire epoch of English art between 1870 and 1910 as the 'heroic period', and identified the heroic fisherman as one of the great stereotypes of the age.[42] Fisherfolk were represented as transcending poverty and other social strictures, and pitted in an age-old battle against the elements. Unlike Henry La Thangue's aged ploughman (*The Last Furrow*, 1895, Oldham Art Gallery), fisherfolk were not beaten by circumstance; they might die but they did so as heroes, and the character and will of survivors remained unbroken.

Fisherfolk were also people on the edge of the isle, on the edge of society, tinged with a touch of exoticism. One visitor assumed a mixture of 'Spanish blood' in Newlyn's women, and Laura Knight thought that some of the Staithes men looked a little like Vikings.[43] Contemporary tourist guides and other travel writers further cashed in on the frisson provided by the image of the adventurous fisherman, playing up smuggling and shipwrecking themes in their descriptions of Cornwall and its inhabitants.[44] The sociologist Rob Shields discusses the liminal nature of the seashore with regard to the status of beaches as sites of carnivalesque rituals: 'The seashore's shifting nature between high and low tide,

and as a consequence the absence of private property, contribute to the unterritorialised status of the beach, unincorporated into the system of controlled, civilised spaces'.[45] This argument, employed by Shields to explain the attractions of Brighton as a pleasure resort, may also serve to illuminate the fascination for urban audiences of fisherfolk: a people perceived to be indigenous to the liminal zone of the coast; as being somewhat outside the conventional regimes of behaviour; and as in touch with a darker, more dangerous coast than the holiday beach. The stereotype of the heroic adventurer sits uneasily next to the image of the tamed, domestic fishing family discussed above, but it was perhaps the tension between these two opposing possibilities that made the image of fisherfolk so interesting and attractive to city-dwellers.

Tragedy at sea was not entirely an urban and visual fabrication, of course. In actuality, fishermen's lives continued to be frequently endangered at sea in late nineteenth-century England (and Europe).[46] However, the accident record of Cornwall was actually very low compared with that of the modern trawling fleets based in East Coast ports, notably at Hull and Grimsby. Between 1884 and 1894, over 2000 men and boys were lost at sea in trawling accidents, making the death rate of trawlermen seven times that of in-shore fishermen.[47] Recent historians have attributed the high death-rate among trawlermen to the fact that these men were employees of vessel owners who were less concerned with the safety of their crew than with increased fish quotas. Cornish fishing vessels, on the other hand, operated on a shared co-operative system which depended on strong family ties.[48] Deaths at sea were thus much more common within the industry of trawling, which was based on capitalist conditions of production than within the more traditional, family-based fishing enterprises beloved of painters. It must be noted that painters of fisherfolk focused almost exclusively on 'old-fashioned' modes of fishing. Artists ignored trawlers and the political issues arising from their activities for local fishermen, despite the presence of trawlers in some of the ports where artists were working (for example, large numbers of East Anglian and Devon trawlers berthed in Newlyn's new harbour in the 1880s and 1890s).[49] As noted above, there is little direct trace of modernity present in images of fisherfolk, and accidents at sea were represented as inevitable blows of fate and natural disasters, never as indictments of profit-driven malpractice.

This unwillingness to confront industrial transformations in contemporary society was, of course, not confined to English painters of fisherfolk. It is a pan-European and widely remarked phenomenon of nineteenth-century painting.

22 A. Stanhope Forbes, *Beach Scene, St. Ives*, 1886. Bristol City Museum and Art Gallery.

Painters rarely chose to represent industry; instead, their engagement with the modern took place in the realm of leisure. My discussion here is indebted to T. J. Clark's seminal insights on the representation of modern leisure in Paris and its environs by Manet, Monet, Degas and others in the 1870s and 1880s.[50] Clark argues that these painters represented the modern primarily as leisure, and that it was new forms of leisure which informed both the form and subject matter of their images. Other authors, notably Nicholas Green and Robert Herbert, have extended Clark's argument to areas farther afield from Paris than Argenteuil or Asnières and linked the representation of landscape and the landscape's inhabitants to one particular modern form of leisure, namely tourism.[51]

To illuminate the way in which representations of fisherfolk were caught up in the cultural practices of modern tourism, it is useful to consider the paintings as informed by specific place-myths. Rob Shields coined the concept of place-myth to characterise a widespread set of core images of a place which often prevails regardless of actual local realities.[52] Place-myths are made up of stereotypes and clichés and, I would argue, are primarily reinforced and spread through repetition.

Paintings of coastal locations can be understood as collectively constructed and maintained representations of place-myths. Let us look at two examples.

The contrast between the almost contemporaneous paintings by Stanhope Forbes, *Beach Scene, St. Ives* (fig. 22) and *Fish Sale on a Cornish Beach* (the former executed in St. Ives, the latter in Newlyn) is striking. The small sketch is suffused with light and atmosphere. Figures are not worked out in the meticulously academic fashion of most compositions of fisherfolk but sketched with broad, abbreviated brushstrokes. The high-keyed palette, strong contrasts between light and shade and reduced detail conjure up the optical experience of being outside on the beach on a sunny day, exposed to the glare of sand and sun. *Fish Sale*, by contrast, lives off the play of reflections on the wet sands and the grey-in-grey tonality of figures, sand, fish, water and sky. Not one leisure seeker is in sight. *Beach Scene, St. Ives* is reminiscent of modern seaside paintings by French artists associated with Impressionism, such as Manet's *On the Beach at Boulogne*, Morisot's *Villa at the Seaside* or Degas's *Beach Scene*.[53] In such paintings of seaside resorts, we see leisure-seekers in modern urban dress, bathers, parasols, soft yellow sand or colourful pebbles, sunshine, steam ships on the horizon and all the paraphernalia of beach leisure still familiar to us today from our own sun-and-surf holidays. The contrast with fisherfolk paintings is striking. Every aspect — plein-air naturalism as opposed to sketchy execution, overcast skies as opposed to sunny weather, rugged salts as opposed to metropolitan vacationers — contributes to the construction of difference.

Largely, these contrasts are to be explained by artists' choice of different geographical locations, and I will return to this point below. Occasionally, however, we can observe the transformation of one location from fishing village to seaside resort. St. Ives appears as the former in canvases such as *Fisherman, St. Ives* by Anders Zorn and *Off St. Ives* by Adrian Stokes,[54] but Stanhope Forbes painted *Beach Scene, St. Ives* as a leisure beach, abandoning the naturalism of his fisherfolk canvases for a sketchy technique and light-hued palette, akin to the French Impressionist beach scenes mentioned above (and particularly reminiscent of Boudin). In images of pleasure beaches, even the loose brushwork and the high-keyed palette seem to have taken on some of the relaxed spontaneity associated with seaside leisure.

Forbes' two paintings articulate two diverse and even conflicting place-myths of the coast: the modern beach resort and the pre-modern fishing village. Each place-myth exerted its own pressures upon artistic representation in terms of facture, composition and so forth but the resultant images also tell us some-

thing of the way these two villages were developing towards the end of the nineteenth century. It is to be noted (and I shall return to this point below) that in this period, painters of St. Ives privileged idyllic scenes of boats at anchor and views of surf, sand and skies, over the figurative fisherfolk dramas popular in Newlyn, speaking to the ideal of solitary immersion in nature sought by beach holidaymakers.[55] To a large degree, the two locations are today shaped by these differences: St. Ives is a flourishing tourist resort that has successfully marshalled its artistic heritage to add to its other attractions of sea and winding lanes, while Newlyn is now the fourth largest fishing port in the United Kingdom but touristically quite undeveloped.[56]

The individual locations of Newlyn, St. Ives, Falmouth and other Cornish coast towns all partook of the larger place-myth of Cornwall. The urban pictorial place-myth of Cornwall had cast the peninsula as a region of fisherfolk. Yet, fishing was by no means the only, or even the most statistically impressive, industry of Cornwall. In 1901, over 23,000 people in Cornwall were engaged in agriculture, over 13,000 in mining, almost 10,000 in building and carpentry, but only 3,743 in fishing.[57] Miners, while described in tourist guidebooks, did not appear in artists' pictures at all. As one anonymous critic pointed out in 1882, those 'callings are eminently poetical and artistic which deal with the more elementary labours of man', with husbandmen, shepherds, fishermen and hunters heading the top of the list while factory labour and mining were regarded as aesthetically unworthy.[58] Thus the entire duchy of Cornwall was constructed by artists as a land of pre-modern fishermen and women and depopulated of miners, carpenters or even agricultural workers. Nor, it might be added, did fisherfolk painters depict the increasing number of tourists to the area.

In the latter half of the nineteenth century, it was arguably tourism more than any other activity which informed most urban audience's images of the coast. City-dwellers equated the coast with the seaside, and the seaside was imagined as a place of holiday leisure, characterised by beaches, bathing huts, yachting, seaside entertainments, relaxed codes of deportment and dress.[59] Seaside tourism had taken off in the first half of the nineteenth century, with the population growth of English coastal resorts at one point exceeding that of manufacturing towns. By 1911, an estimated fifty-five percent of English and Welsh people went on at least one seaside trip every year.[60] In 1859, Cornwall became the last English county to be connected to the national railway network, and almost immediately, the tourists followed.[61] Hotels were built, leisure activities offered, guide-books written, artists' colonies established, and fishing boats were

hired out to holidaymakers.[62] By 1881, over half of the active population of Cornwall and Devon were engaged in the service sector, in particular in tourist services, thereby giving the region a distinctively modern occupational profile.[63]

One can trace the progressive touristification of fishing villages in subsequent editions of early guide-books. In 1850, *Murray's Handbook for Travellers in Devon and Cornwall* warned visitors away from 'those antiquated fishing towns which are viewed more agreeably from a distance'.[64] By 1859, the same handbook granted that the interiors of fishing cottages 'will exceedingly delight artists who entertain "a proper sense of dirt"', thereby adumbrating the area's imminent appeal as a pictorial subject, as a spectacle to be looked at by outsiders.[65] St. Ives began to turn itself into a watering place almost as soon as it was connected to a branch line of the Great Western Railway in 1877.[66] In 1879, *Murray's Handbook for Travellers in Cornwall* still cautioned visitors to St. Ives against the 'effluvia of the cellars' and, while praising the sea-views, conceded that 'a descent into the streets ... will ... somewhat qualify the travellers' admiration'.[67] Eight years later, Baedeker's guide-book of 1887 praised the same town's 'splendid sandy beach' and directed the visitor to 'the best views'. The place had in the interim 'become a favourite bathing and winter resort'.[68] In 1897, one visiting artist wrote about St. Ives: 'There is just enough fishing life going on to give animation, the old town itself is picturesque, the sea is a beautiful colour, while the strands are so good that bathing and swimming are as good as the most exacting could wish.'[69]

By 1893, every trace of earlier criticism had vanished from *Murray's* guide-book. The place-myth of St. Ives had now been entirely assimilated to the tourist gaze. St. Ives was audaciously compared to 'a Greek village', with picturesque cliffs 'richly tinged with aerial hues'. A 'descent into the street, narrow and tortuous', far from qualifying the visitor's initial impression (as it had done earlier), now 'reveals new charms to the lover of the quaint and picturesque'. The former 'effluvia' had miraculously transformed themselves into an 'aroma', and were now, at any rate, confined to the 'fishing-quarter'.[70] The prime attributes of St. Ives as a tourist resort were of a visual nature: beautiful hues, splendid views, and all signs of the village's former incarnation as a fishing port subsumed under the heading of the 'picturesque'. Pictorial equivalents abound: see, for example, Helene Schjerfbeck's *View of St. Ives* or Algernon Talmage's *Evening at St. Ives*.[71]

The high moment of fisherfolk painting came at a time when many of the painted villages (which were also chosen abodes of artists) were no longer entirely traditional fishing ports nor were they yet fully-fledged tourist resorts. John Urry has noted that the rural countryside harbours two principal institu-

tions: 'traditional' ones which appear to be 'naturally' part of the environment (in the case of coastal places, fishing fulfils this function), and new leisure/tourism facilities.[72] Tourists use (and used) the institutions of tourism while on location, but seek to see the 'traditional' as a guarantor of their authentic experience in a supposedly pre-industrial location. Robert Herbert described similar moves with regard to the Normandy coast, as painted by Monet.[73] To execute his paintings of the 1880s, Monet turned his back on the casinos and hotels of Etretat and Pourville and represented the view that tourists sought to see and immerse themselves in, much as visitors to this day prefer to take photographs of empty sands and palm trees rather than of crowded beaches lined with high-rise developments.[74] While Monet's privileging of an immersive experience in nature may be embedded in a tradition of the sublime seaside, as delineated by Alain Corbin, the late nineteenth-century English seaside experience seems to have worked itself out largely (though not exclusively) in the pictorial form of the fisherfolk image.[75]

It needs to be stressed that paintings of pre-industrial fisherfolk are just as much indebted to the emergent tourist gaze of the late nineteenth century as the more direct depictions of seaside leisure, and their exclusions and inclusions are predicated upon the contemporary tourist map of coastal regions. Artists in fishing villages were inevitably caught up in the tourist matrix of their time, despite their own protestations to the contrary.[76] In villages, artists replicated the tourist gaze. Painters viewed their surroundings as a spectacle, or to phrase it differently, as a tourist sight. They shared this mode of viewing with their urban audiences, and this common attitude was instrumental in the popularity of fisherfolk paintings. Fishing itself was, for artists and tourists, an impressive or picturesque sight rather than an economic activity.[77] And one symptom of artists' indebtedness to the tourist gaze is their appreciation of the sea view.

The view, as we have seen in the guide-book texts on St. Ives, was (and is) an essential part of the tourist expectations of a place. In coastal villages, this meant a view of the sea. Gazing at the sea as a 'view' is a quintessentially touristic activity (see fig. 24). Local inhabitants were much less interested in this view. Until the late eighteenth century, most houses in coastal villages turned their backs upon the sea and were often situated behind a dyke.[78] In the old part of Newlyn village, very few houses commanded a sea view, and most had only small windows.[79] Fisherpeople did not seem to need or wish to be reminded of the sea when they were not actually near or out on it. When coastal villages were transformed into tourist resorts, the situation changed. The prized sea view formed a

23 Frank Wright Bourdillon, *The Jubilee Hat*, 1887. Courtauld Institute of Art, London.

24 Robert Jobling, *On the Rocks: Tynemouth*, 1886. Engraving in *The Magazine of Art*, 1886, p. 459, illustration for R.J. Charleton's article 'Cullercoats'.

principal attraction for tourists, and hotels, pensions, and casinos were all crowded along the coast, windows facing the sea. Baedeker's *Handbook for Travellers* of 1887 listed five hotels in Penzance, noting that the Union was 'comfortable, but with no view of the sea'.[80] In 1866, the Penzance Town Council even tried to ban Newlyn fishermen from drying their nets in front of one beach hotel, presumably because this might spoil the view.[81] As we have noted, Murray's guide-book praised the 'splendid sea-views' of St. Ives.[82] The activities that mattered to painters were those that were conducted by fishermen and women against the backdrop of such 'splendid sea-views', and views crop up even in unlikely Newlyn interiors. In Bramley's *Hopeless Dawn* and Bourdillon's *Jubilee Hat* (pl. II and fig. 23), we glimpse a sunny sea view in the distance through a lace-curtained window. In *A Hopeless Dawn*, the sea view is necessary to motivate the narrative; but in *Jubilee Hat* it serves simply as a picturesque backdrop. In both paintings, though, the sight through the window is reminiscent of *Murray's* 'splendid sea views'. Other contemporary commentators also represented seaside villages in terms of views, letting the eye 'range' over the view

'without interruption', catching 'pretty glimpses' of harbour and houses,[83] praising the 'beautiful spectacle' or the 'beautiful scene' of a fishing fleet departing out to sea in various weathers.[84]

Let me return now to the critic R. J. Charleton who introduced this essay. Charleton opens his article with the claim that one cannot appreciate the fishing village of Cullercoats until one has spent some time there. 'It is not a place which strikes you at first sight as being eminently picturesque, and it is hard to account for the fact of its having been such a favourite with so many English artists, until you know it better'.[85] This is a typically anti-touristic move: the superficial observer (or tourist) will pass this place by while the more discerning traveller or anti-tourist will take time to appreciate its more hidden attractions. Charleton continues by claiming that, at first sight, the place is no different from 'many another fishing village which is merging into a watering place'.[86] It is interesting that the writer mentions a 'watering place', that is, a tourist resort, as if the experience of Cullercoats can only become intelligible within the discourse of tourism, although he himself is concerned to liberate it from that very discourse. The remainder of the article is taken up by a discussion of the dangerous lives led by the hardy and dignified fisherfolk. The narrative reaches its emotionally charged high point in a scene during a storm: the women gather anxiously on the shore, the fleet appears but one coble is wrecked on the rocks, the lifeboat is launched but is swept away again, and so forth. It is during this scene, when 'the sky darkens' and 'the very air seems charged with the possibilities of tragic disaster', that the 'secret of the place' is finally revealed (compare fig. 22 on p. 44).[87] Charleton, like fisherfolk painters, forms part of the crowd on shore, or rather, he does not really form part of it because he himself is not directly involved — no relative of his is on any of the boats. He is a spectator, and the anxious happenings are transformed in his eyes, and in the eyes of all coastal painters, into a spectacle. He is engaged in a kind of disaster voyeurism. We are in a world far removed from the tranquil or jolly pleasures of a seaside resort but it is a touristic world of exciting spectacles, nevertheless. There are overtones here also of an earlier Romantic rhetoric where the sea embodied a dangerous but sublime spectacle. As early as the 1830s, tourists were enjoying the view of the sublime from the safety of their promenades or hotels. Emile Souvestre had written of the Breton coast in 1833: 'What a curious and gripping spectacle it is to see a shipwreck at night in our bays'.[88] And in 1836, another French writer told in a humorous anecdote how, during a stay in Ostend, he and other patrons of a café on the dyke had used their binoculars to watch a possible catastrophe unfold.[89]

25 Anton Mauve, *At Scheveningen*, 1887. Rijksmuseum Hendrik Willem Mesdag, The Hague.

In conclusion, I reiterate the crucial point that modernity was (and is) not only to be experienced in cities but also in non-urban areas. Modernisation left its mark on all geographic locations. This had direct economic consequences for fishing villages, as traditional fishing was replaced by new industries, such as mining (as at Staithes), by modern fishing practices (as at Newlyn) or by tourist-related enterprise (as at St. Ives). It was the latter transformation that played itself out in the paintings of fisherfolk. The development of fishing towns as tourist places stood in inverse proportion to the viability of the fishing industry in those towns. The more backward and traditional a village was perceived to be, the higher its potential attractiveness for tourists and for artists. Even as fishing towns were modernising their harbour fronts and building hotels, artists, journals and exhibitions continued to circulate images of pre-modern fisherfolk. These images acted as nostalgic reassurances of the continuity of traditional ways of living for bourgeois, urban audiences at the same time as they provided interesting spectacles of a dangerous and adventurous occupation which tourists wished to observe, but by no means to share in, when visiting coastal resorts.

For many seaside places, the last decades of the nineteenth century represented a transition period during which tourists were taking over while fishing was still

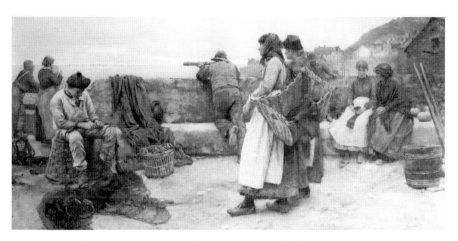

26 Walter Langley, *In a Cornish Fishing Village – Departure of the Fleet for the North*, 1886. Penlee House Gallery and Museum, Penzance.

going on. This transition was not, of course, confined to England alone. A painting by the Netherlandish artist Anton Mauve, set on the Dutch North Sea coast at Scheveningen (fig. 25), shows fashionably dressed tourists on a café terrace gazing out to sea across a beach which is still populated with fisherwomen in regional costume. Such confrontations between tourist and local were not painted by English artists. However, we could interpret fisherfolk gazing out to sea in paintings such as Langley's *Departure of the Fleet* (fig. 26) as acting as surrogate figures for the artists/tourists who are not themselves depicted. Mauve's and Langley's pictures share certain compositional features: a group of figures, separated from the sea by a wall or fence, looking out toward the horizon. Both, I would argue, represent the gaze of the seaside tourist, enjoying the view and scanning the distance for signs of fishing drama. Mauve shows us tourists directly. But Langley's figures, though clothed in the guise of fisherfolk models, are just as much representatives of that tourist gaze as are Mauve's city folk. The anecdotal and naturalistic details which animate Langley's scene serve to disguise the touristic nature of the protagonists' spectating as much as to enhance the viewers' illusion of witnessing an actual event. Late nineteenth-century fisherfolk paintings while appearing to treat a pre-modern subject, are actually (and because of that) quintessentially modern in nature.

This essay is an extended version of a paper given at the conference 'Rethinking Englishness: English Art 1880–1940' at the University of York in July 1997. I would particularly like to thank David Peters Corbett for inviting me to the conference as well as all the delegates who expressed an interest in fisherfolk. Comments and suggestions made by Ysanne Holt, James O'Brien, Mary Beal, Jane Beckett, Andrew Stephenson and one other unidentified member of the audience were particularly helpful. I am also indebted to Christopher Clark for his critical perusal of the text.

The epithet quoted in the title 'toilers of the sea' is taken from R.J. Charleton, 'Cullercoats', *Magazine of Art* (1886), 461. It is also the title of a painting by G. S. Walters, illustrated as an engraving in *The Magazine of Art* (1882), 5.

1 On the painting of peasants, see especially Robert L. Herbert's ground-breaking essay, 'City v Country: The Rural Image in French painting from Millet to Gauguin', *Artforum* 8 (1970): 44–55. See also Klaus Bergmann, *Agrarromantik und Grossstadtfeindschaft* (Meisenheim am Glan: Verlag Anton Hain, 1970); James Thompson, *The Peasant in Nineteenth-Century French Art*, exhibition catalogue (Dublin: Douglas Hyde Gallery, 1980); Kenneth McConkey, 'Rustic Naturalism in Britain', in Gabriel P. Weisberg, ed., *The European Realist Tradition* (Bloomington: Indiana University Press, 1982); Caroline B. Brettell and Richard R. Brettell, *Painters and Peasants in the Nineteenth Century* (Geneva: Skira, 1993); Ingeborg Weber-Kellermann, *Landleben im 19. Jahrhundert* (Munich: C. H. Beck, 1987); Christopher Wood, *Paradise Lost: Paintings of English Country Life and Landscape, 1850–1914* (London: Barrie and Jenkins, 1988); Doris Edler, *Vergessene Bilder: Die deutsche Genremalerei in den letzten Jahrzehnten des 19. Jahrhunderts und ihre Rezeption durch Kunstkritik und Publikum* (Munster and Hamburg: Lit Verlag, 1992), esp. ch. 3.1, 'Der ländliche Lebensraum'.

2 Based on paintings illustrated in Henry Blackburn, ed., *Academy Notes with Illustrations of the Principal Pictures at Burlington House* (London: Chatto and Windus, 1878–1903). I evaluated all rural and coastal scenes, including landscapes or riverscapes, with or without figures, village scenes, genre scenes involving fisherfolk, peasants, shepherds or other rural folk, scenes in fishing villages, seascapes with or without fishing vessels. Excluded are marines with battleships, and coastscapes (i.e. views of the shore painted from inland). The number of rural scenes in proportion to the number of coastal scenes is as follows: 1878: 30/2; 1879: 27/10; 1880: 21/8; 1884: 24/9; 1885: 26/14; 1888: 35/23; 1889: 21/26; 1890: 29/24; 1895: 19/13; 1896: 20/7; 1897: 38/7; 1900: 40/10; 1903: 31/11. Although these statistics cover only the Royal Academy (and only those paintings chosen for illustration in the Royal Academy Notes), they retain representative value because the Royal Academy contained a large cross-section of the year's pictorial output and was a venue for popular paintings. The frequency with which paintings of fisherfolk were chosen for illustration is in itself an indicator of popular and critical response. The above figures are corroborated by Peter Howard's statistical analysis of landscapes exhibited at the Royal Academy between 1871 and 1910; see Howard, *Landscapes: The Artist's Vision* (London and New York: Routledge, 1991), ch. 6, 'The Heroic Period 1870–1910'.

3 Howard, *Landscapes: The Artist's Vision*, ch. 6. On an individual level, a number of painters made their careers by specialising in fisherfolk genre, notably members of the Newlyn artists' colony, in particular Stanhope Forbes and Walter Langley. A glance at Langley's biography reveals that whenever he departed from the subject of Cornish fisherfolk, his sales figures dropped. See Roger Langley in *Walter Langley: Pioneer of the Newlyn Art Colony*, ed. Elizabeth Knowles (Bristol: Sansom & Co. in association with Penlee House Gallery and Museum, Penzance, 1997).

4 For examples, see Anon, '"The Fisher-folks' Harvest" by G. P. Jacomb Hood', *Magazine of Art* (1882), 36 and frontispiece; J. G. Bertram, 'The Unappreciated Fisher Folk: Their Round of Life and Labour', in *The Fisheries Exhibition Literature*, 2 (London: William Clow & Sons, 1884): 200; Vice-Admiral HRH The Duke of Edinburgh, 'Notes on the Sea Fisheries and Fishing Population of the United Kingdom', *The Fisheries Exhibition Literature*, 2:29 ('those who . . . reap the precarious harvest of the sea'); Charleton, 'Cullercoats', *Magazine of Art*.

5 Charleton, 'Cullercoats', *Magazine of Art,* 460–61.

6 Herbert, 'City v Country: The Rural Image in French painting from Millet to Gauguin', esp. 44–45.

7 Bergmann, *Agrarromantik und Grossstadtfeindschaft*.

8 A painting like Stanhope Forbes' *The Lighthouse* (1894, Manchester City Art Galleries) is a rare example which does include a steam boat in the middleground: the exception that proves the rule. I thank Ysanne Holt for pointing this out to me. On new technologies and their repercussions on traditional fishing, see Jeremy Tunstall, *The Fishermen* (London: Macgibbon and Kee, 1962), 19–21; Fritz Bartz, *Die grossen Fischereiräume der Welt: Versuch einer regionalen Darstellung der Fischereiwirtschaft der Erde*, 1 (Wiesbaden: Franz Steiner Verlag, 1964): 92–102; Paul Thompson with Tony Wailey and Trevor Lummis, *Living the Fishing* (London: Routledge and Kegan Paul, 1983), 9–22.

9 The position that only modernist paintings deserve to be studied as serious expressions of the experience of modernity has most recently been reiterated by Stephen F. Eisenman, 'Introduction: Critical Art and History' in *Nineteenth Century Art: A Critical History* (London: Thames and Hudson, 1994), 7–13.

10 Few studies of this kind exist. But see Nina Lübbren, *Rural Artists' Colonies in Europe, 1870–1910* (Manchester: Manchester University Press, 2001), and Lübbren, 'Touristenlandschaften: Die Moderne auf dem Lande', *Anzeiger des Germanischen Nationalmuseums* (Nuremberg, 1999), 63–69, and Edler, *Vergessene Bilder*. Revisionist treatments of the period have, unfortunately, tended to replace one set of canonical works with another, thereby reducing complexity again to a simple model of polar opposites; see, e.g. Gabriel P. Weisberg, *Beyond Impressionism: The Naturalist Impulse in European Art, 1860–1905* (New York and London: Harry N. Abrams and Thames & Hudson), 1992.

11 Alice Meynell, 'Newlyn', *Art Journal* (1889), 98. Stanhope Forbes was enthusiastic about the 'costume' of Newlyn: 'Perhaps the attire of a fisherman comes as near deserving the name as anything we can show (in this country)', Stanhope A. Forbes, 'A Newlyn Retrospect', *The Cornish Magazine* 1 (1898): 86. Elsewhere, however, he compared the Newlyners' 'fringes, pigtails, crinolettes and other freaks of fashion'

unfavourably with his models in Brittany. Forbes, letter to his father, Newlyn 17 February 1884; quoted in Kenneth Bendiner, *An Introduction to Victorian Painting* (New Haven and London: Yale University Press, 1985), 111. A writer in the *Magazine of Art* in 1885 averred that 'the English peasant, who has dropped such distinctive costume as he ever wore, and arranges himself instead in a shabby genteel imitation of his social superior, is far from picturesque', quoted without reference in Michael Jacobs, *The Good and Simple Life: Artist Colonies in Europe and America* (Oxford: Phaidon, 1980), 144.

12 Selected further comparisons:

Stanhope Forbes, *The Slip* (1885, Richard Green Gallery, London, illustrated in Caroline Fox, *Stanhope Forbes and the Newlyn School*, Newton Abbot: David and Charles, 1993, 26) and Alfred Guillou, *Unloading Tuna at Concarneau* (n.d., Musée d'Histoire, Saint-Brieuc, illustrated in *La Route des peintures en Cournouaille, 1850–1950*, Groupement Touristique de Cornouaille, 1993), 79

Harold Knight, *Grief* (c.1901, private collection, illustrated in Peter Phillips, *The Staithes Group*, exhibition catalogue, Nottingham Castle Museum, 1993, frontispiece) and Emile Renouf, *The Widow of the Island of Sein* (1880, Musée des Beaux-Arts, Quimper, illustrated in *La Route des peintres*, 44)

Walter Langley, *Departure of the Fleet* (fig. 26) and Hans von Bartels, *Dutch Fishwives Waiting for the Return of the Fleet* (n.d., Katwijks Museum, Netherlands, illustrated in *Katwijk in de schilderkunst*, exhibition catalogue, Katwijk, Netherlands: Katwijks Museum and Genootschap, 1995, 104)

Percy Craft, *Heva! Heva!* (c.1888, Penlee House Gallery and Museum, Penzance, illustrated in Caroline Fox and Frances Greenacre, *Artists of the Newlyn School (1880–1900)*, exhibition catalogue, Newlyn Art Gallery, 1979, 243) or Fred Jackson, *Launching the Lifeboat* (1890, private collection, illustrated in Phillips, *The Staithes Group*, 37) and Michael Ancher, *The Lifeboat is Taken through the Dunes* (1883, Statens Museum for Kunst, Copenhagen, illustrated in Weisberg, *Beyond Impressionism*, plate 254)

James Clarke Hooke, *The Seaweed Raker* (n.d., Tate Gallery, London, illustrated in Charles Hemming, *British Painters of the Coast and Sea: A History and Gazetteer*, London: Victor Gollancz, 1988) and Jean-Charles Cazin, *Gathering Seaweed* (c.1890, Kirkcaldy Museum and Art Gallery, illustrated in Kenneth McConkey, *Impressionism in Britain*, exhibition catalogue, New Haven and London: Yale University Press in association with Barbican Art Gallery, London, 1995) or Howard Russell Butler, *The Seaweed Gatherers* (1886, Smithsonian Institution, Washington D.C., illustrated in David Sellin, *Americans in Brittany and Normandy*, exhibition catalogue, Phoenix Arizona: Phoenix Art Museum, 1982). The list is endless.

13 Fish selling: Stanhope Forbes, *A Fish Sale on a Cornish Beach* (1885, Plymouth City Museum and Art Gallery); Thomas Cooper Gotch, *Sharing Fish* (1891, David Messum Fine Paintings); William Banks Fortescue, *The Fish Fag* (c.1888, Atkinson Art Gallery, Southport, all illustrated in Fox and Greenacre, *Artists of the Newlyn School (1880–1900)*; Joseph Richard Bagshawe, *Lives O'Men* (1900, private collection); Harold Knight, *Fish Sale* (c.1903, private collection), both illustrated in Phillips, *The Staithes Group*.

14 Anxious and bereaved women: Frank Bramley, *A Hopeless Dawn* (pl. II); Walter Langley *'Never Morning Wore to Evening but Some Heart Did Break'* (fig. 16); Langley, *Departure of the Fleet* (fig. 26); Langley, *But Men must Work and Women must Weep* (1883, Birmingham Museums & Art Gallery); Bramley, *Weaving a Chain of Grief* (1887, collection Patrick Griffin), both illustrated in Caroline Fox and Frances Greenacre, *Painting in Newlyn 1880–1930*, exhibition catalogue, London, Barbican Art Gallery, 1985; Leghe Suthers, *Finery* (n.d., Atkinson Art Gallery, Southport); Henry Meynell Rheam, *Girl in Blue* (1891, private collection) both illustrated in Fox and Greenacre, *Painting in Newlyn 1880–1930*, Harold Knight, *Grief* (c.1903, private collection); Harold Knight, *Staithes Fisherwoman* (c.1903, no location given), both illustrated in Phillips, *The Staithes Group*.

15 Domestic scene in or near fishing cottage: Laura Knight, *Peeling Potatoes* (between 1898–1907, Castle Museum and Art Gallery, Nottingham); Laura Knight, *Mother and Child* (c.1907, private collection); Rowland Henry Hill, *A Busy Hour* (1900, private collection); James William Booth, *In Runswick* (n.d., private collection); Thomas Barrett, *A View of Staithes* (1905, private collection); Harold Knight, *Staithes Fisherwoman* (between 1900 and 1907), all illustrated in Phillips, *The Staithes Group*. Norman Garstin, *Her Signal* (1892, Royal Institution of Cornwall); Thomas Cooper Gotch, *Cottage Interior with Woman Peeling Potatoes* (late 1880s–1890s, private collection); Henry Scott Tuke, *The Message* (1890, Falmouth City Art Gallery); Leghe Suthers, *Dame Trimmer* (1886, Whitford and Hughes, London); Edwin Harris, *His First Catch* (1888, Whitford and Hughes, London), all illustrated in Fox and Greenacre, *Painting in Newlyn 1880–1930*. Walter Langley, *Memories* (fig. 19); Walter Langley, *'Day Dreams'* (City of Bristol Art Gallery); Frank Wright Bourdillon, *The Jubilee Hat* (fig. 23); Norman Garstin, *In a Cottage by the Sea* (1887, Contemporary Art Society, illustrated in Fox and Greenacre, *Artists of the Newlyn School (1880–1900)*, 218).

16 Compare also, e.g. Frederick Daniel Hardy, *Expectation: Interior of a Cottage with a Mother and Children* (1860s/70s, Royal Holloway, University of London).

17 See also Edler, *Vergessene Bilder*, and Weber-Kellermann, *Landleben im 19, Jahrhundert*, 388–94, 'Die Agrarromantik als Gegenbild'.

18 See Linda Nochlin, 'Lost and Found: Once More the Fallen Woman', in *Women, Art and Power and Other Essays* (London: Thames and Hudson, 1989).

19 W. Christian Symons, 'Newlyn and the Newlyn School', *Magazine of Art* (1890), 201; Fox and Greenacre, *Painting in Newlyn 1880–1930*, 31.

20 John Corin, *Fishermen's Conflict: The Story of Newlyn* (Newton Abbot, London and North Pomfret: Tops'l Books, 1988), 16–19. They sent boats to market all along the Channel and up to the Welsh coast, from Portsmouth to Swansea.

21 David Clark, *Between Pulpit and Pew: Folk Religion in a North Yorkshire Fishing Village* (Cambridge: Cambridge University Press, 1982), 23.

22 The Reverend Wladislaw Lach-Szyrma; quoted without reference in Corin, *Fishermen's Conflict*, 9.

23 On the problem of non-local ships fishing in Cornwall in the 1880s and 1890s, see below and Corin, *Fishermen's Conflict*, 9–11, 22–27, 45.

24 Mr. C.E. Fryer, quoted in Thomas Cornish, 'Mackerel and Pilchard Fisheries', *Fisheries Exhibition Literature* (1884), 6:143–44.

25 For example, Percy Craft, *Tucking a School of Pilchards on the Cornish Coast* (1897, Penzance Town Council, illustrated in Fox and Greenacre, *Painting in Newlyn 1880–1930*); Charles Napier Hemy, *Pilchards* (n.d., Tate Gallery, London, illustrated in Hemming, *British Painters of the Coast and Sea*).

26 For example, Henry Scott Tuke, *All Hands to the Pumps* (1889, Tate Gallery, London); Frank Bramley, *A Hopeless Dawn* (pl. II); Frank Bramley, *Saved* (1889, whereabouts unknown, illustrated in the *Magazine of Art* 1890, facing p.150); Walter Langley, *Never Morning Wore to Evening . . .* (fig. 16); Langley, *Disaster!* (fig. 21); Langley *'For Men Must Work and Women Must Weep'* (1883, Birmingham Museums & Art Gallery); Stanhope Forbes, *A Rescue at Dawn* (date and whereabouts unknown, illustrated in *The Windsor Magazine*, 21 (1904–05): 333); Thomas Rose Miles, *Launch of the Life Boat* (probably 1880s, Royal Exchange Gallery, London); all of the following illustrated in Phillips, *The Staithes Group*, Fred Jackson, *Launching the Lifeboat* (1890, private collection); Ernest Dade, *The Lifeboat* (c.1892, private collection); Frank Henry Mason, *The Runswick Bay Lifeboat* (n.d., private collection); Harold Knight, *On the Quay at Staithes* (c.1900, private collection); Harold Knight, *The Last Coble* (1900, Nottingham Castle Museum).

27 Langley, *Disaster! Scene in a Cornish Fishing Village* (1889, City Museum and Art Gallery Birmingham, illustrated in Fox and Greenacre, *Painting in Newlyn 1880–1930*, 34 (fig. 21)).

28 A technique known as teichoscopy.

29 Quoted in Fox and Greenacre, *Painting in Newlyn 1880–1930*, 116.

30 For example, José Julio de Sousa Pinto, *The Lost Boat* (fig. 17); Emile Renouf, *The Widow of the Island of Sein* (1880, Musée des Beaux-Arts, Quimper, illustrated in *La Route des peintres*, 44); Oskar Björck, *A Distress Signal* (1883, Statens Museum for Kunst, Copenhagen, illustrated in Weisberg, *Beyond Impressionism*, plate 262); Hans von Bartels, *Waiting for the Return of the Fleet* (between 1887 and 1912, Katwijks Museum, Katwijk, Netherlands, illustrated in *Katwijk in de schilderkunst*, 104); Elisabeth Nourse, *On the Dyke* (c.1892, whereabouts unknown, illustrated in *Vreemde gasten: Kunstschilders in Volendam 1880–1914*, ed. Verenigen 'Vrieden van het Zuiderseemuseum' (Enkhuizen: Rijksmuseum Zuiderseemuseum, 1986, 20)). Note also the earlier and very successful painting by Jozef Israëls, *Fishermen Carrying a Drowned Man*, acquired soon after its exhibition at the London International Exhibition in 1862 by the National Gallery, London (see *The Hague School: Dutch Masters of the Nineteenth Century*, ed. Ronald de Leeuw, John Sillevis and Charles Dumas, The Hague and London: Haags Gemeentemuseum and Royal Academy of Arts in association with Weidenfeld and Nicholson, 1983, 187). However, even such muted scenes are rare on the Continent. Michael Ancher's dramatic scene *The Lifeboat is Taken Through the Dunes* (1883, Statens Museum for Kunst, Copenhagen, illustrated in Weisberg, *Beyond Impressionism*, plate 254) refers to the rescue of a merchant ship with a view to looting, not to the loss of life of fishermen. Similarly Alfred Guillou's *Adieu* (illustrated in the *Magazine of Art*, 1892, 428) does not refer to the everyday perils of

fishermen but revolves around a doomed family or love story: we see a man among stormy waves, clinging onto his wrecked boat and kissing a drowned woman farewell.

31 My forthcoming book on visual narrative in painting will explore this theme further.

32 Linda Colley, *Britons: Forging the Nation, 1707–1837* (New Haven and London: Yale University Press, 1992), 11. The quotation draws on James Thomson's words of 1740.

33 Limitations of space prohibit an examination of contemporary literature but a glance at Charles Kingsley's poem 'The Three Fishers' (1851) from which Langley took the title of his *But Men must Work, and Women must Weep* (1882, Birmingham Museums & Art Gallery) would suggest similar emphases on heroic tragedy and death at sea in the writings of the period. See Langley, *Walter Langley*, 11, 64–65.

34 Charleton, 'Cullercoats', *Magazine of Art*, 458.

35 Charleton, 'Cullercoats', *Magazine of Art*, 461–62.

36 Meynell, 'Newlyn', *Art Journal*, 98.

37 Symons, 'Newlyn and the Newlyn School', 200.

38 *A Handbook for Travellers in Cornwall* (London: John Murray, 1879), 39.

39 The Duke of Edinburgh, 'Notes on the Sea Fisheries', 31.

40 Thomas Crouch's history of Polperro, quoted in Bertram, 'The Unappreciated Fisher Folk', 230.

41 Charleton, 'Cullercoats', *Magazine of Art*, 462.

42 Howard, *Landscapes: The Artist's Vision*, ch. 6, 'The Heroic Period 1870–1910', esp. 116. See also Howard D. Rodee, 'The "Dreary Landscape" as a Background for Scenes of Rural Poverty in Victorian Paintings', *Art Journal* 36.4 (1977).

43 Symons, 'Newlyn and the Newlyn School', 199; Laura Knight, *Oil Paint and Grease Paint* (London: Ivor Nicholson and Watson, 1936), 94.

44 See, for instance, *A Handbook for Travellers in Cornwall* (1879), 82; Walter H. Tregellas, 'Artists' Haunts: I; Cornwall, the Cliffs, the Land's End' and 'Artists' Haunts: V; Cornwall, the Cliffs (continued), the Lizard', *Magazine of Art*, 1878, mentions shipwrecks, 143; Margaret Hunt, 'Lady Hilda's Town', *Art Journal*, 1885 mentions smuggling, 37; Symons, 'Newlyn and the Newlyn School', mentions wrecking, smuggling and pirates, 199, 201–02.

45 Rob Shields, *Places on the Margin: Alternative Geographies of Modernity* (London: Routledge, 1991), 84. Note, pace Shields, that the 'absence of private property' does not really arise out of the presence of tides but is a culturally specific circumstance. A number of countries do permit the private ownership of stretches of beach, e.g. the United States or Spain.

46 For example, during an autumn storm in 1880, the 14-ton Newlyn vessel *Jane* broke in two off the entrance to Penzance Harbour; all seven men were drowned. This, however, was the first loss of a Newlyn boat with all hands since 1840, and the event proved so traumatic that it was the instigator for a huge fund-raising effort on the part of the inhabitants of Newlyn and neighbouring villages. The money raised was used for the construction of two new piers to form Newlyn's artificial new harbour. The South Pier with a lighthouse was in use by the end of 1886. The new North Pier was officially opened on 3 July 1894. Only two other losses of local fishing boats are

recorded in this period: the *Primitive* of Mousehole in 1874, and the *Malakoff* of Newlyn in 1879. Corin, *Fishermen's Conflict,* 34–37, 40.

47 Thompson, *Living the Fishing,* 21. See also statistics in The Duke of Edinburgh, 'Notes on the Sea Fisheries', 42–46: these statistics reveal that of 624 lives lost among English fishermen over a period of two years in the early 1880s, 573 alone came from Hull and Harwich. In addition to the dangerous practice of ferrying fish from fishing fleets to steam cutters on the high seas, the mistreatment of apprentice boys aboard trawlers was another reason for increased fatalities. In 1882, an official enquiry was launched into the ill treatment and even murder of trawler boys. See The Duke of Edinburgh, 'Notes on the Sea Fisheries', 35–37, Bertram, 'The Unappreciated Fisher Folk', 232–33, and Tunstall, *The Fishermen,* ch. 1.

48 Corin, *Fishermen's Conflict,* 63–64 and Thompson, *Living the Fishing,* 21–22. Staithes fishing, too, depended on boats shared by families; see Clark, *Between Pulpit and Pew,* 24. See also Harriet Bradley, *Men's Work, Women's Work: A Sociological History of the Sexual Division of Labour in Employment* (Cambridge: Polity Press, 1989), ch. 5, 'Fishing', esp. 96–98. On the development of trawling in nineteenth century Europe, see Bartz, *Die Grossen Fischereiräume,* 92–102.

49 In 1894, after the opening of the North Pier, the amount of dues taken in Newlyn harbour increased by almost 50% over the amount taken in 1888 (from £1,387 to £2,054). Many of the new users were East Coast vessels, especially from Yarmouth and Lowestoft, Brixham trawlers from Devon, and even Breton crabbers. Corin, *Fishermen's Conflict,* 22–23, 27, 45. Indeed, the presence of 'foreign' boats in Newlyn led to a riot between local fishermen and incursionists in 1896 which was quashed with the aid of three gunboats and a regiment division. See Corin, *Fishermen's Conflict,* 9–11.

50 T.J. Clark, *The Painting of Modern Life: Paris in the Art of Manet and his Followers* (London: Thames and Hudson, 1984). See also Lübbren, *Rural Artists' Colonies* and Lübbren, 'Touristenlandschaften'.

51 Nicholas Green, *The Spectacle of Nature: Landscape and Bourgeois Culture in Nineteenth century France* (Manchester and New York: Manchester University Press, 1990) and Robert L. Herbert, *Monet on the Normandy Coast: Tourism and Painting, 1867–1886* (New Haven and London: Yale University Press, 1994).

52 Shields, *Places on the Margin,* 47, 60–61.

53 Manet, *On the Beach at Boulogne* (1869, Museum of Fine Art, Richmond); Morisot, *Villa at the Seaside* (1874, Norton Simon Foundation); Degas, *Beach Scene* (1876, National Gallery, London). All illustrated in Robert L. Herbert, *Impressionism: Art, Leisure and Parisian Society* (New Haven and London: Yale University Press, 1988) ch. 7, 'At the Seaside'. A more widely known and arguably more self-conscious follower of French Impressionism in England (than Forbes) is Philip Wilson Steer in his scenes of Walberswick seaside holiday life, e.g. *Children Paddling, Walberswick* (c.1888–94, Fitzwilliam Museum, Cambridge).

54 Zorn, *Fisherman, St. Ives* (1888, Musée des Beaux-Arts de Pau, France, illustrated in Michael Jacobs and Malcolm Warner, *The Phaidon Companion to Art and Artists in the British Isles,* Oxford: Phaidon, 1980, fig. 130); Stokes, *Off St. Ives* (1890, private col-

lection illustrated in Laura Wortley, *British Impressionism: A Garden of Bright Images,*
London: Studio, 1988, 118).

55 For example, Mary McCrossan, *White Herring Boats* (1899 private collection), Adrian
Stokes, *Off St. Ives* (1890, private collection), Louis Monro Grier, *The Return of the
Fishing Fleet* (private collection), and Julius Olsson, *Pounding Surf* (private collec-
tion); all illustrated in Wortley, *British Impressionism.* These categories are not hard
and fast, of course; notable examples of similar views painted at or near Newlyn are
Thomas Cooper Gotch, *The Silver Hour* (Kettering Borough Council), Norman
Garstin, *View of Mounts Bay with the North Pier* (c.1893, Penlee House Gallery and
Museum, Penzance), both illustrated in Fox and Greenacre, *Painting in Newlyn,* and
Henry Moore, *Mounts Bay: Early Morning— Summer* (1886, Manchester City Art
Galleries). I pursue the issue of fishing versus tourist villages further in my 'North to
South: Paradigm Shifts in European Art and Tourism, 1880–1920' in David Crouch
and Nina Lübbren, eds., *Visual Culture and Tourism* (Oxford: Berg, forthcoming).

56 Corin, *Fishermen's Conflict,* 121. On St. Ives' development into a tourist resort, see
Marion Whybrow, *St. Ives 1883–1993: Portrait of an Art Colony* (Woodbridge: Antique
Collectors' Club, 1994).

57 S. Baring-Gould, *Cornwall* (Cambridge: Cambridge University Press, 1910), 71. See
also statistics in Michael Havinden, et al., 'How the Regions Became Peripheral: A
Complex Long-Term Historical Process', in M. A. Haviden, J. Quéniart and J.
Stanyer, eds., *Centre et périphérie / Center and Periphery: Bretagne, Cornouailles /
Devon: Etude comparée— Brittany and Cornwall and Devon Compared* (Exeter: Uni-
versity of Exeter Press, 1991), 17. St. Ives was divided into three neighbourhoods, one
for fishermen, one for 'tinners' and one for 'the gentry'; see memoir of a local resident
quoted in Whybrow, *St. Ives 1883–1993,* 25.

58 Anon., 'The Fisher-Folks' Harvest', 36.

59 See, e.g. Shields, *Places on the Margin,* ch. 2 on Brighton, 'Ritual Pleasures of a Sea-
side Resort: Liminality, Carnivalesque, and Dirty Weekends', and John Urry, *The
Tourist Gaze: Leisure and Travel in Contemporary Societies* (London: Sage, 1990), ch. 2,
'Mass Tourism and the Rise and Fall of the Seaside Resort'.

60 Urry, *The Tourist Gaze,* 18. See also Alain Corbin, *The Lure of the Sea: The Discovery of
the Seaside, 1750–1840,* translated by Jocelyn Phelps (Harmondsworth: Penguin, 1995)
and Shields, *Places on the Margin.*

61 Corin, *Fishermen's Conflict,* 19ff.

62 On hotels and leisure activities, see Corin, *Fishermen's Conflict,* 19ff; *Great Britain:
England, Wales and Scotland, Handbook for Travellers* (Leipzig and London: Karl
Baedeker, 1894, 1897 and 1901); *A Handbook for Travellers in Cornwall* (1879 and
1893), and Whybrow, *St Ives 1883–1993,* 33. The Duke of Edinburgh, 'Notes on the Sea
Fisheries', mentions fishing boats used for leisure purposes, 30 (for similar use in Nor-
mandy, see Herbert, *Monet on the Normandy Coast*).

63 See Havinden *et al.,* 'How the Regions Became Peripheral', 17–18. In 1881, 21.6% of
the active residents of Cornwall and Devon worked in agriculture, 29% in industry,
and 51.5% in tertiary services, most of which were tourist services. Compare this to

the statistics of 1831 (33.3% in agriculture, 32.7% in industry, 32.5% in services) and 1931 (13% in agriculture, 17.8% in industry, 69.2% in services). See also the debate among locals on their region as a tourist attraction, 'How to Develop Cornwall as a Holiday Resort: Opinions of Eminent Cornishmen and Others', *The Cornish Magazine*, 1 (1898).

64 Quoted in Corin, *Fishermen's Conflict*, 50.

65 Quoted in Michael Jacobs, *The Good and Simple Life*, 145.

66 Whybrow, *St Ives 1883–1993*, 25. As early as 1879, Murray's guide-book called it a 'watering-place'; *A Handbook for Travellers in Cornwall* (1879), 124.

67 *A Handbook for Travellers in Cornwall*, 124.

68 *Great Britain* (Baedeker, 1887), 140.

69 W. H. Bartlett, 'Summer Time at St. Ives, Cornwall', *Art Journal* (1897), 292. The artists in St. Ives were instrumental in supporting and even ushering in some of the innovations conducive to urban visitors, for example, in 1889, the painter Adrian Stokes founded a golf club there. The painter W.H.Y. Titcomb was referee in the Lawn Tennis Club Tournament in 1890. The painters' club, founded in 1888 by the marine painter Louis Grier, held a series of weekly lectures and organised an annual Show Day on which the public was invited to view artists' studios and look at works destined for the Royal Academy and other venues. The Great Western Railway ended up providing extra trains on Show Days to cater for the large numbers of visitors. Whybrow, *St Ives 1883–1993*, 34, 36.

70 *A Handbook for Travellers in Cornwall* (1893), 158. It is of note that artists, as far as I am aware, did not represent the business of curing, an essential activity in fishing villages and mainly undertaken by women. Presumably, the fish smells were too overpowering to be endured for the length of sketching sessions but the prosaic activity of curing also did not fit into the romanticised image of hardy, heroic fisherfolk who were associated with an outdoor life in health-giving sea air and not with the filth and confinement of a curing yard. On curing, see Corin, *Fishermen's Conflict,* 47ff. and Cyril Noall, *Cornish Seines and Seiners: A History of the Pilchard Fishing Industry* (Truro: Bradford Barton, 1972), ch. 3. Stereotypical views on fisherfolk as hardy and robust were standard: for examples, see Bertram, 'The Unappreciated Fisher-Folk', 229; Charleton, 'Cullercoats', *Magazine of Art*, 462; Meynell, 'Newlyn', *Art Journal*, 98; Symons 'Newlyn and the Newlyn School', 199; Marion Hepworth Dixon, 'Stanhope A. Forbes, A.R.A.', *Magazine of Art* (1892), 182; Frank Richards, 'Newlyn as a Sketching Ground', *The Studio*, 5 (1895): 176; Forbes, 'A Newlyn Retrospect', 82.

71 Schjerfbeck, *View of St. Ives* (1887, private collection, illustrated in Jacobs, *The Good and Simple Life*, plate 7); Talmage, *Evening at St. Ives* (n.d., private collection illustrated in Wortley, *British Impressionism*, 200). Other examples include: Anders Zorn, *Boats, St. Ives* (1889, Zorn collection. Mora, Sweden, illustrated in Jacobs, *The Good and Simple Life,* fig.131), Louis Monro Grier, *The Return of the Herring Fleet* (n.d. private collection), Adrian Stokes, *Off St. Ives* (c.1890, private collection) and Mary McCrossan, *White Herring Boats* (1899, private collection; all illustrated in Wortley, *British Impressionism*, 98, 118, 213).

72 Urry, *The Tourist Gaze*, 222.

73 Herbert, *Monet on the Normandy Coast*.

74 See also my similar argument with regard to paintings of the late nineteenth century of the Dutch fishing village-cum-tourist resort Katwijk; Lübbren, *Rural Artists' Colonies*, 152.

75 Corbin, *The Lure of the Sea*. See also Steven Z. Levine, 'Seascapes of the Sublime: Vernet, Monet and the Oceanic Feeling', *New Literary History*, 16.2 (1985). Examples of immersive or sublime ocean pictures include Julius Olsson's paintings of St. Ives, e.g. *Pounding Surf* (n.d. private collection illustrated in Wortley, *British Impressionism*, 99) and *Silver Moonlight, St. Ives Bay* (c.1910, Southampton City Art Gallery, illustrated in McConkey, *Impressionism in Britain*, 169).

76 For an extended discussion of this point, see Lübbren, *Rural Artists' Colonies*, 317–27.

77 For descriptions of fishing in terms of a sight, see J. S. Courtney, *Guide to Penzance*, as early as 1845, quoted in Noall, *Cornish Seines and Seiners*, 30 ('Tucking is a sight which the stranger (ie the tourist) should not, on any account, neglect to witness ... it is then impossible to imagine a more exquisite scene ...', and so forth); *A Handbook for Travellers in Cornwall* (1879), 41; Mr. C.E. Fryer, quoted in Cornish, 'Mackerel and Pilchard Fisheries', 143–44; The Duke of Edinburgh, 'Notes on the Sea Fisheries', 31; Charleton, 'Cullercoats', *Magazine of Art*, discussed below.

78 Franziska Bollerey, 'Die Verstädterung des Strandes: Vom Fischerdorf zum Seebad / The Urbanization of the Shore: From Fishing-Village to Sea-Side Resort', *Daidalos*, no. 20, (15 June 1986), 89.

79 Corin, *Fishermen's Conflict*, 52.

80 *Great Britain*, 141.

81 Or lower the tone, for that matter. In 1897, riots ensued in response to plans for a new hotel in Newquay which would entail the enclosure of traditional net-drying grounds. The hotel was built, anyway. In 1898, hotel owners and the town council of Penzance reacted with alarm when a new rail connection to Newlyn was proposed. This would have run along Penzance's promenade, again seriously tarnishing the sea view and other tourist facilities. Corin, *Fishermen's Conflict*, 121–22.

82 *A Handbook for Travellers in Cornwall* (1879), 124.

83 Hunt, 'Lady Hilda's Town', 33, 35.

84 The Duke of Edinburgh, 'Notes on the Sea Fisheries', 31, and Cornish, 'Mackerel and Pilchard Fisheries', 143–44.

85 Charleton, 'Cullercoats', *Magazine of Art*, 456.

86 Charleton, 'Cullercoats', *Magazine of Art*, 458.

87 Charleton, 'Cullercoats', *Magazine of Art*, 458.

88 Souvestre, 'La Comouaille', 691; quoted in Corbin, *The Lure of the Sea*, 245.

89 Félix Pyat, 'Une tournée en Flandres', *Revue de Paris* 33 (Sept. 1836); cited in Corbin, *The Lure of the Sea*, 245.

Haunts of Ancient Peace

Kenneth McConkey

READING Marion H. Spielmann on landscape painting in the Edwardian years is a numbing experience. Every year, the editor of *The Magazine of Art* was required to pen a preface to the annual volume of *Royal Academy Pictures*. It was clearly difficult for him to report upon and conceptualise what might be regarded, in comparison to classical, Biblical and historical subjects, as a low content genre. Thus in 1896 he felt that the visitor 'would not be disappointed' to find a high standard in the landscapes 'where we are accustomed to look for excellence'. By 1903 he was noting that there were 'few surprises', yet the examples reflected 'with breadth and tenderness the love in the British soul for every aspect and humour of nature'. In 1905 the words were almost the same: 'fewer surprises and fewer brilliant successes; yet the subtle and healthy appreciation of nature and its beauties is seen on all sides'.[1] It seems like an endless succession of good, but not brilliant results — as if in academic terms, the examiner found that standards were consistently maintained but there were no high-flyers. There was at the same time a consoling impression of well-placed collective endeavour. And to confirm the examiner's view, the names of the illustrious Edwardian landscape painters, Ernest Waterlow, Alfred Parsons, David Murray, Alfred East, William Llewellyn, Buxton Knight, Bertram Priestman and Adrian Stokes, have sunk into relative obscurity.

In recent years the late-Victorian bourgeois impulse to return to rusticity has been exhaustively studied. The broad characteristics of rapid social change in the countryside have been noted, as have the impressive rearguard actions of writers and intellectuals from Ruskin and Morris to Rider Haggard, in the long list of guilds, preservation societies and pressure groups acting on behalf of ancient buildings, nature, customs, folksongs and handicrafts.[2] The arts and crafts movement, utopian socialism, garden suburbs and other manifestations of these rearguard tendencies were largely motivated by anti-urban, anti-mechanised industrial convictions. Whilst the representation of rustic figures in the period 1880-1914, a closely related sub-genre, has been discussed, the questions posed by

27 Alfred East, *Autumn*, 1887. Manchester City Art Galleries.

pure landscape painting have been largely ignored.[3] This chapter addresses the commonly held beliefs about landscape painting at the turn of the century, its practices and purposes.

The description of this phenomenon is closely bound up with the description of who it was made for and the degree to which an apparently unchanging genre complied with the values and assumptions of its patrons. At this time there were flashy industrialists who took to big Academy pictures; there were garden suburb occupants for whom cabinet landscapes would suffice. Landscapes jostled for attention on the walls of the annual exhibitions along with grand portraits and subject pictures designed for discretely different clienteles. The purchasing committees of the new municipal galleries located in the midst, and created from the wealth, of the new industrial age were substantial market presences. The irony is that large pictures of England's fields and trees, such as Alfred East's *Autumn*, 1887 (fig. 27) and David Murray's *A Hampshire Haying*, 1893 (fig. 28) hung surrounded by the monuments to capital and labour.[4] What motivated the burghers of places like Manchester and Bradford, the buyers of East and Murray, to form their collections? Were they to delight or instruct? Did their selectors wish to produce a representative collection of the best of contemporary

28 David Murray, *A Hampshire Haying*, 1893. Bradford Art Gallery and Museum.

British art for reasons of local pride and prestige? What were the motives of these competing provincial caucuses when it is obvious that neither East nor Murray was representing the hinterland landscape of either of the cities for which their pictures were acquired? Purchasing committees might be provincial, but they certainly were not parochial.

Since the selection committees from northern towns were not only buying landscapes, the analysis of their comparative performance is fraught with problems. The existence of local academies, art clubs, autumn exhibitions and local industrialist collectors had a direct bearing upon the nature of the collections which emerged. Manchester and Liverpool corporations frequently purchased pictures which had been shown in London the previous spring, in their autumn exhibitions—only occasionally making spring purchases in London when they felt they might lose out to a rival.[5] There was an obvious benefit in holding fire because artists frequently reduced their prices with each subsequent exhibition of an academy-piece. Reviewing early catalogues it sometimes seems as though there was a kind of corporate landscape, designed to appeal to municipal tastes. Many self-made industrialists who were motivated by philanthropy had already formed their own collections before serving in a civic capacity on art gallery

committees. They might be expected to replicate their taste for the public and whilst this happened with particular purchases from newly-popular artists, it was not exclusively so.[6] Prominent citizens sometimes bought in order to donate immediately, or sometimes donated in order to augment a civic purchase. Older collections were sometimes acquired as benefactions. There can be no single answer to questions concerning the committee debates in support of collecting policies, which were often not explicitly articulated, except to observe that in the newly-opened galleries of the Midlands and north of England there was a tendency to favour artists who were just becoming established, and that in practice meant painters who were likely to have been trained in France and who, after a struggle, were beginning to achieve success in the Grosvenor, the New Gallery or the Royal Academy. Chantrey, Tate or other prominent purchasers would confirm the profile. There are numerous instances of artists positioning themselves in order to match the template.

Throughout these manoeuvres the collective memory of the great Victorian landscape painters remained a powerful determinant. In the work of John Everett Millais, Cecil Lawson, Benjamin Williams Leader, John MacWhirter, Horatio McCulloch and others, the conception of the British landscape was visually defined. Each plotted his own terrain, became a 'brand' name, formed a particular clientele and collected a shoal of imitators. Each remained enduringly popular up to the Great War, when their most important pictures were reproduced and widely distributed in order to stimulate feelings of national pride. However, although there is ample evidence that the innate national love of nature, as Spielmann liked to claim, stirred patriotism even before the war, little explicit connection is made between particular configurations and the sentiments they encoded. The cultural construction of artistic theory and the development of craft knowledge in the period 1890–1910 is more diverse than Spielmann's tired generalisation implies, and reaching today for convenient clichés about Edwardian jingoism, imperialism and little England, provides only one possible, predictable reading.

By the nineties there was a consciousness that the template must change. George Moore in particular was anxious to dispel the last vestiges of Victorianism in landscape painting. Leader, Fildes, Peter Graham, Herkomer . . . , their names were like a litany to him, as watchwords for rampant commercialism. Writing about art patrons he describes the determination of Mr Smith, a brewer or distiller, to possess a Leader. 'Mr Leader put RA after his name—he charges fifteen hundred. Besides, the village on the riverbank with the sunset behind is

29 Benjamin Williams Leader, *February Fill Dyke*, 1881. Birmingham Museums and Art Gallery.

obviously a beautiful thing'.[7] Mr Smith embodied the 'ordinary perception of the artistic value of a picture' and Leader arrived in the Academy not because his work was specially admired by his peer academicians, but because it was bought by the Mr Smiths of this world. Later dubbed by Lewis Hind in 1924 as a 'ninety per cent painter', that is someone who painted for those who cared nothing for the craft of painting, Leader remained fixed in the popular mind.[8] Prints of *February Fill Dyke* (fig. 29) were issued in 1884 and were instantly popular. For many, these became the experience of English landscape and the exemplification of the sentiment associated with it. Not only were these images endlessly repeated by others, but Leader turned himself into a mechanic, constantly recreating the same damp winter afterglows.[9] In 1916 the weird and jingoistic *Bibby's Annual* reproduced *At Eventide it shall be light*, his 'still loved' exhibit of 1882, and identified the title as containing 'the beautiful promise of the old Hebrew prophet' which held comfort, in the context of the stalemate on the Western Front 'to those enduring the sharp stern struggle of existence'.[10]

 Clearly, whether they wished it to be so or not, younger landscape painters were in dialogue with the hackneyed populist poetry of the older generation

which was still being recited throughout the period. In many cases, established conventions were simply reshaped. The Academy continued to receive endless lingering autumns and golden twilights wrapped in poetic titles like *When Lingering Daylight welcomes Night's Pale Queen* by Ernest Parton, a painter who had fallen, by 1894, into the habit of showing regularly. There were endless variations on the Thomas Sidney Cooper, 'cows in a landscape' theme, continuing up to and beyond 1911, when Fred Hall's Berkshire processional, *The Evening Sun has lengthened every Shade* was shown. In 1894, John MacWhirter showed a Scots landscape, *Twixt the Gloaming and the Mirk*, only to have his title appropriated in 1905 by David Murray in *Tween the Gloamin and the Mirk*. It is almost unnecessary to illustrate these canvases. The essential recipe was a bit of murky swamp, some distant hills, a few proud elms or firs, or sheep or cattle returning to the fold, bound together in an autumn afterglow. These ingredients summoned the timeless twilight which poets dreamed of, and which intellectuals of left and right tried to theorise into existence. Murray's *The Hampshire Haying*, and East's *Autumn*, demonstrate that southern and Scots motifs predominated. The northern English counties claimed comparatively less attention. Presented by painters like Fred Hall, Arnesby Brown, James Aumonier and many others, the southern landscape supporting livestock and human beings was a blissfully unproblematic world. Often it could not quite break free from the long shadows cast by the church towers in Leader's lingering autumns, themselves an attempt to remake an even earlier idyll.[11]

Why did this continue to be so, when Moore's, R. A. M. Stevenson's and D. S. MacColl's criticisms in the nineties repeatedly attempted to raise an awareness of other potential precedents? The answer lies not so much in the nature of those alternatives, as in the power of the collective memory of classic British pictorial archetypes and in the intrinsic character of the landscape itself. Landscape theory in the late nineteenth century stressed the landscapist's power of memory—both for pictures and for observations made on the motif. P. G. Hamerton, writing on *Imagination and Landscape Painting* in 1887, constructed a theory of the landscapist's memory, discussing the imaginative power of the painter to recall and represent absent things and fuse them into 'pictorial wholes'.[12] He gave some attention to the role of images in the mind, the cultivation of the power of recollecting and the role of knowledge as a way of informing recollection. Having been a regular visitor to the Salon since the 1860s, Hamerton was aware of the training methods of Horace Lecoq de Boisbaudran, the master at the Petite Ecole du Dessin who specialised in the training of visual memory and he supplied his

own critique of Lecoq's procedures.[13] Hamerton favoured the process of learning a picture by heart on the motif, without making a sketch.[14] This equally applied to copying the work of others. There were stratagems in this process. Familiarity with a particular species of plant or type of rock formation assisted the process of remembering. The common characteristics of oaks and elms would be instantly recognised and the artist could concentrate upon the particular idiosyncrasies of the specimen before his eyes. There was a serious debate about the degree to which scientific knowledge might impede or assist, about the efficacy of naming and verbal description. Hamerton could not appreciate the ability to construct a scene from a patchwork of details, following Lecoq, and preferred an overall method, working up to points of high focus once the main features of the composition had been noted. To show this he had the engraver C. O. Murray copy well-known works by Gainsborough and others. This led him to a consideration of the specific nature of the artist's knowledge. All of the technical terms might not be in place, but the study of appearances should be no less diligent. The end product of this accumulation was that, with experience and maturity, the artist could express through the painting of a particular tree the essentials of growth and decay which lie in all trees of that variety. Art, for him, as for his first mentor, Ruskin, went beyond mere verisimilitude to the suggestion of the dynamic forces of nature. In setting out his theories, Hamerton was careful to navigate the shallows of photography in order to accentuate the instincts and preferences of individual creators: 'Ruysdael [sic] loved oaks as Corot loved a birch'.[15] These quirks of character along with the peculiar and illogical selection process which operates in the visual memory were regarded as strengths, as ways of differentiating art from imitation, and as the essential descriptors of those signature qualities which artists found in the landscape.

Hamerton's theoretical grasp of landscape owed little to earlier approaches. There were no references to sublimity and picturesqueness although he referred to Claude and Rosa. 'Fancy' was dismissed early on as he got to grips with the mental capacity of the artist to receive, record and then recreate sensory impressions. Although he acknowledged Ruskin, it was clear that Hamerton, who had produced one of the first studies on contemporary French painting twenty years earlier, derived some of his ideas from the salons and ateliers. The southern and northern metaphors did not detain him so much as the artist's power, acting within those terms of reference, to recreate. Thus he admired and quoted from Palmer on Shoreham and praised Cattermole's illustration of *Glendearg*, from Walter Scott, the one for all of the circumstantial details of peasant lore which

cosset the village, and the other for stripping away these same things. And in the end he was more concerned with the effect of 'imaginative art ... in those deserts of brick and stone where multitudes are deprived of nature'.[16]

The question with all of this was, however, to do with the meaning of the result, the landscape as consumed by provincial city dwellers.[17] Hamerton's prototypes were drawn mostly from the old masters and the Academy establishment was largely ignored. The examples from Rubens, Ruisdael, Gainsborough, Constable and Turner, interspersed with etchings by Claude, were carefully chosen. They set out a wider selection of compositional precedents which were difficult to dislodge. They formed a body of knowledge, established standards of excellence and, in doing so, determined the result of dialogues on the motif for painters, and confirmed the expectations of patrons. Thus for instance Ernest Waterlow, a painter who stayed close to his High Victorian mentors, had, by 1906, begun to seem conservative even to his supporters. In his early years Waterlow had worked in the west of Ireland and had produced robust naturalistic landscapes which conceded little to Academy conventions. However when he visited Moret in 1895 and saw Alfred Sisley's work, he was resistant to the impressionist language. Collins Baker noted that 'it so fell out that what he saw of Sisley's sketches induced but surprise and incomprehension: in that the French man unfailingly adhered to one effect of colour in his work, whatever the conditions of Nature ... wherever was the sun, and however different the atmosphere, Sisley always introduced a monotonous violet colour into his shadows'.[18] The contrast between the opulent Edwardian landscape painter who maintained a splendid Arts and Crafts studio, and the impecunious Impressionist, could not be more marked. Waterlow's success was derived from the very formulae which Sisley had rejected.

Alfred East, by contrast, was more eclectic. When returning from Egypt through Algeciras in Spain in 1900, he was entering the *campagna* (fig. 30). The peasants in the foreground of his Royal Academy picture of 1906, formed themselves into a ritual dance as in Claude's *Marriage of Isaac and Rebecca*. The backdrop is a kind of Tivoli. The power of association which worked through these landscapes — and East painted others of this type — lay in reviving for the municipal gallery, the Elysium of the English country house, and it undoubtedly profited East, Murray, Waterlow and others of their generation to tempt comparison with Gainsborough, Claude or Constable. Such references in exhibition notices and monograph articles were an underscoring of quality for the members of the purchasing committee.

Looking beyond literal transcription had brought early success to Alfred

30 Alfred East, *Gibraltar from Algeciras*, 1900. Board of Trustees of the National Museums and Galleries on Merseyside, Walker Art Gallery Liverpool.

East's endeavours in 1887.[19] Scots subjects like *The Land between the Lochs* and *Autumn Afterglow*, shown at the Royal Academy in that year won the praise of critics as 'the best landscapes in the exhibition'.[20] *Autumn*, a third and closely related work, was promptly purchased by Manchester from the first New Gallery exhibition in London the following year. Although his formative experiences were at Barbizon, and he made his debut at the Academy with *Dewy Morning*, 1882, a Barbizon picture, it was with works in a recognisably British tradition that East achieved his first successes.[21] *Autumn* could easily be linked in the minds of those who bought it with the work of Peter Graham or be seen as a modern reprise of Millais' *Chill October*.[22] It might be taken as an indication of the degree to which East, at the outset of his career, courted conventional success which, once achieved, enabled him to forge a distinctive and leading position in landscape painting. Until his death in 1913, the Academy regularly received three or four examples of his work each year. They were always good, and they varied; the techniques and subject matter changed and developed. Chronological sequence is important, if not simply to establish East firmly as an individual

author, or brand identity (he had followers) so much as to indicate the larger pattern in the whole of modern landscape painting at the turn of the century.

A lifetime of studies on the motif led East to hold robust opinions. He enjoined students and readers alike to study nature, not other pictures. At the same time he was acutely aware of the tradition acting through him and he ranged freely through many of the precedents cited by Hamerton. He worked to achieve a broad agreement about this body of inherited knowledge. In common with many others of his generation he looked to French *peinture claire*, and he described its painters as those who 'awoke from their lethargy, and felt in the freedom and individuality of the example of Constable and others that a new era had arrived'. Although, as a *plein-air* naturalist he took out large canvases into the open field, East quickly realised the practical difficulties in this procedure and like the Impressionists, was forced to admit that one could only work for short periods under a changeable climate.[23] In the end he came to be less concerned with literal truth than with the effect, and by presenting Turner's *'Sun of Venice' Going to Sea*, alongside a photograph of the lagoon, he attempted to show the allusive, atmospheric and imaginative qualities of painting.[24] In this East was of a mind with Hamerton. He wrote, 'the copying of things at a moment of arrested action is absurd, this is revealed by the camera … the position of a race horse in violent action seldom gives you the sense of movement'.[25] The heritage of Pre-Raphaelite naturalism, rooted in Ruskin, was still so strong at this point that painters of East's generation needed to distinguish the new values of working on the motif.[26] Thus the sketch for him 'should convey, in the fullest manner, the quick, vivid impression of the place'. It was a question of method and of seeing a particular purpose. The artist is fired by nature in the sketch, by a deliberate act, 'experience', becomes 'material', something more literal and more materially 'material' than the novelists' notes. East was prepared to unveil publicly the stages in the progress of a work, in one instance revealing that the scene had been redrawn on three occasions before being painted in reverse.[27] There are notes on tone and colour, advice on achieving the look of foliage and foreground recession, colour mixing and the use of line, because 'the truth in nature is not always truth in Art'.[28] What were these public revelations intended to achieve? Are artistic decisions, made during the progress of a work intractable? Did they remove troubling discontinuities which were there in nature but which required editing in the process of getting to an exhibition piece? Did East's amendments and revisions make the work more acceptable to his public and hence more saleable? What were the editorial principles?

Clearly the goal of these persistent reworkings was more than just a process of rhyming. Although this was important in itself the reworkings reflected a dialogue in which memory is moulded and modified by desire. In practice the painter would simplify what might in actuality be enormously complicated. The whole scene would be worked over to arrive at a synthetic result. The procedures of Pre-Raphaelite naturalists — in multiplying minutely finished details, inch by inch — were utterly rejected. Landscapists of this generation were looking for the truth of the ensemble. In doing so they had a lot to say about nature and the imagination, and little about the circumstances in which their landscapes were consumed. Like East, their writings and reported interviews are full of notes for guidance, procedures, rituals, recipes, the household management of trees and mountain ranges in a picture — every element became the subject of an artistic anatomy.[29] But there was nothing about what these particular configurations might signify. Shapes, colour, compositional marquetry were all important. Craft knowledge took precedence over theory. How to do it over why to do it.

The status of craft knowledge, often specialist and technical, belied its cultural construction, and the extent to which, by selective use of the past, it was involved in self-validation. East, Vicat Cole and Stokes address fellow painters, but allow others to listen in. Empirical observation, backed by elementary botany, geology and crystallography came, however, to sound banal were it not for the inclusion of local colour. Stories of wind and rain, and flies and midges appeared at the side of the page, interspersed with bits of armchair wisdom. There was a tacit assumption that the contemplation of a surrogate nature in works of art was the principal justification for landscape painting: 'it comes as a relief and a repose to the spirit, disconnected from any personal ambition. It is to the citizen what the fields are to the rustic, the mountains to the mountaineers'.[30] The undeclared intention in all of the mystifying painters' stratagems was to provide images which delight the eye and console the spirit.

The accounts by and about the work of these landscape painters frequently rehearse a familiar trajectory through English art to the Barbizon painters, the 'Men of 1830', and the more recent *plein-air* painters.[31] Vicat Cole presents this general history moving briskly from Claude through Watteau to Wilson, Turner and Constable, taking in Diaz, Dupre, Rousseau and Troyon before arriving at his own generation with East, Murray, Waterlow and Stokes.[32] Adrian Stokes, in his treatise *Landscape Painting*, as late as 1925, follows this line as a justification for his own early pilgrimage to the French countryside. Into his general scheme the painters of the immediate past were slotted: Harpignies for his simplicity

and refinement; Mauve for his charming sense of composition; Corot for his lightness, dexterity and taste.[33] The previous century consisted for Stokes, of a passing of the baton between Britain, France and Holland, and it ended with a swift sprint through the minefield of modernity. There were absolute values embedded in nature and landscape and they could be told or at least implied. The accounts tended to become less certain the closer to the present they came, wavering as they approached Impressionism and, in some cases, knocked sideways by Post-Impressionism. Stokes for instance moves from Mauve to the Glasgow School, giving the final word to Puvis de Chavannes whose 'noble' landscapes, inspired by nature and early Italian art attained 'an elevated distinction of style which commands admiration'.[34] Although they attempted to sound authoritative, these painters' histories conceived of the past as a kind of visual pattern book in which the student, working on site, might think 'Corot' or 'Constable', depending on the look of the clouds or the time of day.[35] They heavily underscored the values and myths associated with the retreat from the urban and total submersion in country life.

In all of this the attitude to Constable was of central significance. There had, by the end of the nineties, been renewed interest in his work, initiated by the realisation of its importance to French painting, and its substantial presence in the art market. The donation of *The Haywain* to the National Gallery in 1886 and the gift of 390 works to the Victoria and Albert Museum by Isobel Constable, the artist's last surviving daughter, the following year, renewed the interest in the artist and in the sites upon which he worked.[36] The publication of Charles John Holmes' *Constable and his Influence on Landscape Painting* in 1902 authoritatively established his impact upon current practice which was considerable.[37] Murray's *Hampshire Haying* would have been inconceivable without Constable's *Salisbury Cathedral from the Meadows*, 1831, in which a haywain crosses the foreground of a storm-filled landscape.[38] In *Hampstead's Happy Heath* 1897 (fig. 31) Murray looks across the Heath as Constable had done. His foreground is peopled with a dog, a donkey, children, a Chelsea Pensioner, women and a perambulator — a familiar miscellany, which Hamerton had warned about, and which drains away the sparkling evanescence of Constable's romantic vista.[39] Murray compounded his connection with Constable in a large work which was purchased for the Chantrey Bequest in 1903. *In the Country of Constable* is a similar reshaping of Constable's favourite motifs as a grandiose picture postcard. The tower of Dedham Church, the lock, the barge, the pollarded trees which Constable elevated to iconic status, have slipped into the background as the inconse-

31 David Murray, *Hampstead's Happy Heath*, 1897.

quential adjuncts of anecdotage.[40] If you went there you would never find this, but there would be enough of it to make you think you had.

Murray was preoccupied with the look of a Constable, with the idea that the suburban mothers of the nineties might be walking through a Constable without realising it. In order to make them comfortable in his foreground, the fire which Constable saw in the scene had to be dampened down and painted in a distinctly ordinary way, so that the topography might be recognised, but nothing else. None of the spontaneity, the free, informal mark-making, so evident in the oil sketches given to the nation in 1887, was appropriate for Murray's Academy performance. There was nevertheless a vital connection to be made between the autonomous brushstroke of the sketch and the grand illusion of the Academy-piece which makes the comparison of *Hampstead's Happy Heath* and Philip Wilson Steer's *Ludlow Walks*, 1898 (fig. 32) so instructive. In Steer the objective was to demonstrate the fine feeling of Gainsborough's, Turner's and Constable's brush — to see that the hills folded into one another, that the trees inclined harmoniously in the same direction and that this ebb and flow could well be

32 Philip Wilson Steer, *Ludlow Walks*, 1899. Southampton City Art Gallery/Bridgeman Art Library.

initiated in the movement of the hand which held the brush. The direct correlation between perception and the act of realisation seemed possible, the more he was able to suspend the problem of composing on the motif.

Memory is supported by constant reference to the crib sheet. As Steer painted, the miniature edition of Turner's *Liber Studiorum* lay by his side.[41] And as if to endorse the meaning of his unsystematic slodges and sweeps of pigment, he was praised for moving from 'a brilliant, unlovely impressionism' to a 'beautiful poetry', from 'raw science' to 'one of the peaks of profound art'.[42] The contemporary and twenties literature on Steer constantly speculates upon the degree to which he needed this reassurance. However, it is rather that, to patrons and critics alike, he gave reassurance in the resolution he achieved between the landscapes he overlooked, the marks he made in response and those revered masters of the English School, who were part of the common heritage and who formed

what MacColl later described as the 'Authorised Version of English Landscape'.[43] There was a nervousness about Steer's incantatory impulse. Lewis Hind found his 'learned technique rather overpowering', while Laver struggled to find ways in which skies might be superior to Constable's. But this did not materially alter the respect in which he was held.[44] Thus the young John Rothenstein in 1929 saluted his 'most remarkable power . . . of envisaging a great expanse of country, and setting it down upon canvas with strength and understanding'.[45]

In the contemporary literature, and as a result of the ritual revisiting of his locations by painters like Steer, Constable's presence emerges almost as an English equivalent to Alfred Sensier's 'peasant-painter', Jean-François Millet. In 1906, for instance, Sir James Linton, veteran President of the Royal Watercolour Society, weighed in on Constable's oil sketches, characterising him as 'self-educated', free from foreign influence: 'his vigorous treatment of his subjects, his largeness of view and full colour, seem to be typical of the sturdy yeoman of this country of ours'.[46] The idea that the love of landscape was somehow indigenous, that it sprang from the British soul, that it was identified with the natural life of the countryside, that it was historically accredited and formed part of a continuing tradition, was thus an essential ingredient in Linton's attitude to the genre, as it was in Spielmann's.

The 'sturdy yeoman' artist 'of ours' was a paradigm. Throughout the writings on landscape painting we are told that its authors were looking for the primordial. When in 1904, Lewis Hind arrived 'In Landscape Land' he stayed with a painter whose whole 'method of living' was 'planned to serve his work', 'he severed himself from town life, turned from the chatter, changing idols and will-o'-the-wisp ideals of the schools, departed and built himself a studio, alongside an old house, in that green solitude I call Landscape Land'.[47] Much is made of the rejection of what Walter Sickert later called 'the din of aesthetic discussion'. Momentary fashions, associated with the city, are laid to one side. We are fleeing the conflagration with the 'Men of 1830'; we are back on the road to Barbizon with Millet, his family and his cartload of unfinished canvases in 1849. The need for this experience, for this claiming of a particular identity for the landscape painter, as a recluse, or dweller in Arcadie, grew in direct proportion to the sprawl of cities in the late nineteenth century and it is more immediately evident in the emergence of peasant subject matter than in the older form of landscape painting.[48] It was publicly maintained long after many of its proponents had returned to the comfortable networks of the London studios. Nevertheless, there continued to be great nationalist pride in Linton's assertion that 'it was

Constable who was to smite the rock and opened out to France the springs of a purer landscape art'.[49]

This Edwardian aesthetic jingoism cannot be allowed to stand. Are we seriously to believe that these sophisticated painters of the era of the packet boat and the P & O liner, who kept studios in St John's Wood and Victoria, were 'sturdy yeomen'? Waterlow and East were as frequently in France, Spain and Italy as they were in Cornwall or the Cotswolds. East's *Chateau Gaillard* and *Algeciras* were no less saleable for not being Suffolk or Old Sarum. Indeed there is evidence that not only were painters combing southern Europe for the homespun values and traditions which were being lost in British agriculture, but also that they were looking to democratise the vision which had enticed the English gentleman traveller of the eighteenth century.[50] The emphasis in recent scholarship upon the exclusively Home Counties idyll presents an incomplete picture. It denies the significance, so readily admitted, of the Barbizon School and French art training. More significantly it prioritises British regional as against international tourist values and it neglects the significance in the art market of exotic foreign subject matter drawn from Asia Minor and the Far East, which was immediately attached to the picturings of empire. Enterprising dealers like the Fine Art Society commissioned artists like East and Mortimer Menpes to record their wanderings in India and Japan, and these entrepreneurial exploits culminated in exhibition/book launches and promotional articles in the art press. Publishers like A & C Black fed the public demand for illustrated travelogues; art magazines were full of advice about suitable 'sketching grounds'.[51]

East's landscapes painted in Spain and Italy thus gave access to alternative traditions in a context in which Englishness was much more expansive than is sometimes claimed. It became easier on these foreign shores to reclaim the lotus land peopled by nymphs and rustics. The women from a nearby gypsy camp spontaneously dance on the roadway in order to remind the educated English traveller of his roots in the *Eclogues* of Virgil. In every case the figure groups owe something to Claude, on occasions, filtered through Wilson and Turner, on others, through the *sous-bois* of Diaz and Corot. East grappled with these conflicting visual languages in order to portray the sublimity of the English Elysium in which nymphs and fauns might sport themselves. In Corfu or Algeciras, it was possible to reaffirm, for fevered plutocrats, the classical values which had rooted in the English psyche with the Grand Tour.

Italianate motifs do not, however, constitute the dominant strand in contemporary landscape painting. It was to the Cotswolds and the valley of the

Ouse that East was constantly recalled by his critics. In 1895 Frederick Wedmore reviewed East's Japanese 'episode', but regarded it as a means of securing a 'fresher feeling' for 'the land an English landscape painter is of necessity born to paint'.[52] Foreign territories contained 'no associations, no traditions, no memories. For painting that is superficial, for painting that is decorative, such remote land may afford a motive; but for the painting that comes from the heart, there are needed the associations of time and the associations of love'.[53] Memory in this sense was more a by-product of unselfconscious absorption and culture, than the schooled response of the painter rhyming off the characteristics of a chosen motif. But the poetic tonalist tradition which East applied to this landscape was not simply based upon a reheating of Constable's imagery, à la Murray. He was much too worldly for that. He looked to the work of Jean-Charles Cazin. 'You cannot say for certain' he wrote, 'what proportions of yellow or blue composed his green. You cannot detect the particular pigment in his delicate greys. But you instantly recognise that he has seen tints in Nature, and that his representation is just and beautiful. You conclude that they are arrived at through a refined and artistic temperament, not the coarse and vulgar ignorance that paints blue blue or green green, and leaves no message beyond the impression that the hand that painted was the hand of a boor'.[54] And he continued, almost, but not quite, paraphrasing Whistler: 'We look for the impression of the moment in a sketch, but the experience of years in a picture. A fine work of art should include the feeling of spontaneity of the sketch with the satisfaction of the sense of completion of a picture ... The landscape expression should be distilled and economical. It should be learned and recited rather than simply read'.[55] Since naturalistic truth was no longer enough in itself, there was frequent allusion to poetic handling in the contemporary criticism of East's work.

Two works define the borders of his position. In 1887 East showed his only suburban landscape, *A New Neighbourhood* (fig. 33) at the Royal Institute, painted from the back window of his studio on the fringes of Hampstead and a striking contrast to Constable's Heath, and Madox Brown's *Work*.[56] It is a bleak winter wasteland, showing a garden suburb under construction. It was awarded a gold medal at the Exposition Universelle in 1889, a decade in which many artists like Raffaelli, Caillebotte, De Nittis and Van Gogh had addressed the wasteland at the periphery of the ever-expanding metropolis. They observed the picket fences and scaffolding and the miserable déclassés, the casual workmen and unhoused rural poor who inhabited this hinterland. In this instance the

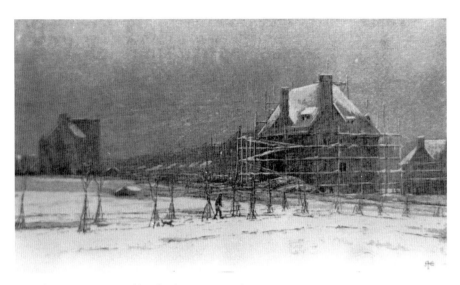

33 Alfred East, *A New Neighbourhood*, 1887. Untraced.

gaunt silhouettes of unfinished houses assume almost symbolic proportions, graphically recording the incursion of suburbia into the countryside. These, it is clear, were not the happy homes of rural England which had grown into the landscape. The remainder of East's career was devoted to the elaborate construction of the visual antithesis of this phenomenon.

Then in 1896, when his career was firmly established, East exhibited *A Haunt of Ancient Peace* (fig. 34), a work which, in its close relationship with contemporary poetry gave visual expression to the essential England of the Edwardian imagination.[57] It shows a traveller, perhaps recently returned from colonial adventures, disembarking at a riverbank whereon, shrouded in foliage, stands a neglected manor. East borrowed his title from Tennyson's *The Palace of Art* in the rooms of which a series of tapestries depicted the moods and types of landscape. The final one depicted

> . . . an English home: grey twilight pour'd
> On dewy pastures, dewy trees,
> Softer than sleep — all things in order stor'd,
> A haunt of ancient peace.

34 Alfred East, *A Haunt of Ancient Peace*, 1896, oil on canvas (126.5 x 184 cm), signed l.r. 'Alfred East'. Szépmüvészeti Müzeum, Budapest.

Beyond these confines was untamed nature, heaths and mountains, cliffs and the sea. For Victorian writers the home was clothed in old tradition, a place of retreat, of seclusion, a bulwark against change and foreign incursion. The house, starkly silhouetted against the sky in the early work, has grown into the landscape in the later one, and is so concealed that it has to be rediscovered. It scarcely seems accidental that six years after the exhibition of this painting, Alfred Austin, then poet-laureate, should publish his volume, *Haunts of Ancient Peace*, an evocation of the magic kingdom of ancient paths, dank woods and still ponds, leading to old inns and crumbling rectories. Austin, Housman, Watson and Edward Thomas, for all their differences, partook of East's neutralised vision. In East's most insistent trope, *The Golden Valley* (pl. III) the landscape opens out in per-fect swaying undulations on a sunlit autumn afternoon. If there had been an encroaching suburb or factory chimney, East would contrive not to see it. The distant roofs are down there in the folds of the landscape, their colours part of its chromatic melody. Now in middle age, more materialistic perhaps, and more cer-tain of the greens and golds, the full-blown chestnuts and flowering meadows

that were so much part of the common mentality, East could extemporise.

What do these grand landscapes mean? How are they to be understood coming at a time when we might expect them to be swept aside by the crashing tide of metropolitan modernism? Their construction is too particular to allow us to remain comfortable with the convenient generalisations. Yes, they draw the eye away from that other world of uncertain relationships which existed in the metropolis. They could so easily function as a soporific to the increasingly disconsolate labouring masses by providing a vision of the heaven to which they might aspire. In this context, continuity with the golden past was vital. In the modern municipal or colonial gallery the great tradition of English landscape continued and was reborn. The country house Arcadia, purged by Constable, medievalised in Tennyson, and filtered through French painting, has become the object of public patronage and by extension, the expression of local democracy and civic pride. And for this *The Golden Valley* is central. It contains the remaking, for its own time of the mythic appearance of the English countryside, a picture which as Charles Marriott observed: 'seemed to exist less . . . as a subject found in Nature than as a theme to support and express a conviction'.[58] The configurations had become so distilled, so rehearsed, so often rhymed out, that the impress in the mind of painter and public had created one of the great archetypes of the age. Landscape paintings of this type were constructed deliberately to appeal to the memory or to help unravel a hundred memories. They were not snapshots of particular places, so much as an attempt to convey the feelings, the whole sensory experience of landscape and its cultural signposts. A noble vista taken from a particular viewpoint, edited, coloured and shaped in recollection, given the fullness, the delight of an experience released from the spectator's past, persuading, coaxing some indeterminate collective memory into the present with coloured pigments on a piece of toile — this, no less, was the Edwardian landscapist's project.

1 *Royal Academy Pictures* (London, Paris and Melbourne: Cassell and Co. Ltd., 1896), ii; *Royal Academy Pictures* (London, Paris, New York and Melbourne, 1903), ii; *Royal Academy Pictures* (London, Paris, New York and Melbourne, 1905), ii. Survey articles of the period such as Adam Palgrave, 'Landscape in England', *The Connoisseur* 9 (1904): 135–42 and Malcolm Bell, 'Landscape art at the Royal Academy', *The Magazine of Fine Arts* (London: George Newnes Ltd., 1906), 109–13, do not develop the essential relationships of 'Britishness', 'nature' and the place of landscape painting much further.

2 See *inter alia* Raymond Williams, *The Country and the City* (London: Chatto and Windus, 1973), and *Problems in Materialism and Culture* (London and New York: Verso, 1980); Jan Marsh, *Back to the Land, The Pastoral Impulse in England, from 1880 to 1914* (London: Quartet Books, 1982); Alun Howkins, *Reshaping Rural England, A Social History* (London and New York: Harper Collins, 1991).

3 A notable exception in this regard is Ysanne Holt, 'Nature and Nostalgia, Philip Wilson Steer and Edwardian Landscapes', *Oxford Art Journal* 19.2 (1996): 28–45.

4 East's *Autumn* was painted in Scotland in 1887 and acquired the following year from the New Gallery, see City of Manchester, *Art Gallery Catalogue ...* (Manchester, 1895), 78; Murray's *A Hampshire Haying* was bought by Bradford in 1895, see City of Bradford, Corporation Art Gallery, *Illustrated Catalogue* (Bradford, 1923), 30.

5 For a brief discussion of late Victorian collecting see Dianne Sachko Macleod, *Art and the Victorian Middle Class, Money and the Making of Cultural Identity* (Cambridge: Cambridge University Press, 1996), 344–73.

6 Liverpool for instance acquired Easts and Murrays from local benefactors in this way. See Walker Art Gallery, *Illustrated Catalogue* (Liverpool, 1927) and Edward Morris, *Victorian and Edwardian Paintings in the Walker Art Gallery and at Sudely House* (London: Her Majesty's Stationery Office, 1996).

7 George Moore, *Modern Painting* (London: Walter Scott Ltd., 1893), 146–52.

8 C. Lewis Hind, *Landscape Painting, from Giotto to the Present Day* (London, Chapman and Hall Ltd., 1924), 2:120.

9 For a full discussion of *February Fill Dyke* see Arts Council, *Great Victorian Pictures*, 1978, catalogue of an exhibition by Rosemary Treble, 49. In addition to contemporary reviews, Treble quotes later assessments of Leader, notably that by J. E. Pythian, *Fifty Years of Modern Painting: Corot to Sargent* (London: Grant Richards Ltd., 1908), 342: 'Mr Leader is one of the most conspicuous examples of the artist who, having made a reputation for a particular kind of work, finds himself able to repeat it year after year, even though manner becomes mannerism, and art artificiality'.

10 *Bibby's Annual* (Liverpool: Priory Publishing Press for J. Bibby and Sons Ltd., 1916), 181. Pictures like *At Eventide it Shall be Light* were, in effect, recalled into service during the Great War. Lewis Hind noted (*Landscape Painting*, 124): 'The average out-of-doors Englishman likes these representations of nature so much that, if he could not afford to buy the picture, he would purchase a reproduction in black and white. The right to reproduce one of these representational landscapes sometimes cost more than the picture itself. But — it can never happen again'.

11 Leader owned Constable's *Willie Lott's House*, 1816 (Ipswich Borough Council), see Leslie Parris, Ian Fleming-Williams and Conal Shields, *Constable, Paintings, Watercolours and Drawings* (London: Tate Gallery exhibition catalogue, 1976), 99.

12 P. G. Hamerton, *Imagination in Landscape Painting*, 2nd ed. (London: Seeley and Co. Ltd., 1887), 5.

13 *Imagination in Landscape Painting*, 12–13. Although Lecoq's methods were known in England through Alphonse Legros, Frédéric Régamey, Jean-Charles Cazin and Léon Lhermitte in the 1870s, his treatise *The Training of the Memory in Art and The Education of the Artist* did not appear until translated by L. D. Luard with an Introduction by Selwyn Image (London: MacMillan and Co. Ltd., 1911). For reference to Luard see Michael Parkin Fine Art Ltd., *Lowes Dalbiac Luard, 1872–1944* (London, exhibition catalogue, 1977).

14 Whistler, who was *au fait* with memory training, amazed the Greaves brothers in the seventies in memorising nocturne effects on the banks of the Thames. His practice was transmitted to Sickert who made repeated reference to memory in his writing on art in the late eighties.

15 *Imagination in Landscape Painting*, 25.

16 *Imagination in Landscape Painting*, 58–59.

17 It should not be assumed that local newspapers were any less adept or less sophisticated than metropolitan ones at making connections on the level of the visual within the current genres of contemporary art. The current work by Laura Newton on art criticism in newspapers on Tyneside in the 1880s demonstrates that local columnists are as likely to draw old masters into a comparison as they are to recall the work of European contemporaries.

18 C. Collins Baker, 'Sir E. A. Waterlow', RA., PRWS. *The Art Journal* (The Christmas Art Annual, London, 1906), 18.

19 East was born in Kettering in 1844 and as was frequently the case with other artists from lower-middle-class backgrounds, he was discouraged in his attempts to make a career as an artist. Only after he had learned the rudiments of shoe manufacture was he sent to Glasgow in 1874 as a representative of his brother's firm. There, freed from family influence he attended the Haldane Academy and consorted with members of what later became known as the Glasgow School. A landscape painter from his youth, he was in Barbizon by 1882, where he painted a small oil sketch of the house of Charles Jacque. See Sir Alfred East Gallery, Kettering, *75th Anniversary Exhibition*, catalogue essay by Kenneth McConkey (Kettering, 1988), 5.

20 *The Magazine of Art* (1887), 290.

21 *Dewy Morning* [untraced], RA ,1883, no.178, shows a peasant woman and her goats under flowering trees.

22 *Chill October*, exhibited at the Royal Academy in 1871 (no. 14), was the first and most renowned of a series of large exhibition-piece landscapes which, with portraits of politicians, dominated Millais' production throughout the last twenty-five years of his life. It was bought by Agnew's in 1875 for over three times its original purchase price and sold on to William, later Lord Armstrong, before 1886. It occupied pride of place in his

saloon at Cragside, Northumberland. See Walker Art Gallery and Royal Academy, *P.R.B. Millais PRA*, catalogue of an exhibition by Mary Bennett (1967), 49–50.

23 Alfred East, *Landscape Painting in Oil Colour* (London, New York, Toronto and Melbourne, 1919, 1st ed. 1906), 93.

24 *Landscape Painting in Oil Colour,* 92.

25 *Landscape Painting in Oil Colour,* 58.

26 Although enduringly popular and frequently republished throughout the Edwardian period, it is clear that Ruskin's writings seemed increasingly opaque to painters. For Lewis Hind on the problems of 'Ruskinism' see *Adventures among Pictures* (London: Adam and Charles Black, 1904), 123–27. See also Rex Vicat Cole, *The Artistic Anatomy of Trees, Their Structure and Treatment in Painting* (London: Seeley, Service and Co. Ltd. (The New Art Library), 1916), 128: 'students — to read Ruskin with profit — require as much intelligence in sifting chaff from grain as he did in his writing. Ruskin should be read for the pleasure derived from style in writing'.

27 *The Artistic Anatomy of Trees,* 27.

28 *The Artistic Anatomy of Trees,* 62. See also Alfred East ARA, 'On Sketching from Nature. A Few Words to Students', *The Studio* 37 (March 1906): 97–103.

29 See Rex Vicat Cole, *British Trees Drawn and Illustrated by Rex Vicat Cole, RBA.*, text revised by Dorothy Kempe, 2 vols. (London: Hutchinson and Co., 1907) and *The Artistic Anatomy of Trees.* See also T. J. Barringer, *The Cole Family, Painters of the British Landscape, 1838–1975,* catalogue of an exhibition at Portsmouth and Bradford, 1988.

30 *Landscape Painting in Oil Colour,* 59.

31 C. Collins Baker, *The Art Journal,* 1906, 2–4; see also J. Lingfield, 'The Art of J. Buxton Knight', *The Magazine of Fine Arts* (London: George Newnes Ltd., 1906), 159–69.

32 Cole, *The Artistic Anatomy of Trees,* 29–46.

33 Adrian Stokes RA, *Landscape Painting* (London: Seeley, Service and Co. Ltd. (The New Art Library), 1925), 66, 244, 249.

34 Stokes, *Landscape Painting,* 249.

35 See Alfred East ARA, 'On Sketching from Nature. A Few Words to Students', 98.

36 For an account of these dispersals see Ian Fleming-Williams and Leslie Parris, *The Discovery of Constable* (London: Hamish Hamilton, 1984), 81–119; Graham Reynolds, *Catalogue of the Constable Collection, Victoria and Albert Museum* (London: Her Majesty's Stationery Office, 1960); Stephen Daniels, 'The Making of Constable Country', *Landscape Research* 16.2 (1991): 9–17; William Vaughan, 'Constable's Englishness', *Oxford Art Journal* 19.2 (1996): 17–27. Vaughan discusses the Constable/Lucas engravings which were popular at this time. For a contemporary discussion see C. J. Holmes, 'Constable's "English Landscape Scenery"', *The Dome* 9 (1898): 221–29.

37 For a discussion of Holmes' contribution to Constable scholarship see Ian Fleming-Williams and Leslie Parris, *The Discovery of Constable,* 106–11.

38 Murray even uses the same kind of wagon — a 'hoop-raved' type — as that in Constable's picture.

39 This was one of three Hampstead pictures shown by Murray in the 1897 Academy. The *Athenaeum* (15 May 1897), 583, took the opportunity to refer to the current concern for the state of the Heath, which 'has suffered so much through "improvements" and smoke'. The foreground, particularly the inclusion of the pensioner was approved, as was the smoke-laden distant horizon. Hamerton had taken a purist line on such intrusions, praising simplicity of treatment and commenting that 'the one dread of the artist is that some part of his work may be condemned as uninteresting. To escape from this criticism he fills it from end to end with heterogeneous matter, and amuses the vulgar spectator by putting the materials of half-a-dozen pictures that might separately have been satisfactory into one inconsistent accumulation' (*Imagination in Landscape Painting*, 27–28). Five years earlier, George Moore had castigated Murray for his eclecticism, when, in London exhibitions, he was simultaneously showing a 'Murray Constable', a 'Murray-Corot' and a 'Murray-Rousseau', see *Fortnightly Review* 7 (1892): 837.

40 East, for instance, counselled against Murray's approach. In 1909, he wrote 'Do not, for one moment, believe that by visiting a particular spot where this or that famous picture was painted you can do the same; that is a great fallacy, quite as big as one as thinking that if you followed the same system or used the same colours or brushes as Turner or Constable, you could produce the same quality of work', Charles Holme, ed., *Sketching Grounds* (London (Studio Annual), 1909, introduction by Alfred East, ARA, PRBA, RE), 2.

41 D. S. MacColl, *The Life, Work and Setting of Philip Wilson Steer* (London: Faber and Faber Ltd., 1945), 80.

42 C. H. Collins Baker, 'Philip Wilson Steer, President of the New English Art Club', *The Studio* 46 (1909): 266.

43 D. S. MacColl, *The Life, Work and Setting of Philip Wilson Steer*, 80.

44 C. Lewis Hind, *Landscape Painting, From Constable to the Present Day* 2 (London: Chapman and Hall, 1924): 197; James Laver, *Portraits in Oil and Vinegar* (London: John Castle, 1925), 78–79.

45 John K. M. Rothenstein, *A Pot of Paint, The Artists of the 1890s* (Freeport, New York: , 1929, repr. 1970), 136.

46 Sir James Linton, RI, 'The Sketches of John Constable RA.', *The Magazine of Fine Arts* (London: George Newnes Ltd., 1906), 16.

47 C. Lewis Hind, *A Wanderer among Pictures* (London: Adam and Charles Black, 1904), 25.

48 Since 1970 an extensive literature has grown on this topic, however, R. L. Herbert's 'City vs Country, the Rural Image in French Painting from Millet to Gauguin', *Artforum* 8 (1970), 44–55, remains seminal.

49 Linton, 'The Sketches of John Constable RA.', 26.

50 Alfred Munnings, for instance, recalled a conversation with Henry La Thangue, who had foresaken England because he could not find 'a quiet old world village' in which to paint. See Kenneth McConkey, *A Painter's Harvest, H. H. La Thangue, 1859–1929*, Oldham Art Gallery, exhibition catalogue, 1978, 13–14.

51 From its inception *The Studio* contained articles on artists' haunts, eventually producing a special number, *Sketching Grounds* ed. Charles Holme, 1909, introduction by Alfred East, containing articles on 23 recommended sites covering Sussex, North Wales, the Highlands, the West Coast of Ireland, to the Pyrenees, Capri, New York and Morocco.

52 Frederick Wedmore, 'The Work of Alfred East RI', *The Studio* 7 (1896): 141.

53 Wedmore, 'The Work of Alfred East RI', 141–42.

54 Sir Alfred East, *Landscape Painting*, 48.

55 East, *Landscape Painting*, 48.

56 This watercolour remains untraced. An oil version of the composition was exhibited at the Royal Academy in 1908 (no. 986), see Roy Miles, *Sir Alfred East, The Forgotten Genius* (London, exhibition catalogue, 1978), no.4.

57 After its exhibition in London, *A Haunt of Ancient Peace* was shown at the Manchester Autumn Exhibition in 1897, see *The Artist* 20 (1897), 566 (illus. p. 565). At some point thereafter it was acquired for the Hungarian National Gallery. Rex Vicat Cole's *A Haunt of Peace* [untraced] was shown at the Royal Academy in 1909.

58 Charles Marriott cited in *Modern Masterpieces of British Art* (London: The Amalgamated Press Ltd., n.d.), 154.

An Ideal Modernity: Spencer Gore at Letchworth

Ysanne Holt

I N 1912, the newly married Spencer Gore and his wife, Mollie Kerr, temporarily left London for Harold Gilman's house in Wilbury Road, Letchworth, to await the birth of their first child. In the few months he spent there Gore produced seventeen pictures, a significant body of work in terms of his own development, which reflect the cultural preoccupation with the city and the country and comprise a mediation of Englishness and modernity.

This essay seeks to problematise a sense of opposition. Englishness, as an ideal of cultural unity informed by romantic native traditions and an instinctive individualism identified with the rural, is often simply contrasted with the negative perceptions of urban modernity either as a fragmented and chaotic experience or as an overly regulated and systematised one. In both perceptions, the foundations of a unified national identity are perceived to be at risk. My aim here is to examine one particular instance in which the rural could be viewed not purely as a refusal or escape from the urban, but as a site where an ideal modernity might be forged.[1] Letchworth as pictured by Spencer Gore appears, initially at least, as a place where both the romantic illusions of individual freedom and of collective progress could apparently co-exist and where the sharp divisions between town and country, so fundamental to much late-Victorian and Edwardian painting, could be dissolved. There was however, as this essay will demonstrate, a significant cost and sacrifice attached to this process.

The period from the end of the century up to the Great War is marked both by a resistance to European modernism and by a struggle to reach an accommodation of what was commonly regarded by contemporary critics as threatening to the national tradition. Ways in which this accommodation took place around 1912 offered an apparent resolution to the polarities of Englishness and modernity but, at the same time, uncovered fundamentally conservative tendencies within modernism itself. My argument is that Gore's representations of the new Garden City of Letchworth, predicated on urban middle-class fantasies about the natural continuity and essential Englishness of rural life, successfully displaced anxieties about modernity and the urban through a personal interpretation of current aesthetic theory and the European paintings to be seen at London

exhibitions. As Jack Wood Palmer declared, at this point: 'Gore was the first to seize on the new movements from France, to examine and assimilate them'.[2]

William Ratcliffe, fellow member of the Camden Town Group, first introduced his colleagues to Letchworth. He had moved there in 1906, three years after its foundation. Gilman and his own young family followed in 1909. Ratcliffe, Gilman and later Gore embraced Ebenezer Howard's wholesome new environment in the Hertfordshire countryside and in doing so affirmed that, although the spectacle of London was a powerful artistic stimulus, it was also the unhealthy, disease-ridden home to an enfeebled race. Statistics of 1912 proved the efficacy of the Garden City and revealed a significantly lower child mortality rate than in major cities in England. Letchworth was 'the healthiest English city' as Ebenezer Howard had promised, and life within it might 'become an abiding joy and delight'.[3] For resident accountant and historian C. B. Purdom: 'the new town, instead of draining the vitality of the race — may maintain it'.[4] His view was underpinned by class prejudice and an illusory belief in the sturdy vigour of the country-dweller, contrasted with the 'unkempt humanity' the 'massed and unheeded populations' of the labouring classes in their crowded metropolitan quarters.[5]

Howard's solution to the deteriorating inner-city conditions, building on widespread anti-urbanism and endemic rural nostalgia, first appeared in 1898. His proposal, traceable to William Morris' *News from Nowhere*, and to American 'city beautiful' plans, was intended to resolve the traditional town or country dilemma. The first Garden City, originally to be named 'Rurisville', would combine 'the most energetic and active town life, with all the beauty and delight of the country'. The resources of modern science would facilitate 'the spontaneous movement of the people from our crowded cities to the bosom of our kindly mother earth'. Areas like Camden Town would be transformed. 'Families; now compelled to huddle together in one room, will be able to rent five or six'. Wretched slums would be pulled down, their sites occupied by parks, recreation grounds and allotment gardens.[6]

Although Garden Cities were intended to provide good, working-class accommodation of a type proposed in endless *Studio* magazine competitions, Letchworth's initial reputation was as a perfect site for wealthy Londoners seeking inexpensive weekend cottages, their attention perhaps drawn by picturesque postcard sets like those produced by Frank Dean and William Ratcliffe.[7] More specifically, Letchworth was renowned, in its early days, as a centre for eccentric middle-class vegetarians and sandal-wearing potters and weavers, hence perhaps the low mortality rate. Unlike Port Sunlight, or indeed Robert Owen's New

35 Spencer Gore, *The Milldam, Brandsby, Yorkshire*, 1907, oil on canvas (51.5 x 61 cm). Private Collection (formerly Piano Nobile, London).

Lanark of the 1830s, Letchworth had no indigenous industrial base. The initial lack of industry, coupled with an emphasis on cottage crafts, encouraged the view that Letchworth was another Chipping Campden without the guiding spirit of C. R. Ashbee.[8] Many early inhabitants, Gore amongst them, were interested in Madame Blavatsky's theosophy, believing it could produce a utopian society of individuals united by some higher state of consciousness: 'a body of strong and joyous men — to preach and practice among the masses of the people a wholesome — emancipating — and a saner mode of living'.[9] While the ideology of social hygiene was implicit, this utopianism was essentially redemptive, conscience-salving and hardly a catalyst for real change.[10] But by this date country life was being presented not simply as a recourse for the well-fed middle classes, it was being advocated as an essential state for a wider public.[11]

By the time he arrived in Letchworth, Gore had abandoned the loose, spontaneous handling of his Slade mentor, Philip Wilson Steer. The style and composition of Steer's late-nineties works was overhauled in the years after 1907. Gore moved progressively away from conventional paintings like *The Milldam, Brandsby*, 1907 (fig. 35), at first revealing the growing importance of Lucien Pissarro in his approach to the intimate, secure gardens and wooded countryside

36 Spencer Gore, *The Garden*, 1909, oil on canvas (40.5 x 51 cm). Fife Council: Kirkcaldy Museum and Art Gallery.

around his mother's home, Garth House at Hertingfordbury.[12] This contrasts, however, with the high-horizoned panoramas, the broad swathes of mature trees and field patterns, which he produced at Applehayes in Devon on three occasions between 1909 and 1913.[13] That was a landscape without personal connotations for Gore but one which, though wide and unpeopled, was nevertheless accessible and, neatly hedged, on a human scale.

In *The Garden*, 1909 (fig. 36) Gore came close to compositions by Monet, like *Path in Monet's Garden*, 1901–2 and the technique of the Pissarros, all committed garden painters.[14] Here cultivated flower beds, the intimate natural viewpoint, and brightly coloured shadows create a harmonious and controlled atmosphere, and the sun-dappled, well-tended, narrow footpath suggests a human presence without the use of figures. The sense of real distance is suppressed by the rising footpath that flattens the picture plane, drawing the spectator into the scene. Nature allows for a solitary contemplation, but it is a regulated and structured experience. It was inevitable that the garden should become a favoured subject for Gore in the Garden City.

37 Spencer Gore, *The Garden, Garth House*, 1908, oil on canvas (51.5 x 61 cm). Board of Trustees of the National Museums and Galleries on Merseyside, Walker Art Gallery, Liverpool.

A garden was also a safe subject commercially in this era and a staple ingredient of gallery stock and exhibitions. Gore's own garden paintings were described by Jack Wood Palmer in the mid 1950s, as 'among the most exquisite evocations of the Edwardian era'.[15] In works like *The Garden, Garth House* of 1908 (fig. 37) the artist had demonstrated his skill at suppressing conflict, a talent which led to his role in so many of the pre-War groups and exhibiting societies. Tensions and insecurities, the reality of that era and of his own family circumstances, have been typically and successfully concealed.[16] A comparison here with certain pictures by Camille Pissarro, like *Kew Gardens* of 1892, is interesting; the arrangement of the canvas, the repeated lines of the formally laid out gardens suggests an idea of nature as pure, tame and unintimidating.[17] The London park, like Gore's mother's garden, resists the chaos of modernity. Something of the same quality occurs throughout Gore's practice as a painter, accounting for his appeal as an individual, his personal history and motivations, his success as an artist.[18]

Gardens have been perceived as sites half way between the unplanned wilderness and the man-made world of the city; the best of all worlds, they balance

human organisation and the unexpected delight of nature. As Dean MacCannell puts it, the garden fills a space between the opposites of nature and culture, where conflict and anxiety might be wished away.[19] A middle-class passion for garden design reached a highpoint during the Edwardian era, and was supported by articles in numerous journals like *The Studio* where it was argued that: 'almost every little suburban villa, in its tiny front plot, shows the desire to bring nature into a pattern'.[20] The significance of suburban and modest country gardens developed as the complexities of urban life seemed increasingly threatening to the preservation of bourgeois individualism. Although to a degree, 'representations of nature — purified and refined — enjoyed passively — without exertion', gardens also demonstrate a need to achieve autonomy and a control less attainable in urban centres.[21] This was their significance for Garden City planners and also, I would argue, for Gore.

After 1910, however, Gore was increasingly preoccupied with the art of Cézanne which he thought possessed a 'wonderful gravity'.[22] His paintings of Letchworth were therefore to concentrate on formal, structural relationships and simplified planes and outlines, rather than a field of unmodulated colour. This shift registers the movement in British avant-garde circles from the later nineties away from what was by then perceived as the dispassionate superficiality of Monet, towards a meditative, empathetic contemplation of the essential spirit of a scene. By 1912, Gore was often in attendance at T. E. Hulme's weekly gatherings at Frith Street, where enthusiasm for Bergson was rife. Hulme, at this point, was still impressed by Bergson's insistence on the rhythmic flux and vital energies underlying material existence which, he argued, were especially susceptible to the artistic intuition.[23] For Bergson and his followers, intuition emerges not just as some special gift or ability, but as a philosophical method that strives for a spiritual interaction between the perceiver and the perceived. Such an ideal had a unique appeal in London immediately before the Great War, forming a common currency, if only temporarily, between a range of factions — from Hulme and Wyndham Lewis to Roger Fry and Bloomsbury. One public expression was provided by Middleton Murry's journal *Rhythm*. For Murry: 'Modernism is not the capricious outburst of intellectual dypsomania. It penetrates beneath the outward surface of the world, and disengages the rhythms that lie at the heart of things — primitive harmonies of the world that is and lives'.[24]

Underpinning this notion is what Alan Robinson described as the romantic evolutionism supporting Frederick Goodyear's assertion, also in the first edition of *Rhythm*, that the ideal society, formerly distanced either historically, geographi-

cally or metaphysically, was now about to be realised. Thanks to Bergson, utopia had turned up on the very doorstep: 'Thelema, the soul's ideal home, has become a plain practical issue'; it lies simply in the ordinary human future.[25]

Much of this echoes the sentiments of the Blavatsky followers at Letchworth. The sense of this trajectory is equally evident in Gore's desire, in 1910, to reconcile both the decorative and the naturalistic elements in his art and to produce an imaginative transformation of existing nature. The artist is no longer simply a passive recorder of outer appearances. Modernism shapes and re-organises. In his enthusiastic response to the Cézannes, Gauguins and Van Goghs at Fry's first Post-Impressionist exhibition, Gore wrote:

> The attempt to separate the decorative side of painting from the naturalistic seems to me a mistake. — Simplification of nature necessitates an exact knowledge of the complications of the forms simplified. This may be done to produce a greater truth to nature as well as for decorative effect. — Gauguin gives his idea of Tahiti just as Goya gives his of Spain. — If the emotional significance which lies in things can be expressed in painting, the way to it must lie through the outward character of the object painted.[26]

Gore in fact echoes Desmond MacCarthy's position in the introduction to the Grafton Gallery show *Manet and the Post-Impressionists*, 1910–11, that the artist must aim at synthesis in design: 'that is to say that he is prepared to subordinate consciously his power of representing the parts of his picture as plausibly as possible, to the expressiveness of his whole design'.[27]

By this stage, acutely aware of the potential of modern French painting, Gore would probably have empathised with Matisse who in his 1908 *Notes d'un peintre*, referred to composition as 'the art of arranging in a decorative manner the various elements at the painter's disposal for the expression of his feelings'.[28] The idea that the wholeness of a picture was essentially the by-product of design, led Gore to stand back from what he was doing and to attempt to see a given subject in its entirety.[29] Unstable light effects, causing movement of tone in local colour, were now to be generalised within a heightened consciousness of the marquetry of shapes. Increasingly the picture plane was emphasised, objects treated in a slab-like way and clumps of foliage left without surface modulation.

This pace of development quickened in August 1912, by which time Gore had been encouraged towards a greater flattening of planes and non-naturalistic colour by moderate followers of Cézanne, artists like André Lhote, Orthon Friesz, Derain and Herbin — all favoured by *Rhythm*.[30] The following year, for

example, O. Raymond Drey in describing the character of the Post-Impressionist movement to his readership commented that:

> every landscape forms a mass composed of numerous smaller masses, all knit together by a natural rhythm in which alone lies the secret of its compelling mood. The mood is the painter's of course; in the painter's conception of nature nothing exists beyond the magic circle of his own vision. Cézanne never spoke of rhythm; probably it never struck him that his pictures were rhythmic. But painters—saw in its rhythmic quality the means to a new aesthetic excitement, more powerful than any that painting had known before, because it touched the strings of a universal capacity for response.[31]

In *Letchworth, The Road*, 1912 (fig. 38) Gore demonstrated the effects of aesthetic ideals like these. Characteristically, the viewpoint is down onto a broad sweep of landscape. Red-roofed and tall-chimneyed houses nestle behind the hedges to the right of the canvas, counterbalanced by a tall tree on the far left. The diagonal stripe of the footpath recedes into the distance, its direction taken up by the ploughed fields in the background. Land and sky are equally divided. Overall recession on the ground is balanced by the pale pinks and greens of the blocky clouds above; the effect brings the eye back to the front of the picture plane. Spatial depth is further reduced by implying undulations in the landscape which are not actually there. It is as if the painter's eye levitates above the landscape in order to find an aerial viewpoint. Smoother surfaces and a dynamic, rhythmic organisation of forms help to achieve compositional equilibrium. Basic forms are found in nature, then abstracted or emphasised according to the desired expression, in this case of a harmonious and regulated natural environment.

In this way Gore's paintings, like many contemporary travel posters, 'give, by means of flat colours and outlines, something of the joy of sunny country lanes, red tiled roofs and bright skies, using colour and tone values quite arbitrarily'.[32] The designs of individuals like Walter Spradbery and F. Gregory Brown were commissioned by London Transport, who were keen to impress on city dwellers the benefits of healthy sunlight and fresh air. While these posters were consciously more explicit than Gore's paintings, both cast in visual terms the new relationship of the middle classes towards the countryside in which it appeared to be what it signally was not, free from conflict and complexity. The process of sub-urbanisation, whereby rural areas were effectively colonised, could now, having found pictorial expression, become legitimised within Edwardian bourgeois ideology.

38 Spencer Gore, *Letchworth, The Road,* 1912, oil on canvas (40.7 x 43.2 cm). Letchworth Museum and Art Gallery.

Although he stalked the periphery of Letchworth, Gore was acutely conscious that this was a 'garden' city. He was already a painter of gardens and in this case individual cottage gardens were subject to the idea of Letchworth in its totality. An early Letchworth planning directive bound tenants to keep their gardens in good condition. 'A garden', it was believed, 'is irresistible to the man of wholesome mind (the complete citizen). He cannot suffer it to fall into neglect'.[33] Such idealism was rewarded by the Howard Cottage Society prize of a week rent-free for the best garden on each estate. Their value lay not only in expression of middle-class individualism, but in terms of a wider mechanism of social control. Gardening conflated conventional aspects of Englishness with modern social organisation and collectivism. At this moment, the two were not antagonistic and seemed mutually compatible.

Planned like a traditional village, with greens and cul de sacs, Letchworth had little urban character. Such planning resonates with contemporary preconceptions about the countryside, which inevitably came into conflict with the

very idea of the 'new' at Letchworth. Unwin wanted a design which would retain the 'outward expression of an orderly community of people—undoubtedly given in an old English village'.[34] This emphasis, also a strong feature of Gore's imagery, contrasted with perceptions of disorder in the city which in his depiction of London parks and backyard gardens, the painter had consistently managed to avoid. Like others, Unwin fantasised about earlier times when 'clearly defined classes [were] held together by a common religion or common patriotism'. Similarly, in 1901 C. F. G. Masterman had spoken of an erstwhile 'England of reserved, silent men, dispersed in small towns, villages and country homes'.[35] Implicit once more is that notion of order in historical Englishness, of organic hierarchies of reserved and silent, well-behaved men and women. But order is also a defining characteristic of modernism. To quote again from Purdom:

> The idea of a complete and perfect city, despite its irreproachable sanitation, freedom from slums, and splendid regularity, was not altogether attractive to many reflective minds. Its formality, order and completeness, its fearful up to dateness were, however desirable in theory, more than a little repellent in prospect—men would not consent to live under the perfect conditions— Would Mr Howard himself enjoy his Garden City, any more than Mr Wells could be expected to be satisfied with his Utopia. The ideal cities are good in books, but none but mad men and dull persons would ever inhabit them.[36]

Order needed to be attained almost surreptitiously, so that modernity and progress could be achieved without sacrificing traditions of Englishness.

Borrowing the term used by Alex Potts, it is possible also to regard the pre-war Garden City and Gore's representations as groping towards an 'ideal modernity'. Letchworth, as a perfectly ordered new city, set down in nature in the rolling English countryside, might be a forerunner in Potts' account of the inter-war period's optimistic ruralism, the 'ideal image of what a modern Britain emerging from the unsightly ravages of Victorianism might become'.[37] Stephen Daniels has taken up Potts' argument in relation to his own discussion of A. L. Parkington's inter-War 'homes for heroes', with their aesthetic of 'clear order and truth to materials'. For Daniels this aesthetic signified what Potts had termed 'ideas of order and health appropriate to a rationally modernised society—both new and organically related to the past at the same time'.[38]

If we look at Gore's depiction of Gilman's house (fig. 39) in Wilbury Road, we see a building which, while a vernacular cottage type, is also as simply formed and clean-lined, that is modern, as Gore's style of painting. A lack of unnecessary

39 Spencer Gore, *Harold Gilman's House, Letchworth*, 1912, oil on canvas, (63.5 x 76 cm).
Leicester Museum and Art Galleries.

detail and even the use of new materials already defined the building style at
Letchworth from around 1905, when one of the cheap cottage designs was of
pre-cast concrete. Stephen Daniels reproduces a line drawing of Willy Lott's
newly restored cottage in the 1920s.[39] It looks remarkably like Gilman's house,
painted by Gore in 1912, with tall sunflowers outside, signifying the new and the
old, health and light at the same time. In other words, what is conventionally
interpreted as formal and aesthetic progress is, on another level, almost com-
pletely subsumed within a quite different social and cultural rhetoric.

Most of Gore's Letchworth pictures are not of the town itself but of its mar-
gins on the edge of the countryside, corresponding with Howard's stress that 'the
free gifts of nature — fresh air, sunlight [and] breathing room — shall be retained
in all needed abundance'. For Purdom this was fundamental: 'In all the modern
utopias town and country are pictured as being in happy relation'. At this period,
Letchworth was spreading rapidly over that surrounding countryside, but the

40 Spencer Gore, *The Beanfield*, 1912, oil on canvas (30.5 x 40.6 cm). Trustees of the Tate Gallery, London.

village concept was uppermost in Garden City propaganda, creating an arche-type modelled, for instance, on the sentimental perceptions of G. M. Trevelyan: where 'the darkest lane was never a mile from the orchards around the town'.[40] Gore's paintings reveal the same double standards, emphasising ultimately that romantic ideal over a planned twentieth-century solution to inner city prob-lems. It is notable too that in the huge debate that Garden Cities generated, there was little comment on their effect on existing rural communities, then in serious decline. Just as Gore's landscape paintings ignore the agricultural worker, so Letchworth was developed primarily from the perspective of sections of city populations, largely ignoring rural experience. Although the original plan was that two thirds of the acreage of Letchworth be divided into allotments and small farms, this scheme was soon curtailed.

The formal elements of *The Beanfield*, 1912 (fig. 40) are organised into stripes and bands of intense colour, all drawn from the natural scene but separated and reformed in interlocking patterns across the canvas.[41] None of these Letchworth

pictures were completed in front of the motif, though in few cases did Gore significantly alter the physical reality of the landscape. At all times the artist was preoccupied with striking the balance between naturalism and the decorative. The object of all the great imaginative painters, he wrote, 'was to reconcile their ideas with the things they saw'.[42] His approach was similar to the architects of the new town itself. Unwin remarked that 'we tried to combine a certain amount of formality in the lines of the plan with a great deal of regard for the natural features of the site, which is undulating and wooded'. Gore similarly grouped and composed the elements as they existed out there, and, contrary to the more descriptive panoramic views of Applehayes, allowed a new awareness of what Kandinsky termed the spiritual significance of form and colour to strengthen his powers of expression.

On the horizon of *The Beanfield* we see the tall chimneys of the brickworks at Baldock. They are patently out there in the scene the painter chose to paint, defining the horizon compositionally. They also point to a co-existence between the timeless world of nature, the flourishing bean crop and a modern world of industry.[43] Both elements, the brickworks and the landscape, are unified in Gore's rhythmic interplay of brightly coloured forms, underscoring Howard's conviction that Letchworth would produce a 'happy unity of art, science and nature' and reconfirming a Wellsian notion of the modern utopia. Significant here is the fact that this is a happy unity without the presence of any figures. Gore was attempting a rendering of the three dimensional forms found in nature onto a two dimensional surface, in such a way that the integrity of the picture surface and the initial individual response to the natural scene cohere. Hence the rhythmical distribution of blocky forms and the expressive use of intense colour.

Typically for Gore, a number of the Letchworth pictures base their composition on roads and footpaths, often of the path from Works Road that wound its way from the new town towards nearby Baldock, like *The Cinder Path*. (fig. 41) Roads and pathways were always attractive to Gore because of their ordering effect: they 'suggest' a human presence and they provide both a formal and a psychological stability. For Purdom, footpaths across the common and rural belt were vital to the Garden City: 'The invitation of the open road, of the little path across the fields, is always there for those who live in the new town'.[44]

As Letchworth was deliberately designed to preserve natural and historical features, the central square and roads were planned to allow views like that of the ancient Icknield Way, just north of the railway station. In 1911 Edward Thomas had made a journey along the walkway which he described in 1913. This pre-Roman

41 Spencer Gore, *The Cinder Path*, 1912, oil on canvas (68.6 x 78.8 cm). Trustees of the Tate Gallery, London.

route, on which Boadicea and the Iceni rode from battle, was originally a broad green strip following a watershed between rivers. As time passed and villages multiplied, the land which the footpath covered was gradually enclosed, causing much speculation as to the original path. As a subject for a painting Gore was perhaps particularly absorbed by the historical reality of the forms and structures which he knew lay beneath the surface of this pathway on the outskirts of Letchworth. He used *The Icknield Way*, 1912 (fig. 42), as the site for a picture which was clearly a turning point in his career, when he came closest to the cubo-futurist forms of Lewis and Bomberg. In his treatment and in the very nature of his subject, a correspondence between ancient landscapes and concepts of the modern is emphasised.

It is quite in character that Gore could produce a series of paintings based around a Garden City, which hardly ever included the figure as a focus of inter-

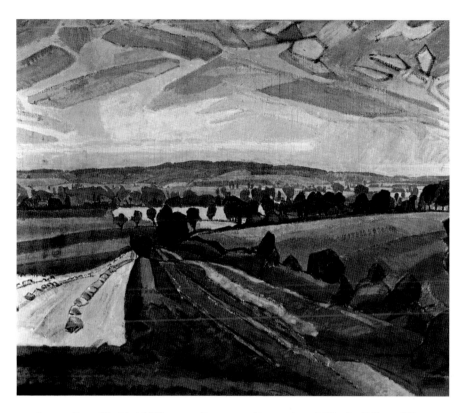

42 Spencer Gore, *The Icknield Way*, 1912, oil on canvas (63.4 x 76.2 cm). The Art Gallery of New South Wales.

est and my argument is that this absence accounts considerably for their success with contemporaries. The remoteness of the figures in the earlier *The Garden, Garth House* is instructive here. Those are not real individuals; their distance prevents recognition and crucially maintains the artist's control. An affinity between people and nature can only be achieved through distancing and integration into a highly structured composition. Here the sweeping footpath provides both formal and metaphorical stability.

Gore's garden-scapes, marked either by the absence of figures or of interaction between them, are concerned above all with people and their problematic relations. In one of the few instances where a figure is brought closer to the foreground of the picture, *Sunset, Letchworth with Man and Dog* (fig. 43) the 'happy unity' of a modernist handling and an ideal modernity is jeopardised. Here the

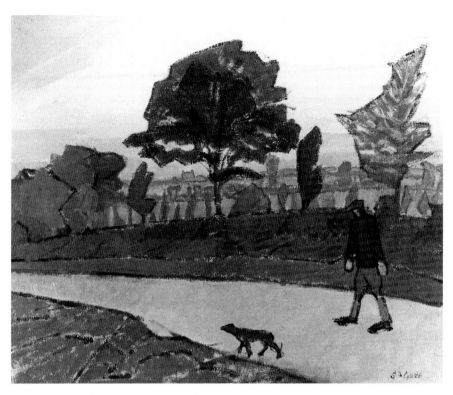

43 Spencer Gore, *Sunset, Letchworth with Man and Dog,* 1912, oil on canvas (50 x 60 cm).
Private Collection (formerly Anthony d'Offay, London).

solitary grey figure, trudging the footpath, is out of place against the background
sunset and the deep foliage. Far from being a natural accessory to a vibrant,
dynamic environment, this is an isolated, suburban man walking his dog off the
lead, strangely disassociated from all around him, unable to adapt properly to
the overall design. He seems to stand rather for the conventionally alienated
result of urban anomie and he illustrates the extent to which the inclusion of the
figure disrupts the pure integrity of the modernist landscape. Was the effect of
this representation intentional? Are we to assume a degree of social critique here
on the part of the artist, as Charles Harrison has suggested in his description of
the trudging peasant in Camille Pissarro's *Hoar Frost*?[45] It would seem unlikely
in this instance, and in terms of brushwork and handling the figure is quite con-
sistent with his surroundings. It was simply impossible to introduce into such a
scene a figure who is neither an appreciative spectator nor engaged in any sym-
bolic, though safely distanced rural (or semi-rural) activity. The grey man is both

compliant and awkward and he can never, given the formal qualities of such a work, emerge as a distinct individual with either a felt life or a grudge to bear. He is effectively tidied away. The conservative effects of this type of modernist handling equate in interesting ways with the broader experience of modernity and with the eventual results of the interaction between town and country during this period.

Although utopian town planners might have envisaged co-operative, organised societies arising from their schemes, what often resulted was the isolation of individuals removed from urban communities which were not always as alienating as middle-class critics depicted them. It has been observed that the social classes at Letchworth simply did not mix; 'social disharmonies would not disappear by offering the working classes scaled down versions of middle class communities'.[46] Somewhat ironically, the effect of Gore's predisposition to avoid painting the interactions between people resulted in representations of exactly those disconnected, lone figures. His are just the 'reserved', 'silent' and 'dispersed' men Masterman had idealised; men unlikely to cause any disturbance. The modern landscape could only ever be an ideal landscape once it had been pictorially and metaphorically emptied out, only then could order, harmony and control be attained.

Letchworth Station, 1912 (pl. IV) which was included in the second Post Impressionist exhibition, is possibly the only Gore Garden City painting to deal with a subject based on the town itself and to involve a number of people. Gore's station, a temporary structure replaced the following year, is far from threatening to the green countryside, as one contemporary critic, P. G. Konody assumed:

> It is about the last subject that any artist with the old fashioned sense of the 'picturesque' would have chosen for representation. But this is far more than a representation of uninviting facts. It may or may not be a 'portrait' of Letchworth railway station. What it suggests is the silent protest of a lover of the green countryside against the intrusion of unbending iron and black smoke. An almost cruel stress is laid on all that is hard and stiff and graceless, dingy and unpleasant in and around a railway station; everything is concentrated on that 'spiritual significance' that has entered so largely into the jargon of Post-Impressionist criticism.[47]

Konody's interpretation says more about his own prejudices than it does about Gore's, but also demonstrates the tensions between progress and preservation implicit in all representations of the English countryside.[48] Gore's *Letchworth*

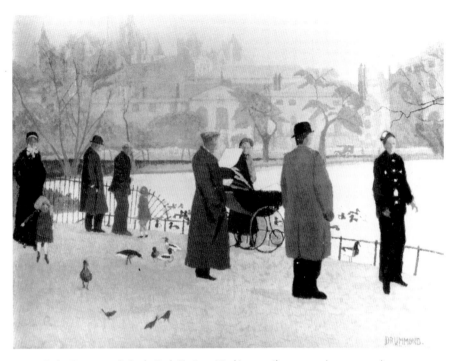

44 Malcolm Drummond, *In the Park (St. James' Park)*, 1912, oil on canvas (72.5 x 90 cm).
Southampton City Art Gallery, Hampshire, UK/ Bridgeman Art Library.

Station is not conceivably an image of grimy unpleasantness. A contemporary photograph reveals the extent to which the artist made slight compositional changes, with the result that the temporary wooden station appears in greater harmony with the surrounding countryside and signs of development, like the new housing to one side of the left-hand platform, is conveniently out of view. Set amidst open fields, under clear blue skies, Gore's station and its waiting passengers are a model of tidy respectability. Preliminary drawings squared up for transfer also show that those passengers were a later addition.[49] When they appear, in the final painting, they are disconnected from each other, ordered rather than vital. If the railway was a symbol of progress, of the developing unity between large cities and the outlying countryside, then the painter here presents us with an ideal vision of a new, civilised, neatly functioning and untroubled England, that was essentially middle-class and of which any corporate designer would have been proud.

Another Camden Town Group member Malcolm Drummond's painting of 1912, *In the Park (St. James' Park)* (fig. 44) can be seen as in some way an English urban response to Seurat's *A Sunday Afternoon on the Island of La Grande Jatte*, 1884–86. To an extent Gore's is a semi-rural version. As Charles Harrison has pointed out in relation to Seurat, the visual unification of a painting style which is both highly figurative and highly coloured, results in the 'petrification' of the figures. Harrison's argument, relevant here, is that the 'technical interests of modernism may be reconciled with the appearances of social life, but only to the extent that one or other is allowed to be inhuman'. As he continues, such a problem is not likely to occur in a pure landscape, 'where the absence of human animation goes unnoticed and where the sense of stillness generated by the assiduous technique appears appropriate and highly expressive'.[50] In another instance the anonymity and the seeming isolation of Seurat's figures have also been related to the anonymity of life in a modern city or suburb, where 'human beings remain — without reference, as faceless as the factory and suburban landscapes they have created, and must inhabit'.[51]

Gore's own motivations, that celebrated diplomacy or, more specifically, the drive to suppress any kind of genuine conflict, significantly influenced his reactions to his subject. These factors, allied with his class position and the effects of shared cultural and political experience; anxieties about inner city disorder and the breakdown of established order, fundamentally helped to shape his representations. Assimilation of modernist forms of art ultimately, here, exemplified a kind of cultural conservatism and supported a wider reluctance to address certain social realities. For instance, privileging the imagination and/or formal innovation made it possible to avoid nagging details like actual individuals. The artist's disingenuous manner of suppressing, avoiding or denying conflict, while successfully forging an 'ideal modernity' resonated strongly with both the broader programmes of modernism, and at the same time with contemporary social and political anxieties and agendas.

Those broader programmes which necessitated the steady colonisation of the country from the city (the urban middle classes, artists, back-to-the-landers, country-retreaters, week-day commuters and suburbanites) all resulted in processes of denial, purification and the displacement of native, rural populations observable in much English painting throughout this period. Ongoing developments in the economic and political spheres were therefore successfully shaped into cultural and aesthetic expression, as Gore's paintings demonstrate. These Letchworth pictures were, for Gore, a perfect site upon which to construct

imaginative solutions to the problems of modern city life. As such, the concept of the rural as fundamentally empty of its existing inhabitants is crucial, for only then could representations like these be effective for their urban audiences.

Ultimately it can be argued that, already in advance of the Great War, the English landscape had clearly undergone a consistent process of ordering. It was readily prepared to be that place of private middle-class contemplation, unhindered by the presence of others, natives or otherwise, that emerges in so much of the art of the 1920s and 30s. As a result, a long process of pre-War cultural and economic developments needs to be seen at least as of equal significance in accounting for later changes in art as the experiences of 1914–18.

1 The term used by Alex Potts in his essay, 'Constable Country between the Wars', in Raphael Samuel, ed., *Patriotism: the Making and Unmaking of British National Identity* (London: Routledge, 1989), 175. See also David Matless, *Landscape and Englishness* (London: Reaktion Books, 1998), especially his discussion of preservationist discourse in the inter-war period, 26–30.

2 Jack Wood Palmer, *Spencer Frederick Gore, 1878–1914* (catalogue of an exhibition, London, Arts Council of Great Britain, 1955), 7.

3 Cited in Donald Read, ed., *Documents from Edwardian England, 1901–1915* (London: Harrap, 1973), 27–30.

4 C. B. Purdom, *The Garden City of Tomorrow: A Study in the Development of a Modern Town* (London: Dent, 1913), 166–67. Purdom was quoting from Dr Arthur Newsholm's 'Vital Statistics' on the gains from being born in a healthy district.

5 See C. F. G. Masterman, ed., *The Heart of the Empire: Discussion of Modern City Life in England* (London: Fisher Unwin, 1902), 7.

6 *To-Morrow: A Peaceful Path to Real Reform*, republished in a revised edition in 1902 as *Garden Cities of Tomorrow*. The Garden Cities Association was founded in 1899. See Donald Read, *Documents from Edwardian England*.

7 Examples of these postcards, from 1906, are in the collection of the First Garden City Heritage Museum, Letchworth.

8 In 1901 Ashbee had considered Letchworth as a potential site for his Guild of Handicraft before moving to Chipping Campden. The Garden City movement, at least at first, shared some of the fundamental aspirations of the 'Simple Life' movement, which had resulted in earlier communities like those at Clousden Hill in Norton, Purleigh in Essex and Eric Gill's at Ditchling. See Fiona MacCarthy, *The Simple Life: C R Ashbee in the Cotswolds* (London: Lund Humphries, 1981).

9 Cited in Jan Marsh, *Back to the Land: The Pastoral Impulse in England from 1880–1914* (London: Quartet Books, 1982), 238–39. Marsh describes the early establishment in

Letchworth of 'The Cloisters', the community of New Age disciples formed by Blavatsky's followers Annie Lawrence and J. Bruce Wallace. Gore's son Frederick remembered that a Blavatsky book, presumably *The Key to Theosophy*, sat on his father's bookshelf. See *Spencer Frederick Gore, 1878–1914* (catalogue of an exhibition by Frederick Gore and Richard Shone, London, Anthony d'Offay, 1983).

10 For discussion of the connections between late Victorian progressive idealists and the appeal of theosophy and eastern mysticism, see Tom Steele, '1893–1900: Socialism and Mysticism', in *Alfred Orage and the Leeds Art Club, 1893–1923* (London: Scolar Press, 1990). For a good critique of utopianism in this period, see Stefan Szczelkun, *The Conspiracy of Good Taste, William Morris, Cecil Sharp, Clough Williams Ellis and the Repression of Working Class Culture in the Twentieth Century* (London: Working Press, 1993), 36.

11 For example, Robert Blatchford's socialist paper *The Clarion* extolled the benefits of practical ruralism, walking, cycling etc.

12 In 1893 Lucien Pissarro moved to Epping Forest, where he painted the small corners of landscapes and wooded lanes which clearly interested Gore. Both Pissarro and Steer produced contrasting types of landscape painting around the turn of the century. As Frank Rutter put it, 'Steer excelled in painting the wide-open spaces of England. Pissarro gave clear and more intimate views of her copses and her orchards', in *Art in My Time* (London: Rich and Cowan, 1933), 121–22.

13 Applehayes farm near Clayhidon in Devon belonged to Harold Harrison, an ex-Slade student, who invited his friends to visit. Gore, Gilman, Robert Bevan and, on one occasion Stanley Spencer, stayed there. There had been no modernisation at Applehayes so it was, for these artists, the epitome of a remote and essentially timeless, rural idyll.

14 There are close similarities in composition and handling with Monet's 1902 *La Grande Allée, Giverny*, which Gore might well have seen at Bernheim-Jeunes on his trip to Paris in 1905. The more striking comparison however is with Monet's *Une Allée du Jardin de Monet, Giverny*.

15 See Jack Wood Palmer, 1955 exh. cat. *Spencer Frederick Gore, 1878–1914*, 4.

16 After financial difficulties in 1904 Gore's father had deserted his family and died two years later. His mother then moved to Garth House, Hertingfordbury, far from the family home at Holywell in Kent. Frederick Gore and Richard Shone described the house, with its tennis lawn and rose gardens 'as the epitome of modest comfortable country life as — for example, in the contemporary short stories of Saki', see *Spencer Frederick Gore, 1878–1914*, exh. cat. 1983, Anthony d'Offay.

17 The Pissarro is in a private collection, but is illustrated in *The Impressionists in London* (London: Hayward Gallery, 1973), no. 36.

18 John Rothenstein, for instance, later praised Gore's talent for 'the reconciling of differences that could honourably be reconciled', in *Modern Painters, Sickert to Smith* (London: Eyre and Spottiswoode, 1952), 198.

19 See MacCannell's discussion in 'Landscaping the Unconscious' in Mark Francis and Randolph T. Hester, eds., *The Meaning of Gardens: Idea, Place, Action* (Cambridge, Mass.: MIT Press, 1991), 94–100.

20 See 'The Garden, with Special Reference to the Paintings of G. S. Elgood', *The Studio* 5 (1895): 51.

21 The quotation is from Nicholas Green in *The Spectacle of Nature: Landscape and Bourgeois Culture in Nineteenth Century France* (Manchester: Manchester University Press, 1990), 52. Green was referring to French parks, but his remarks are equally applicable here.

22 Gore's comment appeared in his article 'Cézanne, Gauguin, Van Gogh &c., at the Grafton Galleries', *Art News* (15 Dec. 1910), 19–20, reprinted in J. B. Bullen, ed., *Post-Impressionists in England: The Critical Reception* (London: Routledge, 1988), 140–42.

23 I have drawn here on a discussion of the relationship between Hulme and Bergson in chapter three, 'The Movement towards Imagism', in Alan Robinson, *Poetry, Painting and Ideas, 1885–1914* (London: Macmillan, 1985).

24 John Middleton Murry, 'Art and Philosophy', *Rhythm: Art, Music, Literature* 1 (1911): 12.

25 Murry, 'Art and Philosophy', 1–3.

26 Spencer Gore, 'Cézanne, Gauguin', rpt. in Bullen, *Post-Impressionists in England.*

27 Desmond MacCarthy, 'The Post Impressionists', Introduction to catalogue of an exhibition *Manet and the Post Impressionists* (London: Grafton Galleries, 8 Nov. 1910–14, Jan. 1911).

28 First published in Paris in *La Grande Revue* in December 1908, rpt. in Charles Harrison and Paul Wood, *Art in Theory: 1900–1990* (Oxford: Blackwell, 1996), 72–78.

29 Gore's particular approach to composition described here was of course especially common in the 1920s. Frank Rutter observed in 1926 that, 'there is less and less of the 'foggy' impressionist type of picture in which 'atmosphere' was the goal, and more and more of a clear-hewn type of picture in which the accent is laid on design'; see 'The Triumph of Design', in *Evolution in Modern Art* (London: Harrap and Co., 1926), 134.

30 John Woodeson noted the influence of Derain in particular on Gore, see 'Spencer F. Gore', unpublished MA report, Courtauld Institute, 1968, 85–88. He points to the similarities between Gore's *Cinder Path* and Derain's *Landscape at Cassis* and later between Gore's *Icknield Way* and Derain's 1908 *Landscape at Martigue.* Gore stayed at Letchworth between August and November in 1912 and the second Post Impressionist show was held between that October and January 1913. Gore himself stated in his article in the *Art News,* that he found nothing of great interest in 'Piccasso [*sic*] and Matisse', but 'such painting as Herbin's *Maison au Quai Vert* (108) arouses our curiosity', 'Cézanne, Gauguin', in Bullen, *Post-Impressionists in England,* 20.

31 'Post Impressionism: The Character of the Movement', *Rhythm* (Jan 1913), 368–69.

32 Quotation from 'Recent Poster Art', *The Studio* 80 (1920): 147–48.

33 Quoted in Purdom, *The Garden City of Tomorrow,* 105. Gardening signalled a positive forward-looking mentality for this author: 'A garden makes you think of the future, for you cannot be in it without wondering how this and that will turn out', 107.

34 Raymond Unwin, 'Town Planning in Practice' (1909), rpt. in Richard T. Le Gates and Frederic Stouts, *The City Reader* (London: Routledge, 1996), 357.

35 'Realities at Home', in Masterman, *The Heart of the Empire,* 7.

36 Purdom, *The Garden City of Tomorrow,* 38–39.

37 Alex Potts, 'Constable Country between the Wars', 175.

38 Stephen Daniels, 'The Making of Constable Country, 1880–1940', *Landscape Research* 16 (1991): 15.

39 Daniels, 'The Making of Constable Country', 14. The illustration of 1928 was reproduced in Herbert Cornish, *The Constable Country* (1932).

40 G. M. Trevelyan, 'Past and Future', in Masterman, *The Heart of the Empire*, also cited in B. I. Coleman, ed., *The Idea of the City in 19th Century Britain* (London: Routledge and Kegan Paul, 1973), 212.

41 Wendy Baron cites Gilman's label on the back of the picture: 'The colour found in natural objects (in the field of beans for instance in the foreground), is collected into patterns. This was his own explanation'. See Wendy Baron, *The Camden Town Group* (London: Scolar Press, 1979), 292.

42 Letter to his pupil J. Doman Turner, cited by John Woodeson, *Spencer Frederick Gore*, catalogue of an exhibition, The Minories, Colchester, 1970, n.p. Gore is often contradictory in his writings, but in general we find him increasingly privileging the imagination and formal innovation.

43 Similar interpretations of comparable compositions have been made, for example, in relation to Van Gogh's *Summer Evening, Arles* of 1888 and of Pissarro's *Banks of the Oise*, 1873. Richard Thomson argues that the two images produce a 'double conjunction of ancient and modern', see *Monet to Matisse: Landscape Painting in France, 1874–1914* (Edinburgh: National Gallery of Scotland, 1994), 125.

44 Purdom, *The Garden City of Tomorrow*, 118.

45 See Charles Harrison, 'Impressionism, Modernism and Originality', in Frascina, Blake *et al.*, *Modernity and Modernism: French Painting in the Nineteenth Century* (New Haven and London: Yale University Press and The Open University, 1993), 189.

46 See P. J. Waller, *Town, City and Nation: 1850–1914* (Oxford: Oxford University Press, 1983), 179.

47 P. G. Konody, 'Art and Artists: English Impressionists', *The Observer*, 27 Oct 1912, p.10, rpt. in J. B. Bullen, *Post-Impressionists in England*, 388.

48 Anna Greutzner Robins has considered Gore's *Letchworth Station* in the context of the painter's 'keen interest in the modern landscape'. She is ultimately in agreement with Konody's interpretation. See 'The English Group', *Modern Art in Britain, 1910–14* (London: Merrell Holberton and Barbican Art Gallery, 1997), 104–5.

49 The drawing is reproduced in *British Modernist Art: 1905–1930* (catalogue of an exhibition, Hirschl and Adler Galleries, 1988), 34. The photograph of Letchworth Station at the time Gore painted it is reproduced in Mervyn Miller, *Letchworth: The First Garden City* (Chichester: Phillimore, 1993), 57 (first pub. 1989). The wooden station was demolished in 1912, just after Gore's painting, so the new houses shown on the photograph must already have been erected by that date, i.e. before the painting.

50 Charles Harrison, *Modernism* (London: Tate Gallery Publishing, 1997), 37.

51 Erich Franz in E. Franz and B. Growe, *Seurat Drawings* (Boston: 1984), 61. Cited in John Leighton and Richard Thomson, *Seurat and the Bathers* (London: National Gallery Publication, 1997), 21.

The Geography of *Blast*: Landscape, Modernity and English Painting, 1914–1930

David Peters Corbett

IN THIS ESSAY I shall argue that there are important continuities in the representation of landscape between the work of some English Impressionists, the modernists of 1914 and the art of the 1920s. English landscape art throughout these years was concerned with developing visual means to acknowledge and represent the presence of modernity in the rural as well as the urban environments of Britain. Although the literature on the subject has largely concentrated on city scenes, radical modernism in England before the First World War was as closely concerned with the presence of modernity in the landscape as in the city. Vorticist works by Wyndham Lewis, Edward Wadsworth and others tackled the problem of how to represent this investment of the mechanical forms and processes of contemporary life in the rural areas of the British Isles. For the Vorticists, this project involved the description of modernity as it appeared at the margins and peripheries of the island, its ports, coasts, moors and hills, places where modernity was most clearly visible because most unexpected and most out of place. In doing this, Vorticism was drawing on strategies developed by its immediate predecessors in the investigation of modernity in English art, including English Impressionists. Although an Impressionist like Spencer Frederick Gore might seem to offer a view of the landscape which draws the teeth of modernity, I suggest that Vorticism's reading of an aggressively modern landscape was already present in important ways in the work of British Impressionists like Gore. The traditions of representation inaugurated and developed by these artists from the 1880s onwards continued to be active in much of the landscape work of the 1920s produced by artists sympathetic to the modernist project of 1914. The widespread post-First World War 'return to order' in Britain, insofar as it was a return to earlier 'pre-modernist' modes of representation, never abandoned the capacity to register and tackle the modernity of the landscape. But the art of the twenties found itself caught up in difficulties which that project brought with it. Although Impressionism seemed to offer an account of the landscape which was free of the aggressive declaration of modernisation as of

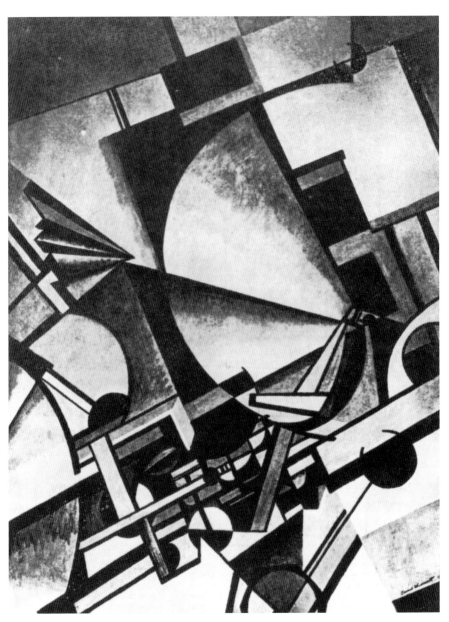

45 Edward Wadsworth, *A Short Flight*, c.1914. Lost, reproduced from *Blast* 1, 1914. © Estate of Edward Wadsworth 2001. All rights reserved, DACS.

the semi-abstract visual idioms Vorticism developed to express them, its appeal to the Vorticists had been precisely its perception of modernity's place in the landscape. To return to those earlier categories of representation as if they were straightforward alternatives to the abstracted medium of the Vorticists was therefore to try and use an idiom for purposes to which it would not easily respond. The presence of the modern was already deeply encoded in such apparently pre-modernist schemes of representation and the desired meanings of returning to them were therefore hard to achieve. For the artists of the 1920s who sought to make the landscape and non-modernist idioms stand for the repudiation of modernity, that fact proved decisively problematic. Modernity continued to assert its presence in the representation of the landscape of England.

<center>I</center>

I want to begin with two images which were illustrated in the first number of the Vorticist periodical *Blast*. The magazine appeared in June 1914 and tends to mark for histories of modernism the high point of advanced art in England before the First World War. The first is a painting by Edward Wadsworth, now lost, with the title *A Short Flight* (fig. 45). It is very much the sort of image one would expect from the advanced radicals of *Blast*. In the photograph, at least, the surface of the painting appears divided into an irregular black and white pattern, describing smoothly inhuman shapes with little sense of either mimesis or figure on ground. Clearly visible are simplified versions of mechanical forms reminiscent of compass, T-square and ruler as well as, more faintly, of industrial forms and objects. But there seems nothing precise enough to identify with any certainty. The firmest impression is of a sort of mechanical clutter not necessarily incompatible with smooth operation.

When we look more closely at the image, however, we begin to see that it is not without representational elements and that, like many Vorticist works, *A Short Flight* adopts a birds-eye perspective, straight down onto the object beneath, so that the subject matter of the image becomes a schematic plan or map of itself.[1] In this case the view is down from above the airborne plane onto the angular shapes of fields, most clearly visible at top and top right. In the centre of the painting the flight, described by both mechanical forms and by the arrowhead shape of the prow, forces its way across the landscape below. There is no sign of the pilot unless we read the T-square shape as a sitting figure. That

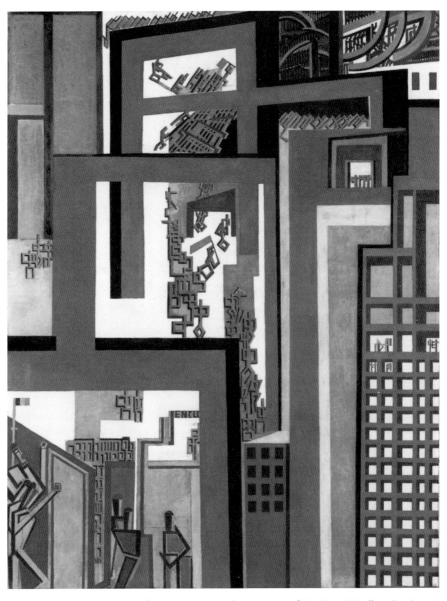

46 Wyndham Lewis, *The Crowd*, 1914–15. Tate, London. © Estate of Mrs G. A. Wyndham Lewis.

absence points towards a central plank of Vorticism's understanding of modern experience. *A Short Flight* presents a summary of the Vorticists' preoccupations with the industrialisation of the British landscape and of the place of the individual subject within it. The absence of the pilot figures the Vorticist diagnosis of the reduction of the individual to an industrial helot, functioning — and hence understandable — only within the context of the mechanical world of modernity in which he or she subsists. As such it opens up discussion into contemporary works by Wadsworth and the other Vorticists in *Blast* and elsewhere. Wadsworth's *Newcastle-Upon-Tyne*, Lewis' *Plan of War* or *The Crowd* (fig. 46) and *Slow Attack* and Etchells' *Dieppe* (all c. 1913-14) all deal in the same coin of mechanism, dehumanisation and the abolition of the individual which *A Short Flight* conveys so eloquently.[2]

The other image is by Spencer Gore (whose obituary is also published in the periodical), and its title is *Brighton Pier* (pl. VI).[3] In contrast to *A Short Flight*, this painting appears to present us with a sunny Edwardian modernity couched in a familiar Impressionist language.[4] The signs of mechanisation and industry are few and are woven completely into the mimetic fabric of the painting's description so that they seem at first glance to contribute to its rhetoric of the pleasant view. In Gore's painting the street lamp, motor car and tug are as naturalised and normal as they could be. And yet this is also a description of modernity, in its evocation of that creation of modern leisure, the 'seaside', as well as of the contemporary as it manifests itself in entertainment (the pier), in the holiday or 'day trip', and in the extraordinary variety of transport by mechanical device that the canvas shows.[5] Its initially sunny impression is attenuated somewhat when we register the stark lines of the balustrade and its companion wall cutting in shadow across the lower right-hand diagonal of the composition to define and enclose the material world where the pedestrians perambulate and the vehicles move gently along the promenade. Looking at this bar of shadow intruding into the picture plane we may begin to feel that Gore's painting is not such a straightforward celebration of modern life as it initially appears to be.

Gore and Wadsworth present two versions of the modern world which the Vorticists and *Blast* set out to categorise and understand. On the face of it they may seem radically incompatible and disjointed versions. Gore's presence might be deemed a piece of piety on the part of the editor, Wyndham Lewis, who we might imagine to have been honouring his dead friend and at the same time demonstrating by concrete example his now abandoned connections to the outmoded artists of the Camden Town Group; to have been referring, in other

47 Spencer Gore, *From a Window in Cambrian Road, Richmond*, 1913. Tate, London.

words, to an art which in his view Vorticism had superseded. But a glance at the second of Gore's pictures reproduced in *Blast*, *Richmond Houses* (fig. 47, now known as *From a Window in Cambrian Road, Richmond*), with its Cézannist faceting and summary, scrubbed paintwork, might also help to adjust that reading.[6] If *Brighton Pier* represents, in an Impressionist style, the encroachment of the sense of modernity onto what Lewis once called 'the last days of the Victorian world of artificial peacefulness', then *Richmond Houses* picks up that invasion of the psychic energies of the new and presents it in an idiom much more like that of the Vorticists.[7] In these and similar works of the same period Gore experiments with the application to modern life of advanced technical representation.[8] Like the Vorticist works in *Blast*, this is a plan, a schematic image and summation which aims to encompass, from some intellectual point of vantage poised above the mêlée of contemporary life, its characteristic forms and meanings.

The fact is that Gore is an entirely appropriate presence within the pages of Britain's most advanced modernist periodical.[9] His subject matter is the same as theirs, the modern as it physically manifested itself in the environment of Britain's landscapes and cityscapes. Gore inserts the balustrade and shadowy interior across the visual field of *Brighton Pier* as a way of acknowledging the presence of modernity within the Edwardian landscape. In Gore's work, modernity invades the scene, transforming the idiom of past representations as it infiltrates the material culture of transport, leisure and the built environment. As Ysanne Holt shows elsewhere in this volume, this is especially true of the paintings Gore made of the suburbs and the rural scene, the suburban and sub-rural world which lay immediately outside the metropolis and formed its hinterland. Vorticism, like Gore and other Camden Town artists, was preoccupied with the landscape as well as with the city, with the fields, towns and geography of Britain as a principle focus of its analysis of modernity and of the character of modern life. *A Short Flight* positions its driving wedge of modernist energy above the checkerboard angularities of the fields rather than above the town as in related Vorticist works such as Wyndham Lewis' *Workshop* or *New York* (both 1914-15). It is the concrete presence of the modern in the landscape, revising the very idiom of our visual response to it, that fascinates and supplies the image with its power. It is, in *Blast* as in the evolution of British modernism as a whole, the dialectic set buzzing by the tense relationship between the mechanisms of modernity and the persisting icons of earlier representational solutions, that powers and sustains the character of the issues they confront.

Gore contended with the demand for representation which these loaded subjects made before the Vorticists. The critic Frank Rutter, a strong supporter of modern art in England, wrote of Gore in 1914 that his sensibility had:

> enabled him to find beauty in the commonplace and romance in the familiar. Seen through his poetic temperament even a red-brick suburban villa was transfigured, the streets of Camden Town were touched with loveliness and music-halls were turned into visions of paradisiac refinement.

It was this capacity to translate the brute facts of everyday modernity into the 'paradisiac' that had given Gore 'his place in modern British art'.[10] Lewis' assessment in *Blast* runs on the same lines. For him, Gore's achievement was to have taken a metropolitan summer, arrayed 'in trivial crescents with tall trees and toy trains ... heavy dull sunlight' and 'exquisite, respectable and stodgy houses', and, in such 'favourite themes', forced together both nature and the modern

urban scene.[11] In doing so, his paintings altered the meanings of both. It was exactly this forcing of the natural and the mechanical into an impacted unity through a painter's vision that seemed to the Vorticists and their precursors to be the necessary task of an art determined to define and communicate the nature of modern experience.[12]

Wadsworth's aerial painting, *Blackpool* (c.1915, now lost), evoked from Lewis a discussion very much in these terms.[13] Asserting that the painting is 'one of the finest . . . he has done', Lewis praised Wadsworth for its association of 'the quality of 'LIFE' with the 'striped ascending blocks' and harsh colours which describe the 'elements of a seaside scene, condensed into the simplest form possible for the retaining of its vivacity'.

> It's (sic) theme is that of five variegated cliffs. The striped awnings of Cafés and shops, the stripes of bathing tents, the stripes of bathing-machines, of toy trumpets, of dresses, are marshalled into a dense essence of the scene. The harsh jarring and sunny yellows, yellow-greens and reds are especially well used, with the series of commercial blues.[14]

This is a description which resonates with the subject of *Brighton Pier* and Lewis' account of Gore as the poet of nature infiltrating 'London back-yards'.[15] Gore's subjects are not so very different from those of the Vorticists. His experimentation with the styles of the European avant-garde in 1913-14 was mobilised as a quest to find an idiom properly suited to the task of bringing the suburban and sub-rural modernity of Richmond or Letchworth into understanding.[16] It is his engagement with the problems of representing the close relationship of the metropolis and the landscape within modernity which makes his presence in *Blast* so apposite to its Vorticist concerns.[17]

II

When the Vorticists took up the task of formulating their position in *Blast*, the emphasis, as Lewis' writing on Gore and Wadsworth suggests, was on the aim to reveal the conditions of their own modernity to the English.[18] That preoccupation carried with it an explicit sense of the interweaving of the nation's identity, its landscapes and seascapes as signifiers of that identity, and the presence of a pervasive but hitherto insufficiently acknowledged modernity at the heart of its experience. A great deal of the argumentation in *Blast* is concerned to assert that

in this way modernity is an alternative to established representations of 'nature', which it supersedes:

> Nature is a blessed retreat, in art, for those artists whose imagination is mean and feeble, whose vocation and instinct are unrobust. When they find themselves in front of Infinite Nature with their little paint-box, they squint their eyes at her professionally, and coo with lazy contentment and excitement to just so much effort as is hygienic and desirable. She does their thinking and seeing for them.[19]

Art, in contrast 'something very abstruse and splendid', is 'in no way directly dependent on "Life". It is no EQUIVALENT for Life, but ANOTHER Life, as NECESSARY to existence as the former' (p. 130). Its subject matter 'must be organic with its time' (p. 34), and is derived from the conditions and forms of actual experience, so that 'in a chaos of imperfection . . . it finds the same stimulus as in Nature: . . . this enormous, jangling, journalistic, fairy desert of modern life serves (the Vorticist painter) as Nature did more technically primitive man' (p. 33).

In this project it is the contemporary experience of modernisation in England which provides the subject matter, because 'the Modern World is due almost entirely to Anglo-Saxon genius' (p. 39) and the 'new possibilities of expression in present life' are 'more the legitimate property of Englishmen than of any other people of Europe' (p. 41). England is the central example of industrialised modernity:

> Our industries and the Will that determined, face to face with its needs, the direction of the modern world, has reared up steel trees where the green ones were lacking; has exploded in useful growths, and found wilder intricacies than those of Nature (p. 36).

Among the qualities in England that *Blast* identifies as relevant to this project are the island and its seafaring traditions and the presence of machinery and technology within the heartland:

> The English character is based on the Sea. The particular qualities and characteristics that the sea always engenders in men are those that are, among the many diagnostics of our race, the most fundamentally English (p. 35).[20]

Its borders are defined by 'the forms of machinery, Factories, new and vaster buildings, bridges and works' (p. 40), and it is these forms and intrusions, mingled with the landscape and the sea which define the English experience of

modernity and universalise it as the diagnosis of the modern world. 'BLESS ENGLAND FOR ITS SHIPS', says *Blast*, and 'BLESS ALL PORTS'. 'BLESS ENGLAND, Industrial Island machine, pyramidal workshop' (pp. 26–27).

It is paradoxically the obduracy and unconsciousness of the English, a consequence of their preoccupation with the invention of the modern world, that makes England the ideal forcing ground for the growth of the new art, 'the most favourable country for the appearance of a great art' (p. 33). 'England which stands for anti-Art, mediocrity and braininess (sic, ie 'brainlessness') among the nations of Europe, should be the most likely place for great Art to spring up in. England is just as unkind and inimical to Art as the Arctic zone is to Life. This is the Siberia of the mind' (p. 146). Confronted with this challenge, art flourishes under adverse conditions, bringing with it a comprehension of the conditions of modernity which its society has immersed itself in creating, 'a movement towards art and imagination' bursting up 'from this lump of compressed life, with more force than anywhere else' (p. 32).

Blast therefore has views about both national identity and the nature of modernity and sees a connection between those two things. It is, in the Vorticists' works and theories, the peripheries of the island, its landscapes and seascapes, on which the mark of modernity has been most powerfully stamped and where it is most clearly visible. This is so because it is at the periphery that modernity is most out of place. Modernity for the Vorticists is pervasive in English, and indeed in British, experience, and its presence must be tracked down to every corner of national life, however remote and unlikely. At the periphery modernity is most ineradicably disjunct and insistent, demanding understanding from its citizens. The Vorticists accordingly take the mechanical forms and structures of the modern world and insert them into the seascapes and the countryside of the British Isles as a means of insisting on the equal modernity of the peripheral and non-industrial spaces of the nation. National identity is the necessary precondition for the emergence of a modern movement which can register and reveal the conditions of experience to an audience hitherto plunged into obduracy and ignorance as a result of its preoccupation with 'Life'. Wadsworth's *Short Flight* and *Blackpool* or Lewis' *The Crowd* enact in their angular and mechanised forms this investment of the national landscapes by modernity. The interest of works like these in producing perpendicular or schematic views derives from their desire to achieve an idiom which could adequately describe and diagnose modern life. Landscapes just as much as cityscapes carry the modernity of the nation, and Vorticist art sets out before 1914 to encompass the meaning of

that fact in the new forms of expression which its modernism generates and which it lays before this vast and attentive audience of 'the unmusical, anti-artistic, unphilosophic country' (p. 32) which contains both modernity and its perfect expression.

<div align="center">III</div>

There is now a significant literature on the impact which the First World War had on the modernists of 1914. The established reading which this literature gives of the role of landscape turns on the argument that the war forced the modernists of 1914 to abandon their commitment to the new, radical art. In a representative essay, 'Machine Age, Apocalypse and Pastoral' written for the catalogue to the 1987 *British Art in the Twentieth Century* show, Richard Cork picks up the position of his major 1976 study of Vorticism and argues that the experience of a mechanised, wholly modern conflict 'profoundly altered' the enthusiastic abstractionists and modernists of 1914 and led them to reconsider their commitment to a hard-edged aggressive radicalism.[21] Traumatised by the horrors which modernity had been seen to wreak in the war, artists contemplated both a return to order and, as a corollary, a return to 'more traditional ways of seeing', as 'the waste and tragic nullity of the war years bred among them a profound mistrust of militant extremism'.[22] In this process the insistence on naturalistic idioms of the War Commissions, which employed many of the radicals as war artists during the conflict, proved decisive.[23]

This is essentially the reading continued in Cork's later book on art and the First World War, *A Bitter Truth*, as well as, with great subtlety, in Samuel Hynes book, *A War Imagined*, which submits that with the death or dispersal into exile of those like Lewis, who had 'defined avant-garde art in England' in 'the brief period before the war began', the impetus of modernism in Britain faltered and declined. Hynes concludes that 'without a surviving centre there could be no continuity with the old, pre-war avant-garde; Futurism was dead, Vorticism was dead; Imagism was dead. If there was to be a post-war Modernism, it would have to begin afresh.'[24] The diagnosis is therefore of a 'crisis of confidence' among the avant-garde in the years during and after the war, a crisis which led, in the case of Wadsworth, Nevinson and other *quondam* modernists, to a spurning of Vorticist painting and a return to representational idioms derived from earlier art in their work of the 1920s.[25]

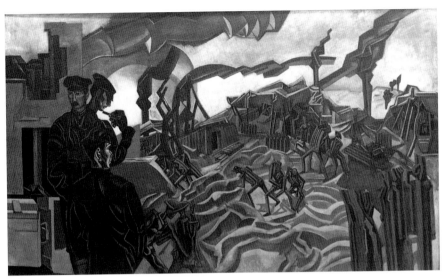

48 Wyndham Lewis, *A Battery Shelled*, 1919. Imperial War Museum, London. © Estate of Mrs G. A. Wyndham Lewis.

In this context, Lewis' major war painting, *A Battery Shelled* (1919) (fig. 48) has figured as an illustration of the impact of the war in redefining modernism and pushing it back towards the naturalistic tradition. In the main, commentary has been content to follow Lewis' own lead and to see the painting as evidence of his capitulation to the demands of the War Commission. Lewis famously seemed to describe a recantation in his autobiography of 1950, *Rude Assignment*:

> The war was a sleep, deep and animal, in which I was visited by images of an order very new to me. Upon waking I found an altered world: and I had changed, too, very much. The geometrics which had interested me so exclusively before, I now felt were bleak and empty. They wanted filling . . . I can never feel any respect for a picture that cannot be reduced at will to a fine formal abstraction. But I now busied myself for some years acquiring a maximum of skill in work from nature.[26]

From this perspective, the figurative idiom of *A Battery Shelled*, its preservation of only the stylistic remainder of abstraction, can seem the final acknowledgement of the 'death of Vorticism' which contemporary critics had so delightedly announced during the war and which Hynes refers to.[27] 'Chronic, unconcealed

schizophrenia' is Cork's assessment of the painting.[28] The undoubted quality and fascination of *A Battery Shelled* somehow makes this abandonment of the radical modernism of 1914 all the worse. I want to suggest that the mixture of realistic and abstracted forms in the painting refers in fact back into the strategies and concerns of radical Vorticist works and provides a continuity with them that was not broken by the pressures the war brought with it. *A Battery Shelled* marks, if anything, the moment when Vorticism begins to define its continuing relevance to post-war practice, and does so on the terms which it had marked out five years earlier before the outbreak of war.

The main attempt to argue for a continuing radicalism in *A Battery Shelled* is a 1982 essay by Michael Durman and Alan Munton, 'Wyndham Lewis and the Nature of Vorticism'. Durman and Munton see the work as 'a Vorticist painting about the suffering caused by war'.[29] The group of figures on the left becomes the explicit realisation of 'Vorticist detachment' (p. 116), analogues of the contemplative spectators who we are encouraged to be as Lewis' ideal audience, and who the authors identify as a central principle of his earlier work. The painting 'is a Vorticist work in that it attempts to hold or control a violent experience and expose it to the contemplative intelligence' (p. 118). The return to explicitly figurative forms in the painting is read as related to a concern to address the experience of the war but also to 'attempt to transform those objects into a critical comment upon the world in which they exist' by defining them as mechanised (p. 117). It is this 'that makes *A Battery Shelled* a Vorticist painting' (p. 117). While I want to build on some aspects of this reading, particularly the emphasis Durman and Munton place on the address the painting makes to the reflective spectator, I also want to argue for a different understanding of the piece, one which places the emphasis on the persistence of the mixed economy of landscape and modernity which the Vorticist works of 1914 had already defined as central to their diagnosis of modernity in Britain. I see the interweaving of figurative and abstract forms in the painting as evidence of the continuation of an account of the landscape within modernity across the moment of the war.

The first thing to say about *A Battery Shelled*, therefore, is that it represents a landscape, although now it is not one seen from above as in the vertical viewpoints of pre-war Vorticism. *A Battery Shelled* brings the mapped schemata of the technologically powered flight above the earth down and rotates it into the same plane as the spectator. But the landscape, ridged and furrowed by the ploughing motion of the bomb-blasts bursting through the soil, continues the semi-abstract description of the pre-war works. The scurrying figures of the

bombardiers, reminiscent of Lewis' mechanised humanoids in *The Crowd* (fig. 46), and the solid, twisted forms of the smoke blowing through the gun pit, replay other aspects of earlier Vorticism. Against this, the left-hand section of the scene introduces a new idiom and places the three living figures directly in front of the picture plane, although in an odd spatial relationship to each other. I think that we are here back in the contrasted but intertwined worlds of the past and the present, of the earlier avatars of modernity that Spencer Gore's painting represents and of the mechanical island, the modernised Britain of 1914. These are different registrations of the modern but they both acknowledge that there is no access to the landscape, to the world referenced in the earlier idioms of English painting, except through the mechanised energies of modernity which Vorticism depicts.

In a sense the capacity of *A Battery Shelled* to hold these two aspects apart is a conceptual gain. The world is not only defined as aggressively modern, the resistance to the acknowledgement of that modernity is now also clearly signalled. Lewis' three contemplative figures are not simply signs of humanity in the face of inhuman experience, they are also figures whose own modernity, their imbrication in the smashing and destructive modernity of the war, means for them a turning away from the realities of response. One figure glances down; a second turns away entirely; only the third figure, nearest to us at the edge of the picture plane, glances coldly into the central ferment of the gun pit and at the scuttling, robotic humans who heave around the instruments of destruction in the midst of a mechanised landscape. It seems to me that Lewis here thematises the refusal to confront modernity and that he sees that refusal, like the landscape itself, as irreparably marked by the modernity which it will not face up to.[30] The face of the figure looking down is made up of the sheer planes and faceted joints of a machine, so that even at the moment of denial the self is ruled by modernity and formed by its pressures. As in the contemporary work of Paul Nash in a different but related idiom, the landscape in *A Battery Shelled* serves as the most powerful signal of the presence of modernity. That fact marks the continuity which connects the revised modernism of *A Battery Shelled* to the semi-abstract radical modernism of Vorticism in 1914. If the idioms are now different, the themes and principal signs for modernity are the same. Lewis' painting shows how hard it was for artists to return to earlier modes of representation. The connection of these idioms to modernity was already inescapable. The abandonment of Vorticist semi-abstraction in the work of the war years raised the possibility of a return to earlier, naturalistic, idioms. To elect for this option threatened to bring with it

an abandonment of the complex investment of modernity in the nation which Vorticism had struggled to diagnose and represent. Yet it turned out to be the case that the available languages of representation were already saturated with the attempt to represent modernity. The 'return to order', or a more naturalistic or representational idiom, could not shake itself free of the pressure of modernity on representation.

<div style="text-align:center">

IV

</div>

My argument so far has been that, contrary to the standard reading of the impact of the First World War on Vorticist and other modernist practice, it is visibly the case that modernists like Lewis were striving in the closing period of the war to sustain the gains which they believed the modernism of 1914 had accrued. In particular the capacity of Vorticist modernism to imagine a visual language which could tackle the survival of persisting modes of experience from earlier, bourgeois, phases of modernity within the mechanical landscape that the twentieth century had brought with it was continued in the late war works of Lewis. In this, the attraction of an artist like Spencer Gore, apparently surpassed in radical practice by the modernists of 1914, becomes clearer. Like the Vorticists, Gore was concerned to worry away at the problem of describing the interweaving of countryside and urbanity, Edwardian comfortableness and a more febrile and frenetic, truly twentieth-century sensibility in his work.[31] He brings both together, sometimes with disturbing results and so, in a more thoroughgoing advanced idiom, do his Vorticist heirs and colleagues. It is this sense of the admixture of landscape and urbanity, of tradition and modernity, which surfaces explicitly when the exigencies of the War Commission's requirements compel a clarification of the Vorticists' visual language. In my argument, *A Battery Shelled* stands for the way in which this process was not as recidivist and despairing as it has sometimes been made to seem. Lewis continues to claim, even in this painting which reintroduces explicit figuration, that modernity colours the landscape and that we are obliged to look frankly at that fact. I now want to push the implications of that reading forward into the 1920s and argue that the influence of this diagnosis of modernity and its interweaving within the continuities which the landscape represented are persisting presences in English painting of the decade.

Richard Cork, in the essay on 'Apocalypse and Pastoral' from which I have already quoted, sees Edward Wadsworth's 1923 painting *The Cattewater, Plymouth*

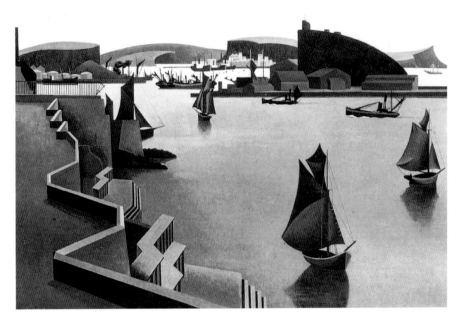

49 Edward Wadsworth, *The Cattewater, Plymouth Sound*, 1923. Private Collection © Estate of Edward Wadsworth 2001. All rights reserved, DACS.

Sound (fig.49) as exemplary of one mode of response to the 'mistrust of militant extremism' he sees as induced by the experience of the war.[32] Reading the stylistic adjustments of Wadsworth's piece as an 'impressive synthesis between his former (Vorticist) language and the new representational urge', Cork argues for *The Cattewater* as an image in which the quiet, human world of the late-Victorian period has returned:

> (Wadsworth's) sense of pictorial structure and economy is still as acute as it was in the Vorticist period, but he no longer needs to paint industrial ports from a dizzying aerial vantage. Now the harbour is unruffled by the 'RESTLESS MACHINES' of *Blast*'s ideal dockland. Wadsworth ensures that the biggest ships are relegated to a distant area of the composition, leaving most of the space for the limpid forms of sailing boats to float gracefully on a quiescent sea.[33]

The painting in this account becomes a return to 'the Victorian world of artificial peacefulness' that Gore represented. If modernity is still present in the machined edges and burnished forms through which this world is seen, essentially it is this

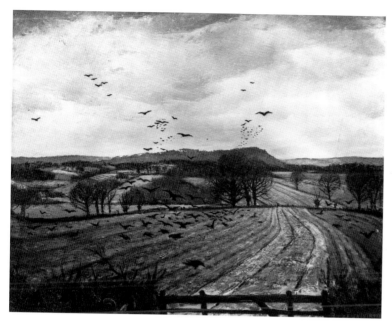

50 C.R.W. Nevinson, *English Landscape in Winter*, c.1925–26. Board of Trustees of the National Museums and Art Galleries on Merseyside, Walker Art Gallery, Liverpool / Bridgeman Art Library.

sense of peacefulness and order which is desired and which the painting works to transmit to the spectator. For Cork, it is part of a narrative that ends in David Bomberg's later works, 'a heartening corrective to dehumanization'.[34]

I think that this account and others like it flatten the depth and complexity of the actual situation into too schematic a form. As Lewis' *A Battery Shelled* suggests, it is not merely the case that artists after the First World War went back to representational forms and traditional subject matter as if these things were themselves unproblematic. As Gore's *Brighton Pier* and *Richmond Houses* demonstrate, the painting of the world of peacefulness was already a difficult and exacting engagement with the existing signs of modernity. It is misleading to make too sharp a distinction between the figurative work which precedes the modernism of 1914 and which the radicals drew on as a tradition of attention to modernity into which they inserted themselves (their rhetoric to the contrary notwithstanding), and the advanced art of Vorticism and its peers. For the reformed radicals to return to representation and the depiction of an ordered world after 1919 was by no means uncomplicated.

In the case of *The Cattewater*, I believe that this complexity continues to work within the image and that this is so because it was in the immediately post-war period impossible for artists to represent a landscape which was not already inflected by the presence of modernity. Attempts to abolish modernity entirely, like C. R. W. Nevinson's self-consciously traditional depictions of the English landscape (fig. 50), risk an utter banality and hollowness.[35] Wadsworth's image perpetuates the Vorticist assertion that landscape is necessarily transformed by the circumstances of industrialisation and mechanisation that surround it. But it also perpetuates the acknowledgement of that fact in pre-Vorticist works like those of Gore and the Impressionists. Merely to return to earlier idioms was not to escape the pressure of modernity within the systems of representation available for the depiction of landscape.

Born and raised in one of the industrial enclaves of the north of England, Wadsworth had plenty of experience of the ways in which landscape and urban industrialisation were not antithetical terms in the British countryside. Around 1914-15 Wadsworth had executed a series of woodcuts of the industrial towns and villages of the West Riding of Yorkshire — Hebden Bridge, Mytholmroyd, Bradford — places in which the signs of industry and the machine are set within powerful natural landscapes. These are places which, like the coasts and ports of earlier work, are geographically peripheral, set on the very edges of the West Yorkshire industrial conurbation and often located at the margins of the country. These sites are the last stops before you cross the Pennine chain out of Yorkshire and arrive in another region, another part of the island. Wadsworth adopts the idiom of Vorticism in order to describe the modernity of these spaces. In *Mytholmroyd* (c.1914) (fig. 51) Wadsworth articulates a series of facets which describe indifferently houses, factories and the surrounding hillscape. In *Fustian Town — Hebden Bridge* (1914–15) or *Bradford, View of a Town* (1914), factory chimneys rise above their geometrical landscape setting and their roofs blend into the rounded shape of an adjacent hill. The argument of these works is the now familiar one that modernity is present in the natural environment, dominating our experience of the landscape, and that representation must accordingly complete the process which Gore inaugurates in *Richmond Houses* and transform the natural setting into an emphatic account of its modernity.

In *The Cattewater* the same process persists. Like Gore's sinister transformations in *Brighton Pier*, Plymouth Sound appears marked by the shadows and clean, sweeping forms of the machine. In saying this I am not arguing that Wadsworth is unaffected by the desire which Cork imputes to the ex-Vorticists

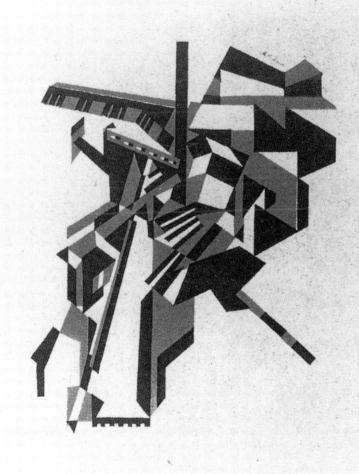

51 Edward Wadsworth, *Mytholmroyd*, c.1914. Private Collection © Estate of Edward Wadsworth 2001.
All rights reserved, DACS.

to return to older forms of representation and subject matter, but that the effect of attempting to do so was not to throw off the issue of modernity. Instead Wadsworth and his peers found themselves confronted with a rather different but equally pressing problem. How was it possible to represent in these older styles and still acknowledge the reality of the modernity of the world without bad faith and without the repudiation of the project to find a way out from the dehumanisation which the war and modernist idiom now seemed to imply. It is, essentially, the problem which Lewis had already identified when he used the more naturalistic figures in *A Battery Shelled* to provoke the issue of the confrontation of modernity or withdrawal from it. Lewis' observers are contemplative, but they are also disengaged, withdrawn and, crucially, inattentive. The problem for artists who continued to think of themselves as possessing some continuity with pre-war achievements after 1919 was how not to look away, how to confront modernity still while seeking the benefits of peacefulness and traditional values. Wadsworth's *Cattewater* attempts to do this by combining the smooth forms of industrialisation with the peace and order of a scene at the furthest cultural distance from the chimneys and factories of the West Riding. But this yoking together of separate meanings carries difficulties with it. It may be for this reason that *The Cattewater*, like the contemporary *Broadbottom, Near Glossop* (1922) or *Fortune's Well, Portland* (1921), is an aspirational picture. These are versions or fantasies of the ways in which modernity and the landscape could still be conceived as connected after the war, but which finally have to be acknowledged as imaginary, ideals of the integration which could not, in fact, happen so straightforwardly.

For the artist faced with this problematic need to acknowledge modernity within the landscape when there was an effective embargo on doing so through an explicitly modernist idiom, the strategies and solutions of the English Impressionists took on retrospectively an enhanced importance. The presence of Gore's paintings in *Blast* had already acknowledged the relevance of the Camden Town diagnosis to the modernist project of revealing the relationships between modernity and the landscape. In the twenties their characteristic mixture of representational and naturalistic idioms and modern subject matter came to provide one of the templates for those ex-radicals who were struggling to articulate modernity's presence within the conventional views demanded by the increasingly conservative tone of the first post-war decade.[36] Artists like Wadsworth, Nevinson and, among the younger generation, Paul Nash, Stanley Spencer and Ben Nicholson all depict landscape in ways which both look away from moder-

nity and attempt to register the presence of the modern within it.[37] In doing so they draw on representational strategies formulated by earlier artists before the advent of the radical and advanced idioms of Vorticist modernism.

<p style="text-align:center">V</p>

In keeping with the spirit abroad in the years after 1919, Wadsworth's paintings struggled to mount a return to figuration as the sign of a renunciation of aggressive modernity and the recasting of the landscape into a continuing symbol of national identity as pre- or counter-modern. He found, however, that this project was impossible to sustain without coming up against the implications of the fact that this figurative tradition was itself coloured by the concern with modernity in the landscape that Gore and his fellow Camden Town artists had addressed in the years before Vorticism. I want to look finally at some examples of Wadsworth's work which seem to catch this sense of the perpetuation of traditional evocations of the Victorian and Edwardian world of peacefulness, but which insert into it some marker of difference, a marker which stands both for modernity and for the possibility of its expression. My point will be that this registration of the modern and its aggressive erosion of traditional certainties is there necessarily within the idiom itself and is not to be read as imported by Wadsworth.

Paintings of the 1920s like *Dunkerque* (1924) (fig. 52) or *La Rochelle* (1923), which are contemporary with or immediately follow *The Cattewater, Plymouth Sound*, offer a normalised, figurative representation of calming dockside scenes. But in *St Tropez* of 1926 (fig. 53) or in the *Quayside/St. Tropez* of 1925, Wadsworth provides a reflection on what this might mean. In *St. Tropez*, as in a number of other works of this period, Wadsworth frames the dockside with its implications of calm, tradition and stability within the schema of national identity as if it were a stage set.[38] Framed by a disquieting pair of Victorian aspidistras, Gore's docks become de-naturalised. They are no longer the assertion that things are as they should be in the post-war world, returned unproblematically to the traditions and stabilities which imagination wished for, and which was attributed retrospectively to a falsely-harmonised version of Edwardian England. Rather that amalgam of national identity, the seafaring race, stability and pre-industrial meanings are placed firmly within a fictionalising frame. What we see when we view these 'quiescent' images, to use Richard Cork's term, is a clear sense of how

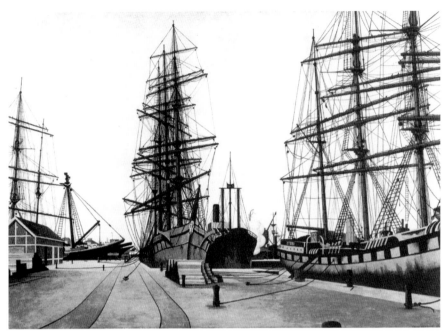

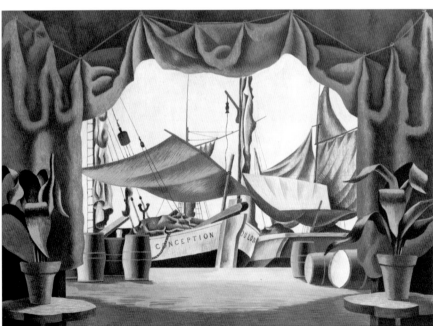

52 Edward Wadsworth, *Dunkerque*, 1924. Manchester City Art Galleries.
53 Edward Wadsworth, *St. Tropez*, 1926. Ivor Braka Ltd., London.

54 Anon., *(Home) by Underground*, 1933. Reproduced by permission of the London Transport Museum.

impossible it is to move away from the acknowledgement that circumstances had changed and modernity was present. Like Gore's views of the Edwardian seaside, modernity invests the world of 'artificial peacefulness'.

In 1933, London Underground produced a poster called *(Home) by Underground* (fig. 54). It makes a fine visual rhyme for Wadsworth's *A Short Flight* with which I began. The poster depicts a man who, between the left-hand third of the image and remaining right-hand space, is translated from the frenetic and mechanical world of modernity to the placid landscape of the garden city. As this occurs—speedily and without effort through the implied agency of modern forms of transport—this post war Englishman steps from a Vorticist background of harsh and jagged urban anxiety to a pastoral context rendered in a simplified but naturalistic idiom. In this single image, the inheritance of Gore which Wadsworth and others had struggled so hard to adapt to the representation of post-war conditions is remade and rendered satisfactory. The poster

abandons the radical or disquieting images of the Garden Cities and the land-scape invested by modernity which Gore offers and replaces them by an ideological mixture of modernity, landscape and anti-modern feeling. It sums up the distance between 1914 and 1930, but it also indicates the force of revisionism towards which many of Wadsworth's post-war works tend and against which many of them were painted. The reduction of modernity to a safe scheme of representation in which the Garden City triumphs over the urban hazards of the metropolis may be the common coin of popular representation in the period between the wars. Wadsworth's work, the heir to earlier, complex attempts to deal with the assertion of the modern world within the traditional spaces of the countryside as well as the city, responds to a more nuanced view.

1 Richard Cork provides a good discussion of this aspect of Wadsworth's Vorticist work to which I am indebted, see *Vorticism and Abstract Art in the First Machine Age,* 2 vols. (London: Gordon Fraser, 1976), 2:369–71.

2 Is it possible that *Blast* reproduced this upside down? See the reproduction in *A Genius of Industrial England: Edward Wadsworth, 1889–1949* (exhibition catalogue, Cartwright Hall, Bradford, 1990), 13.

3 *Brighton Pier* is now in the collection of Southampton City Art Gallery. Gore died of pneumonia in March 1914 at the age of 35.

4 On English and British Impressionism see Kenneth McConkey, *British Impressionism* (Oxford: Phaidon, 1989) and McConkey, ed., *Impressionism in Britain* (exhibition catalogue, New Haven and London: Yale University Press in Association with Barbican Art Gallery, 1995).

5 See James Walvin, *Beside the Seaside: A Social History of the Popular Seaside Holiday* (London: Allen Lane, 1978), John K. Walton and James Walvin, eds., *Leisure in Britain 1780–1939* (Manchester: Manchester University Press, 1983).

6 Richmond Houses is now known as *From a Window in Cambrian Road, Richmond* and is in the collection of the Tate Gallery.

7 *The Letters of Wyndham Lewis* ed. W. K. Rose (London: Methuen, 1963), 293.

8 I am thinking here of paintings like *Cambrian Road, Richmond* (1913–14, Yale Center for British Art,) or *Nearing Euston Station* (1911, Fitzwilliam Museum, Cambridge).

9 Wyndham Lewis, 'Frederick Spencer Gore', *Blast* 1 (1914): 150.

10 Frank Rutter, 'Spencer F. Gore', *Sunday Times* (5 April 1914). This is Rutter's obituary of Gore.

11 Lewis, 'Frederick Spencer Gore', *Blast* 1, 150.

12 The close biographical connections between Lewis and the radicals and the Camden Town Group are set out in Malcolm Easton, '"Camden Town" into "London": Some Intimate Glimpses of the Transition and its Artists, 1911–1914' in *Art in Britain, 1890–1914* (exhibition catalogue, Hull, University of Hull, 1967). See also the discussion in Cork, *Vorticism and Abstract Art.*

13 Richard Cork draws attention to the fact that Blackpool 'was quite possibly inspired by the view to be seen from the top of Blackpool tower', that is, forms a view associated with the perpendicular sight lines of *A Short Flight* and other works; *Vorticism and Abstract Art,* 372, where the painting is also produced from a photograph in the *Daily Mirror* of 11 June 1915.

14 Wyndham Lewis, 'The London Group, 1915 (March)', *Blast* 2 (1915): 77.

15 *Blast* 1:150.

16 See Ysanne Holt's essay in this volume and, on Richmond, *Spencer Gore in Richmond* (exhibition catalogue, Museum of Richmond, London: 1996).

17 Anna Greutzner Robins speaks of Gore in this sense as able to cross the artistic 'party lines with ease'; *Modern Art in Britain, 1910–1914* (exhibition catalogue, Merrell Holberton and Barbican Art Gallery, London: 1997), 149.

18 Terminology is difficult here. The Vorticists use English and British interchangeably and when they say British they almost always mean English. I have tried to acknowledge that real meaning in my own language and to reserve the term British for when the whole island is meant.

19 *Blast* 1:130. Further references are given in brackets after quotations in the text.

20 See on this topic Jane Beckett and Deborah Cherry, 'Modern Women, Modern Spaces: Women, Metropolitan Culture and Vorticism' in Katy Deepwell, ed., *Women Artists and Modernism* (Manchester and New York: Manchester University Press, 1998), and Jane Beckett, '(Is)land Narratives: Englishness, Visuality and Vanguard Culture 1914–18' in David Peters Corbett and Lara Perry, eds., *English Art, 1860–1914: Modern Artists and Identity* (Manchester and New York: Manchester University Press, 2000).

21 Cork, 'Machine Age, Apocalypse and Pastoral' in Susan Compton, ed., *British Art in the Twentieth Century* (exhibition catalogue, London and Munich: Royal Academy of Arts, Prestel-Verlag), 71. See also Cork, *Vorticism and Abstract Art.*

22 Cork, *Vorticism and Abstract Art,* 71.

23 On this see Cork, *Vorticism and Abstract Art,* especially ch. 18, and Sue Malvern, '"War As It Is": The Art of Muirhead Bone, C. R. W. Nevinson, and Paul Nash, 1916–17', *Art History* 9.4 (December, 1986): 487–515.

24 Samuel Hynes, *A War Imagined: The First World War and English Culture* (London: Bodley Head, 1990), 385. See also, Richard Cork, *A Bitter Truth: Avant-Garde Art and the Great War* (New Haven and London: Yale University Press, 1994) and the essay 'Images of Extinction: Paul Nash at the Western Front' in Jana Howlett and Rod Mengham, eds., *The Violent Muse: Violence and the Artistic Imagination in Europe, 1910–1939* (Manchester: Manchester University Press, 1994).

25 See David Peters Corbett, *The Modernity of English Art, 1914–30* (Manchester and New York: Manchester University Press, 1997).

26 Wyndham Lewis, *Rude Assignment: A Narrative of My Career Up-to-date* (London: Hutchinson, 1950), 129.

27 See Corbett, *The Modernity of English Art, 1914–30.*

28 Cork, *Vorticism and Abstract Art,* 535. Cork sees the painting as dramatising 'the most decisive turning-point in Lewis' life as an artist' which 'by extension sounds the Last Post for the Vorticist movement as a whole' (535).

29 Durman and Munton, 'Wyndham Lewis and the Nature of Vorticisim', in Giovanni Cianci, ed., *Wyndham Lewis: Letteratura/ Pittura* (Palermo: Sellerio Editore, 1982), 115. Further references are given in parentheses after quotations in the text. See David Peters Corbett, ed., *Wyndham Lewis and the Art of Modern War* (Cambridge: Cambridge University Press, 1998), for a number of essays which offer readings of *A Battery Shelled.*

30 This reading agrees with my interpretation of Lewis' 1921 *Tyro* pictures. See David Peters Corbett, '"Grief with a Yard Wide Grin": War and Wyndham Lewis' *Tyros*' in Corbett, ed., *Wyndham Lewis and the Art of Modern War.*

31 Characterised by 'exhilaration and oddity' according to Peter Conrad, one of the most recent commentators on the twentieth century mindset. See *Modern Times, Modern Places: Life and Art in the 20th Century* (London: Thames and Hudson, 1998), 9.

32 Cork, *Machine Age,* 71.

33 *Machine Age,* 71.

34 *Machine Age,* 72.

35 *Machine Age,* 71.

36 I don't mean by this to suggest that the Camden Town influence was the only one nor even that it was paramount. It was one of a number of strategies and opportunities which post-war modernists had available to them. My argument is more concerned to explore the ways in which the complexities already at work in earlier examinations of the landscape and modernity perpetuated themselves in the twenties when artists returned to representational idioms. It is the instability of representational accounts of the landscape which is important and which I want to signal here.

37 On this younger generation, and Ben Nicholson in particular, see David Peters Corbett, 'Landscape, Masculinity and Interior Space Between the Wars' in Stephen Adams and Anna Gruetzner Robins, eds., *Gendering Landscape Art* (Manchester: Manchester University Press, 2000).

38 See, for instance, *Tarpaulins* (private collection, 1925) and *Quayside/St. Tropez* (private collection, 1925), reproduced in *A Genius of Industrial England, 1889–1949* (exhibition catalogue, Bradford, 1990), alongside many of Wadsworth's post-war works.

Wyndham Lewis and the *Rappel à l'ordre*: Classicism and Significant Form, 1919–21

Paul Edwards

T HERE IS VIRTUALLY NO LANDSCAPE in Wyndham Lewis's work, though he began with a typical Edwardian enthusiasm for peasants and fishermen, following Pierre Loti and Paul Gauguin to Brittany rather than W. H. Hudson and Stanhope Forbes to Cornwall. And even in Brittany and other places where he sought the 'primitive' in the company of fellow artists Henry Lamb, Spencer Gore and Augustus John, it was really the freaks of cosmopolitanism — the Slavs living on tick in seaside boarding houses, the business man from the Midi who had attempted to transform himself into an American — that caught the young Lewis's fancy. It was a cosmopolitan preference he would maintain after returning to England in 1908 from his five years' European study and travel; it would lie beneath his campaigns to make English painting a full participant in the modernist innovations he had seen in painting on the Continent. At the crucial moments where the European–English relationship was decided, before and immediately after the First World War, Lewis would be the central figure, urging closer participation but resisting vacuous imitation.

In London, his favourite restaurant was Stulik's 'Eiffel Tower', off the Tottenham Court Road, which, together with Helen Saunders, he provided with Vorticist wall decorations. A brief vignette in his 1916 play *The Ideal Giant* suggests what he liked about it: 'The Restaurant is French in its staff and traditions. An Austrian, at present, keeps it, . . . A very large brass vase in the middle, and a Russian wood painting, of a Virgin and Child on narrow wall between the two windows, gives the German cultured touch'.[1] The restaurant (as fictionalised in the play) is located in 'German London', as Lewis somewhat defiantly names it, conscious that the chauvinism engendered by the First World War would deny reality to such a place. 'German London' can stand for the sense of place that animated the imaginative geography of Lewis's Vorticist phase. The cities depicted in *New York* or *The Crowd* (fig. 46 on p. 118) are places of the mind, and it is their potential for generating new ways of experiencing life that Lewis's work celebrates and sometimes questions. When, in his campaign for modernism, he celebrated what might be called the geographical aspect of Englishness, he did so

not through any local or representative characteristic of the landscape, but through the maritime pursuit of global trade. 'England' is an 'industrial island machine, pyramidal workshop, its apex at Shetland, discharging itself on the sea'.[2] The English are attached to the sea, and this, together with the industrial products in which they trade, makes for English exceptionalism. England is exceptional by being the birthplace of Modernity, and by being a place where its products and effects are most concentrated. 'By mechanical inventiveness too, just as Englishmen have spread themselves all over the Earth, they have brought all the hemisphere about them in their original island', Lewis claimed in the original Vorticist manifesto of 1914.[3] English culture, then, is special by virtue of affording the potential for universalism:

> The English Character is based on the Sea. . . . That unexpected universality as well, found in the completest English artists, is due to this. . . . Once this consciousness towards the new possibilities of expression in present life has come . . . it will be more the legitimate property of Englishmen than of any other people in Europe.[4]

Just as Lewis's Vorticism denies that the physical body can any longer be used by the artist, in traditional humanist fashion, as a symbol of our powers, so he intimates that geographically, Englishness cannot be symbolised by reference to the landscape. England is necessarily cosmopolitan and should recognise its potential centrality in the new effort to construct a visual culture of global significance: 'It cannot be said that the complication of the Jungle, dramatic tropic growths, the vastness of American trees, is not for us. For in the forms of machinery, Factories, new and vaster buildings, bridges and works, we have all that, naturally, around us'.[5] Jane Beckett and Deborah Cherry have plausibly connected this celebration of industrial power with a contemporaneous enthusiasm for Britain's imperial mission.[6] But it is modernity, trade and manufacture, above all, that Lewis here celebrates as characteristic of England. In doing so he avoids other, evasive, expedients of the time: the post-romantic tradition of domestic pastoral and an 'imperial' culture that refused to stay at home but rarely rose above the level of the boy's adventure story. Lewis himself was later to mock the former of these traditions for wilfully ignoring its own parasitic dependence on the bloody imperial adventure naively celebrated in the latter. Characteristically, it is Virginia Woolf's celebration of Tennyson in *A Room of One's Own* that he seizes on. A character, Margot, in Lewis's 1935 novel, *The Revenge for Love* (not published until 1937) murmurs lines from *Maud* to herself

('From a passion flower at the gate / Has fallen a splendid tear'), and recalls Woolf's reaction to them, visualising:

> two figures [of Maud and her lover] who, at a likely guess, if you followed them to discover their habitat, would reintegrate the pages of *Framley Parsonage*, but *never* derive from anything more grossly twentieth-century or anything privy to internal-combustion—to name the arch-serpent of the pre-war Eden. '*What poets they were!*' she repeated to herself, in the very words of Virginia Woolf. 'What poets they were!' *They* being those splendid Victorian monogamists—flowering, as great-hearted passion flowers, hyperpetalous and crimson red, upon the spoils of the Angloindies and of the Dark Continent.[7]

This does not mean, however, that Lewis, the most committed modernist and internationalist of his time, had no sense of an 'English' tradition. The opposite is the case, and this essay is partly concerned with his attempt to create after the First World War a kind of 'classicism' that would participate in that tradition yet also be thoroughly European and up to date. But the hegemonic versions of Englishness that he combated were consonant neither with modernity nor with the globalism that 'English' inventiveness had made possible.

It is now a commonplace that there is something, 'unenglish' about modernism: even anglophone literary modernism is almost entirely a 'foreign' import from Ireland, America or Poland, while the English contribution to visual modernism has little international status. Really, of course, Lewis in 1914 is castigating the English for not realising their place, culturally, in the world. He knows perfectly well from his own experience of Munich and Paris that England 'has been the last to become conscious of the Art that is an organism of this new Order and Will of Man'.[8] It is the paradox of England's apparent global supremacy combined with the parochialism and conservatism of its art that Lewis must deal with. By the power of his rhetoric—and, it must be said, by the example of the form of geometric abstraction he pioneered—for a few months Lewis almost made modernism and Englishness a workable combination. But the First World War, which made it possible to brand all visual experiment as not merely frivolous but also as deeply 'unpatriotic', meant that, once the war was over, the work necessary to establish English painting as a participant in European modernism had to begin again. Again Lewis had recourse to his rhetorical skills, issuing what he thought of as a third *Blast*, a modernist manifesto calling for the rebuilding of London using the form-sense developed in Vorticist abstraction: *The Caliph's Design: Architects! Where is your Vortex?* Lewis had himself lived through the whole long

battle of Passchendaele in 1917, and was determined that those who had suffered should be given an environment that could capture their imagination: 'simply for human life at all, or what sets out to be human life — *to increase gusto and belief in that life* — it is of the first importance that the senses should be directed into such channels, appealed to in such ways, that this state of mind of relish, fullness and exultation should obtain'.[9] Once again, England, as a real place, does not offer a physiognomy through which the meaning of modernity is made visible, and Lewis calls on architects to create a cityscape that will induce the relish with which human life should be imbued.

Even before the War, and as part of his attempt to jostle in among other Modernist practices and secure for an English Modernism (Vorticism) a hoped-for position of prominence, much of Lewis's polemical effort had gone into criticising European sections of modernism (Cubism, Futurism, Expressionism) for the limitations of their representations of modernity. This had been the obverse of Lewis's critique of the English refusal even to attempt the task. But in 1919 the whole international movement faced a transformed history, and Lewis shared a general belief that what was needed was consolidation: 'a nice large new world really *has* been discovered. Let us get it into shape'.[10] In fact modernism of the kind Lewis favoured was about to be defeated. In Europe, 'consolidation' would slide into a conservatism that fulfilled the critical role Lewis envisaged even less successfully than the movements he had criticised before the War. In England, modernism was virtually to cease, at least until the thirties. By 1923 Lewis himself would virtually have abandoned painting for writing as the vehicle of his own modernist aspirations, in the face of a hegemonic version of modernism as 'significant form' that would attempt to remove painting from significant history altogether.[11] The 'Group X' that Lewis organised with McKnight Kauffer in 1920 as a counterweight to the Bloomsbury-dominated London Group lacked a communal style and vision and fell apart after a single exhibition. His *Tyros and Portraits* exhibition, held at the Leicester Galleries in April 1921, was not very favourably received, despite Lewis's eschewal of extreme experimentalism in the works exhibited, and the exhibition of more extreme work, promised for Léonce Rosenberg's L'Effort Moderne Gallery in 1922, never materialised, ostensibly because Lewis was evicted from his studio, unable to pay the rent.

This was a sad conclusion after the brave words of 1914 and 1919; but it belies the intelligence and inventiveness of Lewis's actual achievement during the years 1919 to 1922 as he simultaneously maintained his commitment to experiment and produced his own critical version of the classicism that overtook the

modernism of Paris in particular as part of the wider *rappel à l'ordre* that followed the trauma of the First World War. It is the latter part of this dual commitment that is the subject of the remainder of this essay. Although Lewis shared a general belief in the superiority of French painting over English, he always insisted that English painting would never be successful by simply following the French example. *The Caliph's Design*, beginning as a brash manifesto for a modernist architecture, finishes as a carefully considered (though violently expressed) dissociation from those aspects of the painting of the Ecole de Paris and its tasteful English followers that Lewis considered to be obstacles to a modernism that would be genuinely critical. In particular, the pamphlet engages with the series of articles on painting that had been appearing in 1919 in the *Athenaeum* by André Lhote, Clive Bell and Roger Fry.

In France after the First World War, the demand was for art that was 'synthetic' and 'constructive'.[12] The country needed reconstruction, and art was to help that process by abandoning irresponsible pre-war analytical and individualist modes. French painting would again express the national spirit — the inheritance of Hellenic and Latin civilisation. Classical canons of painting place line above colour, and the painterly qualities of analytic cubism would give way to less personal handling of paint. André Lhote, in a series of articles in the *Athenaeum* on the occasion of the reopening of the Louvre after the war, acclaimed David and the brothers Le Nain[13] and praised Cézanne not only as the inheritor of French tradition, but as an embodiment of 'the avenging voice of Greece and Raphael. He constitutes the first recall to classical order'.[14] The 'rappel à l'ordre' found expression in classicising nudes and bathers, a celebration of Latin Mediterranean themes, and in the orderly space of post war synthetic cubism. The most notable symptom was probably the new importance of drawing: pure line drawing in the style of Ingres (for whom drawing was, of course, 'the probity of art'). Picasso, in his portrait drawings of Max Jacob and Daniel Kahnweiler, had begun this trend during the war, and now it spread.

When modernism reshaped itself to accommodate the conservative post war mood it became in one sense much easier to assimilate to an English tradition. By 1922 the direction of painting in England looked clear to Clive Bell, and it consisted in a particular English version of the post-Cézannian classicism expounded by Lhote. In the introductory essay of a collection of his post-war articles, Bell points out that 'our best painter' [Duncan Grant] was setting out to 'exploit the French heritage with feet planted firmly in the English tradition — the tradition of Gainsborough and Constable'. Bell perceives a return to

something missing in Cubism, a humanism that is not manifested in 'drama or anecdote or symbolism', but in a 'mysterious yet recognizable quality in which the art of Raffael [sic] excels—a calm, disinterested, and professional concern with the significance of life as revealed directly in form, a faint desire, perhaps, to touch by a picture, a building, or a simple object of use some curious over-tone of our aesthetic sense'.[15]

Bell's doctrine of 'significant form' accommodates itself to the English landscape tradition, French classicism, Raphael and the Parthenon, but not to anything as ephemeral as 'contemporary actualities . . . what is going on in the street' or to the 'austerer doctrinaires' of Cubism. New painting will have something to say about 'life'. But painters will say it 'not by drama or anecdote or symbol, but as all genuine artists have always come at whatever possessed their imaginations, by plastic expression, or—if you like old-fashioned phrases—by creating significant form. . . . That humane beauty after which Derain strives tius to be found, I said, in Raffael: it is to be found also in the Parthenon'.[16]

In English painting the dominance of this aesthetic was to be a visual equivalent of the ideals of life that eventually found their epitome in the cookery books of Elizabeth David and the couture of Laura Ashley (the true inheritors of Bloomsbury-culture: Virginia Woolf without tears). By 1929 Wyndham Lewis was complaining of the results of this particular 'English' adaptation of the French tradition, promoted by Roger Fry and Clive Bell and evident in the work of the London Group: 'In the wake of Cézanne, Bonnard and the French Impressionists and Post-Impressionists, everything turns out as a formless and cheerless weed or vegetable for some reason. . . . Over this kitchen-garden landscape in England hovers the benevolent, cheaply-fanatical form of Mr. Roger Fry'.[17]

Lewis was equally aware, however, that English painting could not insulate itself from what was happening in Paris. Indeed in 1921 he stated his belief that the French were 'nearer to the greatest traditions of England, today', than the English themselves were. These traditions were those of 'Rowlandson, Hogarth and their contemporaries', which were 'at their flood tide in the reign of Elizabeth'. They had been usurped by Victorian '*sensiblerie*, pathos of Dickens, personality-mania, and so forth'. In the circumstances:

> the best chance for English art is not to stand on its dignity, be stupidly competitive and land-conscious, but to regard itself as thoroughly involved, for better or for worse, with the main intellectual life of Europe, and join its effort, simply and without humbug, to that of France, Germany, or Italy, but

especially France and Paris. Is it afraid of losing its 'English' identity? If such an identity could be lost that way, it is not worth keeping.[18]

Lewis's problem was, as the title of the essay from which this passage is taken shows, with 'Roger Fry's role as Continental Mediator', and with distinguishing his own position from that of Fry and from that of the classicising Ecole de Paris in which he was proposing English painting should involve itself. For Lewis recognised, like Bell and Fry, that 'every French painter, of whatever order, possesses as a certain inheritance' a tradition of technical craftsmanship that is denied to English artists. He also realised that there was an essential truth, if not the whole truth, in the Bloomsbury insistence on the importance of 'form' rather than adventitious sentiment or anecdote in art. Finally, he also shared the general desire to establish some form of 'classicism' as the mode of modernism. These were necessary conditions for a viable, consolidated modernism, but they were by no means sufficient, he argued. Much of Lewis's polemical energy as well as his more reflective analysis, in the essays of 1919 to 1922, went into making these distinctions.

Lewis believed, first, that Bell's aestheticism, with its 'faint desires' was an inadequate basis for an art with the kind of function he envisaged for it, that anyway the purely formal understanding of painting was fallacious. He also believed that French painting in its classicism, was partly reactionary: 'the hysterical second-rate Frenchman [he means André Lhote primarily], with his morbid hankering after the mother-tradition, the eternal Graeco-Roman, should be discouraged'. As for Picasso, Lewis considered he had become something of a pasticheur failing to engage with the great task of modernism. Equally the Cubist obsession with still-life seemed to him fundamentally escapist and reactionary. The critique Lewis makes of these aspects of contemporary 'classicism' in *The Caliph's Design* is a remarkable anticipation, in fact, of a conclusion like Christopher Green's, in *Cubism and its Enemies*:

> In the final analysis, Picasso's and Gris' Corotesque figure paintings, Braque's nudes and every Cubist still-life carried connotations that were profoundly conservative. . . . In general outline the always ordered, always formalist and often chauvinist idea of tradition that was disclosed by their compositions was difficult to separate from that of . . . the arch-reactionary . . . patriots of the Right.[20]

Lewis's own hope from the 'consolidation' of modernism on the other hand, is summarised in the following passage. Freedom was not to be discarded and regimented, but:

How we *need* and *can* use this freedom that we have is to invent a mode that will answer to the great mass-sensibility of our time. We want to construct hardily and profoundly without a hard-dying autocratic convention to dog us and interfere with our proceedings. But we want *one* mode, for there *is* only one mode for any one time, and all the other modes are for other times.[21]

Lewis's commitment to a mode that answers to 'mass-sensibility' is quite serious and was, during the period covered by this essay, accompanied by determined efforts to bring art to a wider public: through critical polemic (*The Caliph's Design*); through practical involvement in the popularising organisation, The Arts League of Service; through popular journalism (he wrote articles in the popular press on War Art, Picasso, the Royal Academy, fashion, applied art and on his own activities); and through the would-be popular format of his magazine, *The Tyro*. The element of self-dramatisation involved in this activity has helped obscure the cultural purposes of the exercise. The fact, also, that Lewis was simultaneously addressing an élite audience in magazines such as *Art and Letters* and through 'experimental' abstractions that had even less chance of a comprehending response than his work from nature has further caused this aspect of his effort to be overlooked.

Lewis's diagnosis of the task facing painters at this time, and his appreciation of the critical weaknesses in current practice in Paris and Bloomsbury are as intelligent and perceptive and as brilliantly articulated as a subsequent historian could desire. But Lewis was of course also a painter, and the scope of his critical understanding of the task of post-war modernism might well have been expected to inhibit his capacity for decisive action in his work. He had too clear a sense of the deficiencies he wished his painting to overcome. In fact his correspondence with his patron, John Quinn, a passage of which is cited below, shows that he was less confident about the value of his painting than he appeared to be in public. Even his over-size 1919 portrait of Ezra Pound, exhibited to much acclaim at the Goupil Salon of that year, failed to satisfy him, and he probably destroyed it. But ultimately it was only through developing his own visual practice that Lewis's theoretical comprehension could have real force, so it is to his paintings and drawings that I now turn. Typically, in that work, he would take some of the critical and technical presuppositions of his contemporaries and criticise them ideologically from the inside, as it were, almost deconstructing them, and in the process transforming them so as to give them a quite changed meaning in his own art.

55 Wyndham Lewis, *Nude I*, 1919, pen and ink, chalk and watercolour (24.8 x 29.2 cm). Reproduced from Portfolio, *Fifteen Drawings*. Photograph courtesy Cambridge University Library.

First, the nude and significant form. Lewis produced a large number of drawings of the figure in this period (figs. 55–60), partly, I think, because he was unhappy about a lot of the drawing in his War pictures, which hovered, sometimes uneasily, between the metaphorical qualities of Vorticism and a naturalist 'humanism' derived from the academic practice of drawing learnt at the Slade School. The pure drawing he now undertook was both a revaluation of that academic practice for the modern world, and a testing (to destruction, almost) of the assumptions inherent in such a statement as that of Roger Fry, discussed in *The Caliph's Design*, that, for the artist. 'A man's head is no more and no less important than a pumpkin'.[22] Typically, Lewis poses the figure, as often in academic practice, to give himself formal problems to solve. He is apparently concerned only with form and the solution of formal problems particularly by line, but sometimes through wash, as well (fig. 55). This is, I think, in some ways a response to the French Ingres revival. Lewis shows that line can be taken in another direction from humanism (or from the ironic 'humanism' of some of Picasso's line drawings). In *Time and Western Man* a few years later, Lewis would

56 Wyndham Lewis, *Nude*,
1920, pencil and wash (36.8 x 25.4
cm). Austin/Desmond Fine Art.

state that his idea of the classical fitted better with oriental rather than Hellenistic modes. He wrote: 'If there is one thing, that eastern art is characterised by more than another it is "line". With Greek art the "line" suffers from the dogmatism of ionian science — of "nature", in short'.[23] There is a difference between the formalism of these drawings and the formalism Clive Bell propounded. Bell's formalism announced itself as a belief that the painter should bring nothing from life, 'no knowledge of its ideas and affairs, no familiarity with its emotions'. Yet Bell was (surely illogically) convinced that the result of such detachment would be a Raphaelesque humanisn or even a Matissian and Mediterranean joie de vivre. One of the things Lewis does is to show that formalism can imply a profound alienation from the human. In fact his impersonal formalism actually amounts to a kind of humiliation of the humans in these drawings, because, of course, the dissociation of form from our experience of life is actually impossible, as Lewis insisted in *The Caliph's Design*. What happens in some of the drawings is a kind of tug of war between the artist's own attempt to

57 Wyndham Lewis, *Red Nude*,
1919, pencil and watercolour
(56.5 x 41.3 cm).
The British Council.

alienate the figures entirely into 'form', and our own refusal to allow it. We always side with the model, however exhilarated we might be at the technical inventiveness and economy in the drawing. A slightly comical example can be seen in the drawing of a seated nude, where there is an almost unavoidable sense of the poor woman having banged her head on the top edge of the sheet (fig. 57). The apparent attempt to reduce an art work to no more than pure form — a pattern of line and colour on a flat surface projecting also the plasticity of a solid volume — does not succeed. And Lewis does not want it to. We are meant to notice that there is an element of cruelty in this and other drawings.

To return to the nature of the formalisation Lewis employs and particularly the line (though a similar point can be made about the almost mechanically competent rendering of volume by wash). His drawing does not submit to nature: in fact the repertoire of lines — mainly a series of arcs that succeed or overlap each other at decisive points on the outline — is deliberately restricted, and I think, deliberately restricted in at least some of these drawings to the

58 Wyndham Lewis, *Seated Nude*, 1919, pen and ink and watercolour (36.8 x 27.3 cm). Cecil Higgins Art Gallery and Museum, Bradford.

mechanical. *Red Nude* is a good example (fig. 57): one cannot help succumbing to an illusion that most of the arcs and lines could be pretty accurately generated by mathematical equations as in geometry. It is customary, particularly in the light of Lewis's Vorticist procedures, to observe that his art transforms the humans it represents into machines. But something quite different is happening here. Here it is, rather, the artist himself who becomes the machine, programmed, as it were, to assemble a limited repertoire of marks into a symbolic version of the visual field before it. The machine-age naturally brings with it its own visual ethos, necessarily different from, but influenced by the contemporary ethos, much as John Constable or an artist of the Sung period was influenced by the scenery with which they were surrounded:

> Just as the sculptors of Nineveh put the lions that were such immediate objects in their life, to good use in their reliefs, or the painters of the Sung period the birds and landscapes found by them in their wilfully secluded lives, so it was inevitable to-day that artists should get into their inventions

59 Wyndham Lewis, *Nude II*, 1919, black crayon, watercolour and gouache (28 x 38 cm). Reproduced from Portfolio, *Fifteen Drawings*. Photograph courtesy Cambridge University Library.

(figures, landscapes or abstractions) something of the lineaments and character of machinery.[24]

But this is not simply a matter of visual predilection, for especially after the First World War, the collocation of a machine (even simply as the source of a visual ethos) and a human body cannot be made innocent. And Lewis is well aware not only of the damage machines do to bodies—he became obsessively occupied with pamphleteering against war during the thirties—but also of the damage they might do to the capacity of art to embody human value. He explains the paradox of virtuosity, the assertion of human skill in the production of the artwork, in an essay of 1922:

> In a great deal of art you find its motive in the assertion of the beauty and significance of the human as opposed to the mechanical; a virtuoso display of its opposite. But this virtuosity, in its precision even in being imprecise, is not so removed from a mechanical perfection as would at first sight appear.[25]

60 Wyndham Lewis, *Male Nude,*
1919–20, pen and ink (35.5 x 23 cm).
Herbert F. Johnson Museum of
Art, Cornell University, Ithaca,
New York.

This 'mechanical perfection' is the negation of the human, as Lewis's subsequent citation of Dostoevsky confirms. The fullest discussion of the body-machine relationship in the modernism of the pre- and post-First World War period (concentrating on Marinetti and Wyndham Lewis) is Hal Foster's 'Prosthetic Gods'.[26] At one point Foster usefully links post-war neo-classic reactions with 'machinic' utopian fantasies: 'If the neo-classical reaction proffered the nostalgic balm of an imaginary body that was pellucidly intact [in reaction to the mutilated bodies of World War 1], the machinic reaction looked to the very mechanisation of the modern body for a new principle of corporal order'.[27] In a footnote he points to the work of Léger and Le Corbusier as meeting points for these superficially divergent trends.[28] My contention here, however, is that Lewis's adoption of what might be called a mechanised persona in the production of these drawings—which makes possible the uneasy exposition of mechanical– human competition we sense as well in the actual content of the drawings—critically exposes the occluded nostalgia/utopianism inherent in contemporary French modernist practice.[29]

The adoption, then, of what might be called a mechanised persona in the production of these images is fraught with a complexity of meanings that cannot be fully expounded here. It duplicates at the level of form the uneasy exposition of mechanical–human competition we sense in the actual content of the drawings. Its full significance in Lewis's art need not concern us here. But since the female nude is its most frequent subject, the question of its misogyny naturally arises and should receive some consideration. Lewis was certainly capable of misogyny (it is expressed most often in his work during 1916–17) but his dealings with gender are always critical. These drawings of female nudes necessarily comment on the genre of the female nude in Western art, and their subversive power in that context is potentially liberatory. The nudes depicted in figs. 58 and 59 are people, and recognition of this awakens reflection on 'The Nude' and on the implications of looking that the genre traditionally elides, or turns to pleasure. Moreover, when Lewis depicts the male nude he performs a similar subversion (admittedly with less intensity) of that the heroic masculine image the Michelangelesque tradition dictates (fig. 60).

In the context of the meanings of formalism, 'classical' genre and technique in the period they were produced, the critical implications of these drawings can be briefly summarised. First, they question, by pushing, a purely formalistic conception of visual art. Second, they import the ethos of a machine-sensibility into the academic tradition of classical linear art that was being revived as witty pastiche or solemn reactionary conservatism in Paris. In so doing, they provide a critique of that revivalism, and by showing a potential inhumanity in their own machine-ethos as well as its attractions, they imply a critique of the placid mechanical classicism of Purism. Their assault upon the body, emphasising its limitations and fragility, becomes both a critique of the reactionary French indulgence in the female nude as an object of appetite, and an insight into the dangerous, but sometimes exciting, machine world bodies now inhabit. How could either the body or the machine be simply celebrated after Passchendaele?

Some of the drawings I have been discussing, or similar drawings of the nude, were included in Lewis's 1921 show, along with others of 'classical' academic genres—portraits and figure studies, all predominantly linear. There were no abstractions, but some representations of comic grotesques Lewis called Tyros. They were invented by Lewis as the personnel of a narrative art that would deliberately oppose the pure formalism of Bloomsbury and its neutral genres. He placed them in the English tradition of Swift, Fielding and Shakespeare. They are intended to go back to that older, truer English tradition that

Lewis complains has been usurped by Victorianism. In 'Roger Fry's Role as Continental Mediator', anticipating the criticism made in *The Revenge for Love*, quoted above, Lewis identifies this Victorianism with Bloomsbury: in view of Bloomsbury's own vision of itself as the destroyer of the shackles of Victorian oppressiveness this was a blow below the belt. Lewis even goes so far as to allude to one of the movement's most subversively anti-Victorian texts, Lytton Strachey's *Eminent Victorians*:

> One of the anomalies in the more experimental section of English painting, is that a small group of people which is of almost purely eminent Victorian origin, saturated with William Morris's prettiness and fervour, 'Art for Art's sake', late Victorianism, the direct descendants of Victorian England — I refer to the Bloomsbury painters — are those who are apt to act most as mediators between people working here and the Continent, especially Paris.[30]

The tradition Lewis asserts is literary as much as visual, as one of its major figures, William Hogarth, had proclaimed in the eighteenth century. (In his famous self-portrait Hogarth included volumes of Shakespeare, Milton and Swift.) Here then, is the tradition Lewis holds up as an alternative to the French Graeco-Roman tradition.

A Tyro is a beginner, and, by documenting the activities of these toothy monsters, Lewis meant to reflect modern post-war conditions. 'We are at the beginning, of a new epoch, fresh to it, the first babes of a new and certainly a better day', he wrote optimistically in his art-paper, *The Tyro*, no. 1, issued simultaneously with the Leicester Galleries exhibition.[31] Once again, only an imaginary geography is adequate for the depiction of these conditions. The Tyros inhabit another star, and their world is only the 'twin' of ours, though saturated with the ideology of 'cheery' fatalism that enabled the British Tommy to survive conditions in the trenches. Not many of Lewis's images of Tyros survive. Of those that do, *A Reading of Ovid* (pl. VII) is the most impressive, and almost the first painting that Lewis expressed satisfaction over. He was pleased with the colour, in particular, though his self-praise to his patron John Quinn also betrays a certain lack of self-confidence that must finally have played a part in his discouraged abandonment of painting in the mid-twenties: 'The "Tyros reading Ovid" . . . is one of the paintings I took longest over, is very carefully painted: as a fragment of a large composition it is quite successful as regards colour. The very strong reds of the hands and faces is set in the midst of grey-blues and strong blues. It is a quite satisfactory painting: it would make a good Altarpiece'.[32] The blues do contrast beautifully with the brick-red

faces of the figures, and the pale blue background against which they are silhouetted has the magical glow that is a mark of Lewis as a colourist at his best. It isolates and projects the figures whose modelling is largely schematic and rhetorical, and it creates atmospheric space without detracting from the intensity of the Tyros' excessive presence. This is a beautiful painting, but its subject-matter mocks the very idea that anyone could look at it purely as 'significant form', and its beauty is hidden from a spectator approaching it with presuppositions derived from an appreciation of French (or Bloomsbury) painterliness.

A full consideration of Lewis's 'Tyro' project is out of place here. My concern is particularly with the 'classical' dimension of this and other paintings included in Lewis's 1921 exhibition. The Tyros are reading Ovid, which makes the painting into a comment on the survival and relevance of classicism in the modern world. The classical ideal looks foolishly anachronistic, but the painting nevertheless asserts a continuity with Ovid's Rome that is belied by the blue business-suits and modern hats of the readers. They are, after all, responding to the text with grins that testify to Ovid's survival and contemporary relevance — though the relevance is clearly rather low-grade in this instance. Lewis, ever-concerned with the dramatic tension involved in the exchange of a look between the inhabitants of the world depicted in the artwork and the spectator from 'our' world, compels us to meet the glance of one of the figures, enforcing a reluctant complicity: these idiots are like me, and I am a participant in the narrative. (Lewis did not exclude himself from this categorisation: he painted himself as one of these grinning simpletons — *Mr. Wyndham Lewis as a Tyro* (fig. 61) in which manic glee is belied by the deathly green cast of the flesh.) As a narrative, the painting depicts the moment when I, the male spectator, have interrupted the reading, and the seated figure on the right has looked over his shoulder, beaming at me as if half-guiltily, to welcome me into the company. (For the female viewer, the 'in your face' brandishing of appetite will have a different connotation.) The reader himself is still glowing ruddily from the pleasure of the text, from which he is not diverted by our intrusion. A feeling of complicity is appropriate because we are all 'babes of a new . . . day', and we are all, before anything else, physical. Tyros are learners: the lost *School of Tyros* showed them at their studies. What they would learn from Ovid, that would account for their sniggers, might well be the art of love: 'In *Cupid*'s School, who'er wou'd take Degree / Must learn his Rudiments by reading me'.[33] In the Dryden translation, which is the one Lewis used, the *Ars Amatoria* was assimilated to precisely the gross beef-eating tradition of Hogarth and Fielding that the caricatural Tyros continue. Lewis would cite a passage of advice that

makes the affiliation clear, a few years later, in *The Apes of God*:

> Be not too finical, but yet be clean;
> And wear well fashion'd Cloaths, like other Men.
> Let not your Teeth be yellow, or be foul;
> Nor in wide Shoes your Feet too loosly roul.
> Of a black Muzzel, and long Beard beware;
> And let a skilful Barber cut your Hair.
> Your Nailes be pick'd from filth, and even par'd;
> Nor let your nasty Nostrils bud with Beard.
> Cure your unsav'ry Breath; gargle your Throat;
> And free your Arm-pits from the Ram and Goat.[34]

What Lewis loved about this earthy rendition of the passage was the resulting doubleness: the grossness of expression seems to negate the officially fastidious content. Though the two Tyros wear 'well-fashion'd Cloaths', and their teeth gleam, however, the image and the passage cannot reliably be connected: the association remains speculative.

The painting is partly about classical revivals and their inherent (and occasionally comic) self-contradictions. It is also an implicit mockery of Victorian medieval revivalism in such works as Ford Madox Brown's *Geoffrey Chaucer Reading 'The Canterbury Tales'*. Classical revivals simultaneously assert a decline from an ideal and an identity with it: contemporary society is too degraded to provide its own symbols for its highest ideals, but Napoleon (or later, Mussolini), is Caesar. Lewis's painting causes the spectator to question whether the inadequacies in the contradictory ideas can actually be kept from contaminating each other. On another level the same paradox occurs. If Lewis's painting is arrogating membership of a tradition that includes Ovid, Dryden and Hogarth, it is also on a narrative level showing that this tradition has an appeal to a pair of grinning idiots. The refined (those who read Ovid in the original, and not for the dirty bits, for whom acquaintance with the classics is a mark of superiority) might be disgusted at the kinship claimed by the grin of the Tyro on the right, but the whole stylistic relish of the painting shows where Lewis's sympathies lie.[35] The world is changing, and the crudeness and coarseness that accompany such transformations are to be celebrated as preferable to contemporary aestheticism and Francophile refinement.

The celebratory dimension of what appear at first sight to be purely mocking images deserves comment. First, it is squarely in the English comic tradition of

61 Wyndham Lewis, *Mr Wyndham Lewis as a Tyro*, 1920–21, oil on canvas (96 x 45.5 cm). Ferens Art Gallery, Kingston-upon-Hull.

Rowlandson or Fielding, where the imperfections of the gross body are revelled in at the same time as they are 'satirised'; Lewis did not simply withdraw in fastidious disgust from the physical body in the way commonly thought ('They stink! My God, they stink!').[36] Second, taken with Lewis's decision to portray himself as a Tyro, it indicates a much less definite ideological attitude than might be expected to the whole social-historical transition that the Tyro project is intended to delineate. Given Lewis's later 'known' social attitudes (broadly anti-democratic and politically authoritarian, though actually a good deal more ambiguous than they seem at first sight), he 'must', in his satire, be taking a reactionary attitude to the cultural developments the Tyros embody. Yet this is not so. For one thing, he was attempting to produce an art that answered to the 'mass-sensibility of our time', and the Tyros are his most obvious attempt to do so: they are inherently far less 'reactionary' than Bloomsbury paintings of readers in deckchairs in English gardens, however enlightened were the attitudes held by the painters and sitters responsible for these representations of the leisured liberal intelligentsia.[37] Most importantly, however, Lewis was aware that no cultural phenomena could simply carry a fixed value. In 1921, to the 'babes of a new

62 Wyndham
Lewis, *Portrait of
the Artist as the
Painter Raphael,*
1921, oil on canvas
(76.2 x 68.5 cm).
Manchester City
Art Galleries.

epoch', definitive critical sorting and evaluation was not yet possible. The Tyros
are grotesque fetishes for a particular moment, erected in the no-man's land
between reactionary élitism and populist utopianism, fending off with their
huge, toothy grins all calls to declare allegiance to one side or the other.

An altogether different image in the *Tyros and Portraits* exhibition also con-
tains a classical allusion that is really only accessible through its title. At the begin-
ning of this essay I quoted André Lhote on Cézanne as embodying the avenging
voice of Raphael and Rome. Lewis mocked the statement in *The Caliph's Design*,
and it may be that the other self-portrait Lewis exhibited (besides *Mr Wyndham
Lewis as a Tyro*) also implicitly mocks Lhote's critical appropriation of Raphael.
For it was exhibited under the title, *Portrait of the Artist as the Painter Raphael* (fig.
62). Against its glaring red background the face has a kind of placidity that can be
called classical, even if 'Raphael' is there only in the title. As in *Reading of Ovid*,
but in an utterly different way, the painting both lays claim to a certain kind of
classicism and translates it into a mode that is quite alien to what that tradition

63 Martin Droushout, *William Shakespeare*, 1623, engraving.

has come, culturally, to stand for. Its geometry and design are simple and schematic, and the head completely lacks the expressionistic intensity of the Tyros. Lewis pointed out to Michael Ayrton that there were no highlights in the eyes: they would have given the image 'the wrong kind of life'. This gives a clue to the nature of the classicism involved here: not so much a historical period, for it is resolutely contemporary, as a mode that removes its objects to an ideal 'timeless' plane. The face of the clock is as blank as the face of the sitter. Lewis discussed this form of classicism in an article called 'The Credentials of the Painter', in 1919, making his point by a quotation from Heinrich Heine which I shall reproduce in my discussion of *Praxitella*. There may possibly be an echo in Lewis's self-portrait of the Hogarth self-portrait already mentioned. I am more confident that, in visual terms, it is not really a portrait of Lewis as Raphael, but is meant to evoke subliminally the image of Shakespeare from the familiar Droeshout engraving from the first Folio (fig. 63). Ostensibly laying claim to one 'classical' heritage, the painting actually, and surreptitiously, lays claim to another.

Shakespeare is central to Lewis's work and to his conception of the artist. Lewis's first publication, in 1913, had been a portfolio of drawings for *Timon of Athens* that had formed the core of his exhibit at the Second Post-Impressionist Exhibition the previous year.[38] In 1927 he would publish a study, *The Lion and the Fox: The Role of the Hero in the Plays of Shakespeare,* showing his continuing preoccupation with the national poet. More mundanely, Lewis thought he looked like Shakespeare, as he jokingly explained to Violet Schiff in 1922: 'once and for all, as you know, it is *Shakespeare* that I physically resemble . . . Shakespeare is the only famous Englishman I have a striking resemblance to'.[39] Lewis makes various comments about Shakespeare's appearance: 'The authenticity of that face even has been doubted: it has been called "an obvious mask", "the face of a tailor's dummy", and many other disobliging things. For there, in place of the massive bearded mask popularly expected of a Homer or an Aeschylus is a delicate egg-like countenance, serene and empty'.[40] The 'English' classic heritage Lewis here lays claim to, then, is a complicated one.

The final 'classical' image I shall discuss is *Praxitella* (pl. VIII), which evokes the classicism of Praxiteles through its title, though again in a paradoxical way, since this fantastically stylised portrait of Iris Barry is as far as possible from the bland ideality of Praxiteles' sculptures of Aphrodite, copies of which are in the Louvre and the Vatican Museum. The painting, with the defiant extravagance of its negotiation between Cubism, naturalism and Expressionism, defies commentary, and is certainly the masterpiece of Lewis's work in oil of the period. The figure is removed from this world, both rendered through a series of quasi-mechanical lines and textures, and herself apparently a mechanical assemblage of sheet metal. At the same time she is human, but with the alien quality of a wasp or grasshopper, dangerous-looking, but also very placid. She is formidably armoured, but as with some of the drawings we feel like reproaching the artist for turning her out in this alienated condition. The painting still has power to shock with the sheer deliberation of its outrageousness.

Lewis had no wish to repudiate what he thought of as the qualities of classicism, which for him had nothing to do with the vitalism of Praxiteles. In 'The Credentials of the Painter', he quotes a passage by Heine on Goethe that conveys, instead, the qualities he valued. Heine is actually complaining about Goethe, but to Lewis it seemed that 'Goethe, as an artist, was the sort of artist a painter is'. By this he means that painting should be classical in this sense. Heine describes an experience of walking through the lower rooms of the Louvre (opened again for 'A First Visit to the Louvre' by André Lhote in 1919)[41] and

looking at the antique statues of the Gods there. Some of these, though Heine does not mention it, are attributed to Praxiteles. (The whole passage recalls also George Eliot's description of Dorothea's reaction to the ancient sculpture at the Vatican, in Chapter 20 of *Middlemarch*, which is perhaps modelled on it.) It seems to me that Praxitella, though on one level the independent, self-confident woman of 1920s London, is also described by Heine's words, just as Lewis would have wished—allowing also for the fact that her gleam is apparently metallic or chitinous rather than marble:

> There they stood with their blank gaze, and in their marble smile a secret melancholy, a troubled memory, it may be, of Egypt, the land of the dead whence they sprang . . . They seemed waiting for the word to give them life again, and break the spell of their ice-bound immobility. Strange, these Greek antiques reminded me of Goethe's poems, which are as perfect, as glorious, as calm, and seem likewise to pine and grieve that their icy coldness cuts them off from the stir and warmth of modern life, that they cannot weep or laugh with us, that they are not human beings, but hybrids of divinity and stone.[42]

Wyndham Lewis explained in his foreword to the Group X exhibition catalogue of 1920 what he considered to be the ideal relationship between English and European (specifically French) art: 'The age of Elizabeth furnishes examples of art that are surely as "national" as it is desirable to be: perfectly interpenetrated with Western European culture, and yet using that culture independently with a freedom considered barbarous by the French'.[43] This describes exactly what Lewis himself achieved in the 'classical' work that has been the subject of this essay. The work is 'perfectly interpenetrated with' developments in European modernism in that it, too, negotiates with classical modes in response to the massive upheaval of the First World War and consequent demands for an art appropriate to an era of national renewal. But Lewis exposes the element of self-deception in the French rappel à l'ordre, its tendency to unrealistic nostalgia or to a Platonism that looked forward equally unrealistically to a mechanically perfected order. For Lewis, the past is irretrievable and the valuation of the likely future has not yet begun. This critical dimension is achieved through the 'barbarous freedom' with which he approaches the models of classicism that French neo-classicism enjoins: Lewis's mentor in such a cavalier approach is the Shakespeare of *Troilus and Cressida*.

This relationship with contemporary French culture bore little resemblance to what was envisaged by the most powerful 'modernist' group in England, or to

the much larger artistic establishment centred on the Royal Academy that virtually controlled the economy of painting in England at the time. For Bloomsbury wished for an entirely de-historicised, and hence de-politicised, emulation of French culture, and its 'formalism' enjoined the selection of subject matter that could pass as neutral but actually expressed the dilute hedonism of a cushioned, rentier élite. There was no possibility raised here that English art could assume a position of critical participation in the French revival of classicism. Clive Bell's strictures on French insularity, in his responses to Lhote's *Athenaeum* articles, are dwarfed by his unquestioning assumption of France's infallible cultural self-sufficiency: 'As for the spring of French inspiration, it is so copious that the creative genius of that favoured race seems to need nothing more from outside than an occasional new point of departure'.[44] Wyndham Lewis briefly held out the possibility of an English modernism that could address the complex crisis facing culture in general in the new post-war world, incorporating certain qualities of classicism but rejecting the ideological implications of the particular forms of classicism that were being revived in France and puffed in England.

What were the reasons for the failure of this effort of Lewis's? His attempt to engage a new mass-sensibility through the Tyros was universally derided as trivial and sensational, his drawing, even when praised, was characterised as 'literary' because of its prioritising of conception over sensation; his attempt to renew popular interest in art was dismissed as undignified self-publicity.[45] The work in the exhibition was not liked, even by John Quinn, who, despite having been until now Lewis's most generous patron, bought nothing from the show. Lewis's personal funds, inherited from his family, were running out, and in 1922 he had to do a moonlight flit from his studio. Most important, in the face of these difficulties, the attempt to build a 'classicism' that would reflect critically on modernity was shown to be an attempt to build bricks without straw. Classicism, by definition, cannot simply be an individual effort. In 1919 Lewis had recognised this: 'there is no great communal or personal force in the Western World of today, unless some new political hegemony supply it, for art to build on and to which to relate itself'.[46] As at the beginning of his avant-garde activities, but now with more damaging results, Lewis's alternative Englishness was out of kilter with the culture's favoured, and complacent, image of itself. For Lewis, the refusal of his bid for a critical classicism by the cultural establishment in England reflected more on that culture than it did on his own work. Built into his 'classicising' works had been an uncertainty about what value to attach to the social phenomena out of which he was making art. This uncertainty now fed back to

call into question the viability of his whole post-war project for the visual arts. His 'only' option (actually available to him because he was as much a writer as a painter) was a massive cultural, political and philosophical analysis that would provide a basis for a previously deferred valuation of modernity and for the realisation of its potential. Lewis retired to the British Museum Reading Room to undertake the analysis, emerging in 1926 as 'The Enemy', and abandoning painting as a public practice until 1933.

1 Wyndham Lewis, *The Ideal Giant* [1916], in Alan Munton, ed., *Collected Poems and Plays* (Manchester: Carcanet, 1979), 123.

2 'Manifesto', in *Blast* 1 (June 1914) (Santa Barbara, Calif.: Black Sparrow Press, 1981), 23–24.

3 'Manifesto', in *Blast* 1, 39–40.

4 'Manifesto', in *Blast* 1, 35, 41.

5 'Manifesto', in *Blast* 1, 40.

6 'Such representations of defensive insularity, secure and inviolate borders and marine supremacy played into and were part of contemporary imperialism'. Jane Beckett and Deborah Cherry, 'Modern Women, Modern Spaces: Women, Metropolitan Culture and Vorticism', in Katy Deepwell, ed., *Women Artists and Modernism* (Manchester: Manchester University Press, 1998), 48. In fact the Vorticist manifestos do not endorse defensive insularity or inviolate borders but relate rather to the 'workshop of the world' image of Britain, which, of course cannot be entirely dissociated from imperialism.

7 Wyndham Lewis, *The Revenge for Love*, ed. Reed Way Dasenbrock (Santa Rosa, Calif.: Black Sparrow Press, 1991), 215. Compare Virginia Woolf, *A Room of One's Own, Three Guineas*, Morag Schiach, ed. (Oxford: Oxford University Press World's Classics, 1992), 17.

8 'Manifesto', *op.cit.*, 39.

9 Wyndham Lewis, *The Caliph's Design: Architects! Where is your Vortex?* [1919], ed. Paul Edwards (Santa Barbara,Calif.: Black Sparrow Press, 1986), 30.

10 Wyndham Lewis, 'What Art Now?' [1919], in *Wyndham Lewis on Art: Collected Writings, 1913–1956*, ed. Walter Michel and C. J. Fox (London: Thames and Hudson, 1969), 114.

11 See David Peters Corbett, *The Modernity of English Art, 1914–1930* (Manchester: Manchester University Press, 1997), chs. 2 and 4.

12 See Kenneth Silver, *Esprit de Corps* (London: Thames and Hudson, 1989), especially ch. 7.

13 André Lhote, 'A First Visit to the Louvre', *The Athenaeum* (22 August 1919), 787–88.

14 André Lhote, 'Cubism and the Modern Artistic Sensibility', *The Athenaeum* (19 September 1919), 920.

15 Clive Bell, *Since Cézanne* [1922] (London: Chatto and Windus, 1929), 36–37.

16 *Since Cézanne*, 36–37.

17 Wyndham Lewis, 'A World Art and Tradition' (1929), in *Wyndham Lewis on Art*, 256–57.

18 Wyndham Lewis, 'Roger Fry's Role as Continental Mediator' (1921), in *Wyndham Lewis on Art*, 197.

19 *The Caliph's Design*, 139.

20 Christopher Green, *Cubism and its Enemies* (New Haven and London: Yale University Press, 1976), 202.

21 *The Caliph's Design*, 96.

22 *The Caliph's Design*, 133. Fry's statement is cited from 'The Artist's Vision', *The Athenaeum* (11 July 1919), in Roger Fry, *Vision and Design* [1920] (London, Chatto and Windus, 1929), 52.

23 Wyndham Lewis, *Time and Western Man* [1927], ed. Paul Edwards (Santa Rosa, Calif.: Black Sparrow Press, 1993), 287.

24 *The Caliph's Design*, 59–60.

25 Wyndham Lewis, 'Essay on the Objective of Plastic Art in Our Time' (1922), in *Wyndham Lewis on Art*, 205.

26 Hal Foster, 'Prosthetic Gods', *Modernism/Modernity*, 'Wyndham Lewis Number', 4.2 (April 1997). Foster criticizes Lewis's 'inhuman' refusal to regard bodies and machines as discrete, from a contemporary perspective in which the whole topic is no longer worth getting excited about: 'the very terms 'body' and 'machine' seem almost archaic, and they are no longer seen as so discrete' (6). This is slightly baffling.

27 'Prosthetic Gods', 7.

28 'Prosthetic Gods', 31 n5.

29 Foster presents Lewis as a proponent of mechanic fantasies rather than a critic of them.

30 *Wyndham Lewis on Art*, 198.

31 Wyndham Lewis, 'The Children of the New Epoch' (1921), in *Wyndham Lewis on Art*, 195.

32 Wyndham Lewis to John Quinn, 2 May 1921, 'Two Men at War with Time: The Unpublished Correspondence of Wyndham Lewis and John Quinn', Richard and Janis Londraville, *English* 39.165 (Autumn 1990): 241–42. Quinn did not buy the painting; he preferred (French) work that 'has "the smear of the brush" and is painting, whereas yours seems to be more like engineering or metal work', Quinn to Lewis, 22 May 1921, *ibid.*, 243

33 'Ovid's Art of Love: Book 1. Translated', *The Poems of John Dryden*, ed. J. Kinsley, 4 (Oxford, Oxford University Press, 1958): 1778 (lines 1–2). David Peters Corbett, in his perceptive commentary on the painting, regards the Tyros' grins as a form of denial of mourning, symptomatic of the willed cheeriness of British culture of the time. He sees the representation as subliminally evoking images of amputees (the chairback and leg of the stool evoke a crutch and prosthetic leg). Our readings seem to me com-

patible, except that Corbett identifies the Ovid text as *The Metamorphoses*, which tells of 'bodies changed into new forms'. See 'Grief with a Yard Wide Grin: War and Wyndham Lewis' Tyros', *Wyndham Lewis and the Art of Modern War*, ed. David Peters Corbett (Cambridge: Cambridge University Press, 1998), 19–20.

34 '*Ovid's* Art of Love', 1792 (lines 576–86); Lewis quotes the passage in *The Apes of God* (London: The Arthur Press, 1930), 135.

35 Richard Cork interprets the painting as endorsing this perspective of the educated reader: 'They appear to be mocking Ovid rather than reading the text with any attentiveness. Indeed, the emptiness of their fixed grins suggests that they would be incapable of understanding Ovid anyway, and Lewis ridicules their attempt to behave with the dignity of intelligent human beings.' Richard Cork, *Wyndham Lewis: The Twenties* (London: Anthony d'Offay Gallery, 1984), [p.8]. The observation is correct, but I do not believe it can be insulated from an accompanying, and threatening, sense of fellowship with the figures.

36 'I was reminded of Mr Wyndham Lewis by this in *Phoenix* (p. 271): "Wyndham Lewis gives a display of the utterly repulsive effect people have on him, but he retreats to the intellect to make his display. It is a question of manners and manners. The effect is the same. It is the same exclamation: 'They stink! My God, they stink!' The [D. H.] Lawrence who thus places Wyndham Lewis seems to me the representative of health and sanity".' F. R. Leavis, 'The Wild Untutored Phoenix' [1937], *The Common Pursuit* (Harmondsworth: Penguin, 1966), 238. In fact Lewis claimed not to object to body odours (and was himself later sarcastic about George Orwell's fastidious aversion to them). In his own contribution to the robust literary tradition of Ovid and Dryden, *One-Way Song* (1933), he included the confession (unfortunately censored by T. S. Eliot), 'I belch, I drink, I stink'. Lewis, *Collected Poems and Plays*, 37.

37 The potential appeal of the stylisation Lewis invented for his comic grotesques can be seen in the echoes of aspects of the style in later commercial or pop imagery, such as the graphic work of Alan Aldridge in the sixties and the images designed to project a persona for Grace Jones during the seventies. Though Lewis's more abstract work of the period is not discussed here, this work also had an influence on graphic art of the period, especially on the poster art of McKnight Kauffer.

38 See Paul Edwards, 'Wyndham Lewis's *Timon of Athens* Portfolio: The Emergence of Vorticist Abstraction', *Apollo* 148 (October 1998): 34–40.

39 Lewis to Violet Schiff. 10 May 1922, 'Letters of Wyndham Lewis to Sidney and Violet Schiff', ed. Victor Cassidy, *Enemy News,* 21 (Summer 1985): 22.

40 Wyndham Lewis, *The Lion and the Fox* (London: Richards Press, 1927), 16.

41 André Lhote, 'A First Visit to the Louvre', *The Athenaeum* (22 August 1919), 787–88.

42 Heinrich Heine, 'The Romantic School', quoted in 'The Credentials of the Painter' (1919), in Wyndham Lewis, *Creatures of Habit and Creatures of Change, Essays on Art, Literature and Society, 1914–1956*, ed. Paul Edwards (Santa Rosa, Calif.: Black Sparrow Press, 1989), 71.

43 *Wyndham Lewis on Art*, 186.

44 Clive Bell, 'Order and Authority' (November 1919), in *Since Cézanne*, 135.

45 For a summary of the hostile critical reception of 'Tyros and Portraits', see David Peters Corbett, *The Modernity of English Art*, 130.

46 *The Caliph's Design*, 120. Of course, such a hegemony, through Mussolini, soon established itself in Italy and, through Lenin, in Russia. In *Time and Western Man*, 80, Lewis denounced fascism's fake-antique classical revival, although he proposed, in *The Art of Being Ruled*, 'some form of' fascism, as a variant of soviet communism possibly suitable for Britain. Wyndham Lewis, *The Art of Being Ruled* [1926], ed. Reed Way Dasenbrock (Santa Rosa, Calif.: Black Sparrow Press, 1989), 320–21. Lewis's deluded 1931 welcoming of Hitler as 'a man of peace' is outside the scope of this essay.

Foreigners and Fascists: Patterns of Hostility to Modern Art in Britain before and after the First World War

Brandon Taylor

THE RHETORICAL DENUNCIATION of modern art and artists is a familiar phenomenon within the history of the last one hundred and fifty years. But the particular abuses hurled against modern art are nowhere uniform or straightforward. I intend to look in this essay at the metaphors and stereotypes mobilised by what would today be called 'rear-guard' critics before, during and after the First World War, and at how these figures of speech were modulated as they passed from individual to individual and from group to group. The immediate post-war, in particular, turns out to have been a moment of some intensity in the rear-guard camp. With the first flush of British avant-gardist and modern art already past, with British art — or English (the terms were so often interchangeable) — groping to reformulate its sense of identity in the wake of a collapse of confidence in modernist methods, and with the economic crises of the 1920s only a step away, rear-guard opinion had a limited but influential field-day. It should be understood of course that terms 'avant-garde' and 'rear-guard' were not in use at that time, at least not in Britain: they belong to later historical reconstructions of how modernism flourished internationally. Nevertheless, the image of the 'avant-garde' in the minds of the 'rear-guard' contained some persistent features. The stereotype of the young artist as hot-headed and given to extremes is familiar. His further patterning as 'decadent' or 'anarchist' imports a politics into rear-guard thought and belief. The more extreme stereotype of modern art as a virulent disease upon the public body, activated by foreign opportunism and commerce and underwritten by Jews, though attractive to a smaller constituency, proved for a time both durable and effective.

That image, or those images, grew and developed in much earlier circumstances. The very identity of 'Britain' as a nation in the face of foreign commercial and military competition was a question widely articulated, at different levels of society, from at least the 1880s on. Though England had been open to immigration since 1826, the intensity of foreign settlement, especially in London and its East End in the 1880s and 1890s and especially the Jewish arrivals from

Eastern Europe and Russia, aroused a mixture of compassion and apprehension among philanthropists and social reformers alike—compassion on account of poverty and disease, and apprehension on account of the rise of social-democratic or anarchist groupings within the East End population.[1]

In the calmer waters of the West End, a parallel apprehension over the influence of 'foreign' populations within the body of British culture took the form of some violent reactions to French art, particularly Impressionism, which had been shown increasingly in London since the 1870s.[2] Both reactions came to a kind of head in the years 1904–5 in ways that make for comparison. On the one hand, the arrival of Russian and other Jews in their thousands, often perceived as physically weak, without marketable trades, rootless and yet at the same time prone to radical political association, fanned anxieties that ever larger numbers of degraded immigrants would exert a negative influence upon the native workforce and, in effect, constitute a disease at the very heart of the national and consequently the imperial organism. The result was the Aliens Act of 1905 which sought to stem the flow.[3]

The fear of destabilisation by foreigners in the field of the fine arts is best represented through the controversy between 1900 and 1904 over the administration of the Chantrey Bequest. The Bequest, set up by Sir Francis Chantrey in 1840 to encourage 'British Fine Art in painting and sculpture', had formed the main purchasing instrument for contemporary art, but had been used by the Royal Academy to acquire exclusively British paintings and sculptures from Royal Academy Summer exhibitions: artists deemed acceptable to the Bequest had thus far included Joseph Clark, Val Prinsep, Walter Hunt, William Small, P.H. Calderon, Arthur Hacker, George Cockram, Mildred Butler, Alfred Glendinning, Charles Maundrell and Frank Dicksee. The fund had recently purchased *Two Crowns* by Frank Dicksee (fig. 64), a painting distinguished by its glorification of English nationhood and its technical conservatism (note too that it captures a time when Jews were not allowed in England). However, the group of 'New Critics' associated with the New English Art Club and the International Society of Sculptors, Painters and Engravers—among them Frederick Wedmore, R. A. M. Stevenson, Frank Rutter, D. S. MacColl and the young Roger Fry, all of them sympathetic to French Impressionism and some of them (for instance Rutter and Fry) soon to admire French Post-Impressionism—pointed out that the Chantrey fund actually specified the purchase of works 'either already executed or which may hereafter be executed by Artists of *any* nation provided such artists shall have actually resided in Great Britain during

64 F. Dicksee, *Two Crowns*, 1900, oil on canvas (231.1 x 182.3 cm). Tate, London.

the executing and completing of such works'.[4] This could include artists who were French in origin or had French connections and whose work departed significantly from the technical and narrative standards familiar in British Academic work.[5] As D. S. MacColl put it:

> If the Chantrey Trustees are of the opinion that their recent performance in the purchase of Mr Dicksee's Two Crowns (£2000) fulfils the conditions, the view is shared by no critic who has a reputation to lose. The Trust is being administered purely to forward exhibitors in current Academy exhibitions.[6]

The result was a House of Lords Select Committee of Inquiry in 1904, headed by Lord Crewe, that to the chagrin of the traditionalists in the Edwardian art world concluded in favour of the New Critics, altered the terms of administration of the Chantrey Bequest, and effectively opened the path for the establishment at the Tate Gallery in 1926 of a gallery for 'Modern Foreign' art.

Thus while the demands of protectionist British nationalism resulted in fewer Jewish and other immigrants after 1905, in the field of the fine arts a process of gradual institutional modernisation, at the Tate Gallery if not at the Royal Academy itself, was now gradually under way. Yet the New Critics had several vociferous rear-guard opponents, in whose writings the same metaphors of disease, degeneracy and incipient revolution begin to be applied to 'modern' art as some anti-alienists had already applied to immigrant groups themselves. One such was the Essex-born watercolourist Ebenezer Wake Cook, who wrote for the society magazine *Vanity Fair* in 1903–4 and later became art and mental science correspondent of the monarchist journal *The Throne*, before becoming for a time the Honorary Secretary of the Royal British-Colonial Society of Artists: not earth-shattering credentials, perhaps, but enough to gain him a sympathetic following as a rear-guard painter and critic in late-Victorian and early Edwardian London, particularly among the prosperous and the supposedly cultivated by whom *Vanity Fair* and *The Throne* were generally read. 'Ars est celare artem', as Cook put it in one of his articles in *The Throne* ('true art is to conceal art').[7] The point was to decry the explicit display of brushwork and design that occurred in Impressionist art of every type.

It is interesting to note here that positions both pro- and anti-modern art in Britain begin from a perceived tension between the 'low' worlds of mass culture and the potential appeal of high art. Thus Cook's persistent complaint was against the conflation of art and mere novelty, the result of what he believed was an overheated market attitude to art:

The goddess of *Vulgarity* is ousting the modest muse of Painting; and some of the narrowest doctrines that ever gained a moment's credence of the unthinking are preached as saving evangels. Standards are debased that mediocrity may pose as genius, and the untrained as master, at a time when all standards should be raised to exclude the incompetent. A new genius is 'discovered' every month, and the *vocabulary of laudation* is exhausted on works in which the qualities praised are conspicuous by their absence. Decadence is mistaken for progress and 'isms' crop up like mushrooms, and narrow cliquism abounds. *Fads, fudges, and foolish fashions* displace first principles and bewilder the public. In face of this incipient anarchy we drift, drift and drift.'[8]

As a counterweight to 'drift', Cook argued that the Royal Academy, because it stood for the nation, was not only safely above commerce but provided a bulwark against 'anarchy' and 'degeneration' — the latter concept deriving in part from Max Nordau's book of that name, published in English in 1895 and widely read in the conservative camp. The prejudice in favour of foreign and especially French art was fundamentally unpatriotic, Cook now wrote; and in any case, MacColl (perhaps the most powerful voice among the original New Critics) was Scottish and had Scottish sympathies. MacColl had abandoned his role of critic or judge 'and assumes that of advocate, and an advocate plying his functions on the bench is revolting to our British sense of justice and fair play'.[9] Impressionistic surfaces Cook roundly dismisses as 'childish' and 'inept': 'A belief in slap-dash blatant brush-work and suggestive smudges is the main article in the creed of these votaries of decadent "Modernity".' The American-born Sargent revels in 'blatant brushwork, often screens bad drawing, and represents human beings as if born unfinished, with abortive limbs, and vulgarises lady sitters by making them look *painted*.'[10] The reference was to Sargent's bravura society portraits, including those of the family of the wealthy Jewish art dealer Asher Wertheimer, several of which were exhibited at the Royal Academy during Cook's years at *Vanity Fair* (fig. 65).[11] Whistler too had succumbed. Clausen, then Professor of Painting at the Royal Academy, had 'caught the "decadenza" some time ago'.[12] According to Cook, the true genealogy in British art ran from Hogarth to Turner and Landseer through John Martin, 'the most extraordinary genius that ever handled a brush'. As the blight arrived to spoil the fruit of British art, 'cliquism' and 'little Bethelism' had set in, as it was discovered 'that in this advertising age notoriety is cheaper than fame, and carries like emoluments . . . artists are drawn

65 John Singer Sargent, *Ena and Betty, Daughters of Asher and Mrs Wertheimer*, 1901, oil on canvas (185.4 x 130.8 cm). Tate, London.

to producing eye-catching sensations, hence critics may sometimes be touched by nausea and a jading of the faculties' and become 'fooled by Novelty'.[13]

The debate between anti-alienist and assimilationist tendencies—to use the terminology of the immigration debate—necessarily implied competing conceptions of nationhood in the early years of the century. For an anti-alienist like Cook, the nation was a body of undifferentiated Britons confronting a clear choice between stability under the benign guardianship of great institutions, and a degenerate commercialism underwritten by foreign values. His was a conviction that 'deep down in the great heart of the British people there is an instinct for beauty truer than the dangerous "little knowledge" of the pretentious critics'.[14] Yet the modernist assimilationists, while also anti-business and anti-commerce, were disdainful of the patriotic mass. Fry's famous appeal to 'that intense disinterested contemplation that belongs to the imaginative life' is implicitly the contemplation of the adequately sensitive few. 'Ordinary people' (we are supposed to know who Fry means):

> have almost no idea of what things really look like, so that oddly the one standard that popular criticism applies to painting, namely, whether it is like nature or not, is one which most people are, by the whole tenor of their lives, prevented from applying properly . . . Do we not feel that the average businessman would be in every way a more admirable, more respectable being if his imaginative life were not so squalid and incoherent?[15]

Art is redemption in either case, then: for the avant-garde, redemption for the few through form; for the rear-guard, redemption for the many through images of the Beautiful, protected by the Royal Academy under the symbolic tutelage of the King of England. 'We will only find safety', Cook tells his readers finally, 'in electing (to the Academy) men of high ideals whose constituencies are strong enough to resist the malaria of decadence'. Art has given us 'perhaps a truer, and certainly a more gracious revelation of the nature of the True Immanent Spirit of the Universe than is given in the blood-stained history of the Jews'.[16]

It must remain a matter of conjecture who the readers and viewers were who might have been redeemed by these conflicting conceptions of art. Cook's readers at *Vanity Fair* and *The Throne* were clearly comfortably-off, propertied, and no doubt enthusiastic about (in the case of *The Throne* even members of), the British aristocracy right up to, and including, the monarch. Secondly, Cook himself was in his sixties by the time of the *Vanity Fair* articles and must have felt he was speaking for an older sensibility which the younger supporters and

practitioners of modernist art in Britain would wish to displace. Roger Fry's *Manet and the Post-Impressionists* exhibition of 1910–11 elicited further allegations of disease, criminality and madness, not only from Cook, but also from Robert Ross, who, in a long article in the *Morning Post*, drew analogies with Bedlam, Broadmoor, or a rat plague in Suffolk:

> The relation of M. Henri Matisse and his colleagues to painting is more remote than that of the Parisian Black Mass or the necromantic orgies of the Decadents to the religion of Catholics . . . the source of infection [e.g. the pictures] ought to be destroyed.[17]

Mental disorder was also alleged by the academic painters Charles Ricketts and Sir William Blake Richmond, and also in the *Morning Post*. Cook's ally Dr Theo Bulkeley Hyslop, Physician Superintendent to the Royal Hospitals of Bridewell and Bedlam, launched a more insidious tendency in his lecture to the Art Worker's Guild early in 1911, in which he gave voice to a series of earnest accusations to the effect that most Post-Impressionist pictures were guilty of 'shamming degeneration or malingering' in contrast to the 'the true and the natural . . . what is worthy to be portrayed'. Hyslop cited Nordau's description of 'retrogression to beginnings' as 'painted drivelling or echolalia of the brush'.[18]

In the hysterical reaction to Post-Impressionism around 1910–12, it must be said, associations with the Jew are relatively hard to find. The more customary accusation was that Post-Impressionism was 'degenerate . . . like anarchism in politics . . . the rejection of all that civilisation has done'.[19] Indeed Fry himself was later to associate that reaction precisely with the 'cultured' class who could 'speak glibly of Tang and Ming, of Amico di Sandro and Baldovinetti . . . in fact, I found among the cultured [said Fry] . . . the most inveterate and exasperated enemies of the new movement. The accusation of anarchism was constantly made'.[20] It was the cry, in part, of an older generation who had lost the mandate to govern in the Conservative General Election defeat of 1905 and who now clung to protectionist views of the nation and its culture as a time of cultural and political crisis. Succeeding exhibitions, such as Frank Rutter's *Post-Impressionists and Futurists* of 1913, elicited relatively fewer tirades against modernism as such, though the exhibition *Twentieth Century Art: A Review of Modern Movements* at the Whitechapel Gallery in 1914 attracted accusations of a link between 'modernism' and 'Jew', both of course guilty of 'childishness' and 'revolution', in a particularly contradictory way.[21]

Rear-guard opposition to modern art in Britain during the war years,

1914–18, was inevitably complicated by the particular circumstances of the war. The stereotype of the 'foreign' artist as potentially degenerative upon the body of British culture is echoed in the Report of the Curzon Committee, convened to investigate purchasing and display policy at the Tate Gallery in the face of a further surge of advocacy for modern art by the New Critics. In the formation of its new collection, the Curzon Report said in 1915:

> we have not in our mind any idea of experimentalising by rash purchase in the occasionally ill-disciplined productions of some contemporaneous continental schools, whose work might exercise a disturbing and even deleterious influence upon our younger painters.[22]

However, the unique economic, class and social complexion of British avant-gardes at home, such as Bloomsbury and the Vorticist group, now presented a set of additional challenges to rear-guard thought. The particular ruling-class and literary character of the Bloomsbury Group functioned largely to inoculate it from accusations of, at least, serious political subversion — and Bloomsburyites were not aliens.[23] The explicit aggressiveness of the Vorticist group might, however, have been designed with the rear-guard in mind. And competitive career relations, within the Vorticist camp between Wyndham Lewis and David Bomberg or between the Bloomsbury circle and Mark Gertler, demonstrate that hectic moral criticism of radicals could come from within the modern art camp as well as from without.[24] Yet the war years were significant in a more subtle and insidious way, namely in gestating a consensus on the 'radical' right in Britain that would make the pre-war accusations of 'anarchism' and 'decadence' against modern art look mild by comparison. I refer not to the increasingly conventional opposition to Cubist or Vorticist art in the popular press, but to the rise of British fascism and its adoption by members of the British 'cultured' and upper classes.

For this argument we must look outside the world of art to the spread of a belief, particularly regarding areas of high Jewish population such as Leeds or the East End of London, that unconscripted Jews were developing their business careers and would create 'difficulty' after the war.[25] Anti-Semitic literature by staunch ultra-nationalists, such as Leo Maxse's *National Review*, books by the London homeopath Dr. John Clarke such as *The Call of the Sword* (1917) and *England Under the Heel of the Jew* (1918), H. S. Spencer's *Democracy or Shylocracy?* (1918) or Ian Colvin's *The Unseen Hand in English History* (1917) fiercely attacked foreigners and Jews in particular as agents of British decline: Clarke, for example, argued that Britain had degenerated into a 'nation of moneylenders'

that must be 'clear of Shylock's band' (a reference to the banking and broking families of the Rothschilds, Cohens and Montagus), to make way for the reassertion of 'Britain's genius'.[26]

These publications did not directly address modernist or avant-garde art as such. Yet we know that Clarke held anti-Jewish and anti-modernist views because, as a member of the National Vigilance Society, he had raised a storm in 1908 against Jacob Epstein's sculpture cycle on Holden's British Medical Association building in the Strand (the National Vigilance Society had its offices just across the road in Agar Street). In this attack, Clarke had been joined by one Henry Hamilton Beamish, who had worked in Ceylon, Canada and South Africa and who was later to teach Arnold Leese (founder of the Imperial Fascist League). Immediately post-war organisations that articulated a proto-fascist standpoint on politics and culture included Lord Alfred Douglas' short-lived journal *Plain English* and, more significantly, *The Britons*, founded in 1919 by Beamish himself and which published anonymously *The Jews' Who's Who* (1920) and an openly anti-Semitic, anti-Bolshevik, pro-Ku Klux Klan monthly (first issue February 1920) called *Jewry über Alles* (renamed *The Hidden Hand* from September 1920). For these latter groups, the stereotype of the degenerative Jewish presence corrupting British life changed into a far more active representation of scheming international Jewish-Bolsheviks who would destroy world civilisation and in particular the cultural achievements of the British Empire.

Following the Russian Revolution in 1917, the grafting by the Tory right of 'Bolshevism' onto earlier anti-Jewish stereotypes of degeneration and malignancy came almost naturally. The idea of 'Bolshevism' as a sort of political and cultural infection was already part of the mind-set of the British Tory Party. Sir Basil Thompson of Special Branch intelligence, himself a far-right ideologue, explained to the Tory-dominated Coalition Cabinet in 1918 that:

> People who live under the Bolshevik regime describe it as a sort of infectious disease, spreading rapidly, but insidiously, until like a cancer it eats away the fabric of society, and the patient ceases even to wish for his own recovery. A nation attacked by it may, if we may judge from the state of Russia, be reduced to a political and social morass, which may perhaps last for a generation.[27]

Exceptionally vituperative anti-Jewish feeling was now stirred up, in the same month as the first issue of *Jewry über Alles*, by the English publication of the notoriously fabricated *The Jewish Peril: The Protocols of the Elders of Zion*, published first—significantly—by His Majesty's Stationery Office (Eyre and

Spottiswoode) and then reissued by *The Britons* and reviewed enthusiastically in its journal.[28] Although the *Protocols*—which alleged that Jews were plotting to overthrow national governments world-wide—was subsequently shown to be a fake, its appeal to *The Britons*, to *Plain English* and to the other proto-fascist groups which mirrored the British establishment opposition to the Russian Revolution, was immediate and intense.

Thus a wartime shift occurred in the climate of British culture, consisting of a right-wards movement of rear-guard thought in the direction of cultural and political fascism. Outright fascism, it must be said, was relatively rare in Britain in the sense of a 'radical' right-wing movement translating prejudice into organised political violence, crypto or proto-fascist tendencies, drawing room anti-Semitism and ordinary bad manners were always, for the British, more familiar.[29] An important rallying-point for both far-right art criticism and proto-fascist politics, for example, was the *Morning Post*, which had already proved itself sympathetic to attacks on modern art.[30] Under the editorship of Howell Arthur Gwynne (appointed 1911) the *Post* had been instrumental in the generation of the short-lived National Party in August 1917, the party that stood upon 'Reform, Union and Defense' under the leadership of 'men who take their stand upon principle and patriotism, and who set up the standard of a national policy and a purer system of government'—a code meaning 'above party politics'.[31] Owned from 1905 by the militant antifeminist Countess Bathurst, who maintained strict editorial allegiance from its writers and editors, the *Morning Post* had already identified itself with the so-called 'Diehard' wing of the Tory Party and maintained that identification until the newspaper's merger with the *Daily Telegraph* in 1937. In effect, the newspaper forged a position of identity between concepts of 'country' and 'empire' and that of 'Conservative Party'. In the face of a perceived threat from foreign business interests and in fear of 'national impoverishment', the *Morning Post* came to believe that alternatives had to be found to Tory vacillation, the appetites of the masses, continental Communism and British Socialism. In 1920, it enthusiastically endorsed the scare-mongering of the *Protocols*, then printed a series of seventeen articles between 12 and 30 July of the same year elaborating the causes and consequences of the 'hidden conspiracy, chiefly Jewish, whose objects have been and are to produce revolution, communism and anarchy, by means of which they hope to arrive at the hegemony of the world by establishing some sort of despotic rule'.[32] The alliance between the Tory Diehards and the *Morning Post* during Lloyd George's coalition government of 1918–22 was a major source of proto-fascist

Professor MAX GOLDLUST, O.B.E.
And his wonderful Performing Dog,
KOSHER.
(Gold Medal Versailles, Lympne, Spa, &c.)

66 *Professor Max Goldlust, OBE, and his wonderful Performing Dog Kosher, The Hidden Hand*, February 1921.

politics in post-war Britain. Beamish's *The Hidden Hand* was another: two representative cartoons by 'Goy' show Lloyd George being made to jump through hoops by 'Jewish interests' on the one hand (fig. 66), and 'Vestminster' kissing the shoes of Jewish interests on the other (fig. 67). 'Thank heaven there is one daily paper in England sufficiently independent to speak the truth about Jewry' wrote, *The Hidden Hand*. 'We are at war. Jewry is the universal enemy. Every English patriot should subscribe to the *Morning Post*'.[33]

The Hidden Hand's references to artistic culture are irregular, unsystematic and show little curiosity about the varieties of British modernism, but where they do occur they conflate the pre-war and war-time animus against the anarchism and degeneracy of modern art with the figure of the demonised Jew. In January 1923 *The Hidden Hand* published a short article 'Jew Portraits in the National Gallery', claiming mock-ironically that:

"VESTMINSTER," 1921.
This interesting ceremony may be witnessed almost any day.

67 'Vestminster 1921', The Hidden
Hand, August 1921.

there is no more reason why great works of pictorial art, like the Sargent por-
traits of the Wertheimer family (by now destined for the Tate) should be
excluded from the national collection merely because their subjects are Jews,
than that pictures of Negroes, Chinamen or gorillas should be excluded.

and expressing the view that their titles should indicate merely 'A Jew' or 'A Jewess'
in preference to the sitter's real name.[34] *The Hidden Hand* now took up the hunt-
ing cry against Epstein. The erection of Epstein's cycle on the BMA building in
1908 had already caught the eye of the National Vigilance Society (the *Morning
Post*'s offices were only a short distance along the Strand at no. 346), and articles
denouncing the 'vulgarity' of Epstein's statues had appeared within a matter of
days in the London press.[35] By 1920 Epstein was associated by the political right
with artistic 'Bolshevism', Jewish conspiracy and moral subversion.[36] An article
entitled 'Epstein's art and the Learned Elders of Zion', published in *The Hidden*

Hand for February 1924, long after the *Protocols* had been exposed as a fake, now unambiguously implied that Epstein and the critic P. G. Konody—also a Jew—were agents of the Plot, the 'Jew Epstein' making a deliberate attempt 'to influence our English public into admiration of something very different from what it has stamped itself as having admired in the past and so degrading it,' and further, that Epstein's sometime supporter Robert Ross, together with Oscar Wilde, whose tomb in Père Lachaise cemetery Epstein had carved, were sodomites and black-mailers.[37] Something called 'Protocolism' was now rife. In April 1924 a *Hidden Hand* article entitled 'Bolshevist Art and Jew Art Control', written by 'An Artist', launched a broadside against 'the Jew campaign to debase popular taste in art', implicating not only the dealers who elevated art movements from Post-Impressionism to Dada, but international dealers like Knoedler, Seligmann and Duveen, the latter of whom had acquired many works for the Tate and was now involved in the sponsorship of its 'Modern Foreign' and Sargent galleries.[38] Also attacked were the Jewish-controlled Leicester and Goupil Galleries, the Paris dealers of the Rue de la Boetie (Bernheim, Hessel, Rosenberg, Reitlinger), critics like Claude Philips and Konody, Sargent's Wertheimer portraits, Rembrandt, et al:

> Under cover of the names Cézanne, Gauguin, Van Gogh ... we shall see introduced into the museums and held up to the public examples of their more extravagant followers, devoid of talent, conviction or technique—Cubists, Futurists and Dadaists who have brought art to the depths of decadence. There is no doubt that the British public do not like Bolshevist art.[39]

The *Morning Post* itself, though occasionally supportive of art that was genuinely (and narrowly) British, made allegations of lack of good health, mental deficiency, moral abasement, revolutionary politics and Jewishness, mixed into one incompatible and self-contradictory hostility. Its leader 'The Bolshevik in Art' of June 1923 rhetorically asked:

> If the artist does not paint for the public, for whom does he paint? ... Today the walls of picture galleries are defaced with graphic aberrations which are not pictures, and which are not art ... The public ... will not waste their money on futurist, jazz, cubist and other forms of insanity ... The degradation which has befallen British art is appalling to contemplate ... Our Bolshevist practitioners would find it greatly to their benefit of their health to dig in the garden, or break stones, or do anything else in the open air which was both honest and fatiguing.[40]

The Tate in its plans for its Modern Foreign Gallery was 'a dump for work of those addicted to the "isms" of international art anarchy'. Patrons and collectors like Sir Michael Sadler and Lord Henry Cavendish-Bentinck, both of them Jews and modernists, were part of a 'precious bolshie art set'.[41]

The language slides here, fairly effortlessly, from explicitly fascist rhetoric to the proto-fascist tittle-tattle of the far-right daily press. And it shifts again, if not effortlessly then without a major change of gear, to a kind of denunciatory conservatism that is explicitly hostile to modern art and even — here is the proof — reproaches the Royal Academy in the years after the war for being too sympathetic to modern art. That was the position of a further onslaught by Ebenezer Wake Cook, now in his eightieth year and with no overt political affiliations, who in 1924 published a tirade against the Royal Academy of Arts under the Presidency of Sir Aston Webb, tellingly entitled *Retrogression in Art and the Suicide of the Royal Academy.*

Many commentators on Academy exhibitions under Webb's Presidency from 1921 to 1924 had come to the conclusion that the milder lessons of Impressionism, if not Post-Impressionism (certainly not Cubism or Futurism), had been absorbed in England, that a British tradition in the arts had survived the war intact, even amounting to a kind of 'truce' with modern art.[42] For Cook this turn of events was predictably unwelcome. He saw the contemporary situation of British art as even more chaotic and embattled than before, arguing that the real 'Purpose of Art' was to provide 'a great moral uplift . . . as necessary for defence against the awful perils menacing us as the Army, Navy and Air Forces'. As a painter of what he termed 'glorious visions' Cook saw it as his purpose to promote Art as an instrument of Higher Beauty, to 'save the Academy from itself, and to arrest, if possible, the further degradation of some of our Public Galleries'. The reproduction throughout *Retrogression in Art* of Cook's utopian watercolour scenes he intended to demonstrate 'that I have not been working in some old conservative rut, but have striven upwards towards creative freedom, and that modicum of originality which comes of sincerity in self-expression'.[43] The watercolour *Birds of Paradise* of 1924 (fig. 68) shows an Italianate terrace adorned with white, semi-clad or naked maidens amidst carpets, flowers and colourfully exotic birds. Cook's 'visions', at once formulaically removed from history and the modern world, yet erotically suggestive from a narrowly Eurocentric point of view, lay at the antithesis of all of the critical and interpretative ambitions of international modern art and marked Cook as a devotee of 'higher' spiritual philosophy rather than as an anti-Semite or proto-fascist of the *Morning Post* type.[44]

68 E. W. Cook, *Birds of Paradise*, 1924, watercolour, dimensions and whereabouts unknown.

And yet, like *The Hidden Hand* or the *Morning Post*, Cook held that Bolshevism in politics was the counterpart of modernity in art: 'Lenin promised Russia a Heaven', he says, 'and gave it a Hell'. The difference between them was that Russia was aiming to overthrow tyranny, whereas 'the Modernists had nothing to revolt against, and had no promise of better things; theirs was just the anarchical rage of innovation, and the revolt against all authority and established usage which is rampant throughout the world'. The more general disease he termed 'Inversionism':

> When once a person gets caught in the whirl of 'Modernity' he has partaken of 'the insane root that takes the reason prisoner', and 'fair is foul, and foul is fair' to these Inversionists. The pathological aspect of such abnormal tastes is like those cases shown by Dr Soltau Fenwick quoted in the *Morning Post*, where people eat paper, hair, thread, varnish, polish, mud, clay, soot, sand, glass, and live fish. There have been dirt-eating epidemics, as described by Hunter; and the Inversionists who prefer mud to colour, and deformity (bad drawing) to beauty, are equally abnormal. Then there is Satanism and the

69 Augustus John, *Galway, 1916* (1920), oil on canvas (275 x 119 cm).
Tate, London.

Black Mass by the Inversionist in religion; and the burlesquing of all things
hitherto held sacred, by the Bolsheviks in Russia. All these are forms of the
same disease.[45]

What followed was another version of Cook's pre-war rage against Anar-
chism, Nihilism, Syndicalism, Sabotage, New Criticism, and the 'Modernity
Movement'. He could now add that Cubism was 'the art for blockheads'; Futur-
ism merely the latest 'downwards' movement to be supported by critics 'touched
by the general dementia'. Matisse, to complete the catalogue, was 'the most sick-
ening' of the Post-Impressionists, through whose 'whole wild orgy of experiment
there is not one gleam of true and helpful inspiration'. The last word is reserved
for Van Gogh, 'the pathetic tragedy of whose life is piteous beyond words . . . his
works are the *delirium tremens* of art; the poor fellow tried frantically to express
himself in pigment, but he never got much above pavement level'. Cézanne, for
British modernists perhaps the most important single continental artist of all,
was an 'enigma . . . a second- or third-rate still-life painter, and a fourth- or fifth-
rate figure painter . . . a feeble fumbler, verging on insanity', whose reputation

was engineered by 'certain foreign dealers in decadents'. The final disgrace was the election to ARA in 1921 of Augustus John, in Cook's eyes 'one of the most pronounced anti-academic painters' who despite painting well when he felt like it (he seldom did) 'evidently prefers just to dash away, hit or miss', or to descend into patently bad drawing, as in the 'anti-academic, slovenly and faulty in drawing' *Galway* cartoon, then hung in the Tate Gallery (fig. 69).[46]

It may be supposed that such a rear-guard position was not likely to have had many supporters in 1924, except amongst older members of the Royal Academy hierarchy. But the general pace of modernisation in the arts had slowed dramatically. An admiration for Cézanne was becoming a kind of limit upon the most advanced positions in art, witness the early exhibitions of the Seven and Five Society, or the publication in 1922 of Clive Bell's book *Since Cézanne*, not to mention the hesitating acceptance of certain Impressionist and Post-Impressionist methods within the Royal Academy itself. Furthermore the cultural rear-guard was not only alive and well in 1924, but flourished in some very prominent places indeed. I believe it was a short step that separated Fry's 'cultured public [that] was determined to look upon Cézanne as an incompetent bungler, and upon the whole movement as madly revolutionary',[47] and those who felt instinctively that British culture still suffered from the malign presence of foreign and specifically Jewish art. The affair surrounding the relief tablet carved by Epstein for a memorial to the explorer and naturalist W. H. Hudson in Hyde Park is a notorious instance. Supported by Muirhead Bone, Cunninghame Graham and Holbrook Jackson, Epstein had worked on this relief panel, depicting Rima, the heroine of Hudson's book *Green Mansions*, throughout the winter of 1924–25. The furore that greeted the completion of the work united the proto-fascists, the right wing of the Royal Academy and the right wing of Stanley Baldwin's Tory Party as never before.

Several people famously observed 'a shiver run down the spine' of Prime Minister Baldwin as he unveiled the monument in May 1925. The *Daily Mail* screamed for the monument's removal. The *British Guardian* (successor to *The Hidden Hand*) pitched in with more Protocolism, feigning 'surprise' that Epstein was 'apparently the only "artist" who can be found to commemorate adequately the nature-loving Hudson'. The 'expert' support given to Epstein by Konody and Wilenski, it said, was 'entirely Jewish and anti-Christian and is all part of the deliberate plot to destroy Christian culture'.[48] Questions were asked in the House of Commons where, though Epstein's panel was defended by Lord Henry Cavendish-Bentinck, one Lieutenant-Colonel James rhetorically asked

FOR THIS RELIEF NOT MUCH THANKS.

Epstein's Female. "KAMERAD!"
Gilbert's Eros. "I THINK NOT."

70 Sir Bernard Partridge, *For This Relief Not Much Thanks, Punch,* 3 June 1925.

the under-secretary of State for the Home Office (representing the First Commissioner of Works) whether he was aware that the sculptor, 'owing to inadequate knowledge of the English language, thought he had to produce a sculpture dealing with birds, and has erected a scarecrow?'. Sir W. Davidson said that 'this panel shows a deformed female figure, with elephantiasis of the hand'.[49] The traditionalist *Punch* cartoonist Sir Bernard Partridge provided an unusually—for *Punch*—bitter cartoon on 3 June 1925, showing Rima under attack from Alfred Gilbert's more traditional *Eros*, conversation between the two now coded with reference to the degeneracy of foreign cultural imports. 'Kamerad', calls out Rima, to which Eros replies testily 'I think not' (fig. 70).[50]

The debate dragged on through the remainder of 1925. In the Commons, Basil Peto MP, formerly a member of the far-right Unionist Business Committee and soon to join Lord Sydenham's India Defense League and the India Empire Society, pressed for the sculpture's immediate removal, insisting that 'it be not re-erected in any other public place in the country': 'Can the Honourable

Member say whether this work of art belongs to the nation, and if so, whether he will consider the advisability of offering this specimen of Bolshevist so-called art to the Soviet Government of Russia?'[51] In November the matter flared again. The *Morning Post* now published a letter over the signatures of Sir Frank Dicksee, now President of the Royal Academy, Sir Bernard Partridge, Hilaire Belloc, Alfred Munnings, Arthur Conan Doyle and others stating that Epstein's design was:

> by universal consent so inappropriate and even repellent that the most fitting course open to the authorities would be to have it removed bodily. It would be a reproach to all concerned if future generations were allowed to imagine that this piece of artistic anarchy in any way reflected the true spirit of the age.[52]

Messrs Davidson and Peto spoke again in the House (23 November). The *Morning Post* fanned the flames. On 7 December it was reported in the Commons that 'damage by green paint' had occurred to Epstein's panel. Only by dint of sober support in *The Times*, petitions from students of the Royal College of Art and the Slade, and a lengthy and brilliant memorandum to Viscount Peel, First Commissioner of Works, from Muirhead Bone, did the memorial survive.[53]

The Rima episode is important in having focused at least three quite distinguishable rear-guard attitudes to British modernism in the mid-1920s. Stanley Baldwin's 'shiver down the spine' can be taken to express — almost too viscerally — a 'love of England' position associated with a 'common-sense' patriotism of the English middle classes, a position which regarded foreigners with suspicion but which had no overt relation with the radical right. Baldwin held views which grew out of, and endorsed, his Worcestershire countryman's optic. As pressure for a General Strike grew in the early spring of 1926, at the dinner of the Royal Society of British Sculptors he expressed the hope that English towns and the countryside:

> should be permanently beautified by whatever art in its proper place has to offer, and that art should be our native British art. I hope (he went on), in spite of some evidence to the contrary, that we may pass through that curious snobbish subjection to foreign names and tastes which has been rife in this country so long.[54]

As his speech 'England' would soon make clear (it was to be published to popular acclaim before the General Strike and became a staple of popular patriotism right up to the eve of the Second World War):

There are chronicles . . . who said it was the apeing of the French manners by our English ancestors that made us the prey of William the Norman, and led to our defeat at Hastings. Let that be a warning to us not to ape any foreign country. Let us be content to trust ourselves and to be ourselves.[55]

However other signatories to the anti-Epstein letter were known for their proto-fascist views. Hilaire Belloc and Alfred Munnings were already aligned. The third figure, Sir Frank Dicksee, aged seventy-two at the time of the incident and now entering an influential phase of his career, was both emotionally and professionally anti-Semitic. Elected PRA in 1924 with a mission to reverse the partial modernisation of the Academy under Aston Webb, Dicksee turned to address his Academy students on Founder's Day, 10 December 1925 with a motley of white supremacist sentiments and warnings about 'degeneracy'. Identifying 'true' art with 'inner spirit' and cleaving to a standard of 'absolute beauty' derived from classical and high Renaissance principles, Dicksee told his students that contemporary artistic 'primitivism' came from the cave-dwellers to find its expression in the modern 'foreign' art of Van Gogh and Cézanne. 'You of the British race', he told them, 'do not consent to be dragged by the heels behind continental dealers . . . the best works of art of the past are surely better guides than those false prophets who, cry aloud to Baal'. 'Our ideal of beauty must be the white man's', Dicksee fulminated:

> the Hottentot Venus has no charms for us, and the elaborate tattooing of the New Zealand Maoris does not, to our thinking, enhance the beauty of the female form; so in spite of some modern tendencies, if we have to bear 'the white man's burden', in Heaven's name let us at least keep his ideals![56]

Both the tone and the content of Dicksee's advice unmistakably suggest familiarity with the ideals of the British Fascisti, formed in 1923 and from 1924 known as the British Fascists, with its publications *British Lion* and *Fascist Bulletin* and a series of high-profile meetings in London in the mid-1920s. German fascism was still in its infancy in 1925, yet particular kinds of sympathy between the British and Italian Fascists were frequently advertised in these journals and elsewhere: impatience with democratic politics; a sense that the Conservative party was weak and indecisive; a tendency to racial intolerance and the beginnings of a tendency to organised political violence such as the BF's formation of 'Q' divisions of 'young and able-bodied men of pure British race'.[57] Aesthetically, British Fascists decried the sullying of British or Ayrian ideals of beauty and the

organised spread of modern art and literature by foreigners generally, and by Jews in particular, perpetuating the pre-war and war-time discourses against 'degeneracy' and 'disease', but now elevating them and translating them finally into politically active form.

Dicksee's paintings had consistently promoted images of the brooding or triumphant male, moodily fantasising dreams of power and glory against a world torn by frivolity and 'low' concerns; his earlier *Two Crowns* showed a Christian knight from the middle ages, gazing at Christ's thorns. His *End of the Quest* of 1921 (pl. VIII) is representative of his post-war work. The painting contains a pilgrim treating a beautiful young maiden as his shrine, an image glowing with the self-discipline of chastity and constructed according to the compositional formulae of the Italian Renaissance. Now, at the height of his influence in the British cultural rear-guard, Dicksee could be candid with his students: 'Deviating from nature' was unwholesome, morbid; the new order of beauty 'founded on a Negroid or other barbaric type' was an 'unclean presence', he said, a 'miasma' that had been 'spread around and from which it is difficult to escape — it affects the temperature, and in the sum of things lowers the average'.[58] According to Gladys Storey, daughter of the Royal Academician G. A. Storey and confidante of Dicksee's, Dicksee told her that he, Dicksee 'was an admirer of Mussolini, and was himself a Fascist'.[59]

A final circumstance, and one that requires much further examination, is the place occupied in the cultural rear-guard by the British monarchy. History may record the verdict that the 1920s and 1930s was a time when the strong identification between the monarch, a backward-looking Tory party, and a possibly proto-fascist account of culture reached its apogee. The monarch's role within the British art establishment had expanded rapidly throughout the nineteenth century to the point where the 'Royal' imprimatur had become attached to the Royal Society of Painters in Watercolours, the Royal Society of British Sculptors, the Royal British-Colonial Society of Artists, and several other bodies, in addition to the Royal Academy. However the early twentieth century saw a marked decline in the level of the monarch's cultural *savoir-faire* at least by comparison with that acquired and manifested by Queen Victoria and the Prince Consort. As Ross McKibbin convincingly argues in a recent book, the decline began with Edward VII, notwithstanding his wide and varied social circle, which included (to the consternation of some) many prominent Jews. However the court of George V (1910–36), far from maintaining continuity with the cultural ambitions of his predecessors, saw a 'real narrowing of its social and intellectual

range'.[60] Poorly educated, without foreign languages or worthwhile experience of art, both he and his two successors Edward VIII (1936) and George VI (1936–52) absorbed and reproduced the cultural attitudes of the landed-gentry-with-military-connections milieu which they for the most part inhabited: 'they learnt not much more than an average officer of the Armed Forces at the time would have been taught and what they picked up along the way'.[61] A predictable round of Sandringham, Ascot, Cowes, and Balmoral was George V's unpromising milieu. Anything abroad he considered 'bloody'.

The presence of the King or his representative at the art establishment's annual dinners underpinned in the eyes of 'society' and the wider public alike the sympathy between the monarch and conservative, nationalist and high-Tory accounts of culture in the visual arts, and provided a justification, within aristocratic society in Britain, for a far-right antipathy to modern art that continued for many decades. Whilst it is true that George V dutifully performed the opening in June 1926 of the Tate Gallery's 'Modern Foreign' and Sargent wing, sponsored by a meritocracy consisting of Duveen, Samuel Courtauld, Sir Michael Sadler and others, his real sympathies quite evidently lay elsewhere. As an emblem of its pact with King and Country, the Royal Academy President followed a tradition of executing a 'common portrait' of the reigning Sovereign to hang in the Council Room at Burlington House, and frequently acknowledged its Royal patronage by the prominent display of portraits of the royal family at its annual exhibitions—such as the portrait of George V painted by Keeper of the Academy Charles Sims and displayed at the 1924 Academy exhibition to general rear-guard acclaim (fig. 71).[62] The ordered, powerful, landed-gentry culture of the King's court—soon to be widely admired by Hitler and arguably imitated by him in the ceremonial paraphernalia of the Third Reich—was simultaneously celebrated by that other artist with a particular animus against modernists and Jews, Alfred Munnings (fig. 72) whose later conflicts with the Jewish Konody, Eric Newton and John Rothenstein would occupy a further chapter.[63] The political and cultural naivety of George V's successor Edward VIII, finally, and in particular his infatuation with the Nazi Party from the late 1920s until and beyond the abdication crisis of 1936, would on present evidence make the rear-guard attitudes of Baldwin, the Tory right and even Frank Dicksee look innocuous by comparison.[64]

Antipathy towards foreigners and Jews within the different strata of the British art world has had a long and inglorious history. Though it may be correct to say with Gerry Webber, that the radical *political* right in Britain in the 1920s

71 Charles Sims, *His Majesty King George V*, 1924, oil on canvas (281.9 x 200.6 cm), destroyed.

72 Alfred Munnings, *The Return from Ascot*, 1925, oil on canvas, (148 x 244.5 cm). Tate, London.

suffered from an 'inability ... to find a distinct, stable and sizeable' 'constituency' whose interests they could reasonably and exclusively claim to represent the case of the visual arts is nowhere so clear.[65] Though the British avant-garde revived itself in the later 1920s and the following decade, a rabid anti-Semitic conservatism lingered on in Britain at least until 1946, the date of publication of *Addled Art* by Munnings' fascist ally the Australian journalist Lionel Lindsay.[66] Only by that time, perhaps, can it be said that the worst excesses of British rear-guard opinion in the arts had had their day.

I must thank David Peters Corbett, Ysanne Holt, Robert Radford and Juliet Steyn for guiding me to important revisions of an earlier draft of this paper.

1 See W. J. Fishman, *East End Jewish Radicals, 1875–1914* (London: Duckworth 1975), and D. Feldman, *Englishmen and Jews: Social Relations and Political Culture 1980–1914* (New Haven: Yale University Press, 1994).

2 An anthology of responses is K. Flint, ed., *Impressionism in England: The Critical Reception* (London: Routledge, 1984).

3 On the Aliens Act see D. Feldman, 'The Importance of Being English: Jewish Immigration and the Decay of Liberal England', in D. Feldman and G. Stedman Jones, eds., *Metropolis, London: Histories and Representations since 1800* (London, 1989, 2nd ed. 1951, Bell), 56–84.

4 'Extract from the Will of Sir Francis Chantrey', in W.R.M. Lamb, *The Royal Academy: A Short History of its Foundation and Development to the Present Day* (London: 1935), 190. My emphasis.

5 See D.S. MacColl, *The Administration of the Chantrey Bequest: Articles Reprinted from 'The Saturday Review' with additional matter, including the text of Chantrey's Will and a list of purchases* (London: Grant Richards, 1904).

6 MacColl, *The Administration of the Chantrey Bequest*, 14. The Dicksee painting was purchased in 1900. MacColl pointed out that Whistler's *Portrait of His Mother* had gone to the Luxembourg 'at a price beggarly compared with the standard of the Chantrey Trustees' (12). It had cost the Luxembourg £190, in 1892.

7 *The Throne* 1.19 (29 Sept 1906): 24. *The Throne*, a lavish publication even by Edwardian standards, was explicitly aimed at the nobility, and in its mixture of court gossip, foreign travels, property, drawing rooms, gardening etc, was the forerunner of modern publications like *Country Life*. As well as art, Cook also wrote on 'metaphysical healing'.

8 E. Wake Cook, 'The Situation', in his collection from *Vanity Fair* entitled *Anarchy in Art and Chaos in Criticism* (London: Cassell, 1904), 9. My emphases. For a general statement of the early relationships between commerce and modernist art in France, see T. Crow, 'Modernism and Mass Culture in the Visual Arts' in B. Buchloh, S. Guilbaut, D. Solkin, eds., *Modernism and Modernity* (Nova Scotia: Press of Nova Scotia College of Art and Design, 1983), 215–64.

9 Cook, *Anarchy in Art*, 29.

10 Cook, *Anarchy in Art*, 18, 36.

11 The problem of the 'Jewishness' of the Wertheimer portraits is acutely analysed in K. Adler, 'John Singer Sargent's Portraits of the Wertheimer Family', in *The Jew in the Text: Modernity and the Construction of Identity*, ed. L. Nochlin and T. Garb (London: Thames and Hudson, 1995), 83–96.

12 Cook, *Anarchy in Art*, 58.

13 Cook, *Anarchy in Art*, 11, 10, 12.

14 Cook, *Anarchy in Art*, 49.

15 The phrases are from Roger Fry 'An Essay in Aesthetics', *New Quarterly* (London: 1909); rptd. in *Art in Theory 1900–1990: an anthology of changing ideas* ed. C. Harrison

and P. Wood (Oxford: Blackwell, 1992), 81, 86, 80. For a wider argument about modernist art and literature and disdain for the masses, see J. Cary, 'Intellectuals and the Masses', in *Art in Theory*.

16 Cook, *Anarchy in Art*, 37, 61.

17 R. Ross, 'The Post-Impressionists at the Grafton: The Twilight of the Idols', *Morning Post* (7 November 1910), 3, reproduced in *Post-Impressionists in England: the Critical Region*, ed. J. B. Bullen (London: Routledge, 1998), 100–4. For the Ricketts and Richmond references see *Post-Impressionists in England*, 106–8, 114–17.

18 For Hyslop's lecture, see *Post-Impressionists in England*, 209–22, rptd. from *Nineteenth Century* (February 1911), 270–81.

19 Review of 'Manet and the Post-Impressionists', *The Times* (7 November 1910), 12, cited in A. Greutzner Robins, *Modern Art in Britain, 1910–1914* (London: Barbican Art Gallery, 1997), 16.

20 R. Fry, 'Retrospect', in *Vision and Design* (1920; Harmondsworth: Pelican, 1937), 227–28.

21 This is the reading established by J. Steyn, 'Inside-Out: Assumptions of 'English' Modernism in the Whitechapel Art Gallery, London 1914', in M. Pointon, ed., *Art Apart; Art Institutions and Ideology across England and North America* (Manchester: Manchester University Press, 1994), 212–30. For a series of earlier connections between both radicalism and madness and the Jew in Germany, see Sander Gilman, *Difference and Pathology: Stereotypes of Sexuality, Race and Madness* (Ithaca and London: Cornell University Press, 1985).

22 *Report of the Committee of Trustees of the National Gallery* (London: 1915), 26.

23 For the ruling-class character of Bloomsbury culture see N. Annan, 'The Intellectual Aristocracy', in J. H. Plumb, ed., *Studies in Social History: a Tribute to G. M. Trevelyan* (London: Longmans, Green and Co., 1955), and R. Williams, 'The Bloomsbury Fraction', in *Problems in Materialism and Culture: Selected Essays* (London: Verso, 1980), 148–69.

24 For the former, see D. Peters Corbett, ed., *Wyndham Lewis and the Art of Modern War* (Cambridge: Cambridge University Press, 1998); and for the latter, J. Woolf, 'The Failure of a Hard Sponge: Class, Ethnicity, and the Art of Mark Gertler', *New Formations* 28 (Spring 1996): 46–64.

25 C. Holmes, *Anti-Semitism in British Society, 1876–1939* (London: Edward Arnold, 1979), 135.

26 J. H. Clarke, *The Call of the Sword* (London, 1917), 21–22, 26; Holmes, *Anti-Semitism in British Society*, 139.

27 PRO Cabinet Papers, series 26 & 27, report from Sir Basil Thompson of the Special Branch, 21 October 1918; cited in G. Lebzelter, *Political Anti-Semitism in Britain* (London, 1973), 16 and n16, 181. The young Winston Churchill would soon write furiously about an alleged pact between Bolsheviks and a 'formidable sect' outside Russia conspiring to overthrow civilisation, including Bela Kuhn, Rosa Luxembourg, and Emma Goldmann; see W. S. Churchill, *Weekly Dispatch* (22 June 1919); 'Zionism versus Bolshevism', *Illustrated Sunday Herald* (8 February 1920).

28 *Jewry über Alles* (February 1920), 3–4; Holmes, *Anti-Semitism in British Society,* 148.

29 C. Harrison, *English Art and Modernism, 1900–1939* (New Haven and London: Yale University Press [1981], 1994), 157, 167.

30 For a discussion of proto-fascism see Roger Griffin, *The Nature of Fascism* (London: Routledge, 1991), 202–17.

31 Leading article, *Morning Post,* 30 August 1917. For a history, see K. M. Wilson, *A Study in the History and Politics of the Morning Post, 1905–1926, Studies in British History,* Vol. 23 (Lewiston: The Edwin Mellen Press, 1930), ch. 5.

32 The articles were reprinted as *The Cause of World Unrest* (1920), ed. H. A. Gwynne; this passage from the editor's introduction, p.viii. Victor Marsden, himself St Petersburg correspondent of the *Morning Post,* translated the *Protocols* under the title of *Protocols of the Learned Elders of Zion* (1924).

33 *The Hidden Hand* (February 1921), 4. Journals such as *Plain English,* or lobbies such as the Middle Classes Union, launched attacks upon 'the rapacity of the manual worker and profiteer', in other words the Jew; for these and other organisations, see G. C. Webber, *The Ideology of the British Right 1918–1939* (London and Sydney: Croom Helm 1986), Appendix. However support by the 8th Duke of Northumberland for the Diehards in their revolt against the Chamberlain wing of the Tories in 1921–22, and more particularly his founding of the Boswell Press in 1921, provided another forum for anti-semitic opinion when he began publishing *The Patriot* in February 1922. *The Patriot* attracted declared anti-Semites such as Ian Colvin, Nesta Webster and Lord Sydenham, and followed news of the progress of the Italian Fascisti with enthusiasm. Like the Loyalty League (founded in October 1922 at the time of the Carlton Club revolt) which claimed that 'even at this late date the greater part of English men and women is incredibly unaware that the Empire totters literally on the ultimate edge of an unfathomable abyss' (letter to *The Patriot,* 19 October 1922, p. 174, by G. Dent), *The Patriot* was fanatically opposed to Jews, foreigners and Trade Unionists, whether at home or from abroad, and believed that Lloyd George was an unreliable partner whose foreign policy, in Ireland particularly, would ruin the Empire.

34 *The Hidden Hand* vol. 3, no. 12 (January 1923), 3.

35 J. Epstein, *Let There Be Sculpture* (London: Michael Joseph, Readers Union edition, 1942), 2–41 and Appendix I, 233–46. The BMA murals affair is the subject of R. Cork, *Art Beyond the Gallery in Early Twentieth Century England* (New Haven: Yale University Press, 1985), ch. 1. For further anti-Epstein journalism, see T. Friedman, 'Epsteinism', in *Jacob Epstein: Sculpture and Drawings* (Leeds: W. S. Marey and Son, in association with the Henry Moore Centre for the Study of Sculpture, 1989), 35–43.

36 See for example Father Bernard Vaughan's article in *The Graphic* (14 February 1920), reproduced in *Let There Be Sculpture,* 106–7.

37 *The Hidden Hand* 5.2 (February 1924), 22–23.

38 The origins and planning of the gallery are the subject of my *Art for the Nation: Exhibitions and the London Public* (Manchester and New York: Manchester University Press, 1999), ch. 5.

39 *The Hidden Hand* 5.4 (April 1924), 57.

40 *Morning Post* (14 June 1923), 8.

41 *Morning Post* (16 August 1923).

42 See D. Peters Corbett, *The Modernity of English Art, 1914–30* (Manchester and New York: Manchester University Press, 1997), especially ch. 2, 57–99. Talk of a 'truce' is from J. Middleton Murray's 'English Painting and French Influence', *The Nation* (31 January 1920), cited in Corbett, 67.

43 E. W. Cook, *Retrogression in Art and the Suicide of the Royal Academy* (London: Hutchinson and Co., 1924), viii, vii.

44 Cook's adherence to the Harmonial Philosophy of Andrew Jackson Davies and his book *The Principles of Nature, Her Divine Revelations with a Voice to Mankind*, parts of which were published as *The Harmonial Philosophy: A Compendium and Digest of Hermetic Science* (London: 1917) stimulated in Cook the pursuit of what he conceived as beauty 'infinitely too large for its diminutive — prettiness'; see Cook, *Retrogression in Art*, 84

45 Cook, *Retrogression in Art,* 37.

46 The trouble had arisen in France, with Manet, 'whose contribution to art was chiefly vulgarity' and whose Olympia was 'an ugly little courtesan lying naked on a bed, her white chalky flesh relieved against a very dark background, and it screams out like a bad poster', Cook, *Retrogression in Art*, 11, 15, 18, 19, 50.

47 Fry, 'Retrospect', 228.

48 *British Guardian* 6.15 (12 June 1925), 2.

49 *Hansard* (25 May 1925), Col. 966.

50 *Punch* (3 June 1925), 603. Appearing so soon after the unveiling, the cartoon seems to appeal to a readership already familiar with the incident from other sources: the circulation of the *Daily Mail* at this date was 1,800,000 and that of the *Morning Post* about 60,000; see *Newspaper Press Directory* (1923), 485, and Wilson, *History and Politics of the Morning Post,* 169.

51 *Hansard* (21 July 1925), Col. 2009, 2010, p. 67.

52 *Morning Post* (18 November 1925), and 'Take It Away' [leader], p. 12; see the account in Epstein, *Let There Be Sculpture,* 112–13.

53 Reproduced in Epstein, *Let There Be Sculpture,* 263–70.

54 S. Baldwin, 'Among Sculptors', speech delivered at the Dinner of the Royal Society of Sculptors, 25 February 1926, in *Our Inheritance: Speeches and Addresses by the Rt. Hon Stanley Baldwin, MP* (London: Hodder & Stoughton, 1928), 244.

55 S. Baldwin, 'England' in *On England, and other addresses* (London: 1926), 2.

56 F. Dicksee, *Discourse, delivered to the Students of the Royal Academy on the Distribution of the Prizes, 10 December 1925* (London: William Clowes and Sons, 1925), 16, 14, 13.

57 *Fascist Bulletin* (25 July 1925). I am indebted here to K. Lunn, 'The Ideology and Impact of the British Fascists in the 1920s', in T. Kushner and K. Lunn, eds., *Tradition and Intolerance: Historical Perspectives on Fascism and Race Discourse in Britain* (Manchester: Manchester University Press, 1989), 149, who speculates that 'Q' divisions were the forerunners of the British Lion Patriots, in the words of the *British Lion*, 'uniformed and seeking trouble'.

58 F. Dicksee, *Discourse, delivered to the Students of the Royal Academy,* 14–15.

59 G. Storey, *All Sorts of People* (London: Methuen and Co Ltd., 1949), 208.

60 R. McKibbin, *Classes and Cultures: England 1918–1951* (Oxford: Oxford University Press, 1998), 3.

61 McKibbin, *Classes and Cultures,* 3.

62 This painting was done by Sims as Keeper in lieu of one by Aston Webb, an architect. However the portrait proved unpopular with both the King himself and many sections of the press: in particular 'the legs were held to lack royal substance' (Charles Sims, *Picture Making; Technique and Inspiration* (London: Seeley, Service, 1934), 126). Frank Rutter thought that Sims, with his 'disposition to dwell in fairyland', had turned George V 'into a fairy King' (Rutter, *The Little Book of the Royal Academy,* 1924, cited in *The Edwardians and After: the Royal Academy 1900-1950* (London: Royal Academy 1988), 145). Fourteen months later Dicksee became President and after a visit to Buckingham Palace had to inform Sims that the portrait was 'giving offence' (Sims, *Picture Making,* 126), such that Sims, by this time in America, ordered it to be burnt. Due largely to this and other clashes with the traditionalists, Sims committed suicide in 1928. For the position of Sims in the 1920s, see Corbett, *The Modernity of English Art,* 200–8.

63 See Munnings' own account in *The Second Burst* (London: Museum Press 1951), 146–59, 268–77. It is of course significant that the *Morning Post,* in reporting that Munnings' portrait of the Prince of Wales would be hung at the Academy, reminded its readers that the portrait would be hung 'with the sanction of the King'. The *Morning Post* continued: 'The words in italics are particularly interesting. They may be meant as a reminder that the Royal Academy is still as much the King's Academy as it was when its founder, George III, called it "my Academy"', *Morning Post* (7 June 1921).

64 Hitler's infatuation with the British aristocracy is well portrayed in Michael Ryan and Jonathan Ruffle's *Edward VIII: The Traitor King,* Channel 4, 1995.

65 G. C. Webber, 'Intolerance and discretion: Conservatives and British fascism, 1918–1926', in *Traditions of Intolerance: Historical perspectives on fascism and race discourse in Britain,* ed. T. Kushner and K. Lunn (Manchester: Manchester University Press, 1989), 165–66.

66 This miserable publication is L. Lindsay, *Addled Art* (London: Hollis and Carter, 1946), from which the following passages are representative: 'Modernism in art is a freak, not a natural, evolutional growth. Its causes lie in the spirit of the age that separates this century from all others: the age of speed, sensationalism, jazz, and the insensate adoration of money. No great art was created in a hurry, or at the behest of market-rigging dealers … Think of what deformations mean in life … the clubbed foot, the withered hand, the horror of elephantiasis — and you will not be long in seizing the decadent and nihilistic value of this phase of modernism. Natural man, guided by a profound instinct, destroys the weak and malformed at birth' (15,42).

Equivalents for the Megaliths: Prehistory and English Culture, 1920–50

Sam Smiles

IN OCTOBER 1937 Barbara Hepworth held a solo exhibition in London at the Alex Reid and Lefevre gallery. The work she showed there marked the first major public evidence of her turn towards an abstract sculptural aesthetic and it is customarily taken as an example of the maturing of British Modernism towards the close of the 1930s (fig. 73). Hepworth's exhibition took place at the peak of that abstract and constructivist activity celebrated in exhibitions such as *Abstract and Concrete* at the Lefevre Gallery, and *Modern Pictures for Modern Rooms* at the show-rooms of the furniture company Duncan Miller, Ltd in London (both of 1936), the London Gallery's *Constructive Art* exhibition (1937) and the publication of *Circle* (1937).[1] Alongside the development of International Style architecture and the improvement of industrial design, it seemed as though a genuinely modern culture was at last beginning to emerge in Britain.

Hepworth's exhibition catalogue included a foreword written by Desmond Bernal, a Cambridge University crystallographer who also contributed the essay 'Art and the Scientist' to *Circle*.[2] Hepworth valued Bernal's ability to articulate the constructive idea that she could only express intuitively in her work.[3] She believed, furthermore, that his insightful criticism would support that idea against public hostility.[4] Bernal agreed to provide the foreword but what he wrote was a peculiar mixture of formal analysis and cultural speculation. His essay begins:

> The first impressions of the present exhibition suggest very strongly the art of the Neolithic builders of stone monuments . . . Nor is the analogy entirely superficial. Neolithic art with its extreme formalism does not represent a primitive stage in the evolution of art, but an apparent step backwards away from the admirable and living representations of the art of the Cave painters. This backward step is illusory, for Neolithic art is highly sophisticated and expresses the realisation that important ideas can be conveyed by extremely limited symbolic forms: that it is unnecessary to fill in details as long as general intentions are realised.[5]

73 Barbara Hepworth, *Single Form* in Plane Wood (1937) height 167.7 cm. Reproduced in *Axis* 8, Early Winter 1937, subsequently destroyed by the artist. © Alan Bowness, Hepworth Estate.

Bernal then suggests that Hepworth's simplification of form, when compared to her Victorian predecessors, exists in the same relation: an apparent step backwards which is, in truth, a highly sophisticated understanding of the communication possible using a reduced formal vocabulary. As a scientist, he enjoys the way in which the underlying geometry of her art is made visible by reducing sculptural volumes to elementary shapes and combinations of shapes, how the viewer is made aware of subtle differences of surfaces and materials. But for Bernal, evidently, this comparison of Hepworth's carvings with the Neolithic is more than formal. As we have seen, he characterised Neolithic art as using extremely limited symbolic forms to convey important ideas. The question naturally arose whether Hepworth's sculptures did the same:

> The historic associations and geometric significance of Miss Hepworth's work both raise the question of its general significance at the present time now that the particular form that art takes is becoming a matter of acute controversy and even an affair of state.[6]

Bernal concludes that abstract art cannot exist in a vacuum and requires a public setting, much as Neolithic art served its creators' collective ritual needs, and to this end he recommends the integration of abstract sculpture with modern domestic architecture.[7] These sentiments owe a great deal to the fact that Bernal was a Marxist who believed strongly in the utility of culture for the common good, and his writings on the history of science are marked by his insistence that the productive use of the human intellect will liberate all sections of society from intolerance, economic disadvantage and repression.[8] In *Circle* he was emphatic that art needed to escape the cash nexus and become 'a powerful part of the social movements of the time':

> Socially art is not complete unless it passes from the solution of problems to something of more immediate social utility. The artist at the moment is in his work necessarily divorced from organic social expression, simply because in our civilisation there is practically no vehicle for such expression ... but this does not mean that nothing can be done. Even a civilisation in a state of transition must be able to find expression through its arts for the struggles that are going on. The expression need not, in fact should not, take the obvious and hackneyed forms of revolutionary art. Nor, on the other hand, can it be left to the artists in isolation to discover what form it should take ... How

to end this isolation and at the same time preserve the integrity of their own work is the main problem of the artist of today.[9]

Bernal's recommendation for the union of Hepworth's sculpture with modern domestic architecture is thus a partial answer to the question he had recently posed in *Circle*.

To champion Hepworth, however, and to do so by recourse to Neolithic comparisons was not necessarily an orthodox move within British Marxism. More characteristic were demands for a form of realism appropriate to twentieth-century concerns. As Anthony Blunt declared, when reviewing Hepworth's exhibition:

> it is hard to see what relevance the refined aesthetic treatment of problems, which seem to have been a matter of religious convenience to Neolithic man, can have at the present time. The study of primitive arts has supplied new aesthetic blood to sculpture during this century, but at the moment it is not new aesthetic blood that is wanted, but a revitalisation of art by contact with life. To praise Miss Hepworth's sculptures seems to me like saying that a man is a good orator because the shapes which his mouth makes when he speaks are aesthetically satisfying.[10]

Blunt's hesitations concerning primitivist tendencies in modern art were shared by others on the left. In a debate led by Alick West at Marx House in 1935 primitivism, especially the appeal of African art, was analysed as an indicator of the crisis of capitalism. Primitive art, seen positively, promises to restore an emotional life which has atrophied under capitalism; seen negatively it is 'a flight into a more primitive way of thinking, is despair at the intellectual contradictions in a time of economic crisis which capitalism is unable to solve'.[11] Given such an analysis, Epstein and Gill's plans for a modern Stonehenge in 1910 and both Hepworth and Moore's early maturity as sculptors might have been characterised as a product of this same despair.

What unites Bernal's and Blunt's interpretations is their recognition that abstraction has a tangential relationship with direct social engagement; both see it as creative isolation which needs to end, but Bernal, unlike Blunt, refuses to sacrifice artistic integrity on the altar of revolutionary purpose. This debate was of importance to the left. In 1935 the Artists International Association had published *5 on Revolutionary Art*, a book of essays by Francis Klingender, Herbert Read, Eric Gill, A. L. Lloyd and Alick West. In discussing abstract art, Read, and especially Klingender, characterised it as a form of pure, quasi-scientific research,

which is essentially sterile until put to work. Thus, although the AIA itself made common cause with artists from across the spectrum, exhibiting abstract, Surrealist and realist work in exhibitions against Fascism, the British left's critical and intellectual position was much less accommodating to Surrealism and abstraction.[12] Bernal's impatience with 'the obvious and hackneyed forms of revolutionary art' makes sense, therefore, against a background of Marxist antipathy to the kind of sculpture Hepworth was producing, and his 'megalithic' interpretation of her work needs to be seen as a contribution to this debate on the left, attempting to find purpose and meaning in an artistic practice that many of his fellow Marxists would have viewed with considerable suspicion as a bourgeois flight from reality.

It might seem that Bernal's attempt to position Hepworth's practice against a Neolithic background is merely a historical oddity, a footnote to Marxist aesthetics in Britain, but that would be to overlook the significance of prehistory in the 1930s. In the rest of this essay I want to incorporate some other considerations which might further explain Bernal's manoeuvre. My contention is that his invocation of the Neolithic makes particular sense within an English art-world engaged in articulating the possibility of a modern British culture. What I hope to demonstrate is that both modernists and traditionalists deployed aspects of the prehistoric heritage as counters in a game of persuasion. We have only to remember the inclusion of British antiquity in the work of Paul Nash, John Piper and Graham Sutherland to understand its currency between the wars.[13] Running alongside this creative fascination with prehistory was the growing public engagement with megalithic sites as symbols of the national heritage. In paying attention to this double-coding of prehistory we may be able to understand more clearly how the remote past contributed to British modernism. At a time when abstract art in particular was prone to interpretation by left and right alike as a scientific, material and regimented practice, prehistoric forms had value as repositories of humane or spiritual meaning as well as seeming to hold out the possibility of art's social engagement when using 'abstract' means. But, equally, those same monuments were centrally positioned in debates concerning the threat posed by modern developments to Britain's historic heritage. Prehistoric sites were therefore being used to legitimise a variety of arguments concerning modern culture.

It is arguable that the advent of modernity in Britain offered two markedly different prognoses for the future, utopian or dystopian, with the hard, precise and geometrical perfection of the new machine aesthetic set in opposition to an

74 Paintings by Arthur Jackson and John Woods exhibited in *Modern Pictures in Modern Rooms*, Duncan Miller, London, 1936. Reproduced in *The Studio*, June 1936.

established organic, sensitive humanism. Writing in *The Studio* in June 1936, S. John Woods, one of the artists shown in the Duncan Miller exhibition *Modern Pictures in Modern Rooms* (fig. 74), talked of how modern architecture, art and interior decoration 'all deal with the same basic problems, problems of the twentieth century; they take the fundamental qualities of our machine-made environment and with them build new worlds of a new spirit'.[14] *Circle*, equally, talked of 'a new cultural unity ... emerging out of the fundamental changes which are taking place in our present-day civilisation'.[15] But such claims provoked critical resistance from those whose enthusiasm for the modern was at best moderate. For *The Listener* the 'machine art' of *Circle* represented a new cultural order that emphasised precision, science and regimentation over emotional life and lyricism.[16] The response from *The Studio* was even bleaker:

75 Stonehenge. Reproduced in *Circle*, Faber & Faber, 1937. Photographs: Carola Giedion-Welcker and Walter Gropius.

Everyone interested in art must consider whether the process of dehumanising and materialising which [Circle] represents, has not gone far enough, whether a really new cultural unity, if the world continues sane, or if culture is to be gracious instead of fearsome, will not be found in humanism.[17]

There is, then, a tension between Woods' machine aesthetic rhetoric, with its emphasis on modernity, contemporary technology and progress and the invocation of humane and organic qualities vested ultimately in traditional understanding. In this light, it is, perhaps, worth remembering that even in the pages of *Circle*, the epicentre of Constructivism in 1937 and full of appeals to precisely the same sentiments as Woods outlined, Hepworth's essay on sculpture was accompanied by three photographs of Stonehenge taken by Walter Gropius and

Carola Giedion-Welcker (fig. 75). Tellingly, *The Listener* claimed that these photographs were 'the most emotionally satisfying thing in the book'.[18]

This antipathy between 'mechanical' and 'humane' cultural orientations was a matter of debate in a number of contexts in the 1930s, not least the vociferous resistance to the impact of modern life on the countryside. This resistance may be symbolised by the publication, also in 1937, of Clough Williams-Ellis' *Britain and the Beast*, an anthology of essays examining the threat posed to Britain's countryside by urbanisation, road-building, ribbon development and all the unsightly paraphernalia of modern industrial society. It is a complex book, insofar as there is no overriding common statement of aims to be detected amongst its contributors concerning the nature of the problem and the remedies to be adopted. It is, however, witness to the intensity of debate surrounding the processes of modernisation in a country emerging from economic slump and it launched a jeremiad against environmental degradation. Clough Williams-Ellis had been agitating for legislation to control the despoliation of the countryside for some years. As early as 1930 his impassioned introduction to *The Face of the Land* invoked Georgian England, Austen, Trollope and Hardy, Canaletto, Gainsborough, Constable, Turner, Cotman and others besides to witness 'the hectic Saturnalia of ugliness in which we are squandering our inheritance'. Standing on the edge of a Sussex common one November afternoon he describes the modern landscape as a wilderness of pollution and ugliness, marked by congested traffic, concrete, asphalt and steel:

> I stood on a sixty-foot reinforced concrete motorway alone, which hooted and thundered an immense and largely unnecessary traffic at an extravagant speed between uncompromising palisades of steel and concrete. Beyond the dirty drab of the concrete kerbs, heaps of broken asphalt littered the weed-grown waste, from which rose gigantic black telegraph posts on the one hand and electric power pylons of latticed steel upon the other, so forcing horse-men and walkers alike relentlessly on to the unyielding surface of the oil-stained road. A few yards from the Common's end stood a shed of corrugated iron that a score of eye-splitting signs in crude enamels proclaimed to be a garage. Opposite stood a flimsy bungalow with pink asbestos roof and a gim-crack verandah enclosed with coloured glass announcing that it was 'The Lucky Dip Cafe' . . . Well, that is a picture that can be matched from all over England, and it is not a picture that I can pretend to like. If that is 'modern landscape', I would have none of it. I can find no merit in the shoddy or the

76 Cover of *Britain and the Beast*, Dent, 1937. Cover photograph: J. Dixon-Scott.

slipshod or in the arrogant destruction of old beauty when we are impotent to create new.[19]

The photographs in *The Face of the Land* are grouped to show the same sorry story of indiscriminate development of a once tranquil landscape, among which Stonehenge, with its cafe, car-park and derelict airsheds, is meant to prove that nations have the governments they deserve.[20] For Clough Williams-Ellis, as for many others, the treatment of Stonehenge was the acid test of our civilisation's impiety as regards tradition, cultural inheritance and the rest. It features again on the cover of *Britain and the Beast*, the monument silhouetted against a twilight sky (fig. 76); inside, the same photograph is accompanied by the caption: 'A dawn or a sunset? Our current civilisation may be either'.[21]

Williams-Ellis, and others like him in the Council for the Preservation of Rural England, believed that optimism about future developments under the impress of technological progress was seriously misplaced. Modernity itself was in doubt, not just because of its impact on the countryside but also because of its destabilising impact on society as a whole, feeding artificial, consumer-led hungers, coarsening cultural life and throwing up disturbance and social transformation.

These polemics were published when the place of the remote past in general consciousness was growing, with prehistoric remains achieving protection by statute and archaeological research on them being publicly promoted. Attitudes to ancient Britain were increasingly bound up within a wider debate which argued the need to preserve historic sites of all ages from the threat of modernisation, a debate whose preservationist side would include the establishment of lobbying organisations such as the Council for the Preservation of Rural England (1926) and the Georgian Group (1937) as well as extended statutory powers in the Town and Country Planning Act of 1932.[22] The 1920s and 1930s saw a growing popularisation of archaeological investigation as archaeologists made increasingly successful efforts to interest the general public in the historic record. Excavations, like that at Maiden Castle, were open to the public; O. G. S. Crawford wrote on prehistoric archaeology in *The Observer* and founded the journal *Antiquity* in 1927; and between 1924 and 1939 the Ordnance Survey published seven maps of historic Britain, from the Neolithic era to the seventeenth century.[23]

Paul Nash developed a complex understanding of the ways in which that past might figure in a modern artist's work. In 1933 he provided a statement for the publication of *Unit One*:

> Last summer, I walked in a field near Avebury where two rough monoliths stand up, sixteen feet high, miraculously patterned with black and orange lichen, remnants of the avenue of stones which led to the Great Circle. A mile away, a green pyramid casts a gigantic shadow. In the hedge, at hand, the white trumpet of convolvulus turns from its spiral stem, following the sun. In my art I would solve such an equation.[24]

These remarks are, of course, important guides towards understanding Nash's response to megalithic forms, but the anecdotal setting of the encounter is also significant. Quite simply, the experience of walking in a field near Avebury to encounter the stones had only recently been preserved from the threat of

modern development, for sites such as these and their environs had become by the early 1930s almost a test of the national will in resisting the despoliation of the countryside and the historic past. The Ancient Monuments Protection Act of 1882 had allowed the Office of Works to take 68 ancient monuments into Guardianship, among them Stonehenge, Avebury and Silbury Hill. The Act was revised and consolidated in 1913 and again in 1931. By 1932 the number of scheduled sites had risen to over 3000, giving them the possibility of protection from destruction by developers; but this protection was not sufficiently robust to preserve automatically the historic heritage from the encroaching effects of modern living, where the signs of twentieth-century culture, housing development, industry or communications, might 'disfigure' a monument's surroundings. Stonehenge's immediate hinterland was finally taken over by the National Trust in 1929 after a two-year fund-raising campaign to stop speculative building close to the site.[25] Avebury had been similarly threatened in the early 1920s by a Marconi wireless station to be constructed on Windmill Hill in its immediate vicinity, with 800 foot masts and new housing development for the station staff. For archaeologists like O. G. S. Crawford, the arrival of modern technology at Avebury was 'almost a virus', the ruin of the finest prehistoric site left in Europe 'a sacrilege', and he mounted a vigorous campaign in *The Times* and elsewhere to combat it.[26]

In the event the Government questioned the scheme not because of the masts' threat to the prehistoric heritage, but because of their threat to aviation. Writing to Crawford in September 1923, the archaeologist Alexander Keiller was in no doubt about the symbolic import of what had happened:

> It is ironical that Avebury should be preserved from the modern desecration of Wireless, for the sake of the almost equally modern innovation of Flying. However, so long as it is saved it does not matter very much how — although I confess that I should have preferred that the archaeologists of Britain should have defended the site by force, armed with weapons of the period . . . against the onslaughts of Marconi minions of Modernity, armed with Heaven knows what form of electrical atrocity.[27]

Avebury and its environs were preserved from development in perpetuity when Keiller purchased the site in 1924, with further legal controls on development there being established in the 1930s.[28] As he excavated and restored the site Keiller spoke almost deliriously of Avebury's future, all the stones now characterised as 'she': '3000 years after I am gone she will still be standing . . . and as far

as she can see . . . green hills . . . not a house or a petrol station'.[29] Nash's ability to walk in a field near Avebury and experience that unspoiled prehistoric landscape was thus the product of deliberate opposition to modern development and would have been seen as such by the preservationist lobbies and the general public alike. But equally, the prehistoric landscape he encountered was soon to become a modern creation, the product of Keiller's unlimited resources, as recumbent and buried stones were heaved upright and secured in new concrete sockets. When Nash first visited Avebury, apart from the Circle, he would have found a mere four upright stones in the West Kennet Avenue and two at Lower Beckhampton. What we see today is a transformed landscape.

Nash's use of Avebury is significant in the context of this essay because his example seems to reconcile the opposing positions regarding British culture symbolised by *Circle* and *Britain and the Beast*. He had focused on this issue with his customary precision in 1932:

> Whether it is possible to 'go modern' and still 'be British' is a question vexing quite a few people today . . . The battle lines have been drawn up: internationalism versus an indigenous culture; renovation versus conservatism; the industrial versus the pastoral; the functional versus the futile.[30]

As Nash indicates, the question loomed over a variety of concerns between the wars. Modernism was not merely an artistic credo; its impact, understood in a diffuse sense, was part of the experience of modernity itself, that is to say the modernisation of Britain. The articulation of a new culture amid the heritage of the past was of crucial interest in the inter-war period and became one of the key battlegrounds between two registers of understanding what England or Britain might mean. Because it is in the tension between these two sorts of English civilisation, the historic heritage and the progressive present, that the arts and architecture of 1930s England are to be found. Within this debate the primordial past was something of a touchstone for national consciousness.

The coincidence of statutory preservation and artistic or critical uses of the prehistoric past is not fortuitous. In his *Unit One* statement Nash invokes the spirit of English art as a lyrical expression of the land and cites Blake and Turner as historical precedents for his own beliefs. Nash interprets Blake's Albion as the hidden reality of England, the spiritual personality of the land to be set in opposition to its natural appearance. Turner, likewise, is presumed to have penetrated the deceptive mirage of appearances to explore an imaginative reality. For Nash, the modern artist too must explore the genius loci of England:

In the same way, we, today, must find new symbols to express our reaction to environment. In some cases this will take the form of an abstract art, in others we may look for some different nature of imaginative research. But in whatever form, it will be a subjective art.[31]

Nash's involvement with British prehistory, then, is part of his reaction to environment and it resulted in a number of significant paintings in the 1930s. Like John Piper he had a keen interest in archaeology and while in Dorset collecting materials for the Shell Guide to the county, he photographed the remains of the defenders of Maiden Castle, recently unearthed by Sir Mortimer Wheeler's excavations.[32] But his use of megalithic forms was not intended to be illustrative in any way, nor were his landscapes, even when recognisable, topographical in any straightforward manner. Instead, Nash used primeval Britain as a sounding board for his own metaphysical ideas where meditation on the megaliths might put one in touch with the genius loci, the spirit of the land, a spirit that is for Nash the root of English culture. As he said of Blake. 'His poetry literally came out of England'.[33]

Nash was, however, too sophisticated an artist and too stubborn a modernist to let the genius loci overwhelm his forms, which had to function within the terms laid down by a complex art world. His explanation of *Equivalents for the Megaliths* (1935) (pl. IX) is emphatic:

These groups (at Avebury) are impressive as forms opposed to their surroundings ... they are dramatic also, however, as symbols of their antiquity, as hallowed remnants of an almost unknown civilisation. In designing the picture, I wished to avoid the very powerful influence of the antiquarian suggestion, and to insist only upon the dramatic qualities of a composition ... of shapes equivalent to the prone or upright stones, simply as upright or prone, or leaning masses grouped together in a scene of open fields and hills.[34]

Equivalents for the Megaliths, like other allied paintings by Nash, is a bid to solve the equation he described in 1934, an attempt to find 'new symbols to express our reaction to environment'. In these manoeuvres Nash comes close to the doubled vision Bernal attempts for Hepworth, invoking the megalithic past only to transcend it in the interests of modernity. In doing so he found a middle ground between two extreme polarities: on the one hand unthinking, destructive physical effacement of the past, coupled with artistic repudiation of tradition, and on the other nostalgic, preservationist retention of the past and artistic submission

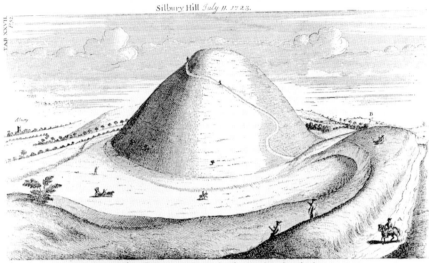

Silbury Hill *July 11. 1723.*

A. *The Roman road.* B. *the Snakes head or hakpen.*

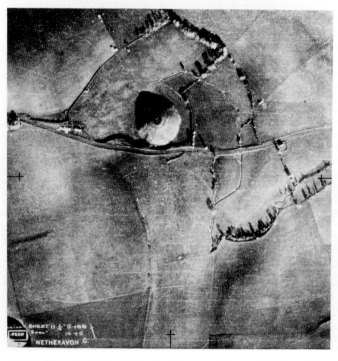

77 Silbury Hill, Wiltshire. (Top) After William Stukeley, 1723. (Bottom) Air Photo. Reproduced in *Axis* 8, Early Winter 1937.

to tradition. To solve Nash's 'equation' the artist was required to effect the more difficult achievement of putting modernity in dialogue with the past without compromising either.

Prehistory was in the air again in 1937, literally so, in the pages of *Axis*, the review of contemporary art.[35] John Piper wrote an article on the impact of flying on human consciousness, pointing out that from the air horizons vanish, just as they have nearly done from painting. His chief concern, however, was to examine the impact of aerial photography on archaeology and to contrast the experience of place provided by an aerial survey with that of an antiquarian, like William Stukeley or Colt Hoare (fig. 77). His stimulus for this was his friendship with O. G. S. Crawford who had pioneered the techniques of aerial archaeological survey and, in collaboration with Alexander Keiller, had published *Wessex from the Air* in 1928. In comparing views of Silbury Hill, Piper articulates two sorts of consciousness:

> Stukeley, above all, wanted to record the effort and the feeling for shape of the men who built it. Size and contour are all-important. The story of the size is well told, and as to the shape to jump, run, walk, or struggle up each slope with Stukeley in his drawing is as real and sharp an experience as to take a journey round a wineglass with Picasso. The air photograph is flat and subtle. The effect of suddenness that the mound gives in the plain, and the sense of size that the surroundings try to contradict, is as strong as that of all Stukeley's fold-explorations.[36]

To liken Stukeley to Picasso may seem quixotic, even playful, but there is, I think, an echo here of that turn away from abstraction to a renewed engagement with landscape and with historic places in Piper's art that marks the closing years of the 1930s. For Piper, it seems, just as the flat language of aerial photography is but one equally valid language of archaeological representation, so the status of abstraction itself may simply be that it is one artistic language, as valid as any other, rather than being the only language of modernity. Indeed, what comes across strongly in Piper's article is this: no matter that he enthuses about the precision and accuracy of aerial photography, he emphasises and endorses the human element in Stukeley's image. And, by looking at Stukeley from a twentieth-century perspective, comparing the experience to viewing a Picasso wineglass, Piper seems to suggest that we can find modernity in the pre-modern. It is as though Piper were patiently elaborating a complex alibi for his return to representation, suggesting that the modern can incorporate human interest by

re-instituting the link to the past sundered by abstraction. In like manner, but moving our analysis on to the abstract wing, we might interrogate the editorial decision to place an illustration of a Miró opposite the aerial photograph of Silbury Hill that closes Piper's essay. Both are without horizons; both rely on linear and circular features inscribed on a flat surface. Is it not reasonable to consider prehistoric earthworks as prefigurations of radical modernity? To answer 'yes' to that question is to domesticate the modern with a vengeance.

What I want to suggest therefore is that Bernal's detection of Neolithic parallels in Hepworth's art is not an isolated critical position. Although the early 1930s seemed to usher in a promise of extensive cultural renewal, by its close a range of artistic practices had been brought into some sort of accommodation with the historic legacy of English culture. The very ferocity of the debate about artistic purpose seems to have contributed to this development. As Myfanwy Evans noted:

> we have got into the middle of . . . a thousand battles. Left, right, black, red (and white too, for the fools who won't take part and so constitute a battle line all on their own), Hampstead, Bloomsbury, surrealist, abstract, social, realist, Spain, Germany, Heaven, Hell, Paradise. Chaos, light, dark, round, square. 'Let me alone—you must be a member—have you got a ticket— have you given a picture—have you seen *The Worker*—do you realise—can you imagine—don't you see you're bound to be implicated—it's a matter of principle. Have you signed the petition—haven't you a picture more in keeping with our aims—*intellectual freedom*, FREEDOM, *FREEDOM* —we must be allowed, we can't be bound—you can't, you must fight—you *must*.[37]

This quotation is part of the title essay to a book she edited in 1937 entitled *The Painter's Object* and she goes on to open up a gap between the kind of commitment she caricatures in that extract and the individual creativity and belief in their own integrity detectable in the art of Blake, Palmer, Constable and Cézanne. It is an interesting list insofar as Blake, Palmer and Constable would not have been brought into alliance with Cézanne even ten years earlier, but the list and the tone of the essay are increasingly typical of other voices in the 1930s. The question remains, however, whether this resolution, and other such accommodations with the past in contemporary art, architecture and design were necessarily a falling away from the project of modernity as many understood it.

John Piper's essay in the same volume is entitled 'Lost, A Valuable Object', and in it he recounts the history of modernism to date as an assault on the object

which had been traditionally the painter's subject. For Piper, it is evident that this loss of the object has resulted in some very particular artistic tactics to provide a substitute for it:

> And now where are we? Where is the subject, or the object, or the subject or sub-object, or whatever it is your fancy to call it? In oblivion still? One thing is certain about all activities since cubism: artists everywhere have done their best to find something to replace the object that cubism destroyed. They have visited museums, and skidded back through the centuries, across whole continents and civilisations in their search ... They have gone a long way in space as well as time. In this country, for instance, we find Paul Nash identifying all nature with a Bronze Age standing stone, and Ben Nicholson even assisting at world-creation. Henry Moore has landed us back in the stomach of prehistory while Paul Nash, again, leaves us with the bare seawashed bones of it ... It all seems to me an attempt to *return* to the object, not escape from it.[38]

Piper goes on to observe that despite these attempts to recover the object, neither the abstract nor the surrealist artist wish to restore the object to its proper context: 'the tree standing in the field has no meaning at the moment for the painter'.[39] Nash could reply on the contrary that meaning must lie not in the literal context of the given natural world but in the tension between that world and its transmogrification by the imagination and the intellect. And Piper is wrong to accuse Nash of having a horror of context, for Nash's practice might be characterised precisely as wrestling with the problem of context for pictorial objects.

I have drawn a sharp distinction between Piper and Nash to help elucidate Nash's position regarding the importance of 'subjective art' and 'imaginative research' when confronted with landscape, but seen from another viewpoint both artists can be placed together in their emphasis on explicitly British topography in the 1930s. Nash, indeed, had only temporarily abandoned landscape, moving briefly towards abstraction around 1931 and flirting with Surrealism in the later 1930s. Piper had worked in a resolutely abstract idiom in the middle 1930s but from about 1937 he reintroduced spatial devices into his paintings and then quickly moved on to tackle pure landscape and architectural subjects, almost as though recapitulating the eighteenth century's discovery of British landscape, monuments and antiquities for a modern audience. Graham Sutherland, too, imbued in any case with the spirit of Samuel Palmer in his engravings of the late 1920s, now worked with a Palmer-like intensity of vision to produce a series of paintings of Welsh landscapes, where prehistoric monuments and

natural features were subjected to intense imaginative manipulation. Like Nash, but even more loosely, Sutherland's work was seen at the time as affiliated to Surrealism but, if so, it was a version of Surrealism that lacked any political edge and owed at least as much to the English landscape tradition.

What Sutherland's art of the 1930s offered the English spectator could be found spelled out in his own writings and that of artists like Piper, as well as in the criticism of Myfanwy Evans, Geoffrey Grigson and others. It was an aesthetic which relied on two main axioms for its convictions: first, that the British literary and artistic tradition contained within it, in its tendency towards spiritual excess and romantic projection into the object, a proto-Surrealism which had anticipated Surrealism proper by a century or more; second, that the attentive English artist could find in the material heritage of his or her own land the proper stimuli to produce a humanist art, relevant to the needs and aspirations of the British people. The first of these attitudes helps explain the repositioning of William Blake, but also Wordsworth, Palmer, Fuseli, Turner and others as modernists *avant la lettre*; the second provided the stimulus to retrace the romantics' interest in landscape, in freaks of nature, ruins and prehistory. Both together manured the seedbed in which Neo-Romanticism was already putting down its roots. Insofar as this aesthetic was successful, it was in its ability to accommodate modernism to a tradition, to pull its teeth, if you will, such that the disruptive and engaged avant-garde art of continental Europe was naturalised here as modernist sensibility, as an imaginative approach to nature rather than a manifesto for a new society.[40]

We have seen, then, that both Nash and Hepworth's practice was brought into some relationship with prehistory in debates about the function and purpose of modernism. As I have also argued, the English countryside and its megalithic monuments were being used as counters against modernity by the preservationist lobby. The real megalithic landscape was itself a contested site where the forces of technological and economic progress were combated by the guardians of England's historic heritage. I do not mean to imply, even so, that Nash and Hepworth, or Piper and Sutherland, for that matter, can be seen as natural allies of Clough Williams-Ellis but what is clear is the realisation that significant elements within British modernism seem to have negotiated an accommodation with the relics of the past. In this connection it is noteworthy that *Countrygoing*, a conservationist mouthpiece, used a sketch by Paul Nash of an Avebury monolith as an appropriate image for its cover (fig. 78). Published just after the Labour election victory in 1945, it celebrates the sanctity of the English

Countrygoing

78 Cover of *Countrygoing*, edited by Cyril Moore, Countrygoer Books, 1945. 'From a sketch made at Avebury by Paul Nash'. © Tate, London 2001.

countryside and the need to preserve it from indiscriminate development. In one of its essays C. E. M. Joad robustly declared:

> there is little hope for the preservation of England's beauty until more towns-people are so trained and educated that they learn to recognise and to care for it . . . It follows that upon those of us who are acquainted with and sensitive to the values I have tried to describe, a special obligation is laid. We are the high priests of the temple of a half-forgotten cult, the tenders of a sacred but divine flame, upon us is placed the obligation to keep it alight, until such time as we can hand on our charge to our successors. It falls, in short, to us to hold the pass until democracy can safely be let through.[41]

It seems unlikely that Nash himself would have subscribed to such views or approved of such a facile use of his explorations at Avebury, but *Countrygoing*

indicates how the artistic and preservationist appropriation of the prehistoric heritage might coalesce.[42]

It is worth contrasting this situation with some remarks taken from the art critic R. H. Wilenski, writing in 1930:

> the group-mind of today will ... extract from the multitude of small impressions from the present the outlines of our twentieth century culture in England ... For somewhere ... in the deep desire of our century for order and control of the forces of envy and greed, somewhere in the iron determination of our age to banish flummery and panache and look the civilisation of skyscrapers, electricity and aeroplanes in the face, lies the real culture of our age.[43]

As I hope I have shown, skyscrapers, electricity and aeroplanes were but part of a culture which also included meditations on primordial landscape, cultural heritage and a mystic sense of place. Within less than ten years the iron determination of the age Wilenski hoped to celebrate had seen a reconciliation with tradition, finding the essential structure of English civilisation not in radical modernity but in the deep, poetic resonance of an ancestral land.

The cover of the 19 April 1947 edition of *Picture Post* shows the ultimate working out of this tendency (fig. 79). Bill Brandt's photograph of a snow-bound Stonehenge under a lowering sky sits above the banner headline 'Where Stands Britain?' This special issue devoted to the economic crisis of the post-war years, was a departure from the magazine's usual style and was produced as a matter of urgency and at considerable financial loss to help stimulate the debate on national renewal. Shortages in the shops, price rises, poor industrial investment, under-production and short-time working because of the scarcity of raw materials led to questions which are eerily familiar to a British readership fifty years later: Could the social services be afforded? Was industrial enterprise hamstrung by bureaucratic controls? How long would austerity last before the economy recovered? What was Britain's relation to the Colonies to be? What place would scientific research have in the recovery? Faced with a Government calculation that the volume of exports needed to grow by 75% to allow a return to the pre-war volume of imports the economic outlook was bleak indeed. In the midst of this the country lay under snow and ice in the longest and hardest freeze on record, exacerbating fuel shortages and short-time working. The floods that followed devastated agricultural productivity and destroyed livestock and crops. Yet the cover of *Picture Post* showed neither an industrial scene, nor any political

79 Cover of *Picture Post*, April 19, 1947. Photograph: Bill Brandt. Hulton Getty Picture Collection.

figure, no factories on half-time, no queues in the shops, no ruined fields, no image of the contemporary crisis at all. Just Stonehenge on a dismal winter's day.

Stonehenge is rightfully on the cover because it can be reduced to a cipher emptied of specific meaning, for its ability to suggest endurance and longevity. It is precisely because any definite meaning has been evacuated, placing it beyond the reach of any politics or ideological interest, that it can be used to contain such an anodyne and unproblematic appeal to national unity. No matter that the articles inside *Picture Post* offered an economic and political review of the situation, the cover provides another frame of reference, collapsing Britain in 1947 into a strange and transcendental 'Britain'. This other Britain will weather the immediate crisis just as Stonehenge has withstood four thousand years of exposure to the elements. In an unpeopled world Brandt's image is almost pure landscape, but not quite; the vestiges of culture tremble just this side of nature. In eliding Stonehenge with the landscape Brandt mobilises those other currents of thought and feeling which seek the identity of Britain in its 'essential', that is to say its dehistoricised, nature.[44] Thus Stonehenge stands for a Britain which is not a political, social or economic reality, but a mystery, a mystery in which all Britons participate, a mystery whose enigma can be celebrated but never fully understood.

In this essay I have attempted to illuminate the place of prehistory within the cultural climate of the 1920s and after, bringing together two registers of experience, the sites themselves and modern cultural uses made of them. What links these registers is the place of remote antiquity in definitions of Englishness. On the one hand, sites of primordial settlement become invested with the legitimacy and authenticity of primogeniture in contradistinction to the new, brash and raw tokens of modern culture. Stonehenge, Avebury and Silbury Hill thus function as touchstones of a time-honoured national landscape amidst the signs of more recent and probably ephemeral development. On the other, their mute and enigmatic purpose seems to talk abstractly of human achievement at the moment of making, an innocence of purpose that transcends artistic and political ideologies. To produce works of art, or to write about them, with reference to that prehistoric landscape in the twentieth century is thus to resist the idea of modernity as rupture and in its place to attempt an accommodation with the past.

1 For a succinct review of these developments see Jane Beckett, Nicholas Bullock, John Gage, *Circle— Constructive Art in Britain, 1934–40* (Cambridge: Kettles Yard, 1982).

2 Bernal was introduced to Hepworth by Margaret Gardiner, his lover at the time. See Margaret Gardiner, *Barbara Hepworth: A Memoir* (London: Lund Humphries. 1994), 27–28. For Bernal's association with art and artists, see Maurice Goldsmith, *Sage: A Life of J D Bernal* (London: Hutchinson, 1980).

3 'I really should be so interested to know exactly where you think your idea [of constructive art] differs from ours. It seems to me that we know in our work but cannot speak clearly always because we work intuitively whereas you can express it and apply it in constructive criticism because science, surely, does not work as emotionally as ptg or sculpture'. Letter from Barbara Hepworth to J. D. Bernal, n.d., Cambridge University Library, Add. 8287/J84.

4 'Obviously in a normal state forewords should not be necessary but as things are [at] the moment we meet with considerable opposition from the public, and of course sculpture meets with less sympathy than painting on the whole'. Letter from Barbara Hepworth to J. D. Bernal, n.d., Cambridge University Library, Add. 8287/J84.

5 J.D. Bernal, 'Foreword' to *Catalogue of Sculpture by Barbara Hepworth* (London: Alex Reid and Lefevre Ltd., October 1937). Hepworth herself had not made this connection, but once settled in Cornwall she acknowledged Bernal's prescience: 'It's truly grand country . . . very fertile. Unconquerable and strange, and my God how sculptural. Lanyons Quoit, The Men-an-Tol, The Nine Maidens — not far away — incredible stones everywhere so persistent and such an early civilisation . . . It is strange that Bernal's foreword to my show should have mentioned all these early sculptures which I knew nothing about'. Letter to John Summerson, 3 January 1940, cited in Sally Festing, *Barbara Hepworth – A Life of Forms* (London: Viking, 1995), 141.

6 J. D. Bernal, 'Foreword' to *Catalogue of Sculpture.*

7 J. D. Bernal, 'Foreword' to *Catalogue of Sculpture.*

8 See for example J. D. Bernal, *The World, The Flesh and The Devil: An Enquiry into the Future of the Three Enemies of the Rational Soul* (London: Kegan Paul, 1929).

9 J. D. Bernal, 'Art and the Scientist', in J. L. Martin, B. Nicholson & N. Gabo, eds., *Circle, International Survey of Constructive Art* (London: Faber and Faber, 1937), 123.

10 Anthony Blunt, 'Specialists', *The Spectator* (22 October 1937), 683.

11 Quoted in Robert Radford, *Art for a Purpose: The Artists' International Association, 1933–1953* (Winchester: Winchester School of Art Press, 1987), 47.

12 *5 on Revolutionary Art* (London: Wishart, 1935).

13 See Virginia Button, 'The Aesthetics of Decline—English Neo-Romanticism. c.1935–1956', unpublished PhD diss., Courtauld Institute of Art, 1991, 81–86.

14 S. John Woods, 'Are these the Pictures for Modern Rooms?', *The Studio* 140 (June 1936): 332.

15 'Editorial', in *Circle, International Survey of Constructive Art*, v.

16 *The Listener* 117 (4 August 1937): 259–60.

17 *The Studio* 114 (November 1937): 277.

18 *The Listener* 117 (4 August 1937), 259–60.

19 Clough Williams-Ellis, 'Introduction' in H[arry] H[ardy] P[each] and NLC[arrington], eds., *The Face of the Land, The Year Book of the Design and Industries Association 1929–30* (London: George Allen and Unwin, 1930), 12–15.

20 *The Face of the Land,* 40.

21 Clough Williams-Ellis, *Britain and the Beast* (London: J. M. Dent, 1937), opp. 295.

22 See Timothy Champion, 'Protecting the monuments: archaeological legislation from the 1882 Act to PPG 16' in Michael Hunter, ed., *Preserving the Past, The Rise of Heritage in Modern Britain* (Stroud: Alan Sutton, 1996), 38–56; John Sheail, *Rural Conservation in Inter-War Britain* (Oxford: Clarendon Press, 1981), 48–62.

23 The first of these, *Roman England,* was published in 1924, its second edition (*Roman Britain,* 1928) extending to just south of Aberdeen. The last sheets to be published before the War were *Britain in the Dark Ages* (1938–39). See C. W. Phillips, *Archaeology in the Ordnance Survey, 1791–1965* (London: Council for British Archaeology, 1980).

24 Paul Nash in Herbert Read, ed., *Unit 1* (London: Cassell, 1934), 81.

25 See Champion, 'Protecting the monuments'; Sheail, *Rural Conservation.*

26 Crawford had learned of the scheme by May 1923 (communication from H. G. O. Kendall, excavating at Windmill Hill, dated 23 May) and wrote to *The Times* on 2 August 1923 to protest. He also sent letters to all those who might aid the campaign. One of his correspondents was Alexander Keiller. Keiller had read Crawford's 'Air Survey and Archaeology,' published in *The Observer* in 1923, and had written to Crawford on 29 July 1923, offering to help as a qualified pilot and as a financier. On receipt of Crawford's letter about the threat to Avebury, Keiller was immediately ready to help and Crawford floated the idea of purchasing the site. Letters dated 21 August and 30 August 1923. All letters in Alexander Keiller Museum, Avebury, 7810456.

27 Keiller to Crawford. Letter dated 15 September 1923, Alexander Keiller Museum, Avebury, 78510456.

28 Wiltshire County Council initiated a special planning scheme for the environs of Avebury to protect it from undesirable development and launched a funding appeal in 1937 to finance the scheme. In April 1943 Keiller sold all his Avebury property, except the Manor House, to the National Trust.

29 Conversation recorded by the novelist Antonia White, 13 November 1935. See Susan Chitty, ed., *Antonia White: Diaries 1926–1957,* Vol. 1 (London: Constable, 1991), 2. My thanks to Ros Cleal for this reference.

30 Paul Nash, 'Going Modern and Being British', *The Weekend Review* (12 March 1932), 322–23.

31 Paul Nash in Read, ed., *Unit 1,* 81.

32 'The Defenders of Maiden Castle, Dorset' and 'Nest of the Skeletons' [1934–1935] are illustrated in Margaret Nash, ed., *Fertile Image* (London: Faber and Faber, 1951). Nash and Wheeler were both students at the Slade in 1910.

33 Paul Nash in Read, ed., *Unit 1,* 81.

34 Letter to Lance Sieveking, 4 May 1937, quoted in *Paul Nash Paintings and Watercolours* (London: Tate Gallery, 1975), 86.

35 Edited by Myfanwy Evans, *Axis* was launched in January 1935 as a quarterly review of contemporary 'abstract' painting and sculpture and had a run of eight issues before it closed in the winter of 1937.

36 John Piper, 'Prehistory from the Air', *Axis* 8 (early winter 1937): 7.

37 Myfanwy Evans, 'The Painter's Object', in Myfanwy Evans, ed., *The Painter's Object* (London: Gerald Howe, 1937), 5.

38 John Piper, 'Lost, A Valuable Object' in Evans, *The Painter's Object,* 70.

39 Piper, 'Lost, A Valuable Object' in Evans, *The Painter's Object,* 70.

40 See Charles Harrison, 'England's Climate', in Brian Allen, ed., *Towards a Modern Art World* (Studies in British Art 1, London & New Haven: Yale University Press, 1995), 207–25.

41 C. E. M. Joad, 'Problems for Readers', in Cyril Moore, ed., *Countrygoing* (London: Countrygoer Books, 1945), 43. Joad was on the editorial board. My thanks to Ian Wightman for bringing this book to my attention.

42 In this context it is worth remembering that Nash dedicated his Dorset Shell Guide to the CPRE, SPAB and the landowners of Dorset, at a time when all of them were campaigning against a proposed bombing range on the Chesil Beach at Abbotsbury. My thanks to Kate Best for drawing this to my attention.

43 R. H. Wilenski, 'The Italian Exhibition at Burlington House', *The Studio* 99 (January 1930): 12.

44 Significantly Brandt intended to remove Stonehenge from any quotidian banality. 'I'd always planned to photograph Stonehenge under snow . . . The cold would mean there were no visitors and the snow would obliterate so much that's distracting and unnecessary'. See Tom Hopkinson, 'Bill Brandt's Landscapes', *Photography* 9.4 (April 1954), reprinted in Nigel Warburton, ed., *Bill Brandt, Selected texts and bibliography* (Oxford: Clio Press, 1993), 98–101.

Ben Nicholson: Modernism, Craft and the English Vernacular

Chris Stephens

As a number of the essays in this volume indicate, the relationship between modernism in the visual arts and ideas of Englishness continues to be seen, in large part, as one of opposition. The idea that modernism's international focus demanded a transcendence of national cultural identity from those who would have been associated with it seems to persist. Even when Philip Dodd set out to establish the Englishness in the work of that most modern of British artists, Ben Nicholson, he had to find it in Nicholson's debt to the Francophilic Bloomsbury Group.[1] To narrate a history of modernism in Britain before the Second World War is still, apparently, to chart the arrival and appropriation of European theory and practice. Similarly, the notion that an awareness, or use, of English cultural identity (frequently embodied, it seems, in landscape themes) signalled an artist's refusal of modernity is proving resilient. As a small counter to this persistent polarity, I want to suggest a way in which we might see an English cultural identity informing and shaping the development and reception of modernism in Britain in the inter-war period. To do this I shall look at particular physical aspects of works by Ben Nicholson to open up new possibilities for the reading of his art in general.

I shall sketch a few co-ordinates for Nicholson's work of the 1920s and 1930s so that an idea of cultural continuity might be seen to be indexed even in what appear to be his most extremely modernist works. I shall argue that even in his white reliefs—those acmes of reductive modernism—one can read a residual Englishness which, conscious or not, could have served to mollify contemporary anxieties over what were commonly seen as foreign extremes. To uncover ways in which this English sub-text might be discerned I shall consider Nicholson's work in the light of his involvement with contemporary craft, by which I mean not his own interventions into the applied arts but his relationship with the Studio Pottery movement in the 1920s. From that I shall go on to look, briefly, at the kind of Englishness with which we might be dealing, proposing that, through his implicit reference to a domestic vernacular, one might see Nicholson articulating a

feminised national tradition and a feminised modernism. Finally, through a consideration of the position of English traditions in the writings of Herbert Read, I shall suggest a way that this aspect of Nicholson's work might be seen to be reiterated in various ideas of the modern in art and design. The object of this exercise is not to expose a nationalist behind the artist's modernist mask but rather, it is hoped, to demonstrate the complexity of the relationship between modernism and Englishness. In the revelation of the shifting plurality of national cultural identity, the possibility is opened up of a radical Englishness which might be seen to have conjoined with modernist practices for the refreshment of both.

I have approached this project with a sense of unease exacerbated by the conference at which the paper was first presented. Before examining the particular case of Nicholson's white reliefs, one needs to address the question of Englishness and its analysis in this context. Emerging from much of the recent discourse around national identity and cultural production one may discern an essentialist tendency that accepts particular themes as always significant of Englishness. Most obviously, landscape frequently seems to become synonymous with Englishness in a way which seems to me highly reductive of both sides of the equation: landscape and Englishness. As Alex Potts has pointed out, the use of landscape as a nationalist symbol was not unique to Britain.[2] In any case, has it not been possible to paint landscape without participating in an anti-modern retreat into nationalistic tradition? If not, what do we make of the Impressionists, whose depiction of new landscape spaces was as much a part of their modernising of painting as their technique? To see the landscape or the countryside as always a cipher for conservatism and nostalgia is oversimplistic. This point has been eloquently argued recently by David Matless, who has set out the complex matrix of conservatism and radical modernisation that structured the landscape and the countryside in the mid-twentieth century.[3]

If we accept a conception of modernism as a complex pattern of forces and desires, we must acknowledge the potential for landscape and rusticity to signify in different ways. There is a great danger in always associating a particular motif—landscape, say—with a cultural tradition. We should be wary of forgetting the function of history in the signification of national identity. This warning was similarly appended to Robert Colls' and Philip Dodd's collection of essays on Englishness:

> Englishness has had to be made and remade in and through history, within available practices and relationships, and existing symbols and ideas. That symbols and ideas recur does not ensure that their meaning is the same.[4]

As I write, politicians, stimulated by Scottish and Welsh devolution and anxieties over European federalism, are contesting their own revisions of English or British character to remind us of the wisdom of Colls' and Dodd's caveat. In simply equating landscape and Englishness without establishing a historical justification for such an association we risk reproducing the very nationalistic fictions we set out to analyse.

A persistent omission in many of the recent discussions of Englishness in the early twentieth century is any engagement with the absent Celts. The slippage from 'British' to 'English' either implies the rejection or marginalisation of the Scots, Welsh and Irish or it suggests that their cultural identities can be unproblematically assimilated within that of the dominant English. While their absence is often acknowledged, it is rarely analysed or justified. Is it, as Raphael Samuel suggested, that we prefer the term 'English' to 'British' because it has:

> all kinds of pleasant connotations . . . a people rather than a state, Blake's Jerusalem rather than Westminster, Whitehall or Balmoral . . . it conjures up images of rusticity, chronicles of ancient sunlight. 'English' is smaller and gentler than 'British' [which is] . . . an altogether more unconfortable term . . . hard rather than soft and belonging to specific historical epochs rather than a timeless one of 'tradition'. It is a political identity which derives its legitimacy from the expansion of the nation state. Its associations are imperial rather than . . . domestic . . . it is formal, abstract and remote. British . . . allows for a more pluralistic understanding of the nation, one which sees it as a citizenry rather than a folk . . . [and] is therefore more hospitable both to newcomers and outsiders.[5]

In our discussions, we should consider whether we really do mean 'English' and, if so, why we, or our subjects, chose that specific term or concept.

In this particular study of Ben Nicholson's association with vernacular culture, I am inclined to feel that it is a particular perception of a past, rural lifestyle to which he might allude, regardless of its national affiliation. The lost rustic domesticity to which I shall refer might be seen to be as much a part of the romantic past of the Scots or the Welsh as of the English. As it happens, the study of Nicholson usefully exposes his alignment with a (historically specific) perception of inherent difference between English and Scottish character. In a consideration of his artistic lineage, the artist saw his work as growing from a synthesis of his English father and Scottish mother's contrasting attitudes. The construction of the Celtic as different has, of course, served in the definition of

Englishness and William Vaughan and others have shown how Anglo-Saxon and Celtic traditions were used in the 1930s to claim a heterogeneity for British art.[6] In the case of Ben Nicholson, the refreshment of English culture through an infusion from the 'primitive' Celt was clearly demonstrated by his encounter with and use of Alfred Wallis. The perception of Wallis as both Cornish and of another time was vital to the function he played in British high culture. (This is presumably why there has been considerable attention paid to the fact that he was actually born in Devonport, on the Devonshire bank of the Tamar.)

To be clear: I shall claim that the emphasis on the hand-made quality of Nicholson's reliefs associated them with contemporary craft at a time when those crafts were recovering lost native traditions. It is only through that specific association, I will argue, that an idea of traditional English (or British) culture is indexed in the artist's surface textures. There is nothing about texture, hand-madeness or craft which one should see as *intrinsically* English.

The suggestion of a modernist appropriation of native traditions is not new. Recently, several writers have demonstrated how a resurgence of interest in pre-historic and mediaeval British cultural artefacts informed the formulation of British modernism.[7] In March 1931 Paul Nash argued for the compatibility of 'Going Modern' and 'Being British' in *The Weekend Review* and later he and John Piper produced a range of texts in which photographs of ancient sites, such as Stonehenge and Silbury Hill, demonstrated a native formal tradition. Similarly, in 1936 the Scot William Johnstone used photographic juxtapositions to present mediaeval British art as a precedent for modern painting and sculpture. As we shall see later, this interface between what was seen as traditional culture and modernism and modernity exceeded these simple formalist equivalences. Matless' text similarly dislodges the simplistic ideas around the role of landscape in the construction of Englishness by convincingly arguing that, despite being consistently seen as redolent of a nostalgic nationalism, the English landscape was the locus for a variety of modernising discourses.

If the importance of British cultural tradition to a number of modern artists has been acknowledged, Ben Nicholson has generally been seen in terms of inter-national modernism, his position continually revalidated by his direct knowledge of Parisian painting and sculpture. In the catalogue of his 1993 Tate Gallery retrospective, the period during which Nicholson made a number of visits to France was even dubbed 'The Paris Years'.[8] More recently Charles Harrison has claimed that the white reliefs and Barbara Hepworth's abstract sculptures of the same period did not represent the merging of modernism and Englishness;

rather, their status derived from their rejection of Englishness.[9] Following a familiar art historical trope, Nicholson's work has generally been shown to have undergone a process of formal development that culminated with the white reliefs, the first of which was made at the beginning of 1934. This evolutionary model was the basis for Nicholson's 1969 Tate Gallery retrospective (selected by Harrison), as well as for the 1993 exhibition there, and for *Ben Nicholson: The Years of Experiment 1919–39* at Kettle's Yard, Cambridge in 1983.

The way in which the white reliefs have generally been perceived has been influenced by a retrospective view of them through the paradigms of Greenberg's teleological model of Modernism and the whiteness of the modernist interior. Through both, they have been presented as the epitome of a modern art of purity, their status typified in Charles Harrison's claim that:

> As a single and consistent body of work the white reliefs may be seen as the major contribution by an English artist to the European Modern Movement in the first half of the twentieth century.[10]

I want here to dislodge this familiar, exclusively internationalist view and to suggest that in these works one might discern coded references to vernacular English culture. As a result, one must see their relationship to the modernist architecture with which they have repeatedly been compared not as one of equivalence but as one of counterpoint.[11]

To associate Nicholson with notions of English national cultural identity as well as with an international aesthetic is not original; even John Summerson, writing in 1943 with the artist's sanction, described him up until his first relief— as 'a modern painter in the English Romantic tradition'.[12] However, I propose that one may see that specifically English identity persist even in the reliefs if one focuses on a crucial aspect of Nicholson's production that has generally been marginalised. Rather than his abandonment of representation, his introduction of a third dimension through carving or his rejection of colour, one might concentrate on the quality of the surfaces of his paintings and reliefs. With the exception of a relatively small body of work, the single most telling aspect of his production is the modulation of surface texture. I want to consider how we may see this as the embodiment of a set of cultural references in which an English tradition may be indexed and, if so, a particular form of Englishness made manifest.

The white reliefs may generally be seen as models of purity but, rather than distinct from the uneven forms and textures of Nicholson's first painted reliefs and the preceding paintings, their surfaces are highly textured, pitted and

80 Ben Nicholson, *1934 (white relief)*, oil on carved wood (40.6 x 61 cm). Private Collection.

scarred. The artist preferred to have them photographed with strong side lighting which dramatised the changing levels and shapes of the relief. Jeremy Lewison has associated this concern with light with contemporary architectural priorities, but its main function is to emphasise the uneven textures of the surfaces of the works which are flattened out in less dramatic reproductions. One is struck by the undulations, wood-grain, chips and nicks which elaborate and articulate the surfaces of such works as *1934 (white relief)* (fig. 80) or *1935 (white relief)* (fig. 81). Such subtle variations invest the reliefs with a certain weather-worn naturalness, even organicism, while the preservation of chisel marks, despite numerous layers of thick household paint, serves as witness to the artist's carving of the board. Rather than the calculated, pure compositions that they have been repeatedly held up to be, the white reliefs were presented by Nicholson as self-evidently hand-made objects. As such they can be located within a historical trajectory of truth to materials and creative individualism. Though these are basic aspects of modernism in general, if seen in the context of Nicholson's own development and values and, in particular, of his association with potters, they might be further related to a specifically English craft tradition.

The handmade quality evident in much of Nicholson's work has been

81 Ben Nicholson, *1935 (white relief)*, oil on carved board (101.6 x 166.4 cm). Tate, London.

pointed out by others. Along with the transformation of a sophisticated dark fluency into a simple, light, apparently uncomposed manner, it characterised what has been constructed as his mature work. In his paintings from the 1920s onwards an orthodox finish is subverted by the incising of, and pencil drawing over, the paint surface. With these bold, yet understated, gestures Nicholson revealed his appreciation of two key facets of modernist practice: the assertion of the work of art's status as object — through his insistence on its physicality — and the announcement through the object of the individual creativity of its maker. The intrusive brushmarking of the thick white ground of paintings from the late 1920s was developed in works made around 1932 (fig. 82). In these a thick, textured ground was ostentatiously incised before painting, denying any illusionism in the image and emphasising the painting's objecthood and process of manufacture. The assertion of the artist's presence through a nonchalant disregard for the established hierarchies of painting practice thus became a dominant characteristic of Nicholson's work. This continued with the first reliefs of late 1933 in which the irregular shapes, hesitant and unsteady lines and disjunction between colour and form establish an implied ad hoc facture (fig. 83).

Nicholson was hardly unique in the emphasis on the handmade quality of

82 Ben Nicholson, *1932 (painting)*, oil, gesso and pencil on canvas (74 x 120 cm). Tate, London.

his work. In particular, the ethic of craftsmanship and the handmade was funda-
mental to the 'truth to materials' ideology which dominated contemporary
sculpture. A romanticised, individual creativity had been elevated by Eric Gill
when he had insisted that works of art should 'owe part of their quality to the
material of which they are made and of which the material inspires the workman
and is freely accepted by him'.[13] The anecdotal account of the genesis of Nichol-
son's reliefs is consistent with this belief in the artist's instinctive relationship
with his material: in later life, he claimed that he had started to carve in response
to the 'creative accident' of a chip of gesso coming away from a ground that he
was preparing.[14] The values articulated by Gill were, of course, enthusiastically
adopted by Hepworth and Henry Moore. However, it was pottery that Herbert
Read had first held up to illustrate the relationship between truth to materials,
the handmade and the vitality of a successful art object. Through the immediacy
of the relationship between the wet clay, the hands of the potter and the pot's
final form, pottery epitomised the relationship between material, the individual
creator and, drawing on Bergsonian theory, a vital object. Echoing William
Morris, Read wrote:

83 Ben Nicholson, *1933 (6 circles)*, oil on carved board (11.4 x 56 cm). Private Collection.

A pot, whether shaped by the hand alone or by the hand with the help of the wheel, is the direct expression of the thought or intuition by which the hand is set in action and guided. The subtle varieties of beautiful form . . . cease to be beautiful in proportion as they diverge from the forms which clay may be required to assume without violence to its nature.[15]

The immediacy of the manual process of pottery allowed a particular authenticity to be claimed. So, if an analysis of contemporary ceramics reveals a particular aspect to the cult of the handmade, a consideration of Nicholson's relationship with pottery adds certain nuances to our reading of his paintings and reliefs.

Nicholson was associated with William Staite Murray and Bernard Leach, the major figures in the British Studio Pottery movement. In 1927 and 1928 he

84 Bernard Leach, *Jug* and *Tankard*, 1949 (heights 26.4 cm and 12 cm). Victoria and Albert Museum, London.

shared two exhibitions with Murray, whom he might have met as early as May 1923, and proposed him for election to the Seven and Five Society in April 1927.[16] Though it is always claimed that he and Hepworth did not meet Leach before they moved to Cornwall in 1939, they must have known his work much earlier and it seems hard to believe that Nicholson would not have met him and Shoji Hamada, his partner in St Ives, through mutual friends and galleries. Their circles were close: Leach and Staite Murray had worked together and one of Hepworth's early patrons, George Eumorphopoulos, was a collector of Leach's pots. In 1923, an exhibition by Hamada was postponed to make way for one of Nicholson's. In any case, Leach himself showed in the Beaux Arts Gallery (1928 and 1930), where the Seven and Five Society also exhibited.

Nicholson would certainly have been aware of the potters' attempt to establish a vital contemporary ceramic practice through the synthesis of early Oriental and pre-industrial English techniques and forms (fig. 84). Leach, Staite Murray

85 W. Staite Murray, *Tall Jar: 'The Bather'*, 1930 (height 70.8 cm). York City
Art Gallery.

and others, such as Leach's pupil Michael Cardew, sought to counter what was
seen as the deterioration of ceramics through industrialisation by revitalising a
vernacular tradition with alien practices and forms of spirituality and a reasser-
tion of the individualism of the potter. They combined a belief in self-suffi-
ciency, truth to materials, tradition and utility with their search to elevate their
craft and their pots. To raise the status of their work, they emphasised the indi-
viduality of the maker—considering the potter an artist and equating the pots
with sculptures (fig. 85).

The principles upon which the emphasis on individual creativity and the handmade were based derived in large part from the craft traditions and religions of the Far East. However, it was also conceived in terms of the revival of English slipware, a tradition of 'peasant work', that was perceived to have been lost in the industrial revolution.[17] Continuing a process that had its roots in the Arts and Crafts movement, Leach and Murray's revival of handmade ceramics was part of a broader movement that was further strengthened by the publication in 1924 of Herbert Read and Bernard Rackham's history of pre-nineteenth century *English Pottery*.[18] Despite his later positioning as the principal advocate of an international modern art (and of internationalism more generally), this was one of several books by Read that concentrated on English traditional visual culture. In *English Pottery, English Stained Glass* (London, 1926) and *Staffordshire Pottery Figures* (London, 1929) he presented a primitive, largely rustic English visual cultural tradition that, implicitly, offered a model for contemporary art.[19] Indeed, Read's characterisation of the maker of early Staffordshire figures anticipated constructions of Alfred Wallis, who emerged at the same time as a model for Nicholson and Christopher Wood. Comparing these potters to Douanier Rousseau, he described 'a peasant ... [who] because of [a] simple sense ... often strays unconsciously into a realm of pure forms. He blunders into beauty'.[20] A tradition of handmade pottery was thus positioned at the centre of the broader revival of early English visual culture that was marked by such events as the Victoria and Albert Museum's 1930 exhibition of Mediaeval English art.

With *English Pottery* Read and Rackham set out to correct previous histories of English ceramics in which, 'the work of the potters who, with less costly stuff, sought to meet the needs of every day life in the home, was not thought worthy of study' and in which 'the wares which are of purest English blood' were ignored for the foreign inspired products of manufacturers such as Wedgwood.[21] They were at pains to establish a distinctive English character for their subject: if there were similarities between English and foreign ceramics of the Middle Ages, they said, they were determined by the nature of a shared material. The authors, revealing perhaps their institutional context within the Victoria and Albert Museum, identified in the pots 'a national character no less marked than that of English carving in wood and stone, embroidery, wall painting, or stained glass'.[22] They argued that it was, 'a natural result of the insular position of England that English art, no less than other phases of English culture, has shown a markedly individual character as compared with the art of Continental Europe'.[23] This theme was adopted after the Second World War by George

Wingfield Digby who believed the common forms shared by mediaeval and modern English pottery were determined by their indigenous materials:

> the English potter has the sense of working with his own natural materials ... He is producing something directly from his own native soil, vegetation and rocks. Like the English mediaeval potter ... his is what may rightly be termed ... an essentially indigenous art.[24]

It has been suggested that, in revealing the qualities of the clay, Leach's technique of leaving the foot of his pots unglazed served to announce a comparable sense of rootedness: 'The foot is a symbol, here do I touch earth' as Leach was to write.[25]

A correlation was established between the traditional handmade methods and functionalism of pre-industrial pottery and a specific and characteristic English tradition. In their insistence on the primacy of utility, Read and Rackham brought this association of traditional craft and national identity into conjunction with a rural domesticity. This was echoed by Bernard Leach who explicitly established a link between Englishness and the domestic sphere. In retrospect, he recalled the Japanese response to his work in the 1930s: 'We admire your stoneware—influenced by the East', they told him, 'but we love your English slipware—born not made'. 'That sank home', he said, 'and together with the growing conviction that pots must be made in answer to outward as well as inward need, determined us to counterbalance the exhibition of expensive personal pottery by a basic production of what we called domestic ware'.[26] It was this domestic, or standard, ware which J. P. Hodin would later characterise as 'warm in character ... and homely in colour ... suitable for honey, treacle, cream—that is to say for simple, country life, the extreme opposite to life in the metropolis'.[27] Leach had recognised this in his summary of the work of the 1920s which, he wrote, 'expressed the English national temperament of one or two hundred years ago ... Its earthy and homely nature belongs to the kitchen, the cottage, and the country ... it only harmonises with the whitewash, oak, iron, leather, and pewter of "Old England"'.[28]

The world implicit in Read and Rackham's account of English pottery and with which Leach associated his own production was a form of domesticity which Ben and Winifred Nicholson actively sought to replicate in the 1920s. At Bankshead, their home in Cumberland, they chose a simple rural existence, mixing in their domestic environment traditional furnishings with contemporary works of art. Photographs reveal how, by the 1930s, the work of artists such as Piet Mondrian and Alfred Wallis punctuated the world of oak settles and

86 Front kitchen at Bankshead,
Cumbria, c.1935.

87 'At Twyning in Severn Vale' from
Gertrude Jekyll's *Old English Household Life*
(2nd ed. 1925), with Sydney R. Jones, 1939.

Windsor chairs, while a rug made to Ben Nicholson's design covers the flagstones in front of the kitchen range (fig. 86). The scene closely echoed the deliberately nostalgic illustrations of books such as *Old English Household Life*, which was published in 1926 by Gertrude Jekyll, the chief proponent of the cottage garden of imperial Britain (fig. 87).

The origins of the nostalgia for dying rural traditions can be located in the latter part of the nineteenth century and it continued after the Second World War with such publications as Noel Carrington's *Life in an English Village* (1949). By the 1920s Jekyll's book was presented as an explanation of a lost world. In it the Victorian era is blamed for the loss of a domestic life and its attendant paraphernalia, the character of which came from the means of manufacture. Echoing Read's writing on English slipware, Jekyll lamented the loss of a rural craft tradition: 'Lost is the spirit that once pervaded the village homes and brought vitality, form and purpose to labours and workmanship set in country places. Personal expression, interpreted through the cunning of human hands ... now ceases to have the place it once held'.[29] It was just this demise of an English, domestic handicraft tradition that motivated potters like Leach and Murray. Similarly, this fantasy of a pre-industrial world of simplicity was evoked by Nicholson's work.

Through the discourse around pottery a link was established between handmade manufacture and indigenous tradition. As a consequence specifically English cultural references based on an idea of rural domesticity might be read in the manifestly varied surfaces of Nicholson's white reliefs. Furthermore, the idea was established that an object's vitality (a concept fundamental to Nicholson's aesthetic) was determined by the location of the artist and their work within a native tradition. Nicholson's alignment with such a theory is suggested by his insistence to Herbert Read in 1936 (a year before the publication of *Circle*, the high-water mark of British modernism)[30] that he wanted for his art not 'a disembodied idea but one with *grass roots!*'[31]

A glimpse of the domestic environment at Bankshead is of more than anecdotal interest. I believe that we should see Ben Nicholson's art, not in terms of a pictorial or sculptural modernism in isolation, but as part of a wider desire to modernise everyday life. With his first wife, his response to modernity was the development of a new consciousness which encompassed a new life-style and new spirituality as much as new cultural forms. They both believed in Christian Science, a new faith which Ben had encountered in California during World War One and which established a unity between God and individual subjectiv-

ity. In line with this, they pursued a simple life of abstract belief, vegetarianism and an optimistic view of modernity. Winifred Nicholson's later recollection of the period encapsulates their attitude to life: 'Boundaries and barriers were broken down — and the vista ahead was light-hearted. We lived in white houses with large windows, we ate simple foods — the fruits of the earth. We wore sandals and ran barefoot along the boulevards. We talked in the cafes of the new vision'.[32] Thus modern ideas and culture — the fascination with light that informed the International Style of architecture, for instance — were combined with the simplicity and spiritual integrity of a past rural existence.

This was not simply the pursuit of individual integration through a retreat to an idealised rural past, but, I would suggest, the proposition of a modernist view based upon the domestic rather than the public realm. Since Baudelaire's description of the flâneur, modern art and architecture may generally have suppressed the domestic sphere, but I would propose that Nicholson sought to place it at the centre of his art.[33] In this respect he may be seen in relation to the Bloomsbury Group whose social and aesthetic stances were based upon ideas of the modernisation of private life and private domains. Most of Nicholson's art can be seen to depict, celebrate or allude to the domestic space. The still-life, frequently filled with the jugs, decanters and glasses that he inherited from his father, was the mainstay of his painting. Even his landscapes are domesticated: a child-like, illustrational style gives the Cumbrian scenes of 1928–30 a homely feel, while the landscape trope which he developed over many years always viewed the external environment through a window. As well as formally framing the view, this device served to draw the landscape into the domestic realm. In the style which he developed during the Second World War, the landscape is not simply composed as if a still-life, it intermingles with the arrangement of objects through which it is seen. The domestic theme was not unique to Nicholson's painting and may be seen as one of the dominant motifs of the circle of artists with which he associated in the late 1920s, grouped around the Seven and Five Society. The work of David Jones, Ivon Hitchens, Christopher Wood and Winifred Nicholson are all peppered with views of rustic interiors and landscapes seen through windows (fig. 88, pl. X).

So, in their common association with a traditional domesticity, a parallel may be drawn between the crafts and painting of the 1920s. If we accept the common polarity in which the public world is considered to be masculine space and the private feminine, we might see this concern with the domestic sphere in general, and the kitchen in particular, as gendered. If, furthermore, we accept

88 Ben Nicholson, *1929 (Feock)*, oil on canvas (52.4 x 64.4 cm). Private Collection.

the link between the handmade and a traditionally English domestic life, then the texturing of Nicholson's white reliefs might be seen to associate them with feminine domains and female work. Nicholson, himself, related his studio practice and the nature of its products to a gendered domestic labour which he discussed in terms of his own family.

In Ben Nicholson's refusal of the masculine norms of Edwardian culture amongst which he grew up, one might see a reaction against the influence of his father, the prominent painter William Nicholson. Ben had returned to Britain in 1918, following the death of his mother in the influenza epidemic of that summer, and a year later his father had married Edith Stuart-Wortley, to whom he, Ben, had previously been engaged. At that stage his painting style was close to the fluency of William's, and at least one cartoonist depicted him as a chip off the old block working in the shadow of his father.[34] However, he changed his name from Benjamin to Ben and, with his engagement to Winifred, his style changed too. A

tension existed between him and his father from that time. William's last partner, Marguerite Steen, was the author of a novel entitled *The Sun Was My Undoing* and when, later, she was preparing a biography of his father, Ben joked that it 'ought to be called The Son is my Undoing'.[35] There certainly seems to be an Oedipal subtext in his description of his subversion of established painting practice as the outcome of a 'reaction against father's "accomplishment"'.[36]

In contrast, Ben Nicholson sought to emphasise his debt to his mother, the painter Mabel Pryde. In his analysis of parental influence, he compounded gender difference, Celtic identity and a contrast between the 'primitive' and cultured sophistication, writing, 'The M[abel] N[icholson] part in my development is very much more important than anyone realises. My mother was a much more <u>primitive</u> character and but for this corrective a development of W(illiam) N(icholson)'s extreme sophistication <u>could</u> have been dangerous'.[37] He was able to address these issues during his father's last years, at which time he told Herbert Read that he had always felt,

> an intense sympathy and admiration for my mother's strength of character and scotch purpose . . . where father's taste ran to panelled walls, Dighton prints, bar parlours and Chippendale furniture . . . mother . . . said the only rooms she really felt at home in were the studio, nursery or kitchen — she said that after listening to a lot of talk about art it made her want to go and <u>scrub the kitchen table</u>. Scrubbing the top of a really well used kitchen table is very close to the way I work.[38]

Mabel Pryde's paintings certainly reflect this domestic focus, but her son's statement associates his apparently detached, modern and, by implication public, works with the most traditional and private of sites. As it happens, Nicholson claimed that *1935 (white relief)* (fig. 81) was made from the leaf of a mahogany dining table[39] but more to the point is his desire to associate artistic work with domestic labour. While noting his implicit distinction of his mother's Scottish character from English fripperies, one might see in his fixing of his work in the locus of the kitchen a continuity between the white reliefs and the domestic imagery of the paintings of the Seven and Five period.

Through their surface texture, the white reliefs can be associated with a belief in the superiority of the handmade which, in the 1920s and 1930s, was specifically associated with a traditional English domesticity. One can argue, therefore, that registered in their chisel marks and grainy textures is a gendered redefinition of Englishness similar to that which has been identified in the literature of the

period.[40] In his lifestyle, self-management and his work, Nicholson epitomised a challenge to the masculine postures of Victorian and Edwardian English culture. His privileging of his mother over his father can be viewed more broadly as a reflection of, and contribution to, the foregrounding of private life in the public domain in the inter-war period and, as such, as a reaction to both more traditional modes of painting and to the rigid virility of such modernists as the Vorticists. Just as the earlier, representational paintings of Nicholson and his associates had dwelt on the private world of the homely interior, so the white reliefs embodied those values symbolised by the kitchen table.

This aspect of the white reliefs was the subject of public debate at the time of their production, when Herbert Read used their handmade quality and truth to materials to refute Kenneth Clark's criticism of modern art's 'fatal defect of purity'. Clark's anxieties were expressed in specifically nationalistic terms, seeing 'something essentially German' in the predominance of theory and 'the Protestant structure of modern schools'.[41] In response, Read emphasised the fact that the reliefs were 'carved with hammer and chisel out of woods like walnut and mahogany' and explained that they were subjective expressions of nature determined by 'the senses of the artist reacting to a plastic material' just as the forms of natural organisms are moulded by 'sun and soil'.[42] Thus, the critic did not challenge the perceived danger posed by the foreign, but enlisted those handmade qualities which he had previously associated with an English vernacular tradition to mollify Clark's reiteration of an established perception of modernism's totalitarian overtones.[43]

In fact, Read had challenged the perception of Englishness as necessarily conservative. As we have seen, his early writings on English visual culture sought to recover a pre-industrial tradition relevant to modern needs. Furthermore, in 1933 he had edited *The English Vision*, an anthology of texts on the theme and characteristics of Englishness which was republished shortly after the outbreak of war. In his introduction to the second edition Read noted that the book had first been produced, 'when the ideals which it is designed to express were first seriously threatened by the forces which we are now compelled to challenge with arms'.[44] With a collection of the words of 'poets, statesmen and writers who have . . . felt that what they were doing or . . . propounding had about it something intimately linked with their blood and with the soil to which they belonged', Read proposed an English tradition as a model for other nations and cultures. His selection sought to define what he termed 'the English ideal', a specifically national political tradition that he posited in contrast to events in Europe. 'It is

surely desirable', he wrote, 'that in the uncertain and catastrophic times which lie before us, Englishmen should have by them a book which would compendiously remind them of those traditions of liberty, justice and toleration which have always guided our destinies'.[45] Despite its imperialist overtones, he explained that the project was not done in a 'spirit of conservatism or reaction' but because 'the English ideal is active and dynamic' and he wished to emphasise its 'universal validity': 'Alone of national ideals', he wrote, 'the English ideal transcends nationality'. He held this aspect of Englishness up as a model 'to the distracted world [of] one ideal which is above the intolerant extremes which now tyrannise over millions of unhappy people'. So, even one of the most apparently internationally minded members of the British avant-garde sought to define an English tradition that was not conservative and which could inform contemporary life.

Read also suggested an English domestic tradition as a model for modern life. In *Art and Industry* (1934), he presented the no-nonsense functionalism of pre-industrial English domestic items as reassuring and exemplary precedents for modern design. Sixteenth and seventeenth century cutlery, pottery and glass were juxtaposed with modern Continental equivalents and a Windsor chair was set up as the epitome of simple elegance (fig. 89). Thus the furniture of Jekyll's nostalgic rural life was employed to humanise and validate modernist design. Perhaps Nicholson's white reliefs served a similar function, bringing to the modern domestic environment a whiff of tradition and the human. Like the pots of Leach and the woven fabrics of craftspeople such as Ethel Mairet, their overtly handmade quality might be thought to have injected a sense of traditional labour and thus recalled an imagined, past, unalienated folk society.

In the discourse around Studio Pottery, native tradition and hand manufacture had combined to ensure the vitality of the potter's product. Vitality, an equally key component of Nicholson's attitude, was thus seen as deriving from the works' rootedness as much as from the creative individualism of its producer. Read similarly associated a liberal English political tradition with the concept of vitality and held it up as a standard around which Continental modernists might rally. One might argue that, through their invocation of a particular past rural culture, Leach and Staite Murray's pots and Nicholson's paintings and reliefs could have been seen as the cultural by-products, and thus symbols, of this ideological tradition.

To reiterate, there is nothing about craft, the handmade or texture that is *necessarily* English. However, one can argue that in the two decades between the wars the recovery of specifically English vernacular traditions gave craft and, by

114

89 Double page spread from Herbert Read's *Art & Industry* (1934; 2nd ed. 1944) showing: left, 'Demonstration model of a prize-winning chair by E. Saarinen and C. O. Eames'; right, 'Armchair of beech and ash. English; about 1800'.

association, the handmade surface, a nationalistic dimension. In any case, one cannot say that to invoke such a culture is, necessarily, to resort to a particular national identity. The referencing of a primitive, pre-industrial past is, of course, a fundamental aspect of modernism and need not be seen in such specifically English terms. However, in such texts as Jekyll's and, most particularly, in the field of pottery, the vitality of the finished object was seen as a result of its determination by indigenous materials, forms and practices. It is my argument that such was the association of the handmade with native traditions that the subtle texturing of Nicholson's white reliefs, like his other work, could have been seen to embody a particular English identity. To broaden out from that specific point, one can argue that what we know as modernism in Britain drew sustenance from the recovery of native traditions. That recovery was achieved through Nicholson's participation in the feminisation of British culture and the positing of the private and domestic as key components of a modern consciousness.

1 Philip Dodd, 'How Ben Nicholson Proved that You Can be British and Modern', *Tate Magazine* (winter 1993), 30–36.

2 Alex Potts, '"Constable Country" Between the Wars', in Raphael Samuel, ed., *Patriotism: the Making and Unmaking of British Cultural Identity, Vol.3: National Fictions* (London and New York: Routledge, 1989), 162.

3 David Matless, *Landscape and Englishness* (London: Reaktion Books, 1998).

4 Robert Colls and Philip Dodd, 'Preface', *Englishness, Politics and Culture, 1880–1920* (London: Croom Helm, 1986).

5 Samuel, ed., *Patriotism, Vol.1: History and Politics.*

6 William Vaughan, 'The Englishness of British Art', *Oxford Art Journal* 13 (1990): 11–23.

7 See, for example, essays by Andrew Causey and Sam Smiles in this volume, and Judith Collins, 'The Englishness of English Art', in James Peto and Donna Loveday, eds., *Modern Britain 1929–1939* (London: Design Museum, 1999), 69–78.

8 Jeremy Lewison, *Ben Nicholson* (London: Tate Gallery, 1993), 37.

9 Charles Harrison, plenary lecture to *Rethinking Englishness*, York University, July 1997.

10 Charles Harrison, *English Art and Modernism, 1900–1939* (London/Indiana: Allen Lane/Indiana University Press, 1981), 264.

11 For a characteristic comparison of the white reliefs and modern architecture see Lewison, *Ben Nicholson*, 44–52.

12 John Summerson, *Ben Nicholson* (Harmondsworth: Penguin, 1948).

13 Eric Gill, *Sculpture: An Essay on Stonecutting with a Preface about God* (Ditchling, 1918), cited in Harrison, *English Art and Modernism,* 212–13.

14 Charles Harrison, *Ben Nicholson* (London: Tate Gallery, 1969), 28.

15 Herbert Read and Bernard Rackham, *English Pottery: Its Development from Early Times to the End of the Eighteenth Century* (London: E. Benn, 1924), 4–5.

16 For information on Staite Murray see Malcolm Haslam, *William Staite Murray* (London: Crafts Council in association with Cleveland County Museum Service, 1984).

17 For the contemporary use of the phrase 'peasant work' see Edmund de Waal, *Bernard Leach* (London: Tate Gallery Publishing, 1997), 32.

18 Read and Rackham, *English Pottery.*

19 These texts are also discussed in Andrew Causey, 'Herbert Read and the Northern European tradition 1921–33', in Benedict Read and David Thistlewood, eds., *Herbert Read: A British Vision of World Art* (Leeds: Leeds City Art Gallery, 1993), 43.

20 Herbert Read, *Staffordshire Pottery Figures* (London: Duckworth, 1929), 22.

21 Read and Rackham, *English Pottery,* 3–4.

22 Read and Rackham, *English Pottery,* 16.

23 Read and Rackham, *English Pottery,* 37.

24 George Wingfield Digby, *The Work of the Modern Potter in England* (London: John Murray, 1952), 13.

25 de Waal, *Bernard Leach,* 36.

26 Bernard Leach, *Beyond East and West* (London and Boston, Faber & Faber, 1978/1985), 146.

27 J. P. Hodin, *Bernard Leach: A Potter's Work* (London: Evelyn, Adams & Mackay, 1967), 25.

28 Bernard Leach, *A Potter's Outlook, Handworkers Pamphlet no. 3* (London: New Handworkers' Gallery, 1928), 33.

29 Gertrude Jekyll, *Old English Household Life* (London: Batsford, 1925, rev. by Sydney R. Jones, 1939).

30 J. L. Martin, Ben Nicholson, Naum Gabo, eds., *Circle: International Survey of Constructive Art* (London: Faber & Faber, 1937).

31 Ben Nicholson, letter to Herbert Read, 24 Jan. (1936), copy, Tate Gallery Archive 8717.1.3.

32 Cited in Andrew Nicholson, ed., *Unknown Colour: Paintings, Letters, Writings by Winifred Nicholson* (London: Faber & Faber, 1987), 105.

33 See Christopher Reed, ed., *Not at Home: The Suppression of Domesticity in Modern Art and Architecture* (London and New York: Thames and Hudson, 1996).

34 See *The Nicholsons: A Story of Four People and their Designs* (York: York City Art Gallery, 1988), 13.

35 Ben Nicholson, letter to Herbert Read, 28 Feb (1943), copy, Tate Gallery Archive 8717.1.3.

36 Ben Nicholson, letter to Herbert Read, n.d. (1944), copy, Tate Gallery Archive 8717.1.3.

37 Ben Nicholson, letter to Rupert Hart-Davis, n.d. (1956), Tate Gallery Archive 9016.3.

38 Ben Nicholson, letter to Herbert Read, n.d. (1944), copy, Tate Gallery Archive 8717.1.3.

39 Lewison, *Ben Nicholson*, 220.

40 See Alison Light, *Forever England: Femininity, Literature and Conservatism between the Wars* (London: Routledge, 1991), 6–12.

41 Kenneth Clark, 'The Future of Painting', *Listener* 14 (2 October 1935): 544.

42 Herbert Read, 'Ben Nicholson and the Future of Painting', *Listener* 14 (9 October 1935): 604.

43 For more on these see David Mellor, 'British Art in the 1930s: Some Economic, Political and Cultural Structures', in Frank Gloversmith, ed., *Class, Culture and Social Change: A New View of the 1930s* (Brighton: Harvester Press, 1980), 188–89.

44 Herbert Read, 'Introduction', *The English Vision: An Anthology* (London: Routledge, 1933, 1939).

45 Read, 'Introduction', *The English Vision*.

January 1935

AXIS

**A QUARTERLY REVIEW OF CONTEMPORARY
"ABSTRACT" PAINTING & SCULPTURE**
Editor: Myfanwy Evans

● writers in this number

Herbert Read
Geoffrey Grigson
Anatole Jakovski
Paul Nash
H. S. Ede
Myfanwy Evans

● artists

Arp
Calder
Domela
Erni
Giacometti
Gonzalez
Hélion
Hepworth
Jackson
Kandinsky
Miró
Mondrian
Moore
Nash
Nicholson
Picasso
Piper
Richards
Wadsworth

1

two shillings and sixpence

90 *Axis* 1, Summer 1935, cover. Collection of Paul Rennie; photograph by Alan Powers.

The Reluctant Romantics:
Axis Magazine 1935–37

Alan Powers

CHARLES HARRISON has described *Axis* magazine (fig. 90) as 'a sensitive barometer, marking the swift change of interests among the community of modern artists and their supporters.'[1] In his 1997 essay, 'England's Climate', Harrison analyses the changing position of the magazine, its editor Myfanwy Evans and her husband John Piper, and locates a regression from the ideals of internationalism and modernism. His judgement is wholly negative.[2] The purpose of this essay is to look more closely at certain aspects of the magazine and place them in context.

Harrison and others have argued their case within the terms and categories of cultural history and art history, setting up oppositions between nationalism and internationalism, modernism and reaction. An insistence on the objective reality of these categories, however, misses the point of the magazine and its general lesson about how to understand art. Without such terms and categories, it could be argued, art history becomes meaningless, but for those willing to take such a risk, there is a more radical issue of methodology and critical epistemology to be explored.

That issue can be described in broad terms as one of romanticism, and it is not surprising that the Pipers and their circle made conscious connections between contemporary art and the Romantic movement of the late eighteenth and early nineteenth century, but the words 'romantic' and 'romanticism' do not occur frequently in *Axis*. The 'sensitive barometer' had not been pre-programmed to move in this direction. Rather, the group of artists and writers who were regular contributors to Axis were establishing their position from inductive first principles and from their personal response to the culture around them. They arrived at a romantic standpoint more by intuition than intention, and it is important to distinguish between their explorations in the 1930s, and the movement of the 1940s labeled 'Neo-Romanticism' which developed in a related but different way.

91 Opening spread of *Axis* 1, with the article 'Dead or Alive' by Myfanwy Evans; on the facing page, Pablo Picasso, *Intérieure*, 1928.

Axis magazine was founded by Myfanwy Evans (fig. 91) on the suggestion of the French painter Jean Hélion (see fig. 93 on p. 258), who imagined it as an English-language equivalent of his own journal, *Abstraction-Création* launched in 1932. Evans wrote later:

> In August 1934, I was lent a flat in Paris. I had been told by Ben Nicholson and John Piper, both of whom I had recently met, to call on the painter Jean Hélion. From the moment I entered his high, white studio, I was committed to action; talked into it by his eloquence in French and English; conquered by his work and his words.[3]

At Oxford, Evans had been a friend of Nicolete Binyon (later Nicolete Gray) and together they developed an enthusiasm for abstraction. She met John Piper (who at twenty-nine was seven years older than her) at Sizewell in Suffolk in the summer of 1934, when they were both guests of Ivon Hitchens. Piper's marriage to the painter Eileen Holding was breaking up, although she wrote for *Axis* and her constructions were illustrated there.

From the beginning, *Axis* was a product of the interaction between Evans and Piper, who in 1934 was Secretary to the Seven and Five Society, imposing a rule of non-figuration for the Society's exhibitions which Ben Nicholson was chiefly instrumental in enacting. Piper was a late starter as a painter, achieving little success during his first few years after the Royal College. Between 1934 and 1936, however, he won approval among a small public for his abstract works composed of floating, mostly vertical, colour planes suggestive of architectural space (figs. 94–95). He and Evans married in 1937, two years after setting up house at Fawley Bottom near Henley, where they remained for the rest of their lives. Later, Piper became one of the defining painters of Neo-Romanticism, famous for his visions of landscape under dark skies with dramatically high-lighted buildings. Visitors to the house and studio at Fawley Bottom in later years could still see evidence of his earlier enthusiasms. It contained not only his own abstract paintings from the 1930s but also several sculptures by Alexander Calder, a visitor to the house and perhaps the most significant influence on Piper's abstract work, together with László Moholy-Nagy, who was in England from 1935 to 1938 (see fig. 92).

From its foundation, *Axis* was at the centre of abstract art in England, with important connections in Paris (fig. 91). The magazine's subtitle, 'A Quarterly Review of Contemporary "Abstract" Painting and Sculpture', however, put the word abstract in inverted commas, and the editorial and several of the articles in the first number, dated January 1935 — H. S. Ede's 'Modern Art', Paul Nash's 'For but not With' and Herbert Read's 'Our Terminology' — were concerned with loosen-ing the definition of the word so that it could be understood more as a symptom of intention than as a category of formal appearance. Ede, Nash and Read were sig-nificant figures, all sympathetic to manifestations of modernism, but anxious to avoid the kind of closure in the name of international abstraction that Charles Harrison and others have identified with Nicholson and Barbara Hepworth. A similar reluctance simply to accept the terminology of abstraction can be found in Hélion's introductory text for *Abstraction–Création* in 1932 and many of the indi-vidual artists' statements contained within that issue. The problem of the word 'abstract' was referred to again in *Axis* 3, in Myfanwy Evans's 'A Review and a Comment', which moves from a discussion of Cézanne to argue that:

> All good painting is abstract in the sense that it translates a personal need and a universal need into one intense result that satisfies both. But it happens today that non-representational painting is called abstract and that some of

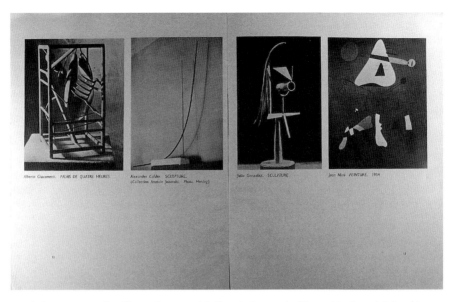

92 *Axis* 1, pages 12 and 13. Illustrations to article 'Inscriptions under Pictures' by Anatole Jakovski, showing Alberto Giacometti, *Palaise de Quatre Heures*; Alexander Calder, *Sculpture* (Collection Anatole Jakovski, photograph Herdeg); Julio Gonzales, *Sculpture*; Joan Miró, *Peinture*, 1934.

it is also abstract in this intense living way; but it is never clear whether abstract painting (meaning non-representational) is being used as a synonym for good painting or not.[4]

An article, 'Comment on England', was contributed to *Axis* 1 by Geoffrey Grigson (1905–85), a writer who exercised an important influence on the direction of the magazine. Grigson was living in Hampstead in the early 1930s and was in contact with Nicholson and Hepworth. He claimed later that the artists he knew at this time were more sympathetic to him than his fellow writers. Introduced to John Piper by Henry Moore in 1934, he described the meeting as like rediscovering an older brother who had been killed in the First World War, a brother who had been interest in antiquarianism and visiting churches and ancient sites. According to Grigson, he and Piper had a relationship almost like a love affair in which they re-enacted their childhood and adolescent explorations of the English landscape and its buildings as soul-mates.

Grigson thought of himself primarily as a poet, and edited the magazine *New Verse* in which W. H. Auden figured largely. His main income came as a journalist on the conservative *Morning Post* where he saw himself involved in a kind of fifth-column activity against the Establishment. Grigson was equally sceptical of the organised left in British cultural politics, believing that any kind of 'party line' was dangerous for creative freedom. This conviction strengthened rather than reduced his belief, shared by Auden, in the role of the artist as an indirect political commentator. Grigson opposed the aestheticism cultivated by the Bloomsbury Group because it removed artists from the political sphere. *New Verse* attacked Bloomsbury relentlessly. 'Comment on England' maintains this belligerent position, upholding the example of Wyndham Lewis, an older enemy of Bloomsbury, who sought Grigson's friendship soon after the launch of *New Verse* and became one of his chief intellectual mentors. Grigson wrote a short monograph on Lewis in 1951, describing him as:

> a man not for sale, combative fearless and independent, but combative in the support of a consistent notion of life and art . . . this formidable man was a pure stimulus to anyone in his twenties meeting him and getting to know him, whether the stimulus was fragmentary or total, whether in his generous conversation it was an illustrated injunction to read Conrad, who was momentarily eclipsed, or to look at Goya; or whether it was the imparting of a whole sense of the nobility and conscious nature of human achievement in the arts.[5]

In discussing their alliance, Harrison accuses both Grigson and Lewis of 'deep and patrician cultural nationalism.'[6] 'Comment on England' is, however, a recognition of the context in which modern artists necessarily had to operate in England, and a warning against two extremes which Grigson believed to be sterile and derivative, the Surrealists ('the new preraphaelites of Minotaure') and the Geometric Abstractionists (whom he characterised as 'unconscious nihilists'). Lewis and Moore, Grigson believed, had a combination of intuition and intelligence rare in English art, about which he was otherwise dismissive. His position, which was more cogent than Myfanwy Evans's editorial, but no less passionate, was one which recognised special conditions in English art but which applied European standards to expose its shortcomings; this love-hate relationship was similar to the editorial stance in relation to English poetry and literary culture of *New Verse*.

Lewis never published in *New Verse* nor in *Axis*, although a note at the end of *Axis* 2 (April 1935) states that 'The article by Wyndham Lewis announced for this

number will be published in a later number', a promise never fulfilled. Even so, his influence can be felt in both magazines, reinforcing the desire on the part of the editors to exercise their own standards of judgement and maintain their independence from existing groups in the world of art. They also shared with Lewis a concern with the cultural and political situation of England, and a belief that Modernism should act on a social level as a kind of spiritual renewal, remaking national identity rather than relinquishing it in favour of a form of international Modernism. Grigson's essay on 'Painting and Sculpture' in the collection *The Arts Today*, which he edited in 1935, includes Lewis within a group of contemporary British artists, the others being Ben Nicholson, Christopher Wood and Henry Moore. What was necessary, Grigson believed, was 'tension between geometry and what affects the beholder as being organic or vital.'[7] This passage occurs in a section which refers to Blake, Turner, prehistoric Sardinian bronze figures and Mondrian, in an attempt to universalise any parochial intent, though the presence of two great English Romantics is indicative of Grigson's belief in their inspirational value. In discussing a parallel group of European artists—Brancusi, Klee, Miró and Hélion—Grigson aimed to show that the English problem was a microcosm of an issue equally relevant to the major figures of Modernism.

Axis often appears to be one side of an argument between Nicholson and a group of his younger admirers, Grigson and Piper prominent among them. Grigson was a fearless critic and in a letter to Nicholson in April 1935 enlarged on some of the arguments made in 'Comment on England', once more introducing Lewis as a benchmark:

> Most contemporary art isn't very grand in England or elsewhere . . . So far as I can see, people are all painting separately all the things someone ought to be painting in one picture; a kind of 'School of X'. A always doing bits of very pale sky, B always doing a couple of doves, C always doing grey walls etc. etc; or its like always walking every day at exactly half past two (or if you like, five minutes earlier each day, in which case you finally get back to night) down exactly the same path, though of course it alters a bit as you walk on it, gets straighter and more familiar, and neater, especially if you pull the weeds out every day, until its so hard that weeds cannot grow. But by this time, as I say, you're walking down the path in the dark, and you strike a match, and look at the label inside your coat and find your name's Mondrian. Now Lewis, however incompletely he may paint because he's been completely doing so

many other things, will never have to strike that match; and you, it seems to me, may have to strike it. I like your pictures. . . . But what they haven't got (very few pictures of now or the last twenty years have) is enough of all the qualities which once made great pictures. . . . The chief thing is that there are many rooms in the house and you cannot shut down ten of them, put sheets over the furniture, and say I will just live in this very white-tiled bathroom which has no steam because it hasn't even a bath or a basin or taps. Of course, it can be said, but out of devilry if I ever got into the bathroom I should probably cover the walls with Dali transfers and pages out of *Minotaure*.[8]

Grigson's close friendship with Piper may have encouraged in the latter a similar sense of revulsion at Nicholson's active manipulation of art politics during the 1930s, the evidence of which is apparent in many of the letters received by Nicholson which are now in the Tate Archive. A letter from Piper of 5 May 1936 states his desire to disengage from Nicholson's campaigns:

There is nobody I'd rather be associated with than you (and Barbara and [Arthur] Jackson) in any continent — but with you and Barbara and Jackson as individuals — as artists — and not as part of a movement . . . I believe that movements are only discovered afterwards, that to form them at the time of their progress is to kill the artists in them. I like Chardin, Cézanne, Ben Nicholson. I dislike the French still-life school, the Post-Impressionists and the Abstract-Concs as groups, as movements, as ideas, as rackets — as any sort of a collection. I think they are, as any of these, dull and deathly.[9]

It is possible that Piper's feelings resulted from disappointment at the break-up of Unit 1 and unhappiness with Nicholson's aggressive stance in the Seven and Five Society. According to Myfanwy Evans, Unit 1 was more about 'Englishness' than it was about international art in the mind of Paul Nash, effectively its founder, 'though he was aware that no live painting or sculpture could go on in England without taking it into account.'[10] Nicholson and Hepworth, however, found such a position unacceptable. It seems altogether likely that Nash made his feelings understood to the Pipers at the time, even though his friendship with Nicholson went back to the Slade School in 1910.

Piper's belief that organised groups and labelled movements were the enemies of creativity was similar to Grigson's position in *New Verse*, where he maintained that poetry could be politically engaged while at the same time he deprecated particular political parties of the left (notably the British Communists) because

of their stultifying effect on artistic independence. Apart from Auden, Grigson's favourite contemporary poet was probably Louis MacNeice who stood apart from specific politics while remaining actively engaged in political and social issues. *Axis* magazine, similarly, stood apart both from the exclusive wing of the Abstractionists and from the opposing Surrealists. Henry Moore, who managed to straddle both movements, was perhaps the best example of Grigson's belief that creativity arises out of tension.

The last article in *Axis* 1 was a review by John Piper of a loan exhibition of fourteen works by Picasso at the Tate. The article is representative of *Axis* writing in its argumentative energy and breadth of reference, and it continued the anti-category theme from the preceding articles by setting up 'classic; and romantic' as opposite poles. Neither pole, Piper argued, was adequate to describe Picasso: '"Picasso is a romantic" is a cheap taunt—if it isn't a compliment. After all, a tiger as a visual entity may quite reasonably be considered as a red splash in perfect control.' As an artist who had affinities both with Abstraction and Surrealism, but who was not reducible to either position, Picasso was the paradigm of *Axis*'s desire to escape from art politics into a greater imaginative reality.

The editorial of *Axis* 2 (April 1935) is a philosophical prose-poem, 'Beginning with Picasso', which is typical of Myfanwy Evans's critical writing. The final paragraph establishes the proper field of artistic activity as the achievement of organic development or growth that has a mystical relationship to what reads as a Neo-Platonic view of the nature of reality:

> An object can be nothing but itself, existing in a clear, everyday light with space round it. A square, for instance. A square realised as an object can be used in a picture to make a definite statement, depending on the particular way it is used for its vigour—not on the convictions or associations of those who look at it. This is a fine base to build on, and one that will bear structural elaboration. It allows the use of forms which are subtle because they signify life without suggesting or recalling it. Forms that exist and are used so positively that they can only be part of a very real world.[11]

Later, Evans wrote 'Picasso was the Protean rock which slipped from our fingers when we clung to it, upon which we foundered when we pretended that it was not there; whose personality and aggression acted upon us like rape just when we had settled for the Mondrian cloister: the complex subtleties of limitation.'[12]

The mystical and philosophical dimension of *Axis* is pursued in articles in the second issue on Kandinsky and Klee, while the cajoling of Nicholson continued

with articles by Herbert Read and Jan Tschichold on the white reliefs, which at this time constituted the most significant aspect of Nicholson's output. The two appraisals seem deliberately contrasted: Read anticipates some imminent new development in Nicholson's art, while Tschichold—the distinguished Czech-Swiss typographer—encourages Nicholson to continue his pursuit of his theme. It is this kind of internal dissent that makes *Axis* difficult to categorise, because the context suggests that the reader is expected to absorb both positions. In this instance, the conflict as such is unimportant, but it is symptomatic of Evans's approach as an editor and as a writer to relish unresolved contradictions and oxymorons. Frances Spalding describes the editorial policy of *Axis* as 'intelligent but inclined to waver', but it is the wavering (or rather the admission of fruitful conflict) that is the defining characteristic of its intelligence.[13] This unstable condition was something like Grigson's 'tensity', a term I shall come back to shortly. As Evans wrote in *Axis* 4:

> It seems to me that in criticism to-day, something is needed which comes between dogmatic evaluation for all time and running commentary dictated by a mood. Criticism in which the price of effort is not permanence. And I should like to state dogmatically that this is the principle aimed at in *Axis*.[14]

A long article by Jean Hélion, 'From Reduction to Growth', is useful in showing how, while being an advocate of abstraction, he would have approved of Evans's dissatisfaction with it as a style-label. 'Artists look for a cul-de-sac in which to build themselves a throne. In fact the most technically perfected works, the most achieved works are now produced in the cul-de-sac position.'[15] Picasso was for Hélion the prime example of an artist who avoided this pitfall: 'To the necessary reductions of others, he opposes permanent additions; to stagnation, life; to formulas, permanent improvisation.'[16]

Hélion does not offer Picasso as a simple solution, however, and criticises the lack of depth resulting from his rapid movement from one manner to another. Neither does he accept any simple evolutionary programme for art, believing that even the best contemporary art is inferior to the art of the past. In the welter of current practice, it is the 'real axis' (referred to at the end of the article as 'the axis of progression') that must be sought. But Hélion insists that abstraction (understood here in terms of Mondrian) is only part of a larger whole: 'It offers certitude, order, clarity but also extreme limitation'.[17] Two words suggest the way forward, 'nature' and 'authentic':

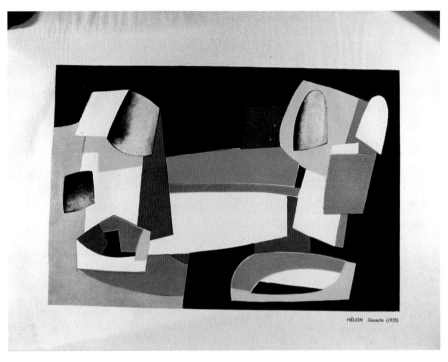

HÉLION *Gouache* (1935)

93 Jean Hélion, *Gouache*, 1935, from *Axis* 4, November 1935, page 3. Reproduced in colour.

It is through an authentic development that art has reached an abstract form, but the fact 'abstract' cannot be taken as principle or aim. It is the aspect of the realisation, a consequence of the degree of conception, a certain stage of evolution. I have not used any element of naturalistic origin (consciously, at least) for many years, and I do not see how I would, but I say No to nothing in advance.[18]

Hélion opposes 'nature' and 'naturalistic', arguing that the strength of old masters such as Poussin lay in their understanding of rhythm as part of the deeper structure of nature—something which the constrained and reduced techniques of abstraction are hardly able to reproduce. Expanding on the theme in his essay, 'Poussin, Seurat and Double Rhythm' in *Axis* 6, 1936 (reprinted in *The Painter's Object*) Hélion states: 'In a picture an element is real when it behaves like nature, when it coincides with its currents. The reality of the picture lies on the canvas,

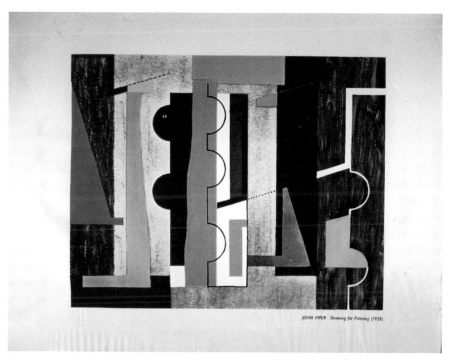

94 John Piper, *Drawing for Painting*, 1935, from *Axis* 4, November 1935, facing page 12. Reproduced in colour.

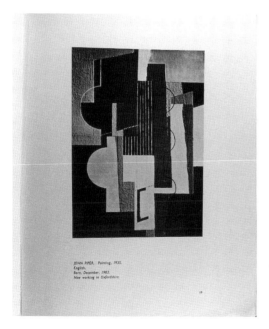

95 John Piper, *Painting*, 1935, from *Axis* 5, Spring 1936, page 19. One of a series of works illustrated from the *International Exhibition of Abstract Painting, Sculpture and Construction*, organised by Nicolete Gray, Oxford, Liverpool and Cambridge.

not at all in the origin of the theme or of its elements. The field of conception belongs to nature. That is why "abstract" is a misplaced word.'[19]

Grigson's article 'Henry Moore and Ourselves' in *Axis* 3, 1935, develops further the idea of 'tension' or 'tensity', the word Grigson also used in *The Arts Today* to describe the source of creative energy which depends on not following a prearranged programme while at the same time being conscious of the attraction of opposite doctrinal poles. In an argument comparable to Hélion's, nature ('life') is set up as a necessary counterpart to the sphere of human interest and concern ('thought'), so that Grigson criticises those works by Moore which he believes are 'vegetative, static or at least slow-moving' but at the same time admires his intuitive way of working. He holds Moore up as representative of the cultural condition of his time, and hopes that through him the alienation from nature suffered by modern people as a whole could be reversed:

> Only the rarest artist is likely to give such abstractions a consistently energetic, dramatic quality, a quality of the life of thought and the required degree of the life of nature, or the organism, in a period like ours which is one of confused and hasty distraction, of possibilities of construction and power of excellence, but of still more enormous likelihood of destruction.[20]

The last part of this passage emphasises the peculiar period in which *Axis* was published. The magazine did not make direct reference to the political situation in Europe, but it can be inferred from the sense of urgency and an awareness that the freedom to experiment in the arts might be short-lived. The word 'reality' covers in different ways the whole spectrum of 1930s art, from Social Realism to Surrealism, but the search for reality, which was a consistent theme in *Axis*, can be related to these threats and to the realisation that part of the purpose of art was to achieve a more profound diagnosis of the spiritual problems of Modernity. In several contributions to *Axis*, Hugh Gordon Porteous, a critic of art and literature who, like Grigson, was a disciple of Wyndham Lewis, expressed frustration at the gap between the élite readership of the magazine, the deeper philosophical problems of the time and a public apparently unwilling to make the necessary effort to reward genuine achievement in art.

The publication of the periodical *Circle: An International Survey of Constructive Art*, edited by Ben Nicholson, the architect J. L. Martin and Naum Gabo in 1937, affirmed a rational and positivist position, more characteristic of the 1920s in Europe. Presenting works by leading continental abstract artists and architects, it emphasised the correspondence between art, design and science,

through its range of contributors and topics. Hélion and the other key contributors to *Axis*, on the other hand, saw nature in terms of processes which could be interpreted through a variety of visual and verbal languages. They did not embrace the irrationality of Surrealism, but created a middle position where experience could feed more directly into imagination. Experience is the test of truth in S. John Woods' article 'Time to forget ourselves' in *Axis* 6, where he argues that Social Realism is likely to be too literal, and that abstraction has the capacity to convey a deeper level of reality which cannot be dependent on rules: 'living implies something dynamic, something which breaks a rule if it is necessary and transcends rules in any case. Out of living comes a live art, something with guts, which doesn't give a damn for anybody and which may stand alongside the art of the great periods.'[21] An anti-theoretical, empirical position, based more on individual artists and their work than on the ill-fitting programmes of different groups, was set out by Evans in the editorial, 'Order, Order' in *Axis* 6 (summer 1936) which came out at the time of the International Surrealist Exhibition. In the wake of the battle surrounding the word 'abstract', the term 'surreal' now seemed to claim 'not only any oddity but ... any sign of intensity and guts in a work of art or piece of behaviour.'[22]

Axis could have given a name to the tendency this term currently represented, but Evans was determined to resist categorisation, writing: 'I have refused perfection and progress on the one hand and eloquent revolution on the other. It is a gesture but it is incomplete unless it is made towards something, and towards something that is not merely halfway between surrealist art and abstract art.'[23] As Piper wrote in a review of Picasso in the same issue of the magazine, 'nowadays we tend to invent the school before we produce the painting.'[24] The argument continues in *Axis* 6 with the article 'Surrealism and Abstraction—the search for subjective form' by J. and M. Thwaites, which responds to the bundling together of so many artists under the banner of surrealism by trying to separate out those—Ernst, Klee, Miró, Masson and Arp—who have greater affinities with the abstract search for form.

The last two issues of *Axis*, dated Autumn 1936 and Early Winter 1937 indicate a further change and development. For the first time, the subject of England shifts from being a geographical contingency to a more active role. *Axis* 7 opens with the article 'England's Climate', written jointly by John Piper and Geoffrey Grigson. Alternate paragraphs are identified as the work of the two authors, and the article has the quality of a conversation between close friends, with aspects of a private language. Andrew Causey refers to 'England's Climate' as 'an article about Blake,

96 Henry Fuseli,
Drawing (Victoria and
Albert Museum) and
Samuel Palmer, *Barn at
Shoreham* (courtesy
Martin Hardie Esq. and
Victoria and Albert
Museum). Illustrations
to 'England's Climate'
by Geoffrey Grigson
and John Piper in *Axis* 7,
Autumn 1936, page 7.

Palmer and Constable'[25] but although these artists are mentioned (the illustrations are of Fuseli, Palmer, Constable and Christopher Wood, figs. 96–97), the article is not about them, nor, in any literal sense, about England or its climate. In Harrison's dismissal of its 'ordinariness' there is an equal misunderstanding.[26]

At issue is the question raised by Grigson in other writings, and in his letter to Nicholson, about the failure of contemporary art to live up to the qualities of past art. As Piper says, 'Any Constable, any Blake, any Turner has something an abstract or a surrealist painting cannot have. Hence, partly, the artist's pique about them now and his terror of the National Gallery. The point is fullness, completeness: the abstract qualities of all good painting, together with the symbolism (at least) of life itself.'[27] Piper argues that symbolic content has to be acknowledged if the quality of life is not to be suppressed in art, although this does not necessarily imply representational symbolism. In one of Grigson's paragraphs, Samuel Palmer is taken as a warning about the danger of loss of vision

Above: CONSTABLE, Brighton beach with Colliers. (Victoria and Albert Museum.)
Below: CHRISTOPHER WOOD, Leaving port. (Coll. Lord Berners. Photo courtesy Redfern Gallery.)

97 John Constable, *Brighton Beach with Colliers* (Victoria and Albert Museum) and Christopher Wood, *Leaving Port* (Collection Lord Berners, photograph courtesy Redfern Gallery). Illustration to 'England's Climate' by Geoffrey Grigson and John Piper, in *Axis* 7, Autumn 1936, page 8.

under the pressure of society; his was 'a tragic life suppressed under the massive weight of a new age.'[28]

The article finishes with a complex passage by Grigson which is often quoted but also apparently misunderstood. The problem concerns the difference between whether history should be viewed as remote and unreachable, with the present as the outcome of evolutionary process, or — as Grigson would have it — whether history should be seen as continuously contemporary and reachable through a direct imaginative connection with artists and writers of the past. The power of imagination will, he believes, defeat the threat of imitative historicism and, through acknowledging the past as a live reference point and standard, will allow contemporary artists to convey the authentic quality of their own living. Thus, he writes:

There is no 'past', there are no pictures painted 'in the past,' equally there is

no exclusive Fair Isle of the present, there is only a human instinct, a being. 'Now' is inclusive; and in the Middle Ages most men did not know whether the year they were in was 1350 or 1351 or 1390. Accept so much, forget the year (though not the realities of the year) and paintings and writings simply become life, they can be felt as thoroughly as life; and 'modern' art can safely walk out from the gay, white armour of its studio into the galleries and begin to learn. It will not be running the eclectic or—facile pejorative—the 'literary'—risk.[29]

In this passage, Grigson shows his concern to activate the imaginative resources of the generation of painters and writers known as the Romantics by going beyond their specific characteristics to rediscover a more profound world-view, one which we might now define as phenomenological. Resistance to the rational modern mind, to those materialist forces which crushed Palmer, was as much a live issue in the intellectual world of Europe in the 1930s and after as any other issue within modernity. As Grigson later wrote of his own inner transformation in the mid-1930s, 'the dry wrappings were beginning to loosen and fall away'.[30] The insularity of England might be reflected in the fact that Grigson and his associates were probably unaware of the European development of phenomenology, but their common cause with this movement shows how Charles Harrison's assumption that *Axis* was separated from the international mainstream depends on a narrow definition of what European thought was most significant.

Grigson's rediscovery of the early work of Samuel Palmer (fig. 98) was representative of the attempt to retrieve an alternative world view. Until the 1934 Royal Academy Exhibition of British Art, Palmer was largely known for his later works, including his etchings, which were an influence on Graham Sutherland and his contemporaries at Goldsmiths' College in the 1920s. Few works of the Shoreham period were in public collections or reproduced in books, but several important examples were shown in 1934 and established Palmer as an artist who exemplified the difference between authentic Romanticism, in his early life, and the sentimental Victorian perversion of Romanticism in his long late career. In an article on Palmer in *Signature* magazine in 1937, and in two books on him published in 1947 and 1960, Grigson emphasised the philosophical basis of Palmer's apparently spontaneous response to the magical quality of nature, assuming that it was Blake who introduced Palmer to the mystical writings of the seventeenth-century German shoemaker Jakob Boehme, who, as Grigson wrote in his introduction to his anthology, *The Romantics*, 1942, 'more than

SAMUEL PALMER: WALL FRUIT TREE IN BLOSSOM (Shoreham Period)
Reproduced by permission of Mrs. Parker

SAMUEL PALMER: OAK TREES IN LULLINGSTONE PARK
(Shoreham Period)
Formerly owned by Herbert Linnell. Exhibited at Walker Art Gallery, July 1937

98 Samuel Palmer, *Wall Fruit Tree in Blossom* (Shoreham period), reproduced by permission of Mrs. Parker; *Oak Trees in Lullingstone Park* (Shoreham period), formerly owned by Herbert Linnell. Exhibited at Walker Art Gallery, July 1937. From *Signature* 7, November 1937, illustrating article 'Samuel Palmer at Shoreham' by Geoffrey Grigson, facing page 16.

anyone else, made the eighteenth century believe that the world was the image of Paradise; it was the type of the heavenly pomp.'[31] In 1960, Grigson wrote that Palmer was 'one of our notable modern discoveries, which followed the discovery of the poems of Gerard Manley Hopkins and John Clare'.[32]

The re-enchantment of nature is a quintessentially Romantic idea, and Grigson's belief that historical time could be telescoped to make these chosen artists of the past contemporary was directed by a conviction that they offered relevant responses to the problems of the present. Grigson himself was brought up in Cornwall and was learned in plants and botany, so that for him, as for many of his generation, the experience of living in nature was the definition of reality. I. A. Richards, one of the founders of the English Faculty at Cambridge, responded in the 1920s to the feeling of despair induced by the First World War by arguing that many people's attitude to nature had become disenchanted because of the increasing influence of science which had produced a distorted

ENGLISH STAINED GLASS. 13th century. Originally in Salisbury Cathedral, now in Grateley Church, Hampshire. (From copy by John Piper.)

99 English Stained Glass,
13th century, originally in
Salisbury Cathedral, now in
Grateley Church, Hampshire
(from copy by John Piper).
Illustration to 'England's
Climate' by Geoffrey Grigson
and John Piper in *Axis* 7,
Autumn 1936, page 4.

and reduced perception of reality. A new imaginative force was needed on the part of the arts to redress the balance and Richards' short book *Science and Poetry*, 1926, shows how, long before *Axis*, the groundwork was laid for a reconstruction of Romanticism within Modernism.

The interest in Romanticism in the 1930s was a response to historical conditions which were producing a general reassessment of English culture. The previous one hundred and fifty years of art were seen to contain many important individuals whose reputations, like Palmer's were being reconsidered in the light of new discoveries. The distant past was also important, and the first illustration of 'England's Climate' is a copy of a thirteenth-century stained glass window at Grateley Church, Hampshire, drawn by Piper in the late 1920s, a work which he later claimed had a particular significance for him (fig. 99). In 1936, Piper published the article 'England's Early Sculptors' in the *Architectural Review*, later reprinted in *The Painter's Object*, which argued for a reassessment of the crude

and primitive carving found on fonts in parish churches. In this and other arti-
cles, Piper was proposing an elision of historical time and, at the same time, that
the belief in the inferiority of English art, assumed by Bloomsbury writers,
should be replaced (as writers around the Royal Academy Exhibition of British
Art in 1934 argued) by a willingness to understand British art as a special case,
not conformable to continental norms. Harrison's paradigm of an absolute
opposition between England and Europe is too extreme to catch the more subtle
proposal implicit in *Axis* that international modernism offers an education for
the eye, through which the value of national traditions can be better understood.
This reappraisal was extended to non-western culture in *Axis* 7, in which W. G.
Archer and his wife Mildred, historians of Indian art, drew parallels between
contemporary folk-art Santhal wall paintings in Bihar and work by Mondrian
and Nicholson. A review of Henry Moore by S. John Woods in the same issue
develops the related discussion of the universal quality of the 'primitive', stating
that 'Moore is the primitive in the purest sense. But his primitiveness is neither
the primitiveness of the savage nor of the noble savage; there is no museum dust
or cobwebs nor is there false romanticising.'[33]

Axis 8, 'Early Winter 1937', was the final issue of the magazine, although a
ninth number was announced in it. The opening article, 'Prehistory from the
Air' was John Piper's main contribution to the whole series. It reinforces the idea
of transhistorical links by presenting aerial reconnaissance photographs of pre-
historic sites, treated as found objects, in conjunction with a painting by Miró.
The article, written from direct experience of the sites, welcomes all possible
forms of representation, so that William Stukeley's engraving of Silbury Hill in
1723 becomes 'as real and as sharp an experience as to take a journey round a
wineglass with Picasso.'[34]

Myfanwy Evans's article 'Paul Nash 1937' rhapsodises over the Englishness of
Nash's work in an entirely novel way, using the words 'climate' and 'weather'
('Paul Nash has absorbed the English climate'), to imply a phenomenological
understanding of space and time. This, Evans suggests, gives Nash a special
advantage in being able to stand outside the politics of art: 'He seems at once
entirely innocent of the predicament [of having to choose between the comfort
of a group or the discomfort of an individual position] and to belong very defi-
nitely to to-day.'[35] The actual nature of his Englishness remains teasingly
unstated, but the text implies that if the art politics of England are a microcosm
of the real politics of Europe, then Englishness can be identified with an ability
to engage with issues (unlike the neutral countries) without being constrained

by doctrine (like the Communists and Fascists). Two other articles in the same issue make direct reference to the European situation, a review by Robert Medley of the 'House of German Culture' and the exhibition of Decadent Art in Munich, and a review of the Paris International Exhibition by the architect Herbert Tayler, who found the Spanish pavilion, by J. L. Sert, which housed Picasso's *Guernica* and a mercury fountain by Calder, the most convincing statement of a modern position.

The word 'romanticism' makes one of its rare appearances when Evans states that in Nash's work, 'the contour of things past is given the aura of things present, so the reality and the romanticism of both is intensified.'[36] This is a further example of the combination of opposite characteristics which has already been identified as typical of Evans and other *Axis* contributors. It is perhaps surprising to find the word 'romanticism' used pejoratively, as a counterpoint to 'reality', when another article in the same issue, 'Background' by Kenneth Walsh comes closest of all the *Axis* articles to defining a spiritual and philosophical basis for romanticism. Walsh, who also contributed 'Abstraction as a Weapon' to *Axis* 5, opposes rational materialism to a description of an alternative form of consciousness leading to a more profound grasp of reality. Abstract art plays a part in the process of exploration, although Walsh denies that its significance can yet be understood, because of the rapidly changing context. The word romanticism continues to be avoided by Walsh, so *Axis* magazine implies, without explicitly stating it, a relationship between romanticism and a spiritual re-grounding of modern art in a more profound experiential reality. It would have been contrary to Evans's mistrust of labels and styles to fall for any simplistic use of the term romanticism, so the ambiguity is no doubt intentional.

Hélion was equally engaged in working out the dialectic between abstraction and the forces of life. Apparently, Mondrian told him in 1933 or 1934, 'basically, you are a naturalist' while Meyer Schapiro maintained in 1936, 'through abstract painting you are seeking a way back to nature.'[37] In a notebook of 1948, Hélion recalled, 'I found myself at the end of 1938 or in 1939 confronted with an abstract system cracking at the seams and life budding mysteriously through it. Realising this, I returned to the motif.'[38] Like Piper, Hélion became a figurative artist, partly under the influence of changing conditions just prior to the war, and treated his abstract work as a formal preparatory training. As he stated in 1944: 'A painting must rely on the tense visual structure of abstract art. It must investigate the mysterious side of man with Surrealism. But it must also comprise what both lacked: reality.'[39]

Similar internal debates can be recognised among others associated with *Axis* but further from its inner core. Herbert Read, a contributor to some of the early numbers of the magazine, was less wary of categories than Grigson and the Pipers, but his writings in the 1930s show a similar desire not to be trapped by them. His introductory essay to the book *Surrealism*, which accompanied the 1936 *International Surrealist Exhibition* in London, which was later reprinted as 'Surrealism and the Romantic Principle', is a well-known example. Read analyses the movement in terms of the opposite positions of classicism and romanticism. His political stance as an anarchist was consistent with an opposition to the politics of technocracy, in accordance with a radical tradition going back to Blake. In the diversity of his enthusiasms in the 1930s, Read supported many artists and movements that could not be described in terms of romanticism, but one could suggest that this very range of interest on his part was a symptom of a romantic outlook. Moreover, Read wrote about his visionary childhood experience of nature in *The Innocent Eye* (1933) in a way that could be compared to Grigson's understanding of his country upbringing as an ultimate test of reality.

Between 1937 and 1939, the implications of a romantic revival in *Axis* became more overt. John Piper's painting changed from abstraction to renderings of buildings and places, some using collage, which were the recognisable precursors of the theatrical style of topographical work with which he made his name during the war years. His article 'Lost, a valuable object' in *The Painter's Object* calls for a return to observational figurative work, although the idea that it presents symbolically, of sitting in a field and concentrating on a single tree was not one which Piper ever followed, and it is arguable that too much attention altogether has been paid to the text. 'Romantic art deals with the particular', Piper claimed in the opening sentence of his book, *British Romantic Artists*, 1942, but although his representational paintings were henceforth linked to specific places, they were never intended to be topographically literal, and sometimes verged on a more expressionist form of abstraction. In articles for the *Architectural Review* and in the *Shell Guide to Oxfordshire*, 1938, commissioned by John Betjeman, Piper began to emerge in some of his other familiar aspects as a photographer and inspired writer about places. Neo-romantic topography was not a new genre, but Piper succeeded in reconstructing it as a fresh idiom more successfully than any other painter.

Piper and Graham Sutherland are rightly linked as early representatives of the fusion between modernism and romanticism. However, although Sutherland

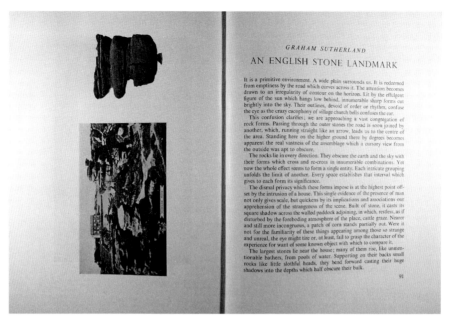

GRAHAM SUTHERLAND

AN ENGLISH STONE LANDMARK

It is a primitive environment. A wide plain surrounds us. It is redeemed from emptiness by the road which curves across it. The attention becomes drawn to an irregularity of contour on the horizon. Lit by the effulgent figure of the sun which hangs low behind, innumerable sharp forms cut brightly into the sky. Their outlines, devoid of order or rhythm, confuse the eye as the crazy cacophony of village church bells confuses the ear.

This confusion clarifies; we are approaching a vast congregation of rock forms. Passing through the outer stones the road is soon joined by another, which, running straight like an arrow, leads us to the centre of the area. Standing here on the higher ground there by degrees becomes apparent the real vastness of the assemblage which a cursory view from the outside was apt to obscure.

The rocks lie in every direction. They obscure the earth and the sky with their forms which cross and re-cross in innumerable combinations. Yet now the whole effect seems to form a single entity. Each intricate grouping unfolds the limit of another. Every space establishes that interval which gives to each form its significance.

The dismal privacy which these forms impose is at the highest point offset by the intrusion of a house. This single evidence of the presence of man not only gives scale, but quickens by its implications and associations our apprehension of the strangeness of the scene. Built of stone, it casts its square shadow across the walled paddock adjoining, in which, restless, as if disturbed by the foreboding atmosphere of the place, cattle graze. Nearer and still more incongruous, a patch of corn stands partially out. Were it not for the familiarity of these things appearing among those so strange and unreal, the eye might tire or, at least, fail to grasp the character of the experience for want of some known object with which to compare it.

The largest stones lie near the house; many of them rise, like unmentionable bathers, from pools of water. Supporting on their backs small rocks like little slothful heads, they bend forward casting their huge shadows into the depths which half obscure their bulk.

91

100 Postcard of Brimham Rock, Yorkshire and photographic detail of rock, illustrations to Graham Sutherland, 'An English Stone Landmark' in *The Painter's Object*, edited by Myfanwy Evans, 1937, page 90.

contributed an article about Brimham Rock in Yorkshire to *The Painter's Object*, he never appeared in *Axis*, and there was an element of rivalry (fig. 100). On the other hand, Piper, Sutherland and Grigson all contributed articles to *Signature* magazine, founded, like *Axis*, in 1935, and edited by the typographer Oliver Simon, who had a personal sympathy for their shared outlook. Sutherland's article 'A Trend in English Draughtsmanship' in *Signature*, 1936, shows that he too realised the damaging effect of excessive categorisation in contemporary art:

> It is our wont, nowadays, in attempting to discuss the nature of things, to make categories. This, however, is an imperfect method of identification, and particularly so when we attempt to discuss the nature of art; for the very qualities which we regard as being especially characteristic of a particular type of art are in fact, elusive, and may be found to be a constituent of another type of art.

Prefaced by a quotation from William Blake, Sutherland's article offers more

101 Graham Sutherland, illustrations to 'Welsh Sketchbook', *Horizon*, vol. 5, no. 28,
April 1942, pages 228–29.

direct evidence for constructing an intellectual lineage for the romantic revival
than does *Axis*, for as a student in the 1920s, Sutherland had made his own dis-
covery of Samuel Palmer. While Blake is credited with being completely repre-
sentative of the type of imaginative and 'subjective' artists that Sutherland
wishes to discuss, he concentrates on Blake's wood-engraved illustrations to
Virgil, the works by Blake which most inspired Samuel Palmer in 1824. Paul
Nash and Henry Moore are the only artists placed in this lineage (although
Sutherland presumably included himself), and he presents a perceptive analysis
of Moore's method in terms of the 'contrarieties' which connect him to Blake:
'We find Moore discovering one thing with the help of another, and by their
resemblance making the unknown known.'[40]

Unlike Piper, Sutherland was never a purely abstract painter, although in the
1930s he made a definite break with his earlier style, finding a new direction in
painting visionary landscapes in Pembrokeshire in the summer of 1936. His
account of this experience, in a published letter in *Horizon* magazine in 1942,

vividly conveys the romantic experience of loss of self in the presence of nature, 'I felt just as much part of the earth as my features were part of me. I did not feel that my imagination was in conflict with the real, but that reality was a dispersed and disintegrated form of imagination.' (fig. 101)[41] At the beginning of the war, Piper, Moore and Sutherland were the only younger artists selected by Sir Kenneth Clark to work as official war artists who could claim connections with the 1930s avant-garde. This was viewed at the time by Nicholson as a betrayal of their modernist principles, a view repeated by Harrison, and it can be claimed that the delicate balance between creativity and precedent proposed in *Axis* was upset by the demand that, as war artists, they should avoid making 'difficult' work.

It was not a simple transformation, however. The conditions of wartime were prefigured in the period of *Axis*'s publication and such an outcome seems unavoidable. Even Nicholson underwent a series of changes while working in St Ives, returning to representation and acknowledging the spirit of landscape and place even in abstract works. Equally important was the generational shift, as Moore, Piper and Sutherland passed the age of forty (between 1938 and 1943) and younger artists began to emerge. Although the three artists enjoyed a success previously unimaginable thanks to their accord with the zeitgeist and Clark's support, Grigson was left with a growing sense of disappointment amounting to betrayal. In 1948, he wrote a strongly-worded attack on Piper and Sutherland in 'Authentic and False in the "New Romanticism"', saying that neither artist had been 'affirmative of life' and that Piper had lapsed too much into a comfortable formula of Englishness.[42] Sutherland, he claimed, appeared to hate nature, and in the weight Grigson places on love of nature we come closest to understanding what romanticism meant for him on a universal plane:

> How ironic it seems that Sutherland should picture death in nature with much learning derived from a lover of the spirit in Blake and a mystical lover of the divine, through living, growing, flowering nature, in Palmer; how ironic — and a portion of the present 'romantic' falsity — to apply the means devised for purposes of love, the means elicited or controlled by love, to the picturing of death![43]

Grigson mentions but refuses to name 'two or even four' younger painters 'in whom love and growth may be more powerful than hate or death', but this article declared the end of whatever *Axis* had begun.[44] Others concurred in regretting what they saw as Piper's decline, while Moore, alone of the trio, continued

to command widespread respect. Grigson affirmed this by writing the *Penguin Modern Painters* volume on his work in 1944. Moore's insistence that there could be a balance between order and intuition remains an important shield against too easy a dismissal of the artists and writers of *Axis*, as it is equally against the tendency to judge the potential of romanticism in 1938 by its outcome in 1948.

In literature, Grigson continued to believe that Auden had achieved the desired creative harnessing of contrary conditions, using an effort of imagination to rescue Englishness from triviality and transform it into something universal without losing its particularity.[45] In 1975 he still believed that, even if the results went off course, there had existed an alternative possibility in the space between the polarities of 1930s art, saying that:

> In English art you ... already had, in the Thirties, a nice balance between Henry Moore, shaping an almost local surrealism of his own in those heavy shapes cohering on the ground, and Ben Nicholson, being severe and clear in an unsurrealistic mystery of tones, areas and layers. Somewhere between the two, possibly, lay the secret egg.[46]

Elusive but not unimaginable, the 'secret egg' deserves its place in the incubator of history.

1 Charles Harrison, *English Art and Modernism 1900–1939* (London and Bloomington: Allen Lane and Indiana University Press, 1981), 319.

2 Charles Harrison, 'England's Climate' in Brian Allen, ed., *Towards a Modern Art World* (London and New Haven: Yale University Press, 1997), 206–25.

3 Myfanwy Piper, 'Back in the Thirties', *Art and Literature* (Lausanne, Winter 1965), 139.

4 Myfanwy Evans, 'A Review and a Comment', *Axis* 3 (1935): 25.

5 Geoffrey Grigson, *The Crest on the Silver: An Autobiography* (London: Cresset Press, 1950), 165.

6 Harrison, 'England's Climate', 224.

7 Geoffrey Grigson 'Painting and Sculpture' in Grigson, ed., *The Arts Today* (London: John Lane, 1935), 73.

8 Tate Gallery Archive, Ben Nicholson papers, 8717.1.2.1422.

9 Tate Gallery Archive, Ben Nicholson papers, 8717.1.23403.

10 Myfanwy Piper, 'Back in the Thirties', 142.

11 Myfanwy Evans, 'Beginning with Picasso' *Axis* 2 (April 1935): 3.

12 Myfanwy Piper, 'Back in the Thirties', 144.

13 Frances Spalding, *British Art Since 1900* (London: Thames and Hudson, 1986), 127.

14 Myfanwy Evans, 'Hélion to-day: a personal comment', *Axis* 4 (November 1935): 9.

15 Jean Hélion, 'From Reduction to Growth', *Axis* 2 (April 1935): 20.

16 Hélion, 'From Reduction to Growth', 20.

17 Hélion, 'From Reduction to Growth', 21.

18 Hélion, 'From Reduction to Growth', 24.

19 Jean Hélion, 'Poussin, Seurat and Double Rhythm' in Myfanwy Evans, ed., *The Painter's Object* (London: G. Howe, 1937), 104.

20 Geoffrey Grigson, 'Henry Moore and Ourselves', *Axis* 3 (1935): 9–10.

21 S. John Woods, 'Time to forget ourselves', *Axis* 6 (Summer 1936): 21.

22 Myfanwy Evans, 'Order, Order' in *Axis* 6 (Summer 1936): 8.

23 Evans, 'Order, Order', 4.

24 John Piper, 'Picasso belongs where?' *Axis* 6 (Summer 1936): 31.

25 Andrew Causey, *Paul Nash* (Oxford: Clarendon Press, 198), 296.

26 Harrison, 'England's Climate', 207.

27 John Piper and Geoffrey Grigson, 'England's Climate', *Axis* 7 (Autumn 1936): 5.

28 Piper and Grigson, 'England's Climate', 5.

29 Piper and Grigson, 'England's Climate', 5.

30 Geoffrey Grigson, *The Crest on the Silver*, 188.

31 Geoffrey Grigson, *The Romantics, an anthology* (London: G. Routledge & Sons, 1942), v.

32 Geoffrey Grigson, *Samuel Palmer's Valley of Vision* (London: Phoenix House, 1960), 1.

33 S. John Woods, 'Henry Moore Exhibition, Leicester Galleries', *Axis* 7 (1937): 30.

34 John Piper 'Prehistory from the Air', *Axis* 8 (Early Winter, 1937): 7.

35 Myfanwy Evans, 'Paul Nash 1937', *Axis* 8 (Early Winter, 1937): 13.

36 Evans, 'Paul Nash 1937', 12.

37 Quoted in René Micha, *Hélion* (Bontini Press: Naefels, Switzerland, 1979), 22.

38 Micha, *Hélion,* 22.

39 *Art News* (15–31 March 1944), quoted in 'Hélion in transition' in *Art News* (15 March 1945), 18.

40 Graham Sutherland, 'A Trend in English Draughtsmanship', *Signature* 3 (July 1936).

41 Letter to Colin Anderson, published with 'Welsh Sketchbook', *Horizon* (1942).

42 Geoffrey Grigson, 'Authentic and False in the "New Romanticism"', *Horizon* (April 1948), 205.

43 Grigson, 'Authentic and False', 206.

44 *Horizon* (April 1948), 213.

45 See 'A Meaning of Auden' (1974) and 'Early Auden' (1977) in Grigson, *Blessings, Kicks and Curses: A Critical Collection* (London and New York: Alison & Busby, 1982).

46 'A conversation with the editor of *The Review*', in Grigson, *The Contrary View: Glimpses of Fudge and Gold* (London and New York: Macmillan, 1974), 236.

English Art and 'The National Character', 1933–34

Andrew Causey

THIS ESSAY looks at concepts of English art over a short period of time, the years 1933–34.[1] The evidence is rich because the Royal Academy's exhibition *British Art, c.1000–1860*, held from January to March 1934[2] stimulated numerous publications.[3] The exhibition occurred at a time of national anxiety, and is examined here against the background of the economic depression, the triumph of Fascism in Germany, and the fear of war. National identity was invoked to boost morale by a government concerned to prevent social disintegration, and the BBC, an institution with a broadcasting monopoly, and close to political leadership, became, in the second half of 1933, an arena for debate on the issue of the English character. There were consistent objectives in the series of broadcasts that came out of the BBC Talks Department:[4] the length of Britain's supposed history as a nation was presented as proof of its people's ability to withstand adversity, and the embeddedness of British character in the land, it was suggested, would be the nation's ultimate security if British industry and trade never fully recovered from the slump. Irrespective of whether the talks concerned society as a whole, or particular professional and cultural activities such as agriculture, enjoyment of the landscape, or the character of English music, the points that broadcasters repeatedly returned to were the importance of the land, the individual character and contribution of the regions, the common interests of all social classes, Britain's moral leadership in the world and a sobriety, reticence and pleasure in nature which were seen as conditioning both the British character and the nation's artistic expression. The search for unity of purpose in cultural events as different as groups of radio broadcasts and an art exhibition is, of course, problematic, even when the common social, political and economic background is as vivid and unusual as that of 1933–34. While the radio talks were clearly designed to define, and create a historical background to, a concept of national identity, the Royal Academy's exhibition was the sixth in a series that had started in 1927, of the historic art of different countries, and there is no evidence that it was in itself part of a strategy to promote Englishness.[5] Though the institutions involved, the BBC and the Royal Academy, had their own identities, resources, policies and audiences, both, nonetheless, sought at that moment to

define in similar ways aspects of the national identity and to suggest similar shapes for the nation's history.

In England, as in other countries, the First World War had stimulated nationalist sentiment, and culturally the 1920s was a decade that valued pre-industrial traditions that could be constructed as 'natural' in a country with as long a history as England's. In so far as modernity was welcomed, it was reluctantly and from economic necessity, and not as a potentially revolutionary force to benefit the populace as a whole. Although a middle of the road modernism was widespread in contemporary art under the guidance of the Paris-orientated Bloomsbury artists, their work, and English art as a whole, was rural rather than city-based and conservative in character. Typical subjects were landscape and portraiture, which complemented what was widely regarded as the best historic English art, painting made between 1700 and the accession of Queen Victoria. The 1920s was the 'Duveen decade', a description that may reflect more on the taste of American collectors as purchasers of highly priced historical English art, than on the English themselves. As Paul Nash, struggling to find a place for modernism after 1918 recalled ruefully later, all the talk was 'of the modern Constables and Cromes'.[6]

The array of new literature on English art that emerged with the Royal Academy's 1934 exhibition cannot, therefore, be used by itself to prove a sudden revolution in taste, a new search for national identity, in response to the depression, events in Germany, or any perceived national threat. Even in 1933, when a number of artists, including Nash, had for some years been engaging in more ambitious experiments, Nash still saw the character of the English school in the 'expression of portrait and scene', and pondered the 'essential spirit which seems to identify them with the English genius'.[7] There is continuity in English taste through the inter-war period, and the appeal to landscape, the country house and the parish church, to country pursuits and the non-urban, even if manifested in different forms, is essentially unbroken.

Even so there were significant refinements in the early thirties to the way English art was understood, which do reflect on the conditions of the country at that moment. New judgements on historic English art in the publications surrounding the Royal Academy exhibition are both a mirror of the moment as well as a staging post in a longer debate on national character stimulated by events that included the First World War, the long-term decline in the competitiveness of British industry, and the country's ambivalence towards modernity. In most of the writing on art in 1933–34, as in the view of society that, as will be seen, the

Conservative leader Stanley Baldwin and his young ally Arthur Bryant sought to enforce, the concept of nationality was essentialist: that there was a British society and there was a national character.

The Depression hit Britain in the middle of 1931, leading to unemployment of three million at the worst point, at the end of 1932. In 1933 there were the first hints of economic upturn, but there was fear nonetheless of internal civil strife, triggered probably by Mosley's Blackshirts. In January 1933 Hitler became Chancellor of a Germany that was in an even worse economic state than England, and started at once to put in place measures to restore German confidence and rebuild the self-esteem of the shattered nation. 1933 was the year of the long and ultimately abortive disarmament conference at Geneva, and Germany's abrupt departure from the League of Nations in October left many fearing the imminence of war.[8] The National Socialists' handling of their first months in power commanded respect in some British circles. In August, for example, a BBC correspondent, S. K. Ratcliffe, who had been selected under the closely controlled German public relations policy to tour the new Germany as a guest of the government, spoke of 'everywhere the signs of a national awakening, a fresh assertion of the national spirit'. He described National Socialism with some naivety as a 'movement not of politics but of communal emotion . . . of concentrated national feeling', and referred back to the changes that had taken place since a BBC predecessor, Harrison Brown, had reported from Germany in the autumn of 1932 on the desperate plight of the pre-Hitler labour market and the unemployed.[9] Neither Ratcliffe, nor those who joined the debate that followed in *The Listener*, altogether endorsed Hitler, but there is an unmistakable inference that Britain in its own demoralised state, with output in heavy industry reduced by fifty percent or more and consequent urban deprivation and despair, had much to learn from Germany. There were favourable reactions in Britain to Germany's 'back to the land' policy as a means of alleviating unemployment and encouraging national and communal feeling. One of the first acts of the National Socialist government was a resettlement scheme turning over former crown and aristocrats' estates in East Prussia to the urban unemployed. In order to root new families in the soil, sales of land granted in this way were forbidden, but new owners could hand down their property to their children. The BBC's correspondent, Colonel Sandeman Allen, reported that the propaganda films and leaflets with which the German Ministry of Agriculture supported the programme were designed to show the beauty of life on the soil, of farms, churches and countryside, that the revival of old peasant crafts and traditional agricultural methods

were encouraged by the government, and that folk singing and dancing were taught in agricultural colleges.[10]

These reports from Germany were broadcast by a BBC which had recently become a public corporation and was led by John Reith, an establishment figure, ally of Baldwin, and a man with a strong sense of the Corporation's duty to inform and educate the public. In the autumn of 1933 the BBC Talks Department initiated what one of its contributors called 'a stocktaking of . . . [British] institutions, empire and character'.[11] Several series of talks ran in parallel and were reprinted in the Corporation's journal *The Listener*. The talks were remarkable for their relative lack of concern with what might have been thought the most pressing problem of the moment, the plight of industry and the level of unemployment, but asked listeners and readers to stand back from immediate problems and reflect, rather, on the inner strength to be gained from the arts, from the study of history, from agriculture and the use, enjoyment and conservation of the land.

'The National Character', broadcast on the BBC's National Programme from October to December 1933, and the longest of these series, was introduced by Baldwin himself, and was the subject of an editorial article in *The Listener*.[12] The talks were written and delivered by Arthur Bryant, who was to become a popular historian of the British national achievement, but started as one of Baldwin's speechwriters, and in 1933 was a lecturer at Ashridge, the Conservative Party training college. Baldwin understood, like Winston Churchill later, the power of the pen in framing the background values of political policy. Baldwin's *On England* had been published in 1926, a year of crisis in British industry and industrial relations and of the General Strike.[13] It promoted the notion that Britain's strength lay in the country, yeoman traditions, and the stability ensured by maintenance of class relationships. *On England* was reissued in a popular edition in 1933, and Bryant's broadcasts were published in book form in 1934.[14]

For Baldwin, in his introduction to Bryant's series, the national character was grounded in England's pre-industrial history; he was concerned with the country's geography, its maritime isolation from other nations, and with the tradition of independent decision making at local level which he traced back to the survival of the Saxon village system. The importance of devolution, regionalism and local independence, perceived to be the nation's inheritance from Anglo-Saxon England, was commonly stressed. *The Listener* editorial, 'The Englishman', emphasised character as the product of geography and physical environment, but also race.

The modern cosmopolitan's denial of the validity of race and the assumption that, all modern people being mongrels, it is only national environment and not national heredity which matters, is already becoming discredited. On the contrary, many of the nations of the world after a long period of neglect have today awakened again to the value of their own racial heritage, and have begun to take social and scientific measures to improve, strengthen and purify the elements which compose it. It is a valuable side of the new nationalism that it teaches each people to cultivate its own good qualities instead of trying to ape or absorb those of everybody else. But, as Mr. Bryant shows . . . nations are not always fully conscious of themselves and the motives for their actions. Beneath the conscious policy lies the unconscious instinct, and it is this which guides the destiny of the group that calls itself a nation at the most critical points in its history. . . . They are the outcomes of century-old movements and minglings of races; they should not lightly be disregarded, but fully explored and made a coherent basis for national development.[15]

It was not an altogether consistent declaration, being critical of present day cosmopolitanism and at the same time emphasising the advantages of racial mixture inherited from England's early history; but it was a typical conservative position.

Bryant emphasised the Englishman and the countryside:

By far the most important factor about our English civilization in estimating its effect on the national character is that it grew in the country. To this, I believe, half our present troubles are due. Our industrial discontent, the restless, unsatisfied state of our family life, the discomfort, ugliness and overcrowding of our towns, may well spring from the fact that every Englishman is so certain that the only lasting Utopia for him must lie in a rose garden and a cottage in the country.[16]

He is explicit that English 'culture is a country culture'[17] and that 'urban England had never discovered a new culture for itself'.[18] Small freeholders and copyholders in pre-industrial times, he said, had not earned much, but had been their own masters. The 'extermination of the freeholding peasant is probably the greatest social tragedy in English history . . . The change left English agriculture without a base—so that when in the next age its enemies assailed it there was no widespread popular interest to defend it. When that happened, something definite had passed from English life'.[19]

The Baldwin–Bryant line was based on 'one England'; it was a plea for unity, so long as unity meant a place for everyone and everyone in their place. It was country-based, regional, yeoman and artisanal, promoting practical, skills-based, and generally pre-industrial values, and non-, if not anti-, intellectual. It attributed fixed functions to mutually dependent individuals and classes, and saw British society as having a regional and social core traceable back to the Anglo-Saxon village structure. The National Character was bred in the home, in the regions, in the country, through craft and manual work. Bryant argues, in a prophetic, if complacent, passage that Britain will still be exercising its true virtues 'when the last ton of coal has been taken from our soil and the last English flag lowered from the seven seas'.[20]

Bryant's attitude was an extreme form of land-owning high Toryism, which rejected the Whig mercantilism on which most of Britain's wealth was based, and its grip at that moment was linked with the perception of contemporary economists that Britain's world primacy as a trading nation was over. André Siegfried, an economic journalist widely read at the time, had written unequivocally in *England's Crisis* (1931, updated 1933), that Britain would not recover its leadership in world manufacture and trade. Britain had not adequately re-invested, but, more than that, the industries on which the first industrial revolution and British primacy had been based, coal and steel, would not play an equivalent role in the future. The alternative, in the minds of a Bryant or a Baldwin, was to re-conceptualise the British contribution in terms, not of industry, but of character, and show Britain to be a country with a solid resilient core of human resource founded on a long history and the ability to endure adverse circumstances. To this way of thinking, Britain was different from younger nations formed during the Industrial Revolution (Germany and Italy were surely in Bryant's mind): they had been born in the era of the growth of cities and industrial expansion, and, he inferred, knew nothing else. But that was a phase of civilisation that would pass, and Britain, with its more deeply-grounded historical experience as a nation would show the rest of the world the way forward through reversion to country strengths. In a book he edited the following year, which included an essay on Hitler, Bryant described the way in which 'for all her economic misery, she [Germany] has found her soul'. In describing Hitler as 'a great German [who has] yet to grow into a great European', the quality he was praising was Hitler's effort at national regeneration.[21]

Introducing the series of twelve talks on 'Rural Britain Today and Tomorrow', the Minister of Agriculture and Fisheries, Walter Elliot, read from the same text:

The nineteenth century is the abnormal period and not the present day. The nineteenth century — with its vast exports of capital, with its dizzy increases of population, with its tides of emigration running like a millrace . . . will not recur in our time. We have to learn to live in our century. All of us have to live within our own lands . . . It may be . . . that with all this newness the more the countryside changes, the more it will be the same thing. The long slow rhythms of the year, seedtime and harvest, spring and autumn, short days and long, have a wonderfully steadying effect on people and may still over-weight the drag of the machines.[22]

There existed in 1933 the framework for a national social strategy grounded in the quality of Britain's natural and human resource, its unique geography, long history and devolved village-based social structure. As a construction of nation-alism it was essentialist in the belief that a national identity existed, and it regarded this identity as having been veiled by industrialism, with present conditions offering an opportunity to throw back the veil and reveal a truer England. The England that was imagined was one explored for the needs and purposes of the present, and there was no questioning whether the earlier periods of history being appealed to, back to the Anglo-Saxon, had had any, let alone the same, sense of national identity.

The Royal Academy's exhibition of British Art opened three weeks after the end of Bryant's talks, on 6 January 1934. The exhibition was planned, and books associated with it (though not, of course, the criticism surrounding it) were writ-ten in the course of 1933, for the most part before any of the broadcasts described had been given. The ways in which the history of British art was constructed by writers and commentators complemented the views of Baldwin and Bryant in several respects: the effect on art of the uniqueness of Britain's geography was stressed, the protection from outside influences offered through being an island, the early coming together of the races to form a nation, the importance of the landscape, the centrality of craft, and the sense that British art was not primarily courtly, catholic or urban, did not have great intellectual ambition expressed through a tradition of complex subject painting, but belonged to gentry and classes residing in the country. English art history was reshaped to give greater prominence to the Middle Ages than it had had before, significance was placed on Anglo-Saxon origins and on regional schools in England's early art as a mirror of political devolution, again perceived to originate in the Saxon village system. The decision to include illuminated manuscripts was a positive one in respect of

the place given to the Middle Ages, because the exhibition was mainly (but not entirely) one of paintings, and manuscripts were not always at that time regarded as such. The decision to include applied arts had the same effect, extending the coverage of the Middle Ages proportionately more than other periods. Tudor and Stuart art continued to be seen, as they had been in the nineteenth century, as the work mainly of foreigners, and their legitimacy within the framework of Englishness was therefore open to question. This enabled writers to argue that court- or London-based art, which might be seen as reflecting the dominant authority of the centre over the regions, was un-English; in particular, it led to the general acceptance that the baroque was antithetical to a true British culture, which was more 'natural' than that of continental Europe because rooted in the country. Historians in the 1930s shared with Victorian writers the sense of Hogarth's importance in restoring a true Englishness and in elevating the popular and down to earth. The eighteenth century continued to be seen as the great century of English art, but within it there was a noticeable tendency to press the cause of Gainsborough's straightforward naturalness (especially when working in Suffolk) against Reynolds' baroque. Just as there was broad agreement to push British art history back in time to establish early origins, so there was a common approach to more recent developments. In the same way that industrialism could be characterised by Bryant as a passing phase, an interpolation in the longer course of history, so in art Victorian painting was not highly regarded. The exception was Pre-Raphaelitism, which could be seen as a rejection of Victorian values, an escape into poetry and fantasy.

The literature that surrounded the exhibition was not of a single kind. It was neither written by one type of author nor directed at a single audience. Some of the new histories of English art were the work of scholars and academics, or curators with scholarly credentials, while most were by critics and journalists who, in some cases, were doing no more than cashing in on the event. Some had published on other national schools to coincide with earlier Royal Academy exhibitions.[23] In the end, though, it was not the books published before the show that reflect most interestingly on the understanding of Englishness at that point, but articles and reviews published around the opening and over the following months. Several were the work of distinguished experts, in some cases at turning points in their own careers. Kenneth Clark, director elect of the National Gallery, wrote a preview article for *The Listener* at the end of December, which was republished in 1938 in a Penguin anthology of contemporary writing on the arts chosen by the editor of *The Listener*, R. S. Lambert. The same

month Herbert Read wrote an inaugural article as new editor of the *Burlington Magazine*, which was to be twice reprinted, in 1936 and 1952. W. G. Constable, just appointed first director of the Courtauld Institute, was in overall charge of selection for the Royal Academy, and wrote the catalogue introduction, which set an agenda that influenced a number of the reviews. James Mann, Constable's deputy at the Courtauld Institute and later director of the Wallace Collection, also contributed to the catalogue. Roger Fry's lectures delivered in connection with the exhibition were to be his last major publication and maintained the internationalist position of someone who had battled for modernism two decades before. Anthony Blunt wrote two exhibition reviews for *The Spectator*, and a number of other younger scholars wrote book reviews. William Rothenstein's Romanes Lecture at Oxford was the nostalgic retrospect of an older artist and writer and represented, in a different way from Fry's, the viewpoint of someone who had contributed to the early days of English modernism.[24]

Whatever they thought the character of English art to be, these authors agreed that there was a national tradition that needed to be identified, even if it was a fragmented and interrupted one, and that there were distinctive features of British art that the exhibition was successful in helping to pinpoint. Fry's was, in some respects, the dissenting view. Fry's published lectures mark a refusal to compromise his integrity in what he believed to be the over-valuation of the British school. Chauvinism, Fry believed, was at risk of becoming a threat to truth. He objected not so much to the idea that there was a British school as to the value placed on it.[25] Support for Fry came from John Pope-Hennessy in a review of Fry's publication in the *Burlington Magazine*, while D. S. MacColl, a veteran supporter of the New English Art Club and of the French influence on English art, took the view that nationalist emotion was necessarily limiting to an artist, the 'mortal part of him', while 'the immortal part is universal'.[26] In what sense were Gainsborough or Constable English? Because they painted English people and English landscapes? MacColl could think of no other reason, as there was nothing, he felt, in their technique that signalled Englishness. MacColl's viewpoint is both salutary, coming from an older critic who had contributed, like Fry, to pulling British art into the continental mainstream earlier in the century, but also limited in the sense that he did not see—as Fry did—that values had changed and new arguments were needed if the pro-European order of early modernism was to continue to be defended. With the first phase of modernism past, a reassessment of nationalism within the wider modernist context had gained a certain inevitability. Altogether, Fry's opposition party was a small and not a

growing one, and it is now that Herbert Read moved into the position of author-itative critic and commentator on English art that Fry had occupied since 1910.

The writing of English art history in 1933–34 needs to be viewed in the context of the decline of Fry's influence and the esteem in which the vigorous inter-nationalism he stood for was held. Equally, it needs to be seen in a longer per-spective: with the lessening of Fry's standing, how was older art writing valued? Briefly, Horace Walpole's seminal *Anecdotes of Painting* (1762), based on the diaries of George Vertue, had covered the Tudor and Stuart periods and art to his own time, praising King Charles I's internationalising English art and making his court a centre of European culture. Walpole's was not a view that appealed to the nineteenth century, which tended to more or less equate the history of Eng-lish painting, when seen as a whole, with the eighteenth and nineteenth cen-turies. Medieval painting was too little known and illumination, for the most part, was not regarded as painting, while the painting of the Tudor and Stuart periods seemed not properly English. Richard and Samuel Redgrave's *A Century of British Painters* (1866), saw Hogarth as the saviour of British art for common sense, direct observation, and freedom from continental precedence. 'Here was the man wanted; the reformer the art needed; one who was determined not to follow, but to lead'.[27] The French historian of English art, Ernest Chesneau, described Hogarth and Thomas Bewick as 'the first two artists who uncon-strainedly express themselves in their art in a truly English style. English by birth, as well as in feeling and temperament, they are proud of their nationality; British to the backbone as the bulldogs and oaks of their own country, they love to proclaim the fact by the choice of their subject. . . . From Hogarth . . . Eng-lish painting may truly be said to date'.[28] Allan Cunningham in his earlier *Lives of the Most Eminent British Painters* (1829) had already used the metaphor of the oak for Britain's artistic tradition: 'Art is, indeed, of slow and gradual growth; like the oak it is long of growing to maturity and strength'. Cunningham also identified the beginnings of English art with Hogarth: 'Before the birth of Hog-arth, there are many centuries in which we relied wholly on foreign skills. With him, and after him, arose a succession of eminent painters, who have spread the flame of British art far and wide'.[29] There was no lack of scholarly research into all periods of English art in the years following, but there was no attempt to re-conceptualise English art history as a whole. W. T. Whitley's four volumes on English art between 1700 and 1837 (1928–1930) came nearest, but, for all its new research, followed an established nineteenth-century pattern in covering only the period from Hogarth to the accession of Queen Victoria.[30]

There was no shortage of writers of the early Modernist period who situated modern English art in its European context. Modernism encouraged the writing of art history laterally and the linking of England to the rest of Europe, at the expense of the search for themes common to English art through the ages. In 1933–34 there was, therefore, no established post-Victorian way of looking at the history of English art as a whole. This essay does not examine areas where new writing accepted nineteenth-century values, and takes as read the importance of Hogarth and the eighteenth century as golden age. Landscape as a — or, in some views, *the*— English contribution was, of course, pivotal to the 1930s argument, in which nature and the land were essential to definitions of the natural identity. But these areas are not examined here because, in terms of art writing, they do not mark a change. The key areas here are the role of the Middle Ages in identifying Englishness, debates around the sixteenth and seventeenth centuries, and how the nineteenth century was to be identified in relation to what Bryant and other traditionalists were starting to define as a post-industrial Britain.

Sir William Llewellyn, President of the Royal Academy, wanted the exhibition 'to bring to British people a better appreciation of the work of their countrymen, but also to demonstrate to other nations the important part that the British School has played in the development of European art'.[31] Certain foreign artists, Llewellyn added, were included because so much of their work was done in England that it was an integral part of the British tradition. Like others, he wanted to make claim for British art as a distinctive school without dismissing completely those moments when a native tradition was hard to discern. In fact, relatively little work by foreign-born artists was included. The whole period from the late fourteenth century to the end of the seventeenth, where many would have been found, was represented only by some forty paintings out of five hundred and twenty, though the addition of miniatures fleshed out the story.[32]

The exhibition organiser, W. G. Constable, took as his starting point in the catalogue introduction the relationship of individuals to tradition. 'Every artist works within a tradition; and it is one of the chief interests of the present Exhibition that it not only exemplifies the achievement of individual artists, but reveals the character and growth of such a tradition in Great Britain'.[33] What constituted the English tradition? Geology, geography, remoteness, and the protection of being an island. 'Another factor of importance is race. Its influence on art is still a matter of dispute. But it is reasonable to suppose that the mixture of Mediterranean, Alpine and Nordic stocks which makes up the British people has produced an eclecticism and adaptability in art as well as in other activities'.[34]

Up to the fifteenth century there was 'not a national art in the modern sense'. England is late arriving at a national school, but Constable is clear that 'to regard English Gothic architecture and sculpture as a provincial manifestation of style whose metropolis was the Ile de France is to fail to realise that it was parallel expression of an analogous creative impulse given local individuality by local needs and circumstances.'[35] The local autonomy fostered by the Saxon system of village communities:

> has been of abiding significance. From them have sprung a local conscious-
> ness and a local activity which have helped to produce two of the chief mon-
> uments of British creative activity — the parish church and the country
> house — wherein are displayed a sense of the genius loci, an adjustment to
> local needs and circumstances, and an individuality and refinement of crafts-
> manship which are peculiarly English.[36]

Constable saw craftsmanship as a key to British achievement, instancing illumi-nations and stone cutting. He stressed the lack of a classical tradition, and the rel-ative weakness of the court compared with other European countries. The ruling classes were neither so remote from others nor so lavish in lifestyle as in countries more closely tied to the Renaissance and its values. British art was intimate and matter of fact, involving itself unostentatiously with reality, portraits of people, land, houses and animals. It is does not reflect great depths of intellectual thought, it is not underpinned by any great abstraction, the influence of Catholicism was slight, the Jesuits of modest influence, and there was little baroque.

Constable upheld 'the universal view of the eighteenth century as one of the great ages of English art . . . The necessary economic basis was there, together with an active and enlightened patronage, which meant a close weaving of art into the texture of life'.[37] He felt that the industrial revolution had been anti-thetical to art; it was disappointing that no regional school had grown up around industrial expansion in the north of England. Anticipating other writers, he excepted the Pre-Raphaelites from these strictures:

> More profoundly British, perhaps, than any of their contemporaries, in their
> decorative instincts, in their passive acceptance of fact in Nature, in their
> descriptive and romantic tendencies, they yet more resolutely than any other
> British painters, turned their backs upon contemporary life and sought to
> live and paint within the closed garden of their own imagination. So was
> opened up a gulf between the artist and other men which was impassable for

a generation or more. It is one of the more heartening signs of the present that that gulf is in the process of being bridged.[38]

This last sentence of Constable's introduction seems to link Pre-Raphaelite painting and Modernism as two areas where the conditions for a great art, the symbiosis of an economic base, enlightened patronage and a 'close weaving of art into the texture of life' break down, a moment which he feels, hopefully, may be past.[39]

With its own starting point and distinct areas of concern, Constable's analysis points, nonetheless, in the same direction as Bryant's. A long national history that acknowledges the value of racial mix in the past, regionalism, local consciousness and lack of a single centre in the country's early art, focus of creative energy in the country rather than at court, the weakness of intellectual pacemakers such as the Jesuits and the Church in general were in continental Europe. The picture is one of moderation, subservience of art to local needs, common sense, and the 'close weaving of art into the texture of life'. Again, the Victorian period and its succession are seen as unfortunate interludes which the country may now profitably put behind them.

Constable's co-author in the catalogue, James Mann, was adviser to the exhibition on armour and works of art, and was working to the same text as Constable. 'Considerable space has been given to the applied arts', Mann wrote, 'for without them English Mediaeval art could not be adequately presented. Its importance is enhanced by the fact that our artistic tradition is more consistent in applied art than in painting, where there occurred a hiatus during the sixteenth and seventeenth centuries, when the field was dominated by visiting foreigners'.[40] Britain had its distinctive craft tradition, Mann argued, which was not flamboyant or decadent, which kept the baroque and rococo at a distance, and he distinguished the British from the French exhibition two years before with its ebony, gilding and elaborate veneers. Richness, he argued, in defining the character of English furniture, was possible without abandon.

Mann makes two points that are relevant to the argument here: applied arts can tell the story of art in the Middle Ages which shortage makes impossible through painting alone, and applied arts can compensate, in exhibition terms, for the lack of a continuous tradition of painting in the Tudor and Stuart periods. The first was not a new idea. Constable had earlier contributed a catalogue essay to the Royal Academy's exhibition of *British Primitive Paintings* in 1923, which had included a small number of works in other media to make up for the

dearth of surviving paintings. He had argued then a point widely taken up in 1933–34, that the rupture to the national tradition in the arts of the sixteenth and seventeenth centuries 'forbade the survival of traditional knowledge'.[41] He was referring not just to the physical loss of so much early painting at the hands of iconoclasts, but to the loss of a whole tradition. The characteristic way of writing English art history inherited from the Victorians, treating Hogarth as a beginning after the reign of foreigners, was, Constable could have added, a product of this loss, and the problem of how to fully reinstate the medieval artistic achievement when so much wall painting was destroyed occupied scholars' and curators' thoughts. But the key precedent for the 1934 exhibition was not the Royal Academy's in 1923, but the Victoria and Albert Museum's *English Mediaeval Art* exhibition of 1930, with over eleven hundred works.[42] If the problem with reconstructing medieval art was the need for many different kinds of object, the V&A, with its large and varied collections, was better placed to mount the show than the Royal Academy.

Though a critic and student of aesthetics rather than an academic art historian like Constable, Herbert Read shared Constable's approach. Like Constable, he felt there was a geographical and racial definition to Englishness, and also that the issue of Englishness began with the Anglo-Saxons. Read proposed that 'the style which is the first to be distinct as a style, and to be associated as a racial blend that was henceforth to be distinctively English, was formed during the so-called Anglo-Saxon period'.[43] Constable's view was more elaborated than Read's but was compatible:

> Up to the fifteenth century, to think of a national art in Great Britain, in the modern sense of the term, is to misconceive the situation. Rather, British art up to that time should be regarded as a local manifestation of styles which embodied waves of creative energy passing over the whole of Northern Europe, yet these manifestations have a consistency which entitles them to the label 'British', and as often as not were formative points in the development of such styles and centres of radiation for their influence. Thus the Saxon school of Winchester represented by such a masterpiece as the *Benedictional of St Aethelwold*, is from one aspect a reflection of the art of the Carolingian Empire; from another it represents a new and vigorous branch of an old tree, whence sprang a whole race of distinctive works, both in England and elsewhere.[44]

These views of medieval art, and others, help to build an identity for England as having a long history and being based on regional centres. As an identity it is

parallel with Bryant's, and was preferred in the 1930s to identities that, in different circumstances, would be equally plausible, involving emphasis on the Tudor revolution in kingship and government or the Act of Union with Scotland.

Read was one of the most forceful in speaking up for the Middle Ages in the formation of Englishness. He was the author, in 1926, of *English Stained Glass*, had claimed in 1932 that glass painting was 'the typical pictorial art of the middle ages'[45] and had used the idea to thread his way round a problem that presented difficulties to others: that too little painting — meaning wall or panel painting — survived from the Middle Ages to make judgements on medieval painting possible. He had been a member of staff of the Victoria and Albert Museum when the museum had put on a show of medieval art in 1930 which Read, as art critic of *The Listener*, had particularly commanded his readers not to miss.[46] He found already discernible in Anglo-Saxon art the calligraphic, linear and free style, which Blake, who had a key position in Read's pantheon of artists, is quoted by Read as calling 'the bounding line and its infinite inflections and movements'.[47] Read felt that Britain had undervalued its Celtic inheritance, and he praised Celtic linearity and its abstractness against Renaissance humanist art. As National Socialism increasingly exposed itself to the world in all its horror, Read, despite earlier allegiances, distanced himself from the classical tradition in the measure that Hitler's regime adopted it. Correspondingly Gothic and Blake's 'bounding line' became emblems of freedom. Read's perception was distinctive because he was also a poet and historian of poetry and literature, and, in the same year, published an anthology of historical writings on the national tradition, *The English Vision*.[48] This parallel allegiance naturally coloured Read's views on painting and helps account for his concern for depth of feeling, and for the lyrical rather than the epic (and his lack of concern, therefore, at the absence of a Baroque tradition in England).

Read's contribution to the debate was, on the one hand, to help push the boundary of English art back to the pre-Conquest, while maintaining the pivotal position of Hogarth whom he thought of as 'indigenous, openly and aggressively national' and in the way almost any Victorian writer could have expressed it, 'the first great name of the English school'. 'The art of painting in England', Read added, 'had for so long been dominated by foreigners that it would have needed a genius of the highest rank to restore the native tradition'.[49] Read's English art is bi-polar, marked, on the one hand, by a linear beauty and grace which overrides nature if necessary in pursuit of strength of feeling and expression; and, on the other hand, characterised by a down to earth realism. He quotes

Ruskin describing this as 'our earthly instinct'[50] which, Read says, can also be found in the marginals of medieval illuminated manuscripts, but which in this essay is represented above all by Hogarth and Cruikshank, names which he says (inaccurately in Hogarth's case) have not generally been used to define the British school in the way that Gainsborough's has.

Kenneth Clark was never committed to English art so specifically as Read, but their views had points in common. Clark began his article by speaking of 'lyricism, freedom, and grace' as common to different periods of English art, including medieval illumination, of which he wrote briefly but fulsomely in 1933.[51] Revising the article in 1938 to give even greater emphasis to the Middle Ages, Clark now opened his article: 'The schools of painting which flourished in these islands at Lindisfarne, Durham, Winchester or Canterbury, from the seventh to the eleventh centuries, gave England a position in European art which she has never held since'.[52] Mentioning, as Read had also, *The Benedictional of St Aethelwold*, he described such artistic achievements as having 'a mastery and vehemence of beauty far beyond any contemporary painting outside Constantinople. The first thing that will strike anyone . . . is their extraordinary vitality achieved by a free and vigorous style of drawing', which he contrasted with 'the flaccid outline of Continental schools'.[53] Emphasis on the paramount importance of drawing is logical enough for a collector who by 1938 was buying the early works of Graham Sutherland and was soon after to help reinforce Henry Moore's public career by commissioning the wartime shelter drawings. But Clark shares what in effect was a common position among writers that, if a British national tradition were to be identified, the regional schools of illumination must be important.

Clark, like Read, foregrounded medieval illumination while maintaining the position of Hogarth as the true founder of the English school. Hogarth followed a period when 'all influential artists [in England were] . . . foreigners or worked in a foreign style'.[54] Clark's commentary, like other writers', is concerned with what Englishness is in the classic period of the eighteenth century. He shares with others absence of regret at the weakness of the English baroque. He values Gainsborough as much as Reynolds on account of his sensibility and intuition, and feels that Gainsborough would have done better still if he had returned from fashionable Bath to his native Suffolk to recapture what Clark sees in his early work as 'a precious quality of paint and a delicacy of perception unique in English art', and which he felt Gainsborough later lost.[55]

It was widely accepted in 1933–34 that Tudor and Stuart painting as the work largely of foreign born or visiting artists was not properly English. Allied to the

issue of native birth was a desire to protect English art on behalf of what was seen as moderation, the regional, and the rural against the courtly, the urban, the baroque, and all forms of excess. Race, as Constable had hinted in his 1934 catalogue introduction, was a touchy issue at the end of the first year of Hitler's rule. In October 1933, Bryant had become seriously mired in a broadcast discussion with a liberal geneticist, Professor H. J. Fleure, with Bryant pressing Fleure to admit, against his judgement, that racial mixture is generally disadvantageous to a nation.[56] Conscious xenophobia in the choice of artworks for the 1934 exhibition was not a possibility, but defining the kind of art that was wanted involved the contribution of foreign born artists being played down. However, there were scholars studying Tudor and Stuart art whose professional interests overrode any sense that the objects of their interest did not fit a particular construction of English nationhood. Constable himself was such a scholar, as was H. G. Collins Baker, Master of the King's Pictures, who worked on baroque art in northern Europe. For Collins Baker there was no urge to demonstrate an unsullied English line since the Norman Conquest. His 1933 *British Painting* diverged sharply from the other publications in discussing Tudor and Stuart painting in some detail, and is unique among books at this moment in having no separate chapter on Hogarth. Though Collins Baker's was a minority viewpoint, his position as an independent scholar critical of received traditions and independent of political correctness in respect of racial origins, places him in an interesting position, parallel to that of Professor H. J. Fleure in relation to Bryant's racial views: in both there is an independence of mind ready to override popular prejudices.

A later review by Ralph Edwards, a curator of furniture at the Victoria and Albert Museum, of the *Commemorative Catalogue* following the 1934 exhibition, criticised the selectors for the poor size and quality of representation of work by sixteenth- and seventeenth-century artists.[57] Interestingly, the review pointed out how the illustrations in the *Commemorative Catalogue* compensated for this with a sizeable group of reproductions of what Edwards regarded as better work from the exhibits of that period, indicating that there had been debate in the scholarly fraternity, which had certainly not surfaced in published reviews, in favour of the neglected English baroque.

The Royal Academy's decision to end the exhibition with Burne-Jones around 1860—rather than, say, with the death of Turner nine years before in 1851—indicated that Pre-Raphaelitism and its immediate succession was under review but that Victorian painting as a whole was not. The Tate Gallery held a Burne-Jones exhibition in 1933 and a William Morris show at the Victoria and

Albert Museum coincided with the Royal Academy's British exhibition. Beyond the Pre-Raphaelite circle, however, the reputation of Victorian painting in general was at a nadir in 1933; it was not part of the Royal Academy exhibition—though the terminal point for all the European exhibitions was 1900—and nobody seems to have regretted it. The painter William Rothenstein, who wrote the catalogue introduction for the Burne-Jones exhibition and lectured at the Royal Academy on the Pre-Raphaelites during the British Art exhibition, was nostalgic. In May, just after the exhibition closed, he gave the Romanes Lecture at Oxford on 'English Painting'.[58] It was then that he visited the Oxford Union, saw the poor condition of William Morris' paintings there, and helped set in train their restoration.[59] In his lecture Rothenstein gave a special position to Blake and—not being restricted by the parameters of the Royal Academy's show—brought his story to present times, with generous praise for artists such as Stanley Spencer and Wyndham Lewis, who, alongside the older Augustus John, Rothenstein felt should be given contemporary mural commissions equivalent to Morris' in the Union. Rothenstein commented, as no other writer on English art in that year did, on the values expressed in Read's 1933 study of contemporary European art, *Art Now*, where Spencer had no place in Read's by no means narrow canon.[60] As one of the older writers contributing to the debate, Rothenstein was motivated by his personal memory of English art before modernism. He had written of Burne-Jones the previous year in terms of a magical world that had served the spiritual needs that nineteenth-century commerce had left unsatisfied: 'it is a small matter that so few today care to enter this enchanted country. For it is our national possession, whose wicket gate we pass through when we wish'.[61] The inclusion of Pre-Raphaelitism alone out of the field of Victorian painting in the Royal Academy's exhibition, and these comments of Rothenstein, are in keeping, in terms of their escapist sentiments, with Bryant's suggestion that what every Englishman wanted was a cottage in the country with roses around the door.

In contrast to Rothenstein's nostalgia, Anthony Blunt presented Pre-Raphaelitism in terms of its relevance to present art:

> In one respect the English exhibition is particularly well timed. It has come at the first moment of the reaction in favour of the Pre-Raphaelites ... Till recently those interested in modern painting tended to consider first and foremost the design, pattern and general conception of a painting. This was perhaps ultimately the effect of the movement in art which ended in

Cubism. . . . It led students to think of paintings as single entities, as coherent wholes. Now . . . instead of talking of design we talk of texture; instead of the general conception we admire skilful detail; instead of standing back from the canvas . . . we study its surface inch by inch . . . We are more interested in the parts than the whole . . . This point of view makes for enjoyment of the Pre-Raphaelites. For, they had none of the sense of monumental design which distinguishes the painters whom they thought they were imitating, and the general conception of their work is often violently distasteful to us. But we are now prepared to look at their craftsmanship and perfection of detail.[62]

Here are two responses to Pre-Raphaelitism that can be described as positive. One is unashamedly backward looking, the other's motivation is less a respect for the movement in itself than a general anti-modernism.

Of all the responses to the Royal Academy's exhibition, none was shrewder in its appreciation of the conditions of the moment than Roger Fry's. His starting point is that 'the spread on the Continent of an intolerance of free opinion, an intolerance which we used to think had passed with the Middle Ages, has given us an enhanced sense of the value of our national distaste for coercion in matters of opinion'.[63] Making art symbolic of national pride was what Fry sought to avoid, and at no time was a critical attitude more necessary than the present. He spoke of a fellow scholar being invited to a conference in Germany and being 'asked to bear in mind that the aim of the conference was to make known the fact that all the greatest art of the world had a Germanic origin'.[64] Fry's insistence on the need, in principle, for a critical approach was allied to another, different issue: the need 'to recognise straight away that ours is a minor school'.[65] Fry did not share others' interest in the early schools of illumination which he does not seem to have regarded as painting, and specified embroidery, *opus anglicanum*, as the characteristic British contribution to the Gothic. His serious interest is aroused only with Charles I's patronage and with later Stuart art, especially Lely. Fry recognised, like other writers, that in the seventeenth century British art owed much to foreigners, but his attitude to that was not negative. English art had been 'drawn into the current of the European tradition; it had only to develop its own characteristic version of that'.[66] Its tragedy was that it failed to do so. Wren succeeded in doing that for architecture, but Hogarth did not achieve it for painting. Fry was interested in Hogarth and in its own terms his discussion is a model of fairness. Hogarth was a moralist and, Fry concluded with regret:

one cannot help wishing that he had paid more attention to cultivating his own very genuine gifts as a painter and less to improving other people. For I think his influence on British art has been bad upon the whole. It has tended to sanction a disparagement of painting as a pure art — has tended to make artists think that they must justify themselves by conveying valuable, or important, or moral ideas.[67]

Fry was impressed, as others were, by the delicacy of Gainsborough's landscapes, especially the early ones, and it is interesting how highly he values Gainsborough in comparison with Reynolds, and how far, despite his regard for the Baroque and for complex figure painting, he was prepared to go in defence of Gainsborough's Suffolk landscapes. Fry's contribution to contemporary British art had been through insistence that it meet the standards of formal invention of the best continental art. Neither the painters he promoted, nor Fry himself as a painter, lived up to the standards he set, but those modernist standards excluded Hogarth and a large part of what other writers regarded as essential to their concept of Englishness.

The Royal Academy exhibition did not extend to the twentieth century, and neither critics of the exhibition nor writers of books on English art who chose to bring their books up to date, with the exception of Wilenski, contributed anything of interest on current art.[68] But contemporary art was subject to the same forces as historical art, even if the results do not emerge in the same way. The period reviewed here, from the middle of 1933 to spring 1934, also defines the effective life of Unit One, the group of painters, sculptors and architects who joined forces under the leadership of Paul Nash to use their collective power for the benefit of an experimental art for that moment. Nash was quoted earlier lamenting the apparent limitations of historic British art at its most successful to portrait and landscape. Nash's letter to *The Times* in June 1933 to launch the group saw the needs of British art in formalist terms that sought to place Unit One in an international context for which European parallels could easily be found.[69] But the personal statement he wrote for the book that Read edited to accompany Unit One's only London exhibition, in April 1934, was dramatically different, mystical in tone, as Nash brought into play for the first time the riddle of the sunflower and a range of imagery including the Avebury standing stones, and what he saw as the ageless beauty of Salisbury Cathedral and its Close, which were to be his enduring preoccupation from that time.[70] Nash's painting had seemed for some time to be constrained by formalist precepts that did not

wholly satisfy him, and this moment was a time of release when a direction that was already implicit, involving an interest in history as written on the face of the English landscape, seemed to become viable without complete loss of face for Nash, who wanted to remain associated with modern practice. Nash was older than most of the artists associated with the Hampstead avant-garde and was not its typical artist, having been well established in the 1920s, when the tenor of contemporary English art was more oriented to tradition. Even so the apocalyptical Romanticism Nash developed is only in small part a product of the socially regressive nostalgia of Baldwin's *On England* or the writings of Bryant.

The establishment of Hampstead as a refuge for avant-garde artists in flight from Fascism from 1933 has created a false impression of London as more receptive to artistic experiment than it was. With the exception of Naum Gabo, none of the artists involved flourished in England professionally or stayed for long. That is not to diminish the achievement of the English artists who acted as hosts so much as to identify differently the English tradition, even as manifested in Hampstead in the thirties. The winter of 1933–34 was the moment of Ben Nicholson's first abstract reliefs, and the emphasis on carving and direct work with materials in Nicholson's reliefs and the sculptures of Hepworth and Moore, the increasing use of wood and allusions to landscape in Moore's sculpture, point to links with craft, natural materials and nature itself. The Hampstead avant-garde showed itself in its emphasis on craft, making, its delight in the natural, to be much less part of a modern, urban culture, than Vorticism had been. The 'English tradition', even when seen at a particular moment in time, in this case the 1930s, cannot be seen as one coherent thing. But there are unmistakable accents and pointers that cannot be overlooked, defined in this essay in terms of craft, sobriety and lack of excess, a secular attitude and some resistance to the intellectual, refusals to prioritise centre or periphery, town or county. Moore and Hepworth, Nash and Nicholson fit this pattern in a way that Mondrian, Gropius and Moholy-Nagy never could.

If cultural nationalism had been a growing force since the First World War, 1933–34 was a significant stage in the consciousness of this, and the language that evolved then to describe it framed the debate as it lasted into the 1950s. Nikolaus Pevsner arrived from Germany late in 1933, and one of his first public statements in England of what was to become his over-riding preoccupation with the nature and influence of English art was a lecture at University College, 'English Art from a Foreigner's Point of View', in the context of the Royal Academy exhibition.[71] In a review of an exhibition — related to the Royal Academy's — of British

art at the British Museum, *The Times* adopted the phrase that was later, in 1955, to become the title of Pevsner's Reith Lectures for the BBC, 'The Englishness of English Art'.[72] Though beyond the scope of this essay, it could be argued that a search for the identity of a core Englishness — an essentialist nationalism — was a major concern of writers on English art from this moment to the mid-fifties, even if by the time of Pevsner's Reith lectures any enterprise of that kind was being seriously questioned.

1 As the role of Britain's constituent parts in the formation of national identity at different times in the country's history is not an issue here, the words 'English' and 'Englishness' are used interchangeably with 'Britain' and 'Britishness'.

2 The first mention of the British Exhibition in the Royal Academy Council Minute Books is on 10 January 1933, when an Executive Committee was established. Details of the Executive Committee, which changed slightly during the exhibition preparations, and the Hon. General Committee are in the Royal Academy Minute Books, *The Full Catalogue* of the exhibition and the *Commemorative Catalogue*. The exhibition showed fifteen medieval illuminated manuscripts, and a considerable number of ivories, alabasters, sculpture, embroidery and armour to substantiate the medieval section. There were tapestries, sculpture, furniture and works of art from later periods, but after the Middle Ages the exhibition was predominantly given to oil paintings, watercolours and drawings. Of the oil paintings only about forty predated the eighteenth century, while around 310 were of the eighteenth century, and a further 165 belonged to the nineteenth century, predominantly from before the accession of Queen Victoria.

3 Publications consulted, with notes on the authors:
(1) Exhibition publications: Sir William Llewellyn PRA, preface, Professor W. G. Constable and (Sir) James Mann, intros., *Exhibition of British Art, c.1000–1860* (London: Royal Academy of Arts, 1934). *British Art, An Illustrated Souvenir of the Exhibition of British Art at the Royal Academy of Art* (London: Royal Academy of Arts, 1934). W. G. Constable and Charles Johnson, eds., *Commemorative Catalogue of the Exhibition of British Art, Royal Academy of Arts, 1934* (1935). Sir William Llewellyn was a painter who had studied with Sir Edward Poynter, a former President of the Royal Academy. Llewellyn had been elected President in 1928. W. G. Constable, who had been appointed in 1932 as Director of the new Courtauld Institute of Art, was a versatile scholar who had recently published, jointly with C. H. Collins Baker, *English Painting of the Sixteenth and Seventeenth Centuries* (Florence and Paris, 1930). He had also been closely involved with other Royal Academy exhibitions, and was author of

the Commemorative Catalogue of the Dutch exhibition of 1929, published in 1930 and joint author, with Lord Balniel and Kenneth Clark (later Lord Clark), of the Commemorative Catalogue of the Italian exhibition of 1930, published the same year. James Mann was Constable's deputy at the Courtauld Institute, became Director of the Wallace Collection in 1936 and in 1939 Master of the Armouries in the Tower of London. He later became Surveyor of the King's Works of Art.

(2) Books: Laurence Binyon, *English Water-Colours*, in the series, Library of English Art (London: A & C Black, 1933). A poet and writer of broad scope, Binyon had joined the staff of the British Museum in 1893 and retired in 1933 as Keeper of Prints and Drawings. He had published *Landscape in English Art and Poetry* in 1930. In 1933–34 he was Charles Eliot Norton Professor of Poetry at Harvard. C. H. Collins Baker, *British Painting, with a Chapter on Primitive Painting by Montague R. James* (London: Medici Society, 1933). Collins Baker had been Keeper at the National Gallery to 1932 and was then Surveyor of the King's Pictures and Head of Research in Art History at the Huntington Library and Art Gallery, California. He was a specialist in Dutch and English seventeenth-century art. Roger Fry, *Reflections on British Painting* (London: Faber and Faber, 1934). Painter, scholar, exhibition organiser and critic, Fry had published *Flemish Art, A Critical Study* (1927) and *Characteristics of French Art* (1932) in connection with earlier Royal Academy exhibitions. The 1951 omnibus edition of these three works omits Fry's preface to the 1934 publication and as a consequence loses the urgency of the issue of nationalism in Fry's mind. *Reflections on British Painting* was derived from a series of lectures given for the National Art-Collections Fund in January 1934. Charles Johnson, *English Painting, from the Seventh Century to the Present Day* (London: Bell, 1932). Charles Johnson, *A Short Account of British Painting and Sculpture* (London: Bell, 1934). Johnson, a lecturer at the National Gallery for many years, was Constable's assistant for the Royal Academy's British Art exhibition and joint editor of the Commemorative Catalogue. S. G. Kaines Smith, *Painters of England* (London: Medici Society, 1934). Kaines Smith had published on historic English art and was author of *The Italian Schools of Painting* (1930) and *Painters of France* (1931), in connection with other Royal Academy exhibitions. He had been director of Birmingham City Museum and Art Gallery since 1927. Miles F. de Montmorency, *A Short History of Painting in England* (London: Dent, 1933). Nothing is known of this author. (Sir) John Rothenstein, *Introduction to English Painting* (London: Cassell, 1933). Rothenstein had been director of Leeds City Art Gallery since 1932 and was to be director of the Tate Gallery from 1938. Sir William Rothenstein, *Form and Content in English Painting, the Romanes Lecture* (Oxford: Oxford University Press, 1934). The painter Sir William Rothenstein was principal of the Royal College of Art (1920–35) and had just published the first two volumes of his memoirs *Men and Memories* (London: Faber and Faber, 1931 and 1932). Horace Shipp, *The British Masters. A Survey and Guide* (London: Sampson Low, Marston, 1934). The art journalist Horace Shipp had written *The Italian Masters. A Survey and Guide* (1930) and *The French Masters. A Survey and Guide* (1931), in connection with Royal Academy exhibitions. Eric Underwood, *A Short History of English Painting*

(London: Faber and Faber, 1933). Underwood, a barrister, businessman and Russian scholar, also wrote *A Short History of English Sculpture* (1933). R. H. Wilenski, *English Painting* (London: Faber and Faber, 1933). Wilenski had written *Introduction to Dutch Art* (1929), *Italian Painting* (1929, jointly with P. G. Konody), and *French Painting* (1931). He also wrote for the same publishers shorter books in their Criterion Miscellany series: *An Outline of English Painting from the Middle Ages to the Period of the Pre-Raphaelites*, and *An Outline of French Painting* (both 1932). Wilenski was one of the most renowned and prolific critics of the period. He was Special Lecturer in History of Art at Manchester University.

(3) Articles and exhibition reviews: Anthony Blunt, 'The English Tradition in Painting', *The Spectator* 152 (12 January 1934) and 'The Pre-Raphaelites', *The Spectator* 152 (19 January 1934). Blunt was art critic of *The Spectator* for much of the 1930s and later director of the Courtauld Institute. Mary Chamot wrote a series of articles in *Country Life*, starting with vol.75 no.1 (6 January 1934). She was on the staff of the Tate Gallery, 1949–65. Kenneth Clark, 'English Painting', *The Listener* 10 (20 December 1933), reprinted with changes in R. S. Lambert, ed., *Art in England* (Harmondsworth: 1938). Clark was Keeper of Fine Art at the Ashmolean Museum to 1933 and had just been appointed Director of the National Gallery. Georges Duthuit, 'The Exhibition of British Art', *Burlington Magazine* 64 (February 1934). Ralph Edwards, 'The English Style', *Design for Today* 2 (February 1934). Edwards, an expert on English furniture, was on the staff of the Department of Woodwork at the Victoria & Albert Museum, and was later Keeper. R. M. Y. Gleadowe, 'Essential Qualities of British Art', *The Listener* 11 (17 January 1934) and subsequent articles. Gleadowe was art master at Winchester and Slade Professor of Fine Art at Oxford, 1928. Herbert Read, 'English Art', *Burlington Magazine* 63 (December 1933), reprinted in *In Defence of Shelley and Other Essays* (1936) and *The Philosophy of Modern Art* (1952). Read had been on the staff of the Victoria & Albert Museum, 1922–31, and was Professor of Fine Art at Edinburgh University, 1931–33. *The Times*, 'British Art, Royal Academy Exhibition. Native Interests and Inspiration', 6 January 1934, and leading article on the same day. *The Times*, 13 January 1934, 'English Art, British Museum Displays'.

(4) Book reviews: Ralph Edwards, review of the catalogue of 'British Art, c.1000–1860', *Burlington Magazine* 66 (March 1935). Sir Charles Holmes, 'Books on British Art', *The Listener* 10 (20 December 1933). Holmes was a former director of the National Portrait Gallery and subsequently the National Gallery and had retired in 1928. John Pope-Hennessy, 'Reflections on British Painting', *Burlington Magazine* 65 (July 1934). John Pope-Hennessy 'English Painting', *New Statesman and Nation*, new series 6 (30 December 1933). Pope-Hennessy was later Director of the Victoria & Albert Museum and subsequently the British Museum. D. S. MacColl, 'Books on English Art', *Quarterly Review* 263 (July 1934). MacColl, painter and critic, had been Keeper at the Tate Gallery and subsequently the Wallace Collection. John Steegman, 'English Painting', *Burlington Magazine* 64 (February 1934). Steegman was later on the staff of the National Museum of Wales and subsequently Director of the Montreal Museum of Fine Arts.

4 The talks series included: Rt. Hon. S. M. Bruce, 'Taking Stock of the Empire', *The Listener* 10 (27 September 1933), introducing a series 'The Commonwealth of Nations' by Professor R. Coupland, Professor of Colonial History at Oxford, from 4 October; Lord Eustace Percy, 'Taking Stock of our Social Machinery', *The Listener* 10 (4 October 1933), introducing a series by different authors on 'Some British Institutions'. The talks series that have been particularly useful here are: 'The National Character', introduced by Stanley Baldwin in *The Listener* 10 (4 October 1933). Baldwin was Conservative leader in the National Government and Lord Privy Seal. There was an editorial article 'The Englishman' in the same issue. The editor, R. S. Lambert, had a background in adult education before being appointed to *The Listener*, then a new journal, at the end of 1929. He was later editor of the Pelican paperback anthology *Art in England*, 1938, which included reprinted articles by a number of the authors discussed here. Also in *The Listener* for 4 October was Arthur Bryant's first article. Bryant's series lasted until 13 December, but the general title 'The National Character' was retained for articles by a variety of authors, British and foreign, until well into the new year. Most of Bryant's articles were published in book form as *The National Character* (London: Philip Allen) the following year. English music was the subject of a series of six talks by Dr Thomas Armstrong, organist of Christ Church, Oxford, published in *The Listener* from 4 October. In *The Listener* in the same week the Minister for Agriculture and Fisheries, the Rt. Hon. Walter Elliot, introduced a series of talks by Professor J. A. Scott Watson on 'Rural Britain Today and Tomorrow', published in *The Listener* from 11 October to 27 December. Scott Watson was Professor of Rural Economy at Cambridge and his talks were published under the same title (Edinburgh: Oliver and Boyd, 1934). A BBC journalist, Howard Marshall, broadcast a series of talks entitled 'Vanishing England' published from 25 October to 29 November, which was prefaced by an editorial, and discussed the role of the public and local authorities in the proper implementation of the 1932 Town and Country Planning Act, and praised the work of the Council for the Preservation of Rural England, the National Trust and the Society for the Preservation of Ancient Buildings.

5 The Royal Academy's one-country exhibitions were *Flemish Art* (1927), *Dutch Art* (1929), *Italian Art* (1930), *Persian Art* (1931), *French Art* (1932), *British Art* (1934) and there was then an exhibition of *Chinese Art* (1935). The background to the decision to have a British Art exhibition is not evident from the Royal Academy Council's Minute Books and the reasons for the order of the exhibitions in general is not known. It may be significant, in relation to the British Art exhibition, that at a previous meeting, 1 November 1932, a proposal for an exhibition of Scottish Art from Sir John Lavery had been rejected. An exhibition of Scottish art was eventually held in 1939. In the debate over Englishness that accompanied the exhibition almost nothing was said about Englishness in terms of the wider definition of Britishness. The Royal Academy's decision to have a British exhibition in 1934 may have been affected by financial exigencies. The RA had been accustomed to making a profit from the exhibitions, but the French exhibition, though successful in terms of attendance figures, only just broke even. The reason must have been the adverse exchange rate which

made foreign loans expensive, and would have made attractive an exhibition that depended on them as little as the British did. At the Council meeting on 6 March a suggestion was made that a British Art exhibition should be organised in Paris. The London exhibition ran from 6 January to 17 March (extended from the planned closing date of 10 March). There were 200,000 visitors, which was much less than for the French exhibition and only a third of the numbers for the Italian exhibition, but was nonetheless regarded as a good attendance. The author is grateful to the Librarian of the Royal Academy for access to the Council Minute Books.

6 Paul Nash, 'Unit One', *The Listener* 10 (5 July 1933): 15.

7 Paul Nash in Herbert Read, ed., *Unit One* (London: Cassell, 1934), 80.

8 Vernon Bartlett, 'Germany leaves the League', *The Listener* 10 (18 October 1933): 570.

9 S. K. Ratcliffe, 'My Glimpse of the New Germany', *The Listener* 10 (9 August 1933): 190. Four articles by Harrison Brown had appeared in *The Listener* between 2 and 23 November 1932.

10 Colonel Sandeman Allen, 'Back to Nature in Germany', *The Listener* 11 (28 February 1934): 359.

11 Rt. Hon. Walter Elliot, 'Twentieth-Century Rural Rides', *The Listener* 10 (4 October 1933): 506.

12 Bryant's series 'The National Character' ran from 4 October to 13 December and was then opened up to other contributors. His first article 'England's Greatest Asset', focused on the varied skills of the population, and the second, 11 October, was 'The Englishman's Roots in his Countryside'. Baldwin's introduction, 4 October, was titled 'Our National Character'. The Editorial article on 4 October was titled 'The Englishman'. See *The Listener* 10 (4 October 1933): 481–88.

13 Rt. Hon. Stanley Baldwin, *On England and Other Addresses* (London: Philip Allan, 1926, popular edition, 1933).

14 Arthur Bryant, *The National Character* (London: Longmans Green, 1934).

15 'The Englishman', *The Listener* 10 (4 October 1933): 488.

16 Bryant, 'The Englishman's Roots in his Countryside', *The Listener* 10 (11 October 1933): 531.

17 Bryant, 'The Englishman's Root', 531.

18 Bryant, 'The Englishman's Root', 531.

19 Bryant, 'The Englishman's Root', 531.

20 Bryant, 'The Englishman's Root', 531.

21 Arthur Bryant, ed., *The Man and the Hour. Studies of Six Great Men of Our Time* (London: Philip Allan, 1934), 24.

22 Rt. Hon. Walter Elliot, Minister of Agriculture and Fisheries, 'Twentieth-Century Rural Rides', *The Listener* 10 (October 1933): 508.

23 See note 3.

24 For references see note 3.

25 Roger Fry, *Reflections on British Art*, republished as *French, Flemish and British Art* (London: Chatto and Windus, 1951), 137 and ff.

26 D. S. MacColl, 'Books on English Art', *Quarterly Review* 263 (July 1934), 83.

27 Richard and Samuel Redgrave, *A Century of British Painters* [1866] (London: Phaidon Press, 1947), 20.

28 Ernest Chesneau, *The English School of Painting*, 4th edn. (London: 1891), xiii.

29 Allan Cunningham, *Lives of the Most Eminent British Painters*, rev. edn. (London: Bell, 1879), 2–3.

30 W. T. Whitley, *Artists and their Friends in England 1700–1792*, 2 vols. (London and Boston: Medici Society, 1928). *Art in England, 1800–1820* and *Art in England, 1821–1837*, 2 vols. (Cambridge: Cambridge University Press, 1928 and 1930).

31 Sir William Llewellyn, preface, *Catalogue of the Exhibition of British Art, c. 1000–1860* (London: Royal Academy of Arts, 1934), v.

32 For more information on the composition of the exhibition, see note 2.

33 W. G. Constable, intro., *Catalogue of the Exhibition of British Art, c. 1000–1860* (London: Royal Academy of Arts, 1934), xii.

34 Constable, intro., xii.

35 Constable, intro., xii.

36 Constable, intro., xii.

37 Constable, intro., xvi.

38 Constable, intro., xvii.

39 Constable, intro., xvii.

40 James Mann, 'Note on the Sculpture and Objects of Art', in the *Catalogue of the Exhibition of British Art, c.1000–1860*, p.xvii.

41 W. G. Constable, intro., *Exhibition of British Primitive Paintings from the Twelfth to the Sixteenth Century. With some related Illuminated Manuscripts, Figure Embroidery and Alabaster Carvings,* Royal Academy of Arts, London, October–November 1923 (London: Oxford University Press, 1924).

42 (Sir) Eric Maclagan, intro., *Victoria and Albert Museum. Exhibition of English Mediaeval Art* (London: Board of Education, 1930).

43 Herbert Read, 'English Art', *Burlington Magazine* 63 (December 1933): 243.

44 W. G. Constable, intro., *Catalogue of the Exhibition of British Art, c. 1000–1860*, xv.

45 Herbert Read, 'English Painting in Perspective', review of Charles Johnson, *English Painting* (London: Bell, 1932), in *The Listener* 7 (30 March 1932): 450.

46 Herbert Read, in 'English Gothic', *The Listener* 3 (14 May 1930): 853.

47 Herbert Read, 'English Art', 244.

48 Herbert Read, ed., *The English Vision. An Anthology* (London: Eyre and Spottiswoode, 1933).

49 Herbert Read, 'English Art', *Burlington Magazine* 63 (1933): 254.

50 Read, 'English Art', 244.

51 Kenneth Clark, 'English Painting', *The Listener* 10 (20 December 1933): 947.

52 Kenneth Clark, 'English Painting', in R. S. Lambert, ed., *Art in England* (Harmondsworth: Penguin, 1938), 15.

53 Kenneth Clark, 'English Painting', 947.

54 Clark, 'English Painting', 948.

55 Clark, 'English Painting', 948.

56 'The Mingling of the Races. A discussion between Arthur Bryant and Professor H. J. Fleure', from the series 'The National Character', *The Listener* 10 (18 October 1933).

57 Ralph Edwards, review of the Commemorative Catalogue, *Burlington Magazine* 66 (March 1935): 112.

58 Sir William Rothenstein, *Form and Content in English Painting. The Romanes Lecture. The Sheldonian Theatre 24 May 1934* (Oxford: Oxford University Press, 1935).

59 Sir William Rothenstein, *Since Fifty. Men and Memories, 1922–1938* (London: Faber and Faber, 1939), 213 ff.

60 Sir William Rothenstein, *Form and content in English Painting*, 32.

61 Sir William Rothenstein, intro., *Centenary Exhibition of Paintings and Drawings by Sir Edward Burne-Jones Bart, 1833–1898* (London: Tate Gallery, 1933), 5.

62 Anthony Blunt, 'The Pre-Raphaelites', *The Spectator* 152 (19 January 1934): 84.

63 Roger Fry, *Reflections on British Painting* (London: Faber and Faber, 1934), 17–18.

64 Fry, *Reflections on British Painting*, 22.

65 Fry, *Reflections on British Painting*, 23.

66 Fry, *Reflections on British Painting*, 33.

67 Fry, *Reflections on British Painting*, 41–42.

68 Of the books by critics and general writers, Wilenski's somewhat eccentric *English Painting* is the most interesting. Wilenski stresses the 'outsiders' of English art, such as Blake, Fuseli, Cruikshank and political satirists and caricaturists, and although the text is not concerned with modern art, Wilenski interleaves it with reproductions of contemporary artists such as Wyndham Lewis, John Armstrong, Edward Burra and Stanley Spencer, who appear to parallel in the present day past manifestations in earlier art that Wilenski wishes to foreground.

69 Published 12 June 1933.

70 Paul Nash in Herbert Read, ed., *Unit One* (London: Cassell, 1933), 79–81.

71 The full list of lectures planned at the Royal Academy and other London venues is in the exhibition catalogue.

72 'English Art. British Museum Displays', *The Times* (13 January 1934). The art critic wrote: 'The exhibition brings home the Englishness of English art' and attributed to Blake, Calvert, Palmer and Linnell, to whom the critic was partly referring, 'national significance out of all proportion to their purely artistic powers. In them … the English genius becomes incandescent and clairvoyant'.

John Ruskin, Herbert Read and the Englishness of British Modernism

Fiona Russell

To examine the role and reputation of John Ruskin in writings which proclaim the arrival of the Modern Movement in Britain may well seem a perverse undertaking. For Ruskin, notoriously, loathed 'the Modern', by which he meant 'all work whatsoever subsequent to the period of the Renaissance — that is to say, the middle of the fifteenth century'.[1] Moreover, a glance at the Index to Ruskin's *Works* reveals the comprehensive quality of that loathing. The entry under the word 'Modern' runs to roughly a page and encompasses 'Modern Age', 'Life', 'Thought' and 'Modernism'. Ruskin's editors, E.T. Cook and Alexander Wedderburn, comment somewhat wearily: 'To collect in one article all references to R.'s indictments of modernism would involve much repetition. See, in addition to passages here noted, England, Europe, Nineteenth Century, Present Time, etc. etc.'.[2] 'Modernism', according to Ruskin, is 'calamitous'. It is characterised by, among other things, 'despondency', 'disbelief' and 'dislike of monks'; 'selfishness', 'sins', 'smoke' and 'superciliousness'. The entry further directs us to Ruskin's views on 'Modern Art', 'Cities' and '"Improvements"'; 'Railways', 'Restoration' and 'Scenery'. Ruskin's views on a Modern Movement might well be imagined.

Yet, even a cursory glance at the aesthetics of the early 1930s reveals many references to Ruskin's works. Moreover, the range of texts invoked by writers and artists — *Modern Painters, The Stones of Venice, Sesame and Lilies, Lectures on Art, Unto This Last* and *Praeterita* — suggests that Ruskin was a rich resource, drawn upon regularly, taken seriously and often patently enjoyed. Eric Gill's debt to Ruskin is perhaps the most self-evident example. A self-conscious, though idiosyncratic, inheritor of the Arts and Crafts Movement, the text Gill most clearly draws upon is *Unto This Last*. Adrian Stokes, on the other hand, was involved in a more complex evocation of Ruskin's ideas. His *Stones of Rimini* and *The Quattro Cento* are steeped in a reading of Ruskin's *The Stones of Venice* and he cites *Modern Painters* with alacrity. For Stokes, Ruskin's preoccupations chimed with his own modernist concerns — about the material of the art object, its perception, and its

connection to nation and to politics. However, it is Herbert Read's complex, developing and sometimes ambivalent relationship with the work of Ruskin that is the subject of this essay.

Read always emphasised the importance of Ruskin within his intellectual and political development.[3] In his autobiographical writing, he recounts how, as a young man, working as a bank clerk in Leeds, he read Carlyle, Ruskin and Morris. Reading Ruskin was a part of Read's early interest in socialism and, as such, his early contact with Ruskin is of a piece with the way in which Ruskin was being read by many in the early years of the twentieth century—as a teacher, moralist and social prophet. David Thistlewood, however, has pointed to other reasons why Read found Ruskin especially appealing as a young man. Read was particularly drawn to 'ideas which took account of the natural, or which were based upon a pre-eminence of natural processes'.[4] As Read's interest in the visual arts deepened, moreover, and as he became interested in psychoanalysis, Ruskin's concern with the psychology of perception—his insistent worrying away at concepts such as 'expression', 'colour', 'space' and 'the imagination'—as also increasingly attractive. Indeed it was at the point where Read was trying—in the late-twenties and early-thirties—to move away from the formal Francophile account of modernism propounded by Fry and others, towards an account of the will or impulse behind artistic expression, that his references to Ruskin on art were most frequent. In *The Meaning of Art* (1931), Ruskin is cited often in order to support and give authority to Read's argument for abstraction and a theory of expressionism.

Given Read's use of Ruskin to bolster his position in *The Meaning of Art*, it comes as a surprise to find Ruskin barely figuring in the texts which followed. In particular, Ruskin is largely absent from those texts which Read wrote whilst involved in the creation of the artists' group, Unit One. This seems a strange absence given Unit One's emphasis on the importance of design, its conviction that the unification of the arts was crucial and imminent, and given Read and Nash's attempts to create a lineage for the 'modern' in British art and design. Moreover, as we shall see, if we look at a range of Read's works in this period, it is clear that he was reading, borrowing from, and deeply influenced by, Ruskin elsewhere.

The absence of Ruskin in texts surrounding the creation of Unit One may well explain why, although Ruskin plays a central and sympathetic role at the outset of Charles Harrison's *English Art and Modernism*, Harrison does not note a revival of interest in his work in the 1930s. Harrison reads the Whistler trial,

and Ruskin's subsequent humiliation, as a decisive turning away from the belief that art and the artist should have a social function, and this turning away as both a defining and a limiting factor in the development of the British avant-garde over the next half-century.[5] Yet the presence of Ruskin's writings on a range of subjects—materials, abstraction, the effects upon art of a nation's politics, character and landscape—in Read's work and that of others suggests that Ruskin could still be a compelling and useful resource. This essay will examine the nature of that resource, its potential and its limits.

Such a study is helpful, I want to argue, because, as Chris Stephens argues elsewhere in this volume, modernism in Britain is largely described in terms of the arrival and appropriation of European theory and practice. The history of modernism Stephens is referring to is familiar, and is told perhaps most influentially in Harrison's *English Art and Modernism*. It is the story of an insular twenties, when some British artists went abroad—for example Christopher Wood and Edward Wadsworth—where they made little impression, whilst younger artists stayed at home—for example Henry Moore—gradually learning for themselves the lessons of pre-war British modernism. This period of stagnation was brought to a close by the belated arrival of international modernism in the early thirties, when a group of significant artists and critics settled in, or returned to, London—including Herbert Read, Henry Moore, Paul Nash, Adrian Stokes, Barbara Hepworth, Roland Penrose, David Gascoyne and Ben Nicholson—bringing with them and developing what they had learned from, or of, international modernism. They were joined there by the European émigrés—notably Walter Gropius and Naum Gabo—and the crucial period 1931 to 1934 saw the development of a 'second substantial phase of modernism in English art' which Harrison describes as 'vernacular modernism'.[6]

Harrison's phrase, 'vernacular modernism', as Stephens points out, has remained largely unexamined. It appears to consist of references to landscape, references to the techniques of the Arts and Crafts Movement, or to the way in which British modernist design and the fine arts found an affinity with the historical (usually rural) British interior of oak settles and beams. Such interests are seen to have softened and qualified international modernism, in so doing robbing it of its relation to, in particular, urban modernity. Norman Foster, in his Foreword to the catalogue for a recent exhibition at the Design Museum, *Modern Britain*, simplifies this view of the British and modernism still further: 'I believe it is not overstating the case that Modernism only really arrived in Britain with [the European] émigrés . . . [The architects] who had pioneered Modernism in

Europe, brought with them a pure strain of what had hitherto in Britain been a hybrid, even decorative style'.[7] European modernism purifies 'a hybrid, even decorative style', and by implication remains vulnerable to it. Foster's account is oversimplified, yet it is interesting, in part, because of the resemblance between it and an account of the relationship between Britishness and modernism which was itself present in the early 1930s.

The late twenties and early thirties saw the publication of a number of polemical introductions which attempted to situate modernism. Rather than produce a new history, Herbert Read countered Roger Fry and R.H. Wilenski's Francophile versions of the Modern Movement by proposing a different geography, a northern Germanic, instead of southern, Paris-centred account. Paul Nash heralded the imminent arrival of the Modern Movement in Britain using the metaphor of invasion and territorial annexation:

> We are invaded by very strong foreign influences, we possess certain solid traditions. Once more we find ourselves becoming conscious of a renaissance abroad, and are curious and rather embarrassed by the event; at once anxious to participate and afraid to commit ourselves, wishing to be modern, but uncertain whether that can be consistent with being British.[8]

Both Read and Nash were anxious to root the Modern Movement in Britain's 'solid traditions'. To this end, both created a series of purpose-built lineages: for Nash, Regency furniture was the best example of modern British design; for Read, pottery was the quintessential modern English art form. But it is striking that these lineages were largely made up of objects and styles, rather than ideas. Perhaps the attempt to find the modern in British before modernism was always liable to lead to the belief that Britain needed only a bit of a clear-out to make room for the modern object in its cluttered interior—much as it had made room for the objects and images of Empire? Shorn of the ideology that underpinned it, the modern object could simply become part of the furniture.

The presence of Ruskin in Read's work, however, points to a potentially rich British resource of ideas, a resource which raised insistent and pertinent questions about the circumstances—political and social—under which art was and could be made. Here was a nineteenth-century precursor writing about the political economy of art, the psychology of perception, the need for a new relationship between art and design, and the nature of the English Character and the English School. Writing in the early 1940s Read maintained that Ruskin was the first of six modern 'philosophers and prophets'—the others being Kropotkin,

Morris, Tolstoy, Gandhi and Gill — 'whose message is still insistent and directly applicable to our present condition'.[9] Moreover, he argued, Ruskin 'in this succession, has a certain pre-eminence and originality'.[10] Yet, whilst Read frequently cited Ruskin, he produced neither a consistent examination of Ruskin's legacy, nor did he attempt to build upon his analysis of, say, the need for a unification of the arts. Instead, Ruskin appeared sporadically, as a stimulating but by no means reliable figure. He was not part of the lineages Read created in order to prepare the ground for the Modern Movement in Britain. He remained an isolated figure and an intellectual cul-de-sac.

I shall argue that this is not merely a case of unacknowledged debt (which by itself would only matter to the over-enthusiastic Ruskinian). The fact that Ruskin was not, perhaps could not be, used as an ideological forbear when arguing the case for the Modern Movement in Britain raises interesting questions about the priorities, self-perception, and limitations of Read and others. Furthermore, the fate of Ruskin and his work points up a number of particular concerns and urgencies which marked the modernism of the early 1930s and which limited its scope.

§

It seems strange that despite his hatred of the 'modern', Ruskin's aesthetics often seem uncannily prophetic. In fact, interesting parallels can be drawn between Modern Britain as envisaged by Unit One and the Middle Ages as described by Ruskin. One of the most frequently cited of Ruskin's works in the early thirties was *Modern Painters*, and both Read and Stokes clearly knew volume three intimately. At the close of that volume there are two contrasting chapters, 'Of Medieval Landscape' and 'Of Modern Landscape'. In the latter, Ruskin describes at length the 'modern' (by which he meant the nineteenth-century) state of mind, which he holds responsible for the 'modern' aesthetic.

The modern mind, Ruskin argues, is characterised by dimness, denial of colour, faithlessness, lack of interest in ordinary life, an abnormal interest in the historical, and an obsession with wildness and nature. 'Now', Ruskin famously argues, after Aristophanes, 'our ingenuity is all "concerning smoke"'.[11] 'On the whole, these are much sadder ages [than the Middle Ages]; not sadder in a noble and deep way, but in a dim wearied way, — the way of ennui, and jaded intellect, and uncomfortableness of soul and body.'[12] The Middle Ages, by contrast, he argues, were an age of light, clarity and colour. Life was vivid and intense: 'Their

gold was dashed with blood; but ours is sprinkled with dust. Their life was inwoven with white and purple: ours is one seamless stuff of brown'.[13] The nineteenth century, Ruskin believes, should truly be called the Dark Ages; the Middle Ages, he maintains, have been mis-named.

For Ruskin, above all, it was his contemporaries' obsessions with landscape and the national past which were the most obvious symptoms of these new Dark Ages. And here, Ruskin locates the British problem precisely, for these are the very vernacular preoccupations which critics have identified as inhibiting the Modern Movement in Britain. Ruskin identifies just these preoccupations as responsible for the thoroughly unhealthy state of contemporary English art, and he goes on to ask why his contemporaries are so keen to live in the past. The romances of Walter Scott, for example, betray an abnormal and disrespectful love of history:

> All other nations have regarded their ancestors with reverence as saints or heroes; but have nevertheless thought their own deeds and ways of life the fitting subjects for their arts of painting or of verse. We, on the contrary, regard our ancestors as foolish and wicked, but yet find our chief artistic pleasure in descriptions of their ways of life.[14]

The nineteenth-century's retreat into the past, he argues, is a result of the fact that it cannot love the present. Likewise, the contemporary love of wild landscape is a reflection of the fact that the British cannot love their contemporary creation, the industrial city. The nineteenth-century painter paints moorland desolation, trees and mountainous rivers, because his audience cannot find pleasure in things closer to home. In the following passage, Ruskin moves from a consideration of a medieval painting to a contemporary landscape:

> Out of perfect light and motionless air, we find ourselves on a sudden brought under sombre skies, and into drifting wind; and, with fickle sunbeams flashing in our face, or utterly drenched with sweep of rain, we are reduced to track the changes of the shadows on the grass, or watch the rents of twilight through angry cloud. And we find that whereas all the pleasure of the mediaeval was in stability, definiteness, and luminousness, we are expected to rejoice in darkness, and triumph in mutability; to lay the foundation of happiness in things which momentarily change or fade; and to expect the utmost satisfaction and instruction from what it is impossible to arrest, and difficult to comprehend.[15]

Here, Ruskin comes close to anticipating the complaints of writers and artists trying to introduce the Modern Movement into a Europe mired in a nineteenth-century past. Ruskin's longing for an aesthetic of 'stability, definiteness and luminousness' brings to mind Gropius's desire for a clear, organic architecture in contrast to the ornamental historical fakeries of the architectural past. His declaration that 'we seek for wild and lonely places because we have no heart for the garden'[16] is reminiscent of a passage from Nash's *Room and Book*, where Nash contrasts the Victorian drawing room ('like nothing so much as a demented parish bazaar') with the clean, light-filled, ordered spaces of the Modern room, from which the Modern aesthete can contemplate nature (like a picture) in the form of a garden: 'It is possible', Nash writes, 'to imagine many lovely compositions in which English country house interiors are conceived in association with the garden view'.[17]

Ruskin's critique of his time was the most forceful critique of the nineteenth century — of its obsession with landscape and history, its imperial clutter, and its failure to do anything about the cramped, dim, ugly lives of its industrial population. Like the aestheticians of the Modern Movement, Ruskin emphasised the importance of today, the necessity of producing art works, architecture, products, even gardens, which reflected the priorities of a rightly ordered and orientated culture. But his was a critique made within its own time. As Ruskin knew only too well, he, like Scott, was no more and no less than a son of the nineteenth century. Ruskin presented his early twentieth-century readers with a paradox: the most visible legacy of this most formidable critic of the nineteenth-century's obsession with the past was the Guild of St George and the work of William Morris. And it is this legacy — and in particular the virulent anti-industrialism associated with it — which proved to be the sticking point for Read: 'I am no yearning medievalist', he wrote, 'and have always denounced the sentimental reaction of Morris and his disciples. I have embraced industrialism, tried to give it its true aesthetic principles'.[18]

Emigré theorists of the Modern Movement, however, did not find Ruskin's legacy problematic. Ruskin and Morris were credited as important precursors of the Modern Movement whose solutions were ultimately flawed. In 1923 Walter Gropius, in 'The Theory and Organisation of the Bauhaus', claimed that:

The second half of the nineteenth century saw the beginning of a protest against the devitalising influence of the academies [of art, which had shut the artist off from industry and the community]. Ruskin and Morris in England,

van de Velde in Belgium, Olbrich, Behrens and others in Germany and finally the Deutsche Werkbund, all sought, and in the end discovered the basis of a reunion between creative artists and the industrial world.[19]

Ruskin and Morris, Gropius maintained, had urged a return to the cultural integration characteristic of the great periods of the past, where art, morality, politics and religion formed a whole. However, they were unable to carry this radical vision through because they could not reconcile themselves to machine production. Instead, Morris's firm found itself in the essentially futile business of reviving handicrafts, and thus, in the end, exacerbated the isolation of the individual artist and craftsman, who was reduced to producing handmade objects for a cultural elite.

According to this account, Ruskin and Morris were radicals, whose ethical position on art and industry anticipated the Modern Movement. Their rejection of machine production, however, was fatal. Gropius argues that there is no alternative to the machine: 'The Bauhaus believes the machine to be our modern medium of design'.[20] A new relationship must be forged with the machine, for 'so long as the machine-economy remains an end in itself rather than a means of freeing the intellect from the burden of mechanical labour the individual will remain enslaved and society disordered'.[21]

In 1936, the German émigré Nikolaus Pevsner presented a similar account of the origins of the Modern Movement, to his new English-speaking readership in *Pioneers of the Modern Movement*, subtitled *From William Morris to Walter Gropius*. 'Morris', Pevsner maintained,

> was the first artist (not the first thinker, for Ruskin had preceded him) to realise how precarious and decayed the social foundations of art had become during the centuries since the Renaissance, and especially during the years since the industrial Revolution ... Ultimately, in 1861, instead of forming a new exclusive brotherhood of artists, such as the Pre-Raphaelite brotherhood had been, and such as he had wished to found when he was studying at Oxford, Morris made up his mind to open a firm ... This event marks the beginning of a new era in English art.[22]

For Pevsner, a lineage for the Modern Movement in Britain is clear; it stretches back to Morris and beyond, to Ruskin, the thinker who preceded him. But what of the lineages created by Read and Paul Nash? One might expect — given that both were arguing the case for the unification of the arts and the beauty of

design, and given Nash's belief that it was necessary to root modernism in Britain's 'solid traditions'—that both would want to root the Modern Movement in their British forbears, Ruskin and Morris. Yet Read, who elsewhere, both before and after this point, frequently cites Ruskin either as a support or as a point of interest, either doesn't mention Ruskin, or ridicules him, and Nash ignores him altogether. In three central texts preparing the way for the arrival of the Modern Movement in Britain—Read's *Art Now* and *Art and Industry* and Nash's *Room and Book*—Ruskin either did not appear at all (*Art Now* and *Room and Book*), or appeared coupled with Morris only to be dismissed as a blind alley.

In *Art and Industry* (1934), Ruskin is to be found in a subsection entitled 'Wedgwood and Morris'. Moreover, the relationship between Ruskin and Morris is not described, as it is in Gropius and Pevsner, as a relationship between a master and pupil, or as a relationship between a thinker and his disciple. It is a relationship between an artist and a critic. Morris, Read argues, was an artist, who read and was inspired by *The Stones of Venice*, and:

> When we have traced the workings of Ruskin's doctrines in the robuster mind and frame of Morris, we have explained the general course of his life; any differences are temperamental, not intellectual. But though Ruskin did sometimes apply his doctrines in an eccentric and wasteful fashion, the virtue of Morris is that with all his enthusiasm, and in spite of his financial incapacity, he was essentially a practical genius, carrying theory into action, embodying beauty in things of use, giving organisation to opinion.[23]

This is an oddly personal passage. Instead of elaborating on Ruskin's thought, Read refers to his 'temperament', and Morris does not fare much better. Ruskin was 'eccentric' and 'wasteful'; Morris was more 'robust'. However, Morris was financially incapable, and the word 'robust' rebounds upon him; the implication of the passage is that Ruskin was weak-minded whilst Morris was a bit of a fool. Having damned the two on the grounds of 'temperament' Read then makes the argument we found in Gropius and Pevsner: Ruskin and Morris rejected the machine, from which there is no escape and without which there can be no Modern Movement: 'We are irrevocably committed to a machine age—that surely is clear enough now, eighty years since the publication of *The Stones of Venice*. The cause of Ruskin and Morris may have been a good cause, but it is now a lost cause'.[24] Ruskin makes further appearances in *Art and Industry*, but, apart from when Read cites him on the qualities of ductility and transparency in glass—thus transforming him into a proto-modernist advocate of truth to mate-

rials — he appears, each time with Morris, only to be dismissed for advocating the tradition of the ornament and for failing to understand the art of construction.

The problem of ornament was also a central concern for Nash in his *Room and Book* (1932), where Ruskin is conspicuous only by his absence. First published as articles in *The Listener*, *Room and Book* was an impassioned attempt to argue that the values of the Modern Movement chimed with the best of British design history. Nash argued that the Regency period saw the development of a comprehensive modern aesthetic in Britain, characterised by simplicity, order, dignity and elegance. This period, however, was brought to a close by the Victorians, who swept away its restrained values and replaced them with chaos, eclecticism and excess.[25] Morris is admitted to have been 'an improvement', but he was 'not altogether helpful'. Moreover, he and his followers were ultimately intent upon persuading the world to return to the Middle Ages, and they 'frightened a good many people into thinking decoratively'.[26]

It seems strange that the two writers most self-consciously concerned with arguing the case for a Modern Movement which could meld with 'strong traditions' in Britain, fail to make more of Ruskin and Morris as predecessors. Why deny Ruskin and Morris a place in the history of the Modern Movement, a place which Gropius and Pevsner were happy to allocate to them? And in Read's case, why deny Ruskin's importance in one body of texts when other contemporaneous texts show clearly his influence upon Read? I want to explore a number of possible reasons, some to do with the history of Ruskin's works and reputation, some to do with the politics of British modernism in the early 1930s, and some to do with the particular character of Read's own version of 'vernacular modernism'.

The fate of Ruskin's reputation in the early twentieth century brings us to Eric Gill — the last of Read's six philosophers and prophets — and the version of Ruskin espoused by him in a lecture, 'John Ruskin', delivered in 1934, the year of *Art and Industry*. Despite Read's friendship with, and admiration for, Gill, his Ruskinianism was precisely the kind of post-Arts and Crafts anti-industrialism the author of *Art and Industry* professed at this moment to despise: 'It is no use attempting to save the arts as Mr Gill and the modernists would have us do by advising architects artists and craftsmen to throw in their lot with industrialism', Read wrote, 'for that can only make the destruction absolute'.[27] Gill, however, was arguing: 'If Ruskin is to be remembered for one thing only, I suggest that he is to be remembered for one book, the book called *Unto This Last*'.[28]

Ruskin, Gill believed, had seen life 'more or less whole'; he had advocated the binding together of art and life, and criticised the divorce between the two

which had come about in the age of industrialisation.[29] Gill recounts the familiar Ruskinian story of art and industry: the artist became isolated in the academy, whilst mass production debased both the worker and thing he made. But whereas Gropius, for example, approved of Ruskin's analysis, Gill approved of his solution as well. There is no future for art and industry, he argues. 'To some extent the business man worships art (especially when he is persuaded that it is a good investment), but you must not interfere with trade. Well, they have made a fine mess of it with their trading and finance. Let us remember Ruskin as the man who foretold their doom.'[30]

Gill's lecture is, at one level, a reminder of how little an understanding of Ruskin's work had developed in the half century since the end of his working life. Ruskin died in 1900, although his active life had ended in 1889. As such, it is as if his posthumous life began ten years before his death with the publication of the requisite reverential biographies and memoirs. In 1903, however, the Library Edition of the *Complete Works* began to appear. But, as critics have noted, its effect was curious. Rather than opening up the possibility of fresh new readings of hitherto neglected works, or even enabling the discovery of major trains of thought, the effect of the edition seems to have been to monumentalise a body of work which had always been occasional, fluid, polemical and engaged. Rather than facilitating access to Ruskin's work, the Library edition appears to have repressed its vitality.[31]

Cheaper editions of individual works, collections of essays and anthologies continued to be published, but the pattern of their publication shows a shift. Whilst in the last decades of the nineteenth century the demand seems to have been for Ruskin as an occasional guide — to Italy or to the nation's pictures, for example — in the early years of the twentieth century it was Ruskin's later works — on the political economy of art, economics and in particular on education — which were repeatedly reprinted. *The Crown of Wild Olive*, Ruskin's lectures on industry and war, was particularly popular, as were *Unto this Last* (his work on political economy) and *Sesame and Lilies* (his essays on education). These works were also heavily anthologised in publications with titles suggestive of their general tone: *Noble Passages* (1907), *Through the Year with Ruskin* (1911), *Pearls of Thought* (1907) and *Insight and Imagination* (1909). It is this Ruskin — sage, teacher, social critic and proto-socialist prophet — which Read encountered in Leeds at the end of the First World War. However, this Ruskin was not being remade for the times so much as retold and his anti-industrialism was central to this version of his thought.

However, in 1933 a major attempt to read Ruskin in the light of twentieth-century concerns and aesthetic priorities appeared, *John Ruskin: An Introduction to Further Study of his Life and Work*. Its author, R.H. Wilenski, was also author of *The Modern Movement in Art* (1927), a Francophile account of the origins of modernism which Read attempted to counter at the outset of the 1930s in *The Meaning of Art* and *Art Now*. Wilenski's *John Ruskin* had far-reaching consequences for the study of Ruskin in the twentieth century. It was also highly readable, and it made a powerful case for Ruskin's relevance 'for problems not only of his own time, but also—and perhaps still more—for problems that confront the world to-day'.[32]

Wilenski focused on Ruskin's writing in three main areas—art, economics and war—and in each he made a case for Ruskin's contemporary relevance. In terms of aesthetics Wilenski pointed to Ruskin's championing of abstraction and to his belief in the importance of truth to materials. He made a major move in relation to Ruskin's writings on economics by laying to one side his anti-industrialism, and focusing instead on Ruskin's belief in the importance of ethical consumption and social security. And finally, and perhaps most powerfully, Wilenski pointed out that Ruskin had lived through half a century of war. He traced Ruskin's changing views on war, from his ignorant and unquestioning youth to the angry despair of *Sesame and Lilies*. Ruskin, Wilenski argued, forced his readers to face the question who pays for war and how. In his hatred of modern warfare and the armaments industry Ruskin had anticipated contemporary concerns about the build-up of arms. Indeed, Wilenski argued, he had anticipated the work of the League of Nations. Wilenski's Ruskin spent the final years of his life watching and writing—alarmed and despairing—as Europe moved inexorably towards all-consuming war.

For Wilenski, Ruskin's concerns were modern and many of his answers were modern also. Ruskin had championed and theorised abstract art; he believed in State intervention and he loathed modern warfare and the industry it engendered. Yet Wilenski's argument for the contemporary relevance of Ruskin seems largely to have been overlooked. This, I want to suggest, is a result of a further way in which Ruskin emerges from Wilenski's study as modern—as a deeply-troubled individual.

Wilenski confesses to having at first found Ruskin puzzling, sometimes impossible. This led him to study his biography. He soon came to the conclusion that Ruskin was a psychological cripple whose difficulties were only now diagnosable as manic depression. Wilenski subtitled his book *An Introduction to*

Further Study of His Life and Work, and it was Ruskin's psychological life which Wilenski saw as the key to his work. Ruskin's work, he maintained, must be read in the light of contemporary psychological insight, and alongside both the mass of letters and diaries he left behind, and the biographies and memoirs published after his death. 'Before we can understand what he wanted us most to understand in his writings', wrote Wilenski, 'we have to rearrange them all and rewrite most of them.'[33] To aid this process, Wilenski placed ten pages of synoptic tables at the beginning of his book, setting out 'Events' (Ruskin's personal history), 'Productions' (works), 'Repute' and 'Health'.

Ruskin's mental health, as outlined by Wilenski, was pitiful: a 'mental invalid' from childhood, he developed manic-depression in early manhood. He was subject to obsessions, irritability, religious and spiritualistic dabbling, rambling, obscurantism, extravagance, 'extreme mobility of interest', and he showed a thoroughly unhealthy interest in girls' schools. He cut a pathetic figure—particularly among artists—over-indulged, lacking in self-control and with little self-confidence. One cannot simply read Ruskin, Wilenski insists. His work can only be read alongside letters, diaries and biographies, from day to day, even hour to hour. Ruskin's art criticism is an 'appalling muddle'; his economic theories can only be understood if one examines the precise economy of his childhood home. According to Wilenski, Ruskin's ideas, even the best ones, are largely rationalisations and projections of his own personal anguish. And fascinating though Wilenski's thesis sometimes is, the effect is to undermine the argument he is simultaneously making for the coherence and prophetic quality of Ruskin's work.

Wilenski's book was influential and has had a very considerable effect upon Ruskin scholarship subsequently. His psychological thesis was compelling, perhaps inevitably more compelling than his reading of Ruskin's work. The consequences of his approach in terms of Ruskin scholarship are not, however, a matter for this essay. I want to point instead to a curious by-product, as it were, of this newly psychologised Ruskin. For, whilst Ruskin's reputation as a sage and a guide suffered, he simultaneously became a less daunting more accessible figure, and as such he could be put to new uses. I want to speculate that in Read's case, a flawed, vulnerable Ruskin became a site of identification. For if Ruskin largely disappeared from view in one group of texts by Read (those dealing with the visual arts) he continued to be used in another body of writing which was more personal and literary. Tracing Ruskin in Read's work in the early thirties reminds one of how diffuse Read's own writing at this point was. In the period

1930 to 1935 Read was writing simultaneously as an art critic, a poet, an anthologist and an autobiographer. Moreover, a consideration of these texts in the light of a possible identification with Ruskin returns us to the question of the Englishness of British modernism at the outset of the 1930s.

As we have seen, Ruskin was either absent or became a figure for ridicule in Read's writing on the visual arts. There are hints, however, that there is more to this for the art critic in Read than simply the connection between Ruskin and the Arts and Crafts Movement. I want to suggest that it is Ruskin's role as art critic in relation to the Pre-Raphaelites which may have been the problem. Ruskin was absent from Nash's *Room and Book*, and neither did he figure in Nash's letter to the Times — which Read incorporated into his introduction to *Unit 1*. In that letter, Nash invoked the origins of the Pre-Raphaelite brotherhood, as an analogous moment to the creation of Unit One:

> This was formed by a few painters who did not like the way English art was going, or rather, it seemed to them that it had stopped going and wanted new life. They offered it a new outlook and a new technique . . . we all know what it led to; an influence which changed the course of English painting to an incalculable degree.[34]

Nash's invocation of the Pre-Raphaelites might be expected to lead him to consider the role of Ruskin in their reception and the development of their work; but, once again, there is no mention of him. However, Ruskin is mentioned in relation to the Pre-Raphaelites — possibly significantly for our consideration of Read — in a series of letters which Nash exchanged with the poet Gordon Bottomley in the early forties. In these letters, Ruskin is seen as a critic who comes upon a group of artists and attaches himself to them. However, his influence is by no means entirely good: 'I thought the detail obsession was mainly Ruskin's wrong-headedness', Nash writes to Bottomley in August 1941: 'I doubt if Ruskin ever counted for much (no more than any critic ever does). Those engaging young men were doing what they gloriously liked; and when a powerful pen-ally turned-up, they of course gave him his head and humoured him'.[35] This is a cutting verdict, and it makes one wonder just how downy the 'nest of gentle artists' Read was later to celebrate actually felt in the early thirties.[36] Perhaps Ruskin's role was down-played in the texts relating to the Modern Movement because Read did not want to identify with Ruskin, in fact wanted to distance himself from any suggestion that he might become 'a powerful pen-ally' in relation to the new brotherhood, Unit One?

Ruskin, however, was playing an important part in a number of literary projects Read was working on around this time, and it was here that Read was developing his own version of 'vernacular modernism', a modernism with a rich vein of post-Romanticism running through it. This modernism is preoccupied with landscape and childhood, but also with the nature of Englishness itself. In 1933, Read published an anthology, *The English Vision*, which aimed 'to present the English ideal in its various aspects as expressed by representative Englishmen'.[37] The anthology was to be a 'guide' in 'uncertain and catastrophic times', and Read intended it to project a vision, 'the English Vision', of liberty, justice and 'toleration'.[38] Ruskin was the writer, along with William Blake, who appeared most frequently in *The English Vision*. But the Ruskin Read anthologised was an introspective, private, troubled figure, preoccupied with childhood, the English countryside and the nature of the English temperament. Read chose 'The Mountain Glory' from *Modern Painters* volume IV (which speculates on the effect of the English landscape on the early development of Shakespeare), passages from *Praeterita* (on 'common sense' and English pride) and sections from the *Lectures on Art* (on the national temper and 'our earthy instinct'). Ruskin is interesting here, not for his diagnosis of art and society, but rather for his sensitivity and his analysis of the peculiarities of the English psyche.

In the same year, Read published a memoir of his chidhood, *The Innocent Eye*, which is saturated with references to Ruskin's own memoir of his childhood *Praeterita*. Ruskin's memoir had played an important part in *The English Vision*, as had the childhood of Shakespeare, and now Read traced his own childhood in the English landscape. The parallels between the two memoirs are striking. Like *Praeterita*, *The Innocent Eye* is a topography of the self: the emphasis is on the first place—the Farm in a Vale surrounded by the Yorkshire moors—and above all on what the child can see. Ruskin's preoccupation with a bounded Eden finds many echoes in Read's memoir: instead of a garden, the child Read inhabits 'a basin, wide and shallow like the milkpans in the dairy . . . the rims were the soft blues and purples of the moorlands',[39] and as in *Praeterita*, this bounded place 'was my world and I had no inkling of any larger world, for no strangers came to us out of it, and we never went into it'.[40] Like *Praeterita*, *The Innocent Eye* is brought to a close by a death, in Read's case the death of his father, and finally, as in *Praeterita*, Read's edenic childhood stands as a touchstone for all that is valuable in his adult feeling sensibility.

The echoes of my life which I find in my early childhood are too many to be

dismissed as vain coincidences; but it is perhaps my conscious life which is the echo, the only real experiences in life being those lived with a virgin sensibility — so that we only hear a tone once, only see a colour once, see, hear, touch, taste and smell everything but once, the first time.[41]

Read was writing *The Innocent Eye* and editing *The English Vision* at a moment when he was deeply involved with the artists of Unit One, and it is tempting to see both books as proof of Read's latent conservatism. They are preoccupied with memory, landscape and in particular childhood and both have about them the quality of a retreat: it is difficult to reconcile either of them with the Read who was to argue a year later in *Art and Industry* for the triumph of the machine. The Ruskin, moreover, who emerged in these books, is a similarly conservative figure, modern only insofar as he is deeply troubled, but not in any sense a modernist.

There is, however, a further possible aspect to Read's identification with Ruskin at this moment which suggests something of the circumstances within, and pressures under which, Read was writing. In his 1945 collection of essays, *A Coat of Many Colours*, Read published an essay entitled 'The Message of Ruskin'. The essay is initially surprising, for when he came to address Ruskin's work in an extended form, Read did not write about him as an aesthetician, a moralist, or a theorist on the political economy of art. Instead he wrote about him as a writer, using *Sesame and Lilies*, Ruskin's famous essays on writing, reading and war, as his principal text.

'The Message of Ruskin' is unequivocal about Ruskin's importance. Quite simply, Read argues, 'in my opinion there is no English writer who has written such magnificent prose'.[42] Moreover: 'The conclusion we must come to, I would like to suggest, is that with Ruskin, as to some extent also with his contemporary Carlyle, criticism is for the first time raised to the rank of an independent art'.[43] Ruskin was a writer, Read maintains, who was forced by the particular character of his times to become a critic. Unable to write creatively in the uneasy, disintegrating atmosphere of the mid to late nineteenth century, Ruskin became a critic, a prophet and a preacher, a prophet and a preacher whose central aim was to lay bare the problem of the spiritual atmosphere in which he lived, the 'mere whirr and dust-cloud of a dissolutely reforming and vulgarly manufacturing age'.[44] The Ruskin of Read's essay is a tragic figure, indeed he emerges almost as an ideal self-image. Like Wilenski, Read fastens on to the fact that Ruskin wrote much of his work in the shadow of war, and at the close of the

essay, Read refers to the last fifteen troubled years in Europe and cites Ruskin — writing in the last decades of the nineteenth century, amidst an earlier period of political turmoil and war — on the importance of words:

> There are masked words droning and skulking about us in Europe just now ... there are masked words abroad, I say, which nobody understands, but which everybody uses, and most people will also fight for, live for, or even die for, fancying they mean this or that, or the other, of things dear to them.[45]

Ruskin's thoughts on the power of words and their abuse in times of war, remind Read only too clearly of 'our own time', and it is not surprising that Read found Ruskin timely. A writer who was becoming principally a critic, a critic, moreover, who felt an urgent need to think through art in disintegrating times, Read resembles Ruskin in practising what E.K. Helsinger has called 'history as criticism', whereby the aim of writing history is not to salvage the past, but rather to serve and affect the present.[46] Ruskin asked: what can the study of art achieve in and for these times? Read was involved in the early thirties in a similar, and similarly urgent, enterprise, and this perhaps explains why, despite his admiration for Ruskin, Read neither thought through, nor built upon, his work. Rather, Ruskin remained a resource to be plundered as and when a particular need arose. Increasingly, however, he also became a personal resource for a post-Romantic version of modernism and for a writer and critic trying to understand his own predicament in troubled times.

There were, however, concomitant losses. Andrew Causey has emphasised the belatedness of thirties modernism in Britain and the way in which the radical reformist impulse behind non-figuration was never really taken on.[47] Perhaps if Read and others had built upon the work of Ruskin and his disciples, the political import of abstract art might have been more evident to them? However, instead of being a radical figure and a British precedent for the rethinking necessary in order to create a new relationship between art and the culture that surrounded it, Ruskin became a figure of pathos and conservatism. He was a modern figure insofar as he was fearful, unstable and ultimately overwhelmed by the prospect of war. The story of John Ruskin and Herbert Read points ultimately to the context in which Read was working. And Paul Nash's call for preparations to be made for an 'orderly invasion', inevitably brings to mind the proximity of another invasion, all too visibly now in preparation, elsewhere.

1 E.T. Cook and Alexander Wedderburn, eds., *The Complete Works of John Ruskin* (London: George Allen, 1903–12), 2:xviii.

2 Ruskin, *Works*, 39:352.

3 See David Thistlewood, *Herbert Read: Formlessness and Form: An Introduction to his Aesthetics* (London, Boston, Melbourne and Henley: Routledge & Kegan Paul, 1984), 2.

4 Thistlewood, *Herbert Read*, 2.

5 See Charles Harrison, *English Art and Modernism, 1900–1939*, 2nd ed. (New Haven and London, Yale University Press, 1994), 1.

6 Harrison, *English Art and Modernism*, 248, 245.

7 Norman Foster, 'Foreword', in James Peto and Donna Loveday, eds., *Modern Britain, 1929–1939* (London: The Design Museum, 1999), 11–12.

8 Paul Nash, *Room and Book* (London, Soncino Press, 1932), 7.

9 Herbert Read, 'The Politics of the Unpolitical', in *The Politics of the Unpolitical* (London: Routledge, 1943), 2.

10 Read, 'The Politics of the Unpolitical', 2.

11 Ruskin, *Works*, 5:319.

12 Ruskin, *Works*, 5:321.

13 Ruskin, *Works*, 5:322.

14 Ruskin, *Works*, 5:326.

15 Ruskin, *Works*, 5:317.

16 Ruskin, *Works*, 5:323.

17 Nash, *Room and Book*, 8, 47.

18 Read, 'The Politics of the Unpolitical', 44.

19 Walter Gropius, 'The Theory and Organisation of the Bauhaus', in Herbert Bayer, Walter Gropius and Ise Gropius, eds., *Bauhaus, 1919–1928* (Boston: Branford, 1952), 21.

20 Gropius, 'The Theory and Organisation of the Bauhaus', 23.

21 Gropius, 'The Theory and Organisation of the Bauhaus', 20.

22 Nikolaus Pevsner, *Pioneers of the Modern Movement: From William Morris to Walter Gropius* (London: Faber & Faber, 1936), 22–23.

23 Herbert Read, *Art and Industry: The Principles of Industrial Design* (London: Faber & Faber, 1934), 28–29.

24 Read, *Art and Industry*, 33.

25 Nash, *Room and Book*, 21.

26 Nash, *Room and Book*, 21.

27 Read, *Art and Industry*, 33.

28 Eric Gill, 'John Ruskin' [1934], in *Essays: Last Essays and In a Strange Land*, intro. Mary Gill (London: Cape, 1947), 171.

29 Gill, 'John Ruskin', 169–70.

30 Gill, 'John Ruskin', 172.

31 See Brian Maidment, 'Interpreting Ruskin 1870–1914', in John Dixon Hunt and Faith M. Holland, eds., *The Ruskin Polygon: Essays on the Imagination of John Ruskin* (Manchester: Manchester University Press, 1982), 159–71.

32 R.H. Wilenski, *John Ruskin: An Introduction to Further Study of His Life and Work* (London: Faber & Faber, 1933), 302.

33 Wilenski, *John Ruskin,* 186.

34 Paul Nash, letter to *The Times,* 2 June 1933, cited in Herbert Read's introduction to Herbert Read, ed., *Unit 1: The Modern Movement in English Architecture, Painting and Sculpture* (London, Toronto, Melbourne and Sydney: Cassell, 1934), 10.

35 Paul Nash to Gordon Bottomley, 15 August 1941, in *Poet and Painter: Letters between Gordon Bottomley and Paul Nash, 1910–1946,* intro. Andrew Causey (Bristol: Radcliffe Press, 1990), 238, 240.

36 Herbert Read, 'A Nest of Gentle Artists', *Apollo,* 76, no. 7 (new series), 536–40.

37 Herbert Read, ed., *The English Vision: An Anthology* (London: Eyre and Spottiswoode, 1933), v.

38 Read, ed., *The English Vision,* vi.

39 Herbert Read, *The Innocent Eye* (London: Faber & Faber, 1933), 10.

40 Read, *The Innocent Eye,* 10.

41 Read, *The Innocent Eye,* 12–13.

42 Herbert Read, 'The Message of Ruskin', *A Coat of Many Colours: Occasional Essays* (London: Routledge, 1945), 232.

43 Read, 'The Message of Ruskin', 232.

44 John Ruskin, cited in Read, 'The Message of Ruskin', 233.

45 Ruskin, *Works,* 18:66.

46 See E.K. Helsinger, 'History as Criticism: The Stones of Venice', in R. Rhodes and D.I. Janik, eds., *Studies in Ruskin: Essays in Honor of Van Akin Burd* (Athens, Ohio: 1982).

47 See Andrew Causey, 'Herbert Read and Contemporary Art', in David Goodway, ed., *Herbert Read Reassessed* (Liverpool: Liverpool University Press, 1998), 123–43.

Ideologies of Englishness and Internationalism in Modernist Ballet

Ramsay Burt

This essay looks at the relationship between modernism and ideologies of national identity and internationalism in two English ballets of the 1930s: *Façade* (1931) and *Dark Elegies* (1937). *Façade*, which is often said to be a quintessentially English ballet, was created by an English choreographer, Frederick Ashton, and set to music by the English composer William Walton; it is a setting of poems by the English poet Edith Sitwell, and was designed by the English painter and designer John Armstrong. *Dark Elegies* was also made by an English choreographer, Antony Tudor, but the other artists who were involved or whose work was used in the production were of different nationalities: it was set to the Austrian composer Gustav Mahler's 1902 song cycle *Kindertotenlieder* which itself set poems by the German poet Friedrich Rückert, and it was designed by the Russian emigré painter Nadia Benois. Tudor had been inspired by the latter's paintings of bleak Scandinavian landscapes, two of which were used as designs for backcloths. However, if *Façade* could be said to appeal to an English sensibility while *Dark Elegies* was more attuned to an international framework of references and debts, this is not merely because of the nationalities of the artists whose works were used to make these ballets. The different sensibilities these ballets evoke need to be located in the differing social and artistic networks within which Ashton and Tudor were situated and the consequent differing ideologies of modernism which informed their artistic practices. *Façade* articulates an upper-class modernism—not just that of the Sitwells but also that of the Bloomsbury group under whose auspices the ballet was commissioned and first performed—while *Dark Elegies'* modernism is closer to that of the left-leaning experimental theatre and film movements in Britain in the 1930s and the Artists International Association.

The binary distinction I seem to be making here between these two ballets appears a conventionally tidy one. However nationalism and internationalism in the context of the 1930s in Britain is more complex and contradictory than this. Modernity constituted an internationalising force (though there were national and international aesthetic modernisms). Capitalism's need for ever greater mar-

kets led, during the period, to an increasing industrial standardisation which had effects both on a national and international level: in Europe and North America this standardisation eroded both class distinctions within countries and disparities between life styles in different countries by encouraging everyone to consume increasingly similar goods. The degree to which capitalism undermined national sovereignty was demonstrated by the 1929 Wall Street Crash which, though an American event, precipitated financial failures and rising unemployment across Europe. As well as the internationalism of big business, there was also the cosmopolitan internationalism of the upper and upper-middle classes for whom travel abroad was believed to bring freedom from local or national prejudice. Visits to continental Europe often led to a greater acquaintance with the arts. In Britain, ballet was, in the late 1920s at least, always foreign: the names of all ballet movements (for example *plié, entrechat, pas de deux*) are French but for the first three decades of the century ballet was also Russian as a consequence of the success of Diaghilev's Ballets Russes. Ballet, therefore, could be said to be a cosmopolitan taste. However, in addition to the privileged cosmopolitanism I have just described, there was also a left-wing internationalism, predicated on the idea that the working class across Europe had more in common with one another than they had with their ruling classes. The Popular Front of the 1930s was a broadly-based left wing alliance against fascism which led to the formation of the International Brigades who fought for the elected republican government in the Spanish Civil War. From an English point of view, both in the performing and visual arts there were identifiable modernist styles largely associated with the left which could either be seen positively as international or negatively as foreign. As I shall show, this was the case with the reception of *Dark Elegies*.

While it is possible to identify these different ideologies of internationalism, it is more difficult to define what was meant in Britain in the 1930s by the term British. London has always been a magnet for the arts. Ninette de Valois, whose life work has been to create, through the Royal Ballet and its school, a tradition of British ballet where none existed before, was born and brought up in Baltiboys, in what is now Eire in an Anglo-Irish family. Ashton himself was born in Ecuador and brought up in Chile; he came to England as a teenager, his father being an ex-patriot businessman and for a time a British consul. Robert Helpmann, who joined de Valois' company in 1933, was from Australia, while Walter Gore who danced with Ashton in the Ballet Rambert was Scottish and Maude Lloyd who danced in all Tudor's ballets during the 1930s was from South Africa. On arrival in London, all were absorbed into a hegemonic cultural identity that

supposedly transcended subordinate provincial and colonial identities. If there is a British cultural identity over and above the political function which cultural institutions like the Royal Ballet serve, this is surely a hegemonic English cultural identity, attained through the subordination of other provincial and expatriot colonial identities.

What the analysis of ideologies of nationalism and internationalism in *Façade* and *Dark Elegies* reveals is the extent to which national identities are informed by class interests and are gendered. All these identities are, in a sense, no more than constructions, in that, as Benedict Anderson proposes, nations are social and political constructs—imagined communities: 'All communities larger than primordial villages of face-to-face contact (and perhaps even these) are imagined'.[1] Cultural forms, including ballet, play a significant role in the definition and redefinition of these constructs and the maintenance of a hegemonic consensus. The importance of the identities that result from these processes should not, however, be underestimated. Despite seeing national identity in these constructionist terms, Anderson acknowledges that the question he finds most difficult to answer is: why are individuals prepared to die for an imagined, constructed community which they think of as their nation? *Façade* and *Dark Elegies* reveal different aspects of the way in which cultural products inflect the strong feelings that can be aroused by ideas of national and international identity.

At the end of the nineteenth century, national identity in Britain was linked to notions of an expansive and confident manhood expressed through myths about Imperial pioneers. In many ways the manliness associated with the British Empire was the opposite of cosmopolitan in that it was predicated by default upon a lack of interest in the arts in general and an almost 'virtuous' ignorance of the arts in an international context.[2] By the 1920s and 1930s these outgoing British male characteristics had given way to a more insular and vulnerable sense of hegemonic English identity. The context for these changes was the aftermath of war, the decline of empire, the deleterious impact of modernity, capitalism's need for increasingly homogeneous, international markets, and the effects of the 1929 stock market crash. In economic and political terms, the idea of an English ballet tradition therefore arose at a time when older ideas of Englishness were in decline. My argument is that whereas the modernism of *Façade* attempts to resist this loss of a class specific and conservative Englishness in the face of internationalising forces, *Dark Elegies* articulates a more liberal or left-inclined and distinctly international modernism which allows a more direct expression of a strongly charged but generalised and undefined sense of loss.

The ballets indicate the relationship between shifts in ideologies of hegemonic English identity and changes in gender ideologies because of the transformation that had taken place in the status of ballet between the late-nineteenth century and the 1930s. In the 1890s, in London and across most of Europe, ballet enjoyed a low status. It was generally located in music halls, where women dancers were the main focus of attention, while male roles were increasingly performed by female dancers 'en travestie'.[3] Diaghilev's Ballets Russes reintroduced male dancers in the early years of the twentieth century. What had for some been a titillating display of femininity was thus superseded by a display of male physicality and sexuality for heterosexual female and homosexual male spectators.[4] As Lynn Garafola has pointed out, the Ballets Russes' London performances in the 1920s were written about by many leading intellectuals, particularly those associated with the Bloomsbury group including Roger Fry, Clive Bell, James Strachey, Ezra Pound, and Richard Adlington.[5] Writing in 1920 Fry infers that the company's work helped domesticate the modernism which he had previously felt unable to educate British audiences to appreciate: 'Now that . . . Picasso and Derain have delighted the miscellaneous audience of the London Music Halls with their designs for the Russian Ballet, it will be difficult for people to imagine the vehemence of the indignation which greeted the first sight of their works in England'.[6]

This view of Diaghilev was not, however, universal. Terence Gray, the owner of the Festival Theatre in Cambridge and a disciple of Edward Gordon Craig wrote scathingly in 1926 that:

> The Russian ballet still has a vogue ... for the very wealthy patronize it freely and employ it regularly to assist them in the process of digestion, stipulating only that in return they shall not be required to think or feel anything, but be allowed just to sit with half-closed eyes and be dimly conscious of a kaleidoscope of pretty, harmoniously moving colours and pleasing musical vibrations.[7]

Gray was in effect criticising the Ballets Russes for maintaining commercial aesthetic conventions. As Michael Sidnell points out, in the 1920s and 30s: 'the "commercial theatre", as it was so frequently and contemptuously called, purveyed to an undiscriminating bourgeoisie the "culinary" entertainment of make-believe complacencies, decked out in tinsel and focused on stars'.[8] Many believed that theatre should be uplifting and revitalise a decadent society; however, while dance could be a way of facilitating this, traditional ballet as such did not appear to Gray and others to be an appropriate means. If both *Façade* and

Dark Elegies used serious music and were designed by modern painters rather than scenographers, it was Diaghilev who had established this tradition of using 'serious' modern music and painting. *Façade*, however, was essentially a vehicle for showcasing the technical prowess of two ballerinas Markova and Lopokova. It thus remained within the conservative conventions of traditional theatrical production, while *Dark Elegies* was in line with attempts to reform and revitalise theatre through modernist experimentation.

While Ninette de Valois began teaching dancers and producing ballets at the Old Vic Theatre in 1926 (moving to Sadlers Wells in 1931), the other important figure in the development of modern ballet in England during the 1920s and 30s was Marie Rambert. Both had been members of the Ballets Russes, but whereas de Valois developed the support structure for a ballet company in a working theatre, Rambert discovered and nurtured choreographic talent. It was Rambert who taught both Ashton and Tudor. She gave each of them their first opportunity to choreograph a ballet and her company danced both *Façade* and *Dark Elegies*.[9] A short extract from the film *The Red Shoes* (1947) shows the fictitious Victoria Page (Moira Shearer) making a guest appearance with the real Ballet Rambert at the real Mercury Theatre. It also shows the tiny stage and 150 seater auditorium (fig. 102) in which *Façade* and *Dark Elegies* were performed, and the figure of Marie Rambert herself, wincing at a mistake made by the operator of the hall's primitive sound system.[10] Throughout the 1930s, the Ballet Rambert performed twice a week at the Mercury Theatre. It was not only their home but also served as a base for the many theatrical enterprises of Rambert's husband—Ashley Dukes. In February 1937 the Group Theatre under Dukes' management presented the first production of Auden and Isherwood's play *The Ascent of F6* at the Mercury a fortnight after the premiere of *Dark Elegies* at the Duchess Theatre.[11]

In *The Red Shoes* Page/Shearer is dancing in *Swan Lake*—a nineteenth-century 'classic' of the ballet repertoire. Beth Genné has shown that the idea of dancing the classics was in fact new in the 1930s.[12] Both Ballet Rambert and de Valois' Sadlers Wells Ballet Company not only performed new ballets, but also through the 1930s started to perform a 'classic' repertoire of nineteenth-century ballets, aimed at acquiring respectability.[13] Believing that creating choreography was a male job, de Valois only choreographed very few works herself. One of her best known and longest lasting ballets, *The Rake's Progress* (1935), was based on Hogarth's cycle of paintings. Set in the eighteenth century it was designed by Rex Whistler. De Valois had an aversion to artistic radicalism and was particularly caustic in her comments about German modern dance that she dismissed as

102 Interior of the Mercury Theatre. Photograph by Paul Wilson, reproduced courtesy of the Rambert Dance Company Archive.

'based on a primitive form of "jungle ability".'[14] The largely pacifist, left-leaning work of the German choreographer Kurt Jooss (whose company was based in England during the 1930s)[15] gave de Valois 'the uncomfortable feeling that in everyday life they may possibly wear a uniform and answer to numbers instead of names'.[16] It is a sign of her conservatism that de Valois subsequently employed Ashton but not Tudor. While she was unsympathetic to German modern dance, many of those who danced for Marie Rambert, including Tudor himself, were very interested in German dance and in Jooss' work in particular.

Marie Rambert initially trained in Eurythmics with Emile Jaques-Dalcroze in Dresden. Diaghilev hired her to help Nijinsky use Eurythmics to teach his dancers the complicated rhythms of Stravinsky's score for *Le Sacre du printemps*, and she herself danced in the ballet. *Sacre* has gone down in history for the near riot that accompanied its first performance. It is now recognised as the most radical piece in choreographic terms that Diaghilev ever produced. Rambert presumably

derived from this experience her flair for encouraging choreographic talent and innovation. Diaghilev's later ballets, such as *Parade* (1917) — which had choreography by Massine, a libretto by Cocteau, music by Satie and was designed by Picasso — were generally not as formally advanced as *Sacre* in terms of choreography: none of them followed Nijinsky's lead in rejecting altogether the traditional codes of dignified, aristocratic self-presentation that are inscribed in the technical vocabulary of ballet. Diaghilev developed a strong, sophisticated audience for ballet particularly in London, cleverly using the cachet of artistic radicalism without offending more conservative sensibilities.

The ballet *Façade* is indebted to Diaghilev's legacy and to *Parade* in particular. First, it is an example of the type of 'artists' ballet' which, as we have seen, Diaghilev invented; its Englishness is the counterpart of the Russianness of ballets with Russian themes by Russian painters, composers, and choreographers like *Sacre* and *L'Oiseau de feu* (1910). Second, the commissioning of *Façade* in 1931 was a response to the vacuum left by Diaghilev's death in 1929, and it was produced to cater for the London audience that Diaghilev had created. Third, Osbert and Sacheverell Sitwell saw *Parade* in Paris in 1917 and it has been suggested that they used its example to encourage their sister Edith to conceive of *Façade* as a consciously avant-garde musical entertainment. Both works referred to popular art. *Parade* referred to circus performances. But, as Kenneth Silver has shown, an important visual source for Picasso's designs for *Parade* were the nineteenth-century French popular prints known as Images d'Epinal after the town where some of them had been printed.[17] It was Cocteau who showed these to Picasso. Silver argues that the ballet therefore evoked a lost world of the French middle-class nursery, which was decorated with children's alphabets and other children's illustrations from Epinal. Wilfred Mellers and Rupert Hildyard[18] have argued that the Englishness of Edith Sitwell and William Walton's *Façade* (1923) is produced through articulating a historically specific, anti-bourgeois nostalgia for a lost Edwardian golden age that had been destroyed in the carnage of the First World War. Pamela Hunter, moreover, has suggested that many of the poems in the cycle *Façade* (published in 1922), which was written immediately after the war, evoke the disappearing world of popular seaside entertainment in the late Victorian and Edwardian period which Sitwell remembered from childhood stays in her family's house in Scarborough.[19] Frank Howes notes that William Walton's setting of Sitwell's 'Tango-Pasodoble' includes musical references to the popular song 'I do like to be beside the seaside', and identifies elsewhere in Walton's setting of *Façade* other references to music hall songs and popular musical material.[20] Ashton

103 William Chappell and Walter Gore in 'Popular Song' from *Façade*. Photograph by Malcolm Dunbar, reproduced by courtesy of the Rambert Dance Company Archive.

himself, as I shall show, makes similar references to music hall in his 1931 ballet. This attempt to recuperate a lost and idealised working-class culture as a source of spontaneity and vitality appealed in the 1920s and 30s to those who mourned a perceived loss of notions of national identity and older ideas of Englishness.

Walton arranged a suite of seven dances for Ashton's ballet which was performed without the poems themselves being declaimed.[21] The ballet was originally commissioned by the Camargo Society—a subscription society that annually from 1930 to 1933 hired a theatre for a short season, commissioned new ballets and hired dancers and musicians to perform them. Two of the key players in the society's affairs were Maynard Keynes, its treasurer, and his wife Lydia Lopokova who had been one of the principals of Diaghilev's Ballets Russes[22] both of whom were members of the Bloomsbury group. The Bloomsbury circle constituted the classic type of intelligentsia who, in Pierre Bourdieu's formulation, use connoisseurship of vanguard culture to secure class privilege, and ballet was an area through which Bloomsbury connoisseurship was exercised. As Janet Wolff has pointed out, this social grouping constituted a tight, closed circle, via intersecting social relations and systems of cultural production, that exerted a 'considerable power and influence in the intellectual and cultural life of the period'.[23] They were also extremely liberal in their attitudes towards sexuality. Julie Kavanagh in her recent biography of Frederick Ashton recounts that Ashton and his friend William Chappell were often invited to parties on the fringe of the Bloomsbury group. The two were popular for an impromptu cabaret act, in which they performed deadpan male versions of the Charleston and Black Bottom; these were eventually incorporated into *Façade* as the Popular Song (fig. 103).[24]

Façade received its premier on 26th April 1931 at the Cambridge Theatre, and was danced by Lopokova together with Ashton, Alicia Markova and other dancers (including Tudor in a minor role) on loan from Rambert's company (then called the Ballet Club). Marie Rambert immediately bought the costumes and it was first danced at the Mercury Theatre a few weeks later. It consists of seven numbers:

Scotch Rhapsody—*pas de trois*
Yodelling Song—a milking scene *à quatre*
Polka—solo *en pointes*
Valse—*à quatre danseuses*
Popular Song—*à deux hommes*
Tango Pasodoble—*à deux*
Finale, Tarantella Sevillana—*ensemble*

104 Alicia Markova in the Polka from *Façade*. Reproduced courtesy of the Royal Academy of Dancing Archive.

The Times review of the premier was generally complimentary but ended by remarking: 'One doubt arises. If the Ballet is going to laugh at itself so freely, it must take care in future not to laugh in the wrong place'.[25] Markova gives a useful example of the piece's humour in her description of the Polka, her solo section in the original production (fig. 104):

> The set at the back had [a] farmhouse door, and I was painted in my polka costume on that door. Before the Polka, in the milkmaid scene, I had to stand in that door and open the lower part, which would reveal the real part of me on *pointe* with the skirt, while the upper part was the painted image. During the introduction for the Polka, I had to push open the door and stride out — and I strode out wearing bloomers, not the pretty-pretty costume they wear today. On the opening night there was a gasp in the audience — everybody thought I'd lost my skirt. Fred [Ashton] had wanted to surprise them, so at the dress rehearsal I didn't drop the skirt, but at the performance I danced in the bloomers. The Polka was a comment on the music-hall which Fred and I both had experienced. It was based on music-hall jokes: the fall-over step and my bloomers and boater hat. All the movements in it featured a tilting of the boater hat. The pas de chat steps in the middle should have little wobbling head movements — today they go with the music, but originally it was syncopated, and had lots of detail in it.[26]

As Markova says, Ashton not only worked in the early thirties as a choreographer for Marie Rambert, but also arranged dances for music halls, cabarets and West End theatres. Markova, who in the twenties had been a star of the Ballets Russes, also worked in a wide variety of venues, often in dances arranged for her by Ashton.[27] Because Rambert couldn't afford to pay much, both at the time were dependent on working in the despised commercial theatre. Part of the joke in the Polka was therefore the incongruous blurring of ballet and music hall with which both were equally familiar. This is dance referring to dance. Music hall was, however, also a subject through which, in different ways, the Camden Town group of painters and the poet T. S. Eliot had represented contemporary life. Ashton's use of music hall conventions, therefore, served a double purpose. First, just as 'the painting of modern life' used metropolitan working-class subjects to break with the older traditions of narrative painting, 'modern' ballet deconstructed the outmoded formality of nineteenth-century ballet through references to modern life. Second, by referring to music hall, Ashton accentuated the formal precision of the ballet steps and arm gestures that make up most of the Polka solo, which

originally ended with a difficult ballet tour de force, a double turn in the air,[28] the sort of step an educated ballet audience would expect to see a ballerina who had danced for Diaghilev perform. Ashton's use of music hall conventions therefore constitutes a modernism that accentuates class differences while recuperating the pleasures of mass cultural entertainment.

Façade is also full of reference to foreign-ness. But such references have a faux-naive exoticism which owes more to the novels of Ronald Firbank than to Sitwell's poems, or which suggest a camp appreciation of her writing: the back-drop includes a Swiss chalet; there is an Alpine yodelling song and a Scotch (not Scottish) Rhapsody; the Tango Pasodoble refers to Argentina, while the finale is a Sevillian Tarantella (though the Tarantella is of course Sicilian). Ashton himself had commented on the colourfulness of foreign nations at the end of an article in the *Dancing Times* in 1930:

> As a final word, British choreographers should endeavour bravely to show the world the richness of our native endowments and not be intimidated by the more colourful characteristics of other nations, for through honesty to ourselves our merits cannot fail to find appeal to a public as discerning and sensitive to good dancing as the British.[29]

This comment must be seen in the light of the Russification of English dancers by Diaghilev. It was he who in the 1920s had given Hilda Munnings the stage name Lydia Sokolova, Patrick Healey the name Anton Dolin, and Lillian Alicia Marks the name Alicia Markova. It is through mimicking of foreignness in *Façade* that Ashton flatters the sensibilities of his discerning English public.

Ashton, who had known the South American tango from his childhood in Lima, himself danced the Tango Pasodoble with Lopokova. He portrayed an oily 'Dago' while she was a naive debutante up from the country. Dorothy L. Sayers' 1932 novel *Have His Carcase* includes the following description of a professional dancer at a provincial seaside hotel: 'Mr Antoine . . . was rather surprisingly, nei-ther Jew nor South-American dago, not Central European mongrel'.[30] Belinda Quirey gives a dance context for this prejudiced remark:

> In the 1920s the change to a totally new deportment and style [of social danc-ing] left many middle-aged men in the world of the waltz, and unwilling to learn new tricks. Many of their middle-aged wives, on the other hand, had taken to the new style. There was therefore a demand for good partners and this was supplied by many professionals. As a rule these were very pleasant

men and nearly all the ones I knew I liked very much. But to the normal English male they were simply gigolos. 'Damn dagos', was the usual condemnation.[31]

There is also a complicated in-joke involved: Ashton as an Englishman (though brought up in South America) impersonates a dago, and Lopokova, Russian (but married into the English upper class), impersonates an English debutante. According to Markova:

> The whole thing between Sir Fred and the debutante was almost as if he didn't wish to touch her. The debutante is naive; everything he tries to teach her goes wrong. There were roars of laughter all the way through. Just as she thinks she is getting the rhythm of the walk across in front of him, he tips her over in the air. With a fast lift, where he whirls her round on the ground and they come face to face, again there were roars of laughter.[32]

The possibility of laughter 'in the wrong place' it will be recalled, worried *The Times* critic. The critic's unease was surely because 'good taste' — the ability to be 'discerning and sensitive to good dancing' as Ashton put it — was generally used to secure class privilege and to exclude 'those not of that class, social network, or world view'.[33] This 'good taste' was 'English' only in so far as it was a component of the world view of a particular upper-class social network. Just as *Façade* uses music hall to demonstrate class difference, it also uses 'foreignness' to demonstrate national difference. In both cases Englishness and privileged class status were signified through the precision with which the highly valued, technical vocabulary of ballet movements were executed by English ballerinas who had danced for Diaghilev. Ballet was nevertheless made to seem normal and unremarkable, by presenting lower-class and foreign dancing as exaggerated, colourful and remarkable.

In 1935 Ashton took up a full-time post as dancer and choreographer with Ninette de Valois' Vic Wells Ballet. This left Marie Rambert deprived of her main choreographer and she therefore gave more opportunities to Antony Tudor. Tudor, who had danced the opening Scotch Rhapsody in the original *Façade*, was very different from Ashton and neither liked the other very much. Whereas Ashton was middle-class and privately educated, Tudor was the son of a Smithfield butcher who had studied in night school and was both unwilling and unable to fit into the social networks to which Ashton belonged. A very different world view therefore underlies *Dark Elegies*.

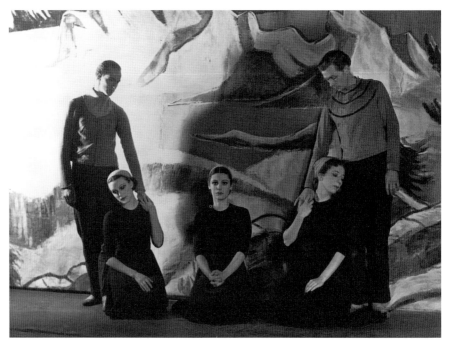

105 Members of the original cast of *Dark Elegies*, l. to r. Anthony Tudor, Maude Lloyd, Peggy van Praagh, Agnes de Mille, Walter Gore. Photograph by Houston Rogers, reproduced courtesy of the Theatre Museum/Rambert Archive.

In his song cycle *Kindertotenlieder*, Mahler sets six poems by Rückert which describe a seaside community mourning the loss of children in a storm at sea. For *Dark Elegies* a coastal scene by Nadia Benois is used as a backdrop for the first five songs of bereavement which culminate in a song about a storm (fig. 105). There is then a short break during which a second backdrop of a calm lake scene is lowered, and the ballet ends with a final song of resignation. Throughout, the tenor sings on stage, sitting at the front to one side on a low stool, originally accompanied by a two piano version of Mahler's score. He is dressed in the same plain, modern style as the dancers. Benois intended her costumes to evoke Scandinavian peasant dress, with plain peasant skirts and headscarves over leotards for the women, and trousers and fisherman's smocks for the men. Each song is danced as a solo or duet, with featured dancers emerging from the group to dance their part. There are always other dancers watching or dancing with the principals as an on-stage audience or community, and the number on stage

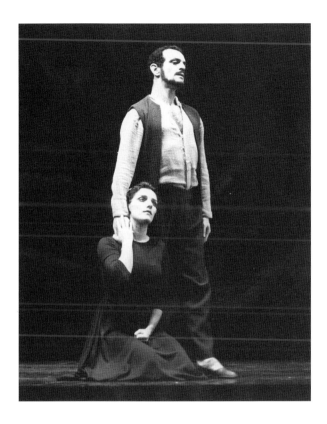

106 Performance (1980) of *Dark Elegies*, dancers Lucy Burge and Yair Vardi. Photograph by Anthony Crickmay. Reproduced by courtesy of the Victoria and Albert Museum.

gradually increases until there are twelve for the climactic storm section and the final song of resignation.

Some critics called *Dark Elegies* a symphonic ballet in order to describe its plotless interpretation of the mood of the music. Tudor utilises an austere, refined movement vocabulary for the ballet which is a foil to the lush chromaticism of Mahler's music. Critics complained that Tudor had not used any real ballet movement, and *Dark Elegies* certainly has some material that is perhaps more 'theatrical' than dance: performers bow their heads, or fall bowing to the floor, and at one point a man places his hand on a woman's shoulder as if to console her (fig. 106). Sometimes the group perform folk-like line or a circle dance material.[34] But only ballet dancers would mark out linear positions with their legs, beat the ground with their feet, rise up on *pointe* or jump in the way the dancers do in *Dark Elegies*. Occasionally they also make decorative, recognisably balletic shapes with their arms (see fig. 107), but the arms are also used

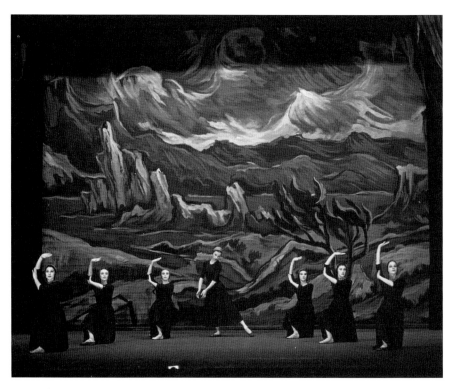

107 Performance (1957) by the Rambert Dance Company of *Dark Elegies*. Reproduced by courtesy of the Rambert Dance Company Archive.

to articulate space in a three dimensional way around the body which is distinctly unballetic and reminiscent of early German modern dance. Tudor is known to have admired the work of Mary Wigman and Kurt Jooss.[35]

Most of the critics were initially unsympathetic to *Dark Elegies*. *The Times* commented that: 'It is difficult to think of a work less appropriate to dancing than this song cycle'.[36] This may be because Mahler was out of fashion as a composer in Britain in the 1930s. The critic of the *Morning Post* (20 February 1937), for example, complained: 'The effect of Mahler's excessive chromaticism, rather smudgily played, gave an impression of wailing even greater, I fancy, than that intended by the composer, and Mr. Tudor's choreography unquestionably preserved the same mood.' P. J. S. Richardson (the 'Sitter Out') in the *Dancing Times* felt that although the movements succeeded in conveying an atmosphere of charged emotion, they were 'at times somewhat obscure and seemed to have been invented rather meaninglessly to fill in time'.[37] C. W. Beaumont glumly

concluded: 'Unfortunately it takes more than courage to produce a good ballet. If experiment were all, the Ballet Rambert would be giving us a masterpiece with each new presentation'.[38] Peggy Van Praagh, who danced in the original production, recalls that, on the first night, Hugh Laing forgot his climactic solo to the fifth 'storm' song and improvised it.[39] This, she suggests, was the reason for the poor notices the premier received, but, she continues: 'The ballet actually "caught on" with the public after a few performances, when the sense of tragedy was felt by the cast and the public'.[40] Michael Huxley, in his fascinating examination of the way in which the critical reception of *Dark Elegies* has changed over the years, suggests that the initially cool reception was because of the ballet's unfamiliar movement style and may also have been due, in part, to its similarities with German modern dance.[41] One critic complained that 'there was a great deal of processional movement of a not-too-purposeful order, and too little call upon foot-technique to hold the eye's attention'.[42] I have argued that Ashton's *Façade* signified Englishness through the subtle ways in which he used ballet to frame a supposedly shared upper-class, English world view. In *Façade* complex technical feats are displayed for an informed and appreciative audience. Tudor, however, uses technically difficult steps and lifts almost surreptitiously in *Dark Elegies* to heighten the overall tension. *Dark Elegies* not only disrupted contemporary expectations of ballet as an arena within which to affirm insular, class-based values, but also did so in a modern way whose movement style included material that was identifiably international.

One of the critics most sympathetic to Tudor's work at the time, A. V. Coton, praised *Dark Elegies'* simplicity of conception:

> No synopsis, none of the customary stage trappings, were required to convey that this was a highly sensitive and completely unsentimental creation on the theme of death ... The treatment is remarkable for a refreshing absence of any of the balletic or dramatic cliches of situation, gesture, or dress normally associated with the idea of dying.[43]

A reviewer of a programme of Tudor's work including *Dark Elegies* in Oxford later that year responded in a similar way, enthusing that: 'The whole point is to get away from the classical ballet formula and do something new'.[44] As Maude Lloyd, who danced in all Tudor's pieces at the time, observes: 'It is very difficult to appreciate now, when we see naturalistic gesture done (and over-done) on stage, that until the 1930s one never saw real people with real emotions in ballet. What Tudor did was to bring the essence of a natural gesture into ballet, refine it

and yet retain its imagery and power for the audience'.[45] Tudor's ability to create a refreshingly new and deeply moving work by freeing theatre dance from the stultifying conventions of traditional theatre attracted the attention of those who were interested or involved in experimental and progressive theatre. Michael Sidnell might almost have been describing *Dark Elegies* when he writes of Jacques Copeau, whose *Théâtre du vieux colombier* had inspired members of the British Group Theatre, that he 'let the audience "see" verbal poetry, demanded physical virtuosity of the actors and was a purification of a theatre surfeited with luxurious, inartistic, bourgeois naturalism'.[46]

Whereas Ashton had arranged dances in a variety of different West End theatre productions, Tudor had not. In order to support himself, Tudor taught evening classes in ballet history[47] at Morley College and Toynbee Hall, worked as freelance stage manager in the commercial theatre, and, around the time he was working on *Dark Elegies*, he had started a fruitful collaboration with two young, progressive BBC producers Stephen Thomas and Willem Bate who worked for the then new medium of television. Tudor and Thomas' *Fugue for Four Cameras*, broadcast on 2 March 1937 attracted the interest of experimental film makers.[48] Tudor is one of a small number of dancers in Ballet Rambert who are listed as members of the Group Theatre in its early years.[49] Although Tudor was not directly involved in any of their productions, he had danced in ballets choreographed by its director (and former member of both the Ballet Russes and Ballet Rambert) Rupert Doone.

Tudor was also mentioned in 1939 as a possible future collaborator with the more Communist-oriented Unity Theatre.[50] There is little to directly connect Tudor with the left as such. It is interesting, however, that one critic who appreciated his work was the young painter and member of the Euston Road Group, Lawrence Gowing. The two had things in common. Tudor was from Finsbury, and his father a master butcher. Gowing was from Hackney where his father was a master draper. In November 1938 Tudor, having left Ballet Rambert, based his new London Ballet at the East End settlement house and Adult Education Institute, Toynbee Hall. In March 1939, Gowing participated in an Artists International Association exhibition at the nearby Whitechapel Art Gallery; the painter Nan Youngerman recalls that they invited an ordinary working man who was passing by to open the exhibition. One of Gowing's paintings at the time was of Mare Street in Hackney. He later commented: 'I privately thought of the subdued but respectful manner in which I painted as in some way identifying with people deprived of the fruits of their labour, among whom I should have numbered the

entire population of Hackney'.[51] Tudor's attitude towards basing his ballet company in the East End of London was similarly subdued and respectful. As Coton observed of the first night audience at Toynbee Hall: 'Contrary to the naive expectations of certain parts of the audience there were few tail coats and backless gowns—and even fewer silk chokers and hobnailed boots. Ballet had come to the East End, not as an act of patronage to the East Enders, but . . . because a large part of the ballet-going public lived in or near the district'.[52]

Two of the dancers in the original cast of *Dark Elegies* have suggested that Tudor was responding to the mounting destruction of the Spanish Civil War.[53] There is no direct reference in the ballet either to war or to Spain. Instead, the piece, by exploring a generalised, abstracted situation, presents human experiences that could be seen as universal, transcending barriers of class and national identity. It is the way in which the choreography frames emotional experience that allows the ballet to be interpreted in an open way. In the duet during the second song, for example, when the female partner (initially Maude Lloyd) is lifted high on her partner's shoulders, conventional expectations are disrupted. She does not take up a conventional ballet *porte de bras*, extending her arms out into the satisfyingly clear and effortless closure of a conventionally spectacular sequence. Instead she sometimes arches right back into a prostrate image of desolation, or doesn't reach outwards at all, but curls up into a foetal crouch. Lloyd calls these 'leaps into the air in an attitude that collapsed'.[54] Here and elsewhere in *Dark Elegies* emotional experience is suggested not so much by what dancers actually do, but by the impression of what they seem restrained from doing. Lloyd says: 'He tried to get into the movement this agony that was held back. The important thing was that we weren't allowed to show emotions with our faces, we weren't allowed to act. But all the emotion had to be done through the movement'.[55] In *Dark Elegies* it is as if members of the community are confronting a gap between their emotional experience and the austere physical means through which they are compelled to try to express it. A refusal to close this gap allows an opening out of the possibilities of signification, a free-floating, unconstrained meaningfulness that exceeds and confounds what appears to be the disciplining intention behind ideologies of ballet as an emblem of upper-class taste. It is this excess that ultimately emerges as the melancholy sense of exaltation which reverberates throughout the final resignation section of the ballet.

Façade's positive critical reception and *Dark Elegies*' initially negative reception augured Ashton and Tudor's subsequent careers. Tudor left England in 1939 to work in New York, and became extremely influential in the development of

modern ballet in the United States and continental Europe, while Ashton subsequently became artistic director of the Royal Ballet; by the end of his life Sir Fred had become a friend and confidant of members of the Royal family. Ultimately the difference between the English modernism of *Façade* and the international modernism of *Dark Elegies* lies in the difference between their responses to the experience of loss. *Façade* fetishises the other as working-class or foreign in order to disavow the gradual loss of signifiers of social and national difference. *Dark Elegies* evokes the abyss of loss and mourning through a melancholy elaboration of its dancers' failure to bridge the gap between emotion and its embodiment as expressive movement. Whereas *Façade* marks the other in order to leave upperclass English social identity as the an unmarked, unremarkable norm, *Dark Elegies* refuses to present technical virtuosity as a signifier of unremarkable class privilege. Instead it choreographs a community whose modernist universality implies that differences of class and of national identities are unremarkable. Englishness has often been characterised through clichés like 'sang froid' and 'stiff upper lip' which refer to emotional reserve or inarticulateness, and both these ballets either implicitly or explicitly evoke such qualities. But whereas *Façade* exclusively associates an English reserve with upper-class sensibilities, *Dark Elegies* represents emotional reserve through articulating ideologies of modernism that seemed to offer the possibility of transcending distinctions of national and social differences.

1 Benedict Anderson, *Imagined Communities,* 2nd ed. (London: Verso, 1991), 6.

2 See Joseph Bristow, *Empire Boys: Adventures In A Man's World* (London: Harper Collins, 1991); Michael Roper and John Tosh, eds., *Manful Assertions* (London: Routledge, 1991).

3 See Lynn Garafola, 'The travestie dancer in the nineteenth century', *Dance Research Journal* 17.2, and 18.1 (1985–86): 35–40.

4 See Ramsay Burt, *The Male Dancer: Bodies, Spectacle, Sexualities* (London: Routledge, 1995).

5 Lynn Garafola, *Diaghilev's Ballets Russes* (Oxford: Oxford University Press, 1989), 335, 481.

6 Fry mentions music hall because, following the war, the impoverished Diaghilev had been forced to accept bookings from the music hall proprietor Sir Oswald Stoll. Fry's comment must however be understood in the context of the comparatively conservative nature of Picasso and Derain's ballet designs in the immediate post-war years and the relatively conservative choice of paintings in Fry's earlier post-impressionist exhibitions. Roger Fry, *Vision and Design*, 4th ed. (London: Chatto & Windus, 1928), 292.

7 Cited in Michael Sidnell, *Dances of Death: The Group Theatre of London in the Thirties* (London: Faber and Faber, 1984), 30.

8 *Dances of Death*, 33.

9 *Façade* and *Dark Elegies* were sometimes even performed by Ballet Rambert on the same programme. Although *Façade* was produced by the Camargo Society 26 April 1931, many of the dancers were drawn from Rambert's company (then called the Ballet Club) and, following the piece's success, she purchased the set and costumes and the ballet went into her company's repertory being first performed at the Mercury Theatre, 4 May the same year. When Ashton joined De Valois' Vic Wells Ballet Company in 1935 he 'took' *Façade* with him as he explained in a letter to Marie Rambert at the time (see Jane Pritchard 'Two letters' in Stephanie Jordan and Andrée Grau, eds., *Following Sir Fred's Steps* (London: Dance Books, 1996), 101–14). *Dark Elegies* was made for the Ballet Rambert and was not performed by the Vic Wells. It was subsequently performed by the Royal Ballet in 1980.

10 The film shows the real exterior of the Mercury Theatre, but the interior has been recreated in a studio. Peggy Van Praagh tells a story that in the middle of performing Tudor's tragic *Dark Elegies*, 'just before the fourth song someone had to rush off and change the record, and the next thing we heard was: "And Peter looked out and saw his grandfather . . . " We all broke up!' Part of Prokofiev's *Peter and the Wolf* had been put on by mistake. Peggy Van Praagh 'Working with Antony Tudor', *Dance Research*, 2.2 (1984): 67.

11 Dukes had hired the Duchess theatre for his highly successful production of T. S. Eliot's *Murder in the Cathedral* which had premiered at the Mercury Theatre. He sent this on tour to allow a short season by the Ballet Rambert: private communication from Jane Pritchard, Archivist at Ballet Rambert, July 1997.

12 Beth Genné, 'Creating a Canon, Creating the "Classics" in Twentieth-Century British Ballet', *Dance Research* 18.2 (Winter 2000): 132–62.

13 Nicholas Sergueyev (1876–1951) was a member of the Imperial Russian ballet who left St. Petersburg after the revolution with notated scores for several nineteenth-century ballets. He produced versions of *Coppélia, Giselle, The Nutcracker, Swan Lake* and *Sleeping Beauty* in London during the 1930s.

14 Ninette de Valois, *Invitation to the Ballet* (London: John Lane, 1937), 174.

15 One of the more exciting tales from 1930s dance history is the secret escape from Nazi Germany of the entire Ballets Jooss, who smuggled with them their music, costumes and props. They preferred to go into exile rather than sack Jewish company members. Leonard and Dorothy Elmhirst offered a home at Dartington college for both the Ballets Jooss and the Jooss Leeder Dance School. See Anna and Hermann Markand, *Jooss: Dokumentation von Anna und Hermann Markand* (Köln: Ballett-Bühnen-Verlag, 1985)

16 *Invitation to the Ballet*, 179.

17 Kenneth Silver, 'Jean Cocteau and the Image d'Epinal: an essay on realism and naiveté', in *Jean Cocteau and the French Scene* (New York: Abbeville, 1984), 81–105.

18 Wilfred Mellers and Rupert Hildyard, 'The Cultural and Social Setting', in Boris Ford, ed., *The Cambridge Cultural History*. Vol. 8, *Early Twentieth Century* (Cambridge: Cambridge University Press, 1992), 2–24.

19 Edith Sitwell, *Façade: With an Interpretation by Pamela Hunter* (London: Duckworth, 1987).

20 Frank Howes, *The Music of William Walton* (Oxford: Oxford University Press, 1965), 16.

21 The musical version of *Façade* existed in a number of versions setting different combinations of poems. The original Entertainment consisted of 21 poems. Three more sections were subsequently added to the ballet version. See Howes, *Music of William Walton*, 12–14, for further details.

22 Julie Kavanagh, *Secret Muses: The Life of Frederick Ashton* (London: Faber and Faber, 1996), 114–15.

23 Janet Wolff, 'The failure of the hard sponge: class, ethnicity, and the art of Mark Gertler', *New Formations* 28 (Spring 1996): 56.

24 Kavanagh, *Secret Muses,* 109.

25 *The Times,* 27 April 1931, p. 10.

26 Jordan and Grau, *Following Sir Fred's Steps,* 177.

27 *Following Sir Fred's Steps,* 177.

28 *Following Sir Fred's Steps,* 178.

29 Frederick Ashton, 'A word about choreography', *Dancing Times* (May 1930), 125.

30 Dorothy L. Sayers, *Have His Carcase* (London, New English Library, 1974), 83.

31 Belinda Quirey, *May I Have The Pleasure? The Story Of Popular Dance* (London: BBC, 1976), 87.

32 Jordan and Grau, *Following Sir Fred's Steps,* 177.

33 Wolff, 'The failure of the hard sponge', 56.

34 Peggy Van Praagh said that Walter Gore's solo in *Dark Elegies*: 'was inspired by a national dance Tudor saw when he was on holiday in Jugoslavia—or somewhere in the Balkans—in which the feet were "straight" [i.e. not turned out as in classical ballet]. That set a style (though it was not the same for my solo, or Maude Lloyd's pas de deux)'. Van Praagh, 'Working with Anthony Tudor', 57.

35 A. V. Coton and Cyril W. Beaumont (*Daily Telegraph* 20 February 1938) both mention Central European Dance in contemporary reviews. Coton wrote: 'Tudor with great skill and daring has matched the classical neatness of turn and expressiveness of carriage [i.e. of ballet] with the freer plastic gestures, drawn from the Central European style of movement': A. V. Coton, *Writings on Dance 1938–68* (London: Dance Books, 1975), 62. By the late 1930s, the association of German modern dance and Nazism led its British exponents to euphemistically call it Central European Dance. Peggy Van Praagh, who was one of the dancers with whom Tudor choreographed *Dark Elegies* recalls going to see the Ballets Jooss and Mary Wigman with Tudor. Van Praagh, 'Working with Anthony Tudor', 59.

36 *The Times,* 20 February 1937.

37 'The Sitter Out' [P. J. S. Richardson], 'The Ballet Rambert', *Dancing Times* (April 1937), 4.

38 *Daily Telegraph,* 20 February 1937.

39 Patricia Clogstoun, one of the younger members of the original cast, recorded the fraught circumstances in which the piece was made in her press cuttings book, a copy

of which is in the archives at Ballet Rambert: 'It was not ready by Monday 14th February when it was originally to be performed [at the beginning of the second week of Rambert's four week season at the Duchess Theatre]. And amidst Madame's [Marie Rambert's] tears and many miseries was put off to Friday that week. On Wednesday the last movement had not yet been made up, and as for Hugh's [Laing's] solo it had hardly been thought of.' Rambert did not have an easy working relationship with Tudor during 1936 and 1937 and he left Ballet Rambert shortly after the season at the Duchess Theatre.

40 Van Praagh, 'Working with Anthony Tudor', 66.

41 Michael Huxley, 'A history of a dance: an analysis of *Dark Elegies* from written criticism' in Janet Adshead, ed., *Dance Analysis: Theory and Practice* (London: Dance Books, 1988), 141–60.

42 *Sunday Times*, 21 February 1937.

43 Coton, *Writings on Dance 1938–68*, 62.

44 John Irvine, *Isis* (16 June 1937), quoted in Judith Chazin-Bennahum, *The Ballets of Antony Tudor* (New York: Oxford University Press, 1994), 80.

45 Maude Lloyd, 'Some recollections of the English ballet', *Dance Research* 3.1 (Autumn, 1984): 51.

46 Sidnell, *Dances of Death*, 37.

47 In these he sometimes used dancers and gave what were probably the earliest lecture demonstrations in Britain.

48 *Fugue For Four Cameras*, 2 March 1937, music Bach Fugue in D Minor, dir. Stephen Thomas, Maude Lloyd dancer. See Chazin-Bennahum, *The Ballets of Antony Tudor*, 265, and Janet Rowson Davis, 'Ballet on British Television 1933–1939', *Dance Chronicle* 5.3 (1982–83): 245–304.

49 'Ballet on British Television 1933–1939', 273.

50 See Colin Chamber, *The Story of Unity Theatre* (London: Lawrence and Wishart, 1989), 184.

51 Lawrence Gowing, *Lawrence Gowing* (London: Arts Council of Great Britain, 1983), 12.

52 Coton, *Writings on Dance 1938–68*, 65.

53 Judith Chazin-Bennahum mentions Peggy van Praagh and Margaret Dale in this context, *The Ballets of Antony Tudor*, 74.

54 Lloyd, 'Some recollections of the English ballet', 41.

55 Lloyd interviewed in 'Ballet Rambert, The First 50 Years' directed by Margaret Dale, BBC2, broadcast 22 May 1978.

Behind Pevsner: Englishness as an Art Historical Category

William Vaughan

I

THIS ARTICLE IS CONCERNED with the ways in which Englishness has been treated as a stylistic category by art historians using the systematic methods of formal analysis that were developed at the end of the nineteenth century, in particular by the Swiss scholar Heinrich Wölfflin.[1] In one sense this might seem a very old-fashioned thing to do. Wölfflin's methodology is hardly regarded as canonical any more. However it remains relevant, both because many of the issues that his process of categorization raised have never been resolved, and because there are a number of survey texts[2] still in use that are based on it. Indeed, there are even signs of a Wölfflin revival under way — to judge by the fulsome praise given to him in the recent major study of Tiepolo by Svetlana Alpers and Michael Baxandall.[3] In the case of the stylistic categorization of English art, the method can be seen at work in Sir Nikolaus Pevsner's *The Englishness of English Art.*[4] This book was an expanded and annotated version of the author's Reith Lectures, which were broadcast in October and November 1955 — in themselves a reworking of lectures delivered during the Second World War.[5] Still in print it remains — at a popular level at least — the most authoritative exploration of the unique identity of British visual culture available in the English language. This is partly because no one else has subsequently ventured into this field with a book-length study: but it is also partly because the issue of national identity has remained a key issue in Britain, at a time when the country has been experiencing the effects of a continuous (if uneven) reduction of economic power and international status. Pevsner published his book in the same year as the Suez crisis — that definitive indicator of the termination of Britain's role as an imperial power. In the years since then Britons have become increasingly concerned about their national persona. It is interesting to see that while the term 'Englishness' appears never to have been used in the title of a book published in Britain before Pevsner, it has been employed on many occasions since — particularly in relation to literary and other cultural studies.[6]

Pevsner's book itself is so approachable and good-humoured that there might seem to be little harm in it; even if its characterization of Englishness is heavily marked by the assumptions of the time in which it was written. Such Englishness' does, after all, have a certain period charm — like the characters in an Ealing comedy. However it does present a huge problem in its central premise that what is special about the visual art of this country is its peculiar national character; a character, moreover that can be assumed to be a discrete entity. Hardly less problematic is the assumption that this entity can be isolated and identified by means of formal pictorial analysis.

<div align="center">II</div>

Pevsner's assumption that such a procedure was possible rests, as has already been indicated, on the practices that had been developed and schematized by Heinrich Wölfflin. Pevsner's principal mentor was his doctoral supervisor at the University of Leipzig, Wilhelm Pinder.[7] Pinder was to be critically important for Pevsner's study of regional forms of art. But Pinder's concepts of style history were a development, rather than a challenge, to the principles laid down by Wölfflin. It was with his blessing that Pevsner did, in fact, go to study with Wölfflin for a time at the University of Munich. Long before that Pevsner knew well, as all art history students of his generation did in Germany and Central Europe, Wölfflin's *Principles of Art History*. Published originally in German in 1915, this presented a summation of the master's methodology.[8] The key tool for exemplifying this was the technique of binary comparison. It is one that art historians still pay tribute to today in their surviving habit of delivering lectures on their subject using two screens, thus privileging the processes of discourse that depend upon the analogies that can be drawn from paired images. This practice — apparently introduced by Wölfflin in his lectures at Basel University in the 1880s — was also mirrored in the typographical layout of the Swiss art historian's books. The typical double-page spread employed was that in which one illustration is placed top left on the left hand page, and a facing one is placed top right on the right hand page, with the text dropped in between. This became in fact a standard form of layout for German language art history books in the early twentieth century. Pevsner's *Englishness of English Art* does not quite adhere to this pattern; largely one suspects for reasons of economy. Amongst other things, Wölfflin's method requires a book to be printed throughout on paper of suffi-

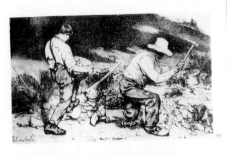

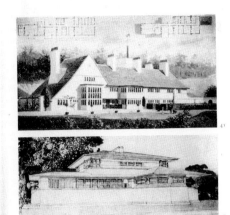

108 Nikolaus Pevsner, *The Englishness of English Art*, pages 74–75. On these pages British art is compared with French Realism and American Modernism to demonstrate the 'Distrust of Extremes' that characterises Englishness.

cient quality to take reproductions. Both the Architectural Press edition and the Penguin edition bunch the illustrations in groups on special reproduction quality pages, enabling the text to be printed on cheaper paper. However, the illustrations themselves are to a large degree grouped as comparative pairs (fig. 108).

Wölfflin built his principles of formal analysis upon methodologies current in the natural sciences. Already in the early nineteenth century binary comparison had become regularly employed in such new areas of study as comparative anatomy. It had been a method much employed by Darwin, and had become a tool in particular for both biological and social studies influenced by Darwin's ideas, notably those by Francis Galton.[9] Assumptions about the relation between physical type and cultural product were commonplace at the time in which Pevsner was developing his ideas. One popular example of this—which

Pevsner would undoubtedly have known from the time when he was first in Britain—appeared in a series of articles written by Cyril Burt for *The Listener* in 1933 on the subject of 'How the Mind Works'. Burt was famous—and later infamous—for maintaining the existence of innate physical and psychological characteristics of different ethnic groups and relating these to their intellectual performance.[10] In one of the articles he wrote for *The Listener*, entitled 'The Psychology of Social Groups', he analysed the different racial groupings of Europe and linked them with their pictorial products.

> In the jargon of the modern psychologist, the Southerner is an extrovert; the Northerner an introvert. The contrast comes out most clearly in literature and art. . . . The art of Italy is clear and sunny like its climate; that of the north, misty and erratic, like the northern weather. In fact the weather and the climate of the various countries have actually been held responsible for the temperaments produced.[11]

To bolster his argument, Burt includes both a comparative spread of the heads of different European racial types, and a comparison of an *Adoration of the Magi* by Raphael with one by Dürer to demonstrate the difference between the extrovert and introvert ways of painting.

Burt became celebrated for basing his claims about innate characteristics on the study of identical twins. Believing that he could develop objective methods of testing innate ability led to the construction of 'intelligence tests' which became a notorious feature of the Eleven Plus examination, which determined whether state-educated children in Britain should proceed to grammar schools for an academic education or not. Later much of Burt's work was exposed as fraudulent, being based on fabricated evidence: seemingly independent researchers who corroborated his findings later turned out to be Burt himself publishing under pseudonyms.[12] Burt's case might make it easy to dismiss all he was talking about as nonsense. Yet we should remember that there were many other scrupulously honest and meticulous scholars at the time who supported views similar to his.

We are now highly aware of the dangerous consequences of using this 'objective' method of investigation to reinforce national prejudices and stereotypes. But we must remember that the comparative method—whether used in binary or multiple mode—is not in itself a reprehensible or inappropriate practice. Comparison is, after all, a necessary part of any analytical procedure. The problem is that it is simply a tool, and it can be applied in inappropriate as well as appropri-

ate circumstances with seemingly equal success. Like most processes of commensuration, it always produces a result, no matter what data is used. In the comparison made by Burt cited above, the whole procedure was based on the prior assumption that there must be a correlation between the art of a particular culture and the racial types dominant within the social group in which that culture arose. Given that assumption, it then becomes simply a matter of looking for, say, the features in a Raphael that can be used to support an image of Italian-ness and those in a Dürer that can support similar assumptions about the Germanic.

Burt's misuse of the process is certainly a warning that it must be applied with caution. In particular, in the case of binary comparisons, it is important to remember that each comparison is made around an axis; in the case given by Burt above, it is an axis that runs between introvert and extrovert. There is assumed to be some normative point between the two states. Both are, in effect, some kind of deviation from this norm, travelling in opposed directions.

Wölfflin's binary comparative process is based on a similar series of polarities. His argument moves by means of positing pictures along different comparative axes. There is a further link between Wölfflin's method and those common in the natural sciences. He views the characteristics of images in what might be called an essentially physiognomic manner. Their nature is to be encapsulated in a set of discernible formal features. Collectively these form what is known as the 'style' of the work. It is these physical stylistic traits that provide the key to the psychological state to which the picture is assumed to bear witness. Wölfflin expresses this idea in *Principles of Art History* with great reductive clarity. He claimed that there were three basic characteristics to be revealed through the use of a binary comparative analysis of the stylistic forms of a work of art. These are the 'personal style' of the individual maker; the 'period style' of the age in which the work was made; and 'the style of the school, the country, the race'.[13]

We shouldn't be mealy-mouthed about this last feature. Wölfflin said 'race' and he meant it.[14] On the other hand, we shouldn't exaggerate either. Wölfflin's view that each country had a distinct, essentially racial, character was a common one in the period in which he was writing. And while this assumption became a major contributing factor to the disasters that have been (and still are being) precipitated by racism in the twentieth century and beyond, we would not be right in assuming that the views of Wölfflin and his contemporaries were identical with those of the Nazis and later racists. Race had a tangible identity for Wölfflin, but this did not mean that such an identity should necessarily be used as a criterion for domination or persecution.

Wölfflin himself had little interest in British art. But his *Principles* did not exclude such a study. Wölfflin had in fact made a point of stressing that his comparative method—unlike the connoisseurial practices he sought to replace—put all forms of artistic practice—whatever their period or place of origin—on an equal footing. He claimed to have disposed of the hierarchical canon of judgement that assumed that Classical and Renaissance art provided a norm for a universal aesthetic taste. Pevsner's doctoral supervisor, Wilhelm Pinder, had been one of those who had used this licence both to follow Wölfflin in studying the art of the Baroque, and also to make a systematic study of the unique character of German art that was in many ways a prototype for Pevsner's similar study of the peculiar nature of the art of the English.[15]

Wölfflin's claim to have replaced a centralizing measure has been challenged—in particular by Gombrich, who perceives a concealed classical norm within the comparative axes that Wölfflin employed.[16] But whatever the validity of Wölfflin's method, there is no doubt that it did provide a stimulus to art historians in Germany and Central Europe around 1900 to launch into studies of art outside of and opposed to the classical tradition—including the puzzling phenomenon of British art. In this period there was a certain degree of radical appeal about British art for some Germans. It could be seen to represent a raw form of naturalism that provided the starting point for the modern rebellion against the classical norm. The British could be seen as the 'primitives' of the modern movement, people with an innate naturalistic tendency and common sense—as evident in empirical science and in the 'experiments' of Constable's *plein-air* studies. This was the view taken by Richard Muther in his celebrated study *Art in the Nineteenth Century*, in which Hogarth is celebrated as the initiator of modernity.[17] It can also be seen in the reverence accorded to the Arts and Crafts movement, and to the traditional English house as celebrated by Hermann Muthesius.[18]

This anglophilia had its political dimension. It was part of an attempt to promote a 'northern' culture to posit against that of France in the wake of the Franco-Prussian war and attendant upon the increasing political and military power of Imperial Germany. Until about 1900, Britain seemed a natural ally in this process. The interest in Britain as a kind of 'primitive' of modernism fitted in with the feeling that that country had now shot its bolt, and that it was up to Imperial Germany to carry on the progress of the Nordic races. It fitted in with a

view of the English—along with the Dutch and many of the Germanic groups in Scandinavia and around the Baltic as *Niederdeutsch*, or 'low Germans'.

A significant book that promoted this view was Julius Langbehn's *Rembrandt als Erzieher* (Rembrandt as an Educator)—a highly influential work that ran into many editions following its initial publication in 1889.[19] In line with the new materialism—and inspired by some extent by Nietzsche—Langbehn claimed that Germany had suffered in earlier times from the debilitating effects of metaphysics and idealism. In order to flourish in the modern world it was necessary for Germany to reawaken the pragmatic and practical side of the German psyche. This could be achieved by returning to the more primitive domain of the *Niederdeutsch*. Rembrandt, in Langbehn's eyes, represented the sturdy self-reliance and unsentimental realism that was needed. So did Shakespeare—who is also characterized as a *Niederdeutsch* in Langbehn's book.

In the first instance, as has already been suggested, this interest led to pro-British sentiment. But as political rivalry between the two imperial powers grew the situation became more complex. Ultimately, it was Britain's unwillingness to share the German *Reich*'s view of itself as the new world master that constituted a major cause of the First World War. Pro-British sentiment in Germany naturally waned during the war itself, and immediately after. But as early as the 1920s it revived and a number of thorough studies of British culture were published in Germany, the most influential being Wilhelm Dibelius' *England* of 1923, which was also translated and published in England.[20] Within the context of the Weimar Republic, it seemed that there was all the more need for Germans to study and absorb the pragmatic spirit. Interest was high both amongst the political left and the political right. For the left, British culture could still be read as a form of early modernism, emerging out of the advanced social and economic conditions of the eighteenth century. The biting critiques published in that age could be seen as an early creative reaction to the new capitalist society. Brecht's reworking of John Gay's *Beggar's Opera* to produce the *Threepenny Opera* is a case in point.[21] From the right wing perspective, British culture provided the pleasure of a traditional and conservative homeland, in which a Germanic royal family still held sway.

Thus, among art historians in Germany and Central Europe one finds the late 1920s to be a time of limited but distinct and focussed interest in British culture—including its visual art. The Marxist art historians Friedrich Antal and Francis Klingender, began to involve themselves with issues relating to British art at much the same time that Nikolaus Pevsner did. It was also the period in

which research for the most extensive analysis of British visual art as an art historical category ever produced was being undertaken. This was the work of the Austrian art historian Dagobert Frey, who finally produced the results in his book *Englisches Wesen in der Bildenden Kunst* (English Character in the Visual Arts) in 1942, at the height of the Second World War.[22]

Antal and Klingender produced studies that were pioneering in their perception of British art in terms of wider cultural and social contexts—in particular the former's *Hogarth and his Place in European Art*, which challenged the isolationist view of British art—and the latter's *Art and the Industrial Revolution* in which artistic production was viewed in the context of British economic development.[23] Such work emphasized the importance of viewing artistic production in terms of a material context. Pevsner and Frey, however, were working from a different standpoint. While sympathetic to the broader cultural associations evoked by the British artistic tradition, they still gave priority to the more formal concerns of Wölfflin, and followed his method of isolating the essential characteristics of pictorial style by means of binary comparison. There were, as well, differences of emphasis between the two. Frey was from the 'Vienna School' and—in line with such leading figures as Max Dvoràk—took a greater interest in applying techniques borrowed from psychology and anthropology than did Pevsner.[24] But they both shared the Wölfflinian view that a leading stylistic element in art was that group of formal features which revealed national characteristics, and it was this that enabled them to talk with so much confidence about the essential features of British art as a continuum that transcended historical periods, rather than investigating aspects of it in terms of specific circumstances, as Antal and Klingender did.

Since both Pevsner and Frey adhered to Wölfflin's view there is some justice in examining their books in terms of binary comparison. Both can be seen as part of the war effort of the respective countries in which they were published. For just as Frey was preparing Germans to gain a closer understanding of the culture of the country they seemed to be on the verge of occupying, so Pevsner's lectures—originally delivered around the time the Frey's book was published—were intended to reassure Britons of the resilience and permanence of their national identity. It is indeed very moving to think of Pevsner delivering his lectures to the adult working students of Birkbeck College in the heart of London during the Blitz. Both Pevsner and his audience were under siege at the time, and he was using the occasion to compliment the people he had come to live among—and who had provided a refuge for him—on their indomitable spirit.

When referring to Frey's book in the foreword to his own, Pevsner generously commented that although it was published in the middle of the war, 'yet it is absolutely free from any hostile remarks, let alone any Nazi bias—a completely objective and indeed appreciative book, written with great acumen, sensitivity, and a remarkably wide knowledge.'[25] In a literal sense this is true. There is certainly no overt propaganda in the book, and the tone is sympathetic toward British art and to Britain in general. On the other hand we should not overlook some details of Frey's life that Pevsner perhaps did not know. Frey was at the time of the publication of his book Professor of the History of Art at the University of what was then known as Breslau—that is, the Polish city Wroclaw—and had taken a key part in the Germanization of the part of Silesia in which it lay. There is no doubt that he was an active supporter of Nazi cultural policy there.[26] If his attitude towards Britons was more benign than it was towards Poles, it is probably because he subscribed to the view of the English as *Niederdeutsch* and felt that he was examining in Britain an essentially Germanic culture. Seeing the Third Reich as the successor of the British Empire as a world dominator, he was fascinated in learning of the nature and 'mistakes' of this earlier Germanic Reich in much the same way as Britons had been keen to learn from the history of earlier empires such as Venice and Carthage during the height of Imperial Power in the Victorian Era. As will be seen later, this interest coloured many of Frey's assumptions, even if it did not precipitate any propagandist outbursts.

Frey's book—published in Berlin in 1942—was in fact part of a scholarly series called *England und Europa*, which set out to gain an understanding of the particular role of Britain within European culture. It was, therefore, part of a larger intellectual project. Despite this—and despite Frey's activities in Poland—one should still acknowledge that the author did bring a wide set of cultural concerns to bear on his work. It was always his aim—to some extent fulfilled in the post-war period—to erect a genuinely comparative method for all artistic cultures, and one that was not based on notions of superiority. This process—which he called *Vergleichenden Kunstgeschichte* (Comparative Art History)—was outlined in an article published in 1947.[27] As he stated in *Englisches Wesen* he intended his study of British art to be a model for this larger and more comprehensive scheme.[28]

In his introduction to *Englisches Wesen*, Frey makes it clear that he is indebted not just to Wölfflin and such later art historians as Hans Sedlmayer (who had analysed French art from a national point of view), but also to the work of anthropologists and biologists. Indeed, hard though it might be to credit this

now, he saw his study as constituting a move away from the cult of authorial personality in art history towards the objective placement of art within a historical context. Anthropological studies were the key to his kind of new art history. He took the notion of 'material culture' seriously; though following leading anthropologists of the later nineteenth century, he saw racial characteristics as being a central part of that material context.

In Frey's view British art was particularly well suited to provide a test case for the analysis of the ethic components of style. As an island, Britain had been relatively resistant to invasions and settlement. This meant that the racial origins of its inhabitants were relatively few and therefore easier to unravel than in the case of most countries in continental Europe. Furthermore, since the last invasion leading to settlement (that of the Normans in 1066) had been so long ago, there had been ample time for its effects to have become fully absorbed and to produce the amalgam that he designated the 'Englishes Wesen'. Celt, Saxon and Norman all made their contribution to this national character, though their contributions were each of a different kind. In his characterisation of the basic racial structure of Britain, Frey was following the descriptions given by British anthropologists of the later nineteenth century. He used in particular the work of John Beddoe, frequently citing that author's highly influential *Races of Britain*.[29]

Both Pevsner and Frey believed that 'Englishness' or, as Frey puts it 'englisches Wesen'[30] was the fundamental feature that distinguished the artistic productions of the British Isles from those of others. As Pevsner himself remarked, there was a high degree of agreement between him and Frey about the salient visual features of this phenomenon. Both of them agreed that Englishness can be discerned as a visible entity in art in Britain from the time of the Anglo-Saxons. Its two principal features are a descriptive interest in earthy realism and a formal obsession with linearity. The first can be seen, for example, in the 'Babwyneries' of the Middles Ages[31] and the satires of Hogarth. The latter can be traced from early medieval manuscripts through Elizabethan miniatures to the 'flaming line' of William Blake, and the sinuous one of *fin-de-siècle* designers and architects such as Aubrey Beardsley and Charles Rennie Mackintosh.

Earthiness and linearity might seem to be opposed characteristics. Frey and Pevsner have different ways of account for this — as will be seen later. But I think it is worth observing that the binary comparative method they employed might itself be a contributing factor to the emergence of this paradox. As Gombrich has remarked, the Wölfflinian process of binary comparison is built around a concealed norm.[32] Gombrich identifies this norm as the sense of form evident in

the art of classical antiquity, in particular Athenian sculpture from the fourth century BC. This has functioned as a key reference point for European high visual culture since at least the time of the Renaissance. Measured against such a norm different art forms can be shown to be deviant, but in wildly different directions. Thus, in comparison to Greek sculpture Hogarth might appear excessively earthy, while Blake, on the other hand, would seem to lack substance, to be too linear. If some other comparative norm had been set up — say that of the Japanese woodcut — then quite different characteristics might have emerged. It would be possible to see a Blake print as volumetric, for example, if it were set beside one by Hokusai. A more important point to bear in mind is that this binary comparative method, with its concealed classical norm, ensured that the different artistic productions of Britain were almost inevitably bound to be assessed in terms of negative characteristics, in terms of a series of deviancies. Even if the discussion of these was sympathetic — as it was in both the case of Frey and Pevsner — the sense of paradox and eccentricity was bound to remain.

For rather similar reasons, 'Englishness' was seen by both Frey and Pevsner as being antipathetic to modernity. Despite the role that certain British artists played as precursors to modernism, the national peculiarities were such that it was impossible for the visual culture of this country to acclimatize itself to the fundamental reforms that were the hallmarks of modernity in the twentieth century. Pevsner is far too polite and pro-English to characterize this as a failing. Rather, he sees it as consequence of a traditional British virtue; moderateness. The British simply lack the extremism to make good modern artists:

> If England seems so far incapable of leadership in twentieth-century paint-ing, the extreme contrast between the spirit of the age and English qualities is responsible. Art in her leaders is violent today; it breaks up more than it yet reassembles. England dislikes violence and believes in evolution. So here, spirit of the age and spirit of England seem incompatible.[33]

In Wölfflinian terms, period stylistic features were working against those of race. Frey, by contrast, is more emphatic in linking the failure of the English to come to terms with modernity with the country's political and economic decline. Yet however put, the implication is the same: That Englishness, no matter how appealing and valid within its own terms, is essentially limiting and outmoded.

Pevsner's view on Englishness is all the more striking since he had come to Britain in the first place as an apologist for contemporary architecture. He was interested in studying the role that British art and design had played in the

emergence of modernism — particularly in relation to the work of his friend, the founder of the Bauhaus, Walter Gropius. The result of his researches was published in 1936 under the title *Pioneers of the Modern Movement*, later to be called *Pioneers of Modern Design; from William Morris to Walter Gropius*.[34] During the 1930s — and particularly after the British Art Exhibition at the Royal Academy in 1934 — Pevsner became increasingly interested in the more traditional aspects of British art and architecture and in their preservation. It was this interest that led him, after the war to launch his magnificent survey of the architectural heritage of Britain with the *Buildings of England* series.

So far I have been considering what Pevsner's and Frey's studies share. However the differences are also striking. As types of publication they are completely distinct. Frey's study is a detailed exposition. It runs to over four hundred pages and is copiously footnoted. The coverage of the subject is impressive and up to date for the time. It was a scholarly book in a scholarly series. Pevsner's book, on the other hand, was aimed at broad audience. It began life as a series of lectures, and the engaging tone used in these was carried into the book that eventually emerged from them. It is footnoted sparingly and the bibliographic references are brief.

Perhaps the most striking difference occurs in the attitude to chronology. Frey's book is a historical narrative. It traces a history of 'englisches Wesen' from the Anglo-Saxons to the present. He sees the phenomenon as evolving as the nation grows. Pevsner, on the other hand, avoids a chronological arrangement. While admitting that Englishness has varied in its nature and intensity from period to period, he still sees it as having at its kernel some timeless element that can be teased out in an unmediated manner by comparisons between art works of vastly different periods and circumstances.

As well as these differing attitudes to chronology, there is also a major difference in interpretation. This emerges in the authors' opposed attitudes to the racial structure and dynamics of Britain. Both authors accepted Wölfflin's assumption that the art of each country possessed a national style that reflected its racial constituents. However, they have different views about precisely what was being reflected in the case of Britain. Pevsner sees British art as reproducing a seamless, if somewhat paradoxical, entity. He sees Englishness as gradually coming into being in the early middle ages — rather in the same way as the modern English language did. It is a cultural entity without conflict, marked by benignity, common sense and 'fair play'. Perhaps because he was writing during the period of the final collapse of the British Empire, he stressed tolerance rather than the powers of leadership so often emphasized by writers on British national

identity in earlier ages.[35] Thus, when considering the birth of the Independent Irish state he talks of a sensible 'letting go' of Ireland, much in the same way that one might talk of 'letting go' a troublesome servant.[36]

It is a striking feature of the seamless image of Englishness that Pevsner creates that it contains virtually no reference at all to those parts of Britain where Anglo-Saxon dominance has traditionally been most challenged — that is, in the celtic regions of Ireland, Wales and the north of Scotland. Celtic art is hardly mentioned at all, except as an occasional eccentric intrusion. Thus there are a few fleeting comments about Celtic influences in early medieval English manuscripts and, much later on, to Mackintosh's responses to the 'unpredictable curves of Celtic illumination and metalcraft'[37] around 1900. Celticness was a vague and distant heritage that occasionally added a dash of fantasy to Englishness but which had no central part in its construction. It acts as an exotic stimulant, a bit of seasoning in the stew.

Perhaps because he was viewing the matter from wartime Germany, Frey takes a very different view of the matter. Indeed, this is the one point at which his narrative can be said to be radically different from that of Pevsner. In contrast to the seamless Englishness described by Pevsner, Frey detects a *rassische Spannung* or 'racial tension' running throughout the history of art in Britain.[38]

Frey took his cue from British nineteenth century anthropologists in this matter. He used the survey of racial types in Britain published by John Beddoe both to establish the persistence of two distinct racial groups — the Celtic and the Anglo-Saxon — and to map these against class and political divisions. It had been a contention of Beddoe's that people of Celtic origin were to be found lower on the social scale in Britain than those of Anglo-Saxon descent.[39] Frey does not see Celtic separateness as a thing of the past — as Pevsner does — but as a persisting phenomenon. Perhaps German rapprochement with the Ireland of Devalera during the war may have encouraged Frey to stress the independence of Celtic culture and its irreconcilable difference to that of the Anglo-Saxons. Pevsner, for his part, may have wished to play down racial separateness in view of his own situation. As a German of Jewish origins, who settled permanently in Britain at the time when the Nazis came to power in his native country, he had every reason to fear and revile racial prejudice. His backgrounding of the Celtic element is not motivated by any hostility or disdain for the Scots or the Irish. It is an attempt to preserve the integrity of Englishness, which he sees as a trans-racial amalgam that had forged a distinctive English culture out of disparate strands of ancient British, Anglo-Saxon and Norman-French cultures in the fourteenth century. It was

Abb. 15. Irisches Steinkreuz in Kilirea
Gedrungene, plattenförmige Grundform

Abb. 16. Angelsächsisches Steinkreuz in Ruthwell
Schlanke, obeliskartige Grundform

essentially a 'high' culture that existed — like government itself — above the vested interests of the different racial groups who may have contributed to its construction. Unlike Frey, he sought to soften Wölfflin's racial element into a national one. 'For nation', as he said, 'as a self-conscious cultural entity, is always stronger than race.'[40]

Pevsner's stress on the 'self-conscious' aspects of culture also forms a contrast to Frey. Frey, in a somewhat Jungian manner, prefers to dwell on the *un*self-conscious impact of racial elements. He sees the Celtic and the Saxon as a persisting pair of innate contraries that form a dialectic, sometimes stimulating each other, sometimes in conflict, but always distinguishable from each other.

Frey based his study of Celticness to a large degree on the work of the apologists for Irish art. Like these, he sees the Celtic as being more related than the Saxon to the Mediterranean tradition. For Frey there is an innate form consciousness in the Celt that the Anglo-Saxon lacks. He demonstrates this by a

Abb. 204. John Singer Sargent, Bildnis des Lord Ribblesdale
Isolierte Gestalt als lotrechte Mittelachse (vgl. Abb. 202, 203), Ausdruck der Distanzierung

109 (facing page left)
Dagobert Frey, *Englisches Wesen in den bildenden Kunst*, illustration 15, Irish Stone Cross in Kilirea.
The caption can be translated as 'stocky slab-like fundamental form'.

110 (facing page right)
Dagobert Frey, *Englisches Wesen in den bildenden Kunst*, illustration 16, Anglo-Saxon Stone Cross in Ruthwell.
The caption can be translated as 'slender, obelisk-like fundamental form'.

111 Dagobert Frey, *Englisches Wesen in ben bildenden Kunst*, illustration 204, Lord Ribblesdale.
The caption can be translated as 'Isolated figure as perpendicular central axis. Expression of distancing'.

contrast of Celtic and Anglo-Saxon treatments of comparable art forms, such as the standing cross (figs. 109, 110). Using the familiar process of binary comparison, Frey sets his two crosses against each other across the page spread of a book. The 'Anglo-Saxon' Ruthwell cross can be seen to be tall and thin, the Celtic one from Kilirea short and round. The distinction is also brought out in the differences in the crosses' decorative patterning—the Anglo-Saxon showing a straight and angular pattern, the Celtic one of circularity. As has already been said, this comparative method is based on a method of physiognomic analysis. Here it seems to be taken to the point where the physical features of the maker are related to the artefact. As the Renaissance dictum has it 'every painter paints himself'. Here the short round Celt is contrasted to the tall thin Englishman. For good measure, Frey also includes English full-length portraits, in which the tendency towards tall-thinness seems as clear as it is in the Anglo-Saxon cross, notably Sargent's portrait of Lord Ribblesdale (fig. 111).

Frey does, it is true, attempt to characterize the distinction also in terms of material practice. The Saxons, he points out, come from a part of Europe where trees are plentiful and their methods of construction were heavily influenced by this (the Saxon verb for 'to build' was, in fact, timbren). This could be used to explain their tendency to construct forms with long thin lines, reproducing the shapes of the wood they traditionally used. The Celts, on the other hand, coming from a stonier terrain, worked with the broader and less manageable forms of stone. But if this distinction might just work in pre-Conquest Britain it can hardly be held to account for the continuation of such features in subsequent centuries when very different material conditions prevailed. Frey does in fact abandon his own argument quite quickly and reverts to a more psychological view of the forming principle along the lines of a shared racial *Kunstwollen*. He sees this tendency being discernable in individual craftsmen of different racial elements. Thus, when considering the Eleanor Crosses constructed in the thirteenth century he is intrigued to find one set of sculptures which are given a broader and curlier treatment. Imagine his joy when he uncovers a record that shows that one of the craftsmen working on this particular cross was from Ireland.[41]

For Frey the early Middle Ages is a period of assimilation, where there is a harmonizing of Anglo-Saxon and Celtic forms that accords with the growth of the sense of a unified English nation. The emergence of English as the official language in the fourteenth century — together with the creation of such English literary masterpieces as *Piers Plowman* and the works of Chaucer is matched by the emergence of an independent form of Gothic — the perpendicular. Frey detects the presence of the Celt in this work. The straightness of the perpendicular is, of course, the Anglo-Saxon element. But Frey also points to the contrasting glory of the perpendicular — the spreading and intricate fan vault — and sees in this the Celtic element. As with Pevsner, the Celtic provides an imaginative topping, the fillip to spice up Anglo-Saxon order and logic. Having behaved itself in the lower regions, so to speak, the building can let off steam with some rich fantasy in the roof.

Bizarre though this is, it hardly marks the limit of the deductions Frey can draw from his principle. Following the argument that Celticness and Saxon are innate form principles evident in individuals whether they are aware of it or not, he pursues his principle into the eighteenth century, the time when Celticness could be held to have been at its most obscure — in England at least if not in Scotland, Wales and Ireland. Taking that classic stereotype of English art, the portrait, he detects a residual Anglo-Saxon tendency in the height and angularity of the forms. The attenuated aristocrats of Reynolds' portraits are brought in to support

Abb. 211. William Hogarth,
Bildnis des William James

Keltischer Formcharakter. Krause
Linienführung

Abb. 212. Sir Joshua Reynolds,
Bildnis des Admiral Keppel

Englischer Formcharakter.
Isolierte Gestalt, vertikaler Linienfluß

112 Dagobert Frey, *Englisches Wesen in ben bildenden Kunst*, illustrations 211, 212. Line Drawing Comparison of William Hogarth's *William James* with Joshua Reynolds' *Admiral Keppel*. The caption under Hogarth's portrait can be translated as 'characteristic Celtic form. Curling treatment of line'. That under Reynolds' portrait as 'characteristic English form. Isolated figure, vertical flow of lines'.

his claim. However, there remains a more problematic figure to cope with. This is Hogarth, whose penchant for swirls and circularity seems to run counter to the Anglo-Saxon mode (fig. 112). There can be only one explanation. Hogarth must be a Celt. Such mundane notions as the claim that Hogarth's tendency might be accounted for by reference to the contemporary rococo style that he absorbed as an apprentice engraver are brushed aside. Instead Frey looks into Hogarth's origins. Although he cannot come up with definite evidence, he is able to point out that the place of birth of Hogarth's father is Cumbria which (as the name suggests) is an outpost of Celtic settlements in the north of England. Frey supports his claim further by reference to Hogarth's physiognomy and character; small, rotund and lively — active and aggressive, occasionally to the point of paranoia.

We can now see the absurdity of Frey's position and argument. But before being too smug about it, we should recall again the extent to which this linking of physique and psychological type was a commonplace of the period — as evidenced in the article on southern and northern European types by Cyril Burt cited earlier.[42]

Pevsner, as has already been said, studiously and sensibly avoids this kind of racial association in his formal analysis of Britishness. In his book he alights in particular on Frey's claim about Hogarth and censures it both for the lack of evidence about Hogarth's putative Celtic ancestry and even more so for the assumption that such an ancestry could in any case lead to the emergence of this atavistic tendency. Yet while dismissing Frey's claim, Pevsner offers an alternative explanation for both Hogarth's particular nature and for Frey's general theory of racial tension that is in its own way equally startling for its assumptions:

> To this day there are two distinct racial types recognizable in England, one tall with long head and long features, little facial display and little gesticulation, the other round-faced, more agile and more active. The proverbial Englishman of ruddy complexion and indomitable health, busy in house and garden and garage with his own hands in his spare time and devoted to outdoor sports, is of the second type. In popular mythology this type is John Bull. In art Hogarth seems to represent it, whatever anthropologists may say. But it is a type less often expressed in art than the other; for it often turns against art. That is why in this book it plays far too modest a part. As was emphasized in the Introduction, a book dealing with art can only demonstrate those national qualities which express themselves in art. It is doomed therefore to be lop-sided in the end, if it is used as a guide to national character, and not to national art.[43]

In one sense Pevsner has sent Frey packing. But in another he has shown himself to be just as susceptible to the assumption that a certain racial type produces a certain kind of psychological make-up which disposes it to certain types of cultural preferences. He has not characterized this as a division between the Celt and the Saxon. Rather, he has characterized it in terms of class, with the short round chaps belonging to the vulgar world of popular taste and the long thin ones espousing the qualities of high culture.

Pevsner's exclusion is made in order to maintain the seamless view of British art. His definition of what counts as art would be recognized well enough by those who see art in classic Marxist terms as conveying the ideology of the ruling class. But it does not necessarily fit in with the conflicts that exist within British art. Frey's discussion of this 'tension' in racial terms also misses the point that this tension is essentially a social one. On the other hand, the conflation of the two may make more sense than one thinks at first if one remembers that anthropologists have seen a tendency for class divisions to align with those of racial groupings in the British Isles.

Recent discussions of Englishness have shown an increasing awareness that it is a historically determined concept that takes on different connotations at different times. It has also become increasingly clear that the term is used with a powerful political purpose.

A few years ago I published an article with the somewhat mischievous title 'The Englishness of British Art'.[44] In this article I argued that the term Englishness had become used to pinpoint a cultural dominance of the whole of the British Isles. What Englishness implies is a cultural continuity that reaches back to Anglo-Saxon times. Originally confined to England itself it has spread since the eighteenth century to cover the whole of the British Isles, embracing both English and non-English communities. It is seen, in true imperialist terms, as a phenomenon that has melded together a disparate group of peoples and provided a harmonious structure which encompassed all that was acceptable about each group — rather in the same way as 'Romanness' might have been used to characteristic the essential unifying powers of the Roman Empire. It is for this reason that it was used, until quite recently, as being virtually indistinguishable from 'Britishness'. Indeed, it drew its strength from the claim that 'Britishness' was essentially English, with other elements providing no more than tributary contributions. It is no accident that, at the moment when the British Empire was in terminal decline — and when even the political dominance of the English within Britain itself had successfully been challenged — 'Englishness' began to be defined as a cultural phenomenon. As so often happens, when real power begins to decline the symbols of power are more insistently presented. This seems to me to be a reason why Englishness became so heavily promoted in the period after the Second World War. Pevsner's book seeks to preserve, in an almost nostalgic manner, the image of Englishness that in his eyes encapsulated the uniqueness of the British achievement. There is no room for conflict or tension within his affectionate characterization. It is interesting that Pevsner — while criticizing Frey's admittedly absurd assumptions about the effect of Hogarth's putative ancestry on his art — never openly challenged Frey's view about racial tension. Perhaps he thought such things were simply better not talked about. In any case, since Frey's book was never translated into English it never had any impact in Britain and perhaps to this day has never been looked at by more than a handful of people outside Germany. It is hardly surprising that Frey's book was not translated. His view is that of the complete outsider and, while respectful, his view of British culture and its future was hardly encouraging. Pevsner, on the other hand, was the outsider who had joined the tribe and could give a cosy and faintly

humorous account of the people that he had come to live among. He gave Britons the view of themselves that amused and flattered them—rather in the manner of books such as George Mikes' *How to be an Alien*, first published just after the Second World War.[45] This is doubtless the reason why it has remained in print to this day.

This article has explored ways in which Pevsner's book rests on methodologies and assumptions about national identity that are seriously in need of replacement or revision. Fortunately this is work that has been carried out over the last decade, and the other essays in this collections show the fruits of such study. Such changes are, I like to think, one of the best tributes that can be made to Pevsner. He himself, when he published *The Englishness of English Art*, was making an original contribution to the perception of British art, locating it within its cultural context in a way that Roger Fry had failed to do in his *Reflections on British Art*, and also moving the debate away from the racial assumptions that had shaped the arguments of Dagobert Frey in *Englisches Wesen in der bildenden Kunst*. In the 1950s, when the book was first published, these were positive and progressive things to do. But much has changed since then, and it is for this reason that the whole question of art and national identity has to be reconsidered.

Pevsner was working within an artistic practice that assumed the national element in art to be an essential characteristic. We would be wrong, however, to think that Pevsner thought this element was unvarying. For while stressing the importance of the national in assessing art, he allowed the possibility that its features could change. 'National qualities', he says near the end of his book 'are far from permanent. There occur every now and then cultural changes, changes of heart and mind, which go so deep that they may bury certain qualities for ever or for a long time and beget new ones.'[46] Given the multicultural and multi-ethnic nature of contemporary Britain, this is surely something that we should consider very seriously.

1 For a discussion of Wölfflin's method see M. Podro, *The Critical Historians of Art* (New Haven and London: Yale University Press, 1982), 132–34.

2 It might seem invidious to name names, but the basic Wölfflinian assumptions about the formation of style can be found in such period studies as G. Richter, *A Handbook of Greek Art* (London: Phaidon, 1959); Peter and Linda Murray, *The Art of the Renaissance* (London: Thames and Hudson, 1963). It should be pointed out that such works

were written at a time when the history of art as the history of stylistic development was still largely taken to be the norm.

3 Svetlana Alpers and Michael Baxandall, *Tiepolo and the Pictorial Intelligence* (New Haven and London: Yale University Press, 1994). See especially p. 9.

4 Nikolaus Pevsner, *The Englishness of English Art* (London: The Architectural Press, 1956). Subsequently republished by Penguin Books in several editions. The references in this article are to the original Architectural Press edition.

5 As a course of lectures at Birkbeck College, University of London in 1941–42; *Englishness of English Art*, 9.

6 For example, Fred Inglis, *The Englishness of English Teaching* (Harlow: Longmans, 1969); Robert Colls and Philip Dodd, eds., *Englishness: Politics and Culture 1880–1920* (London: Croom Helm, 1986); Godrey Smith, *The English Companion: An Idiosyncratic A to Z of England and Englishness* (London: Routledge, 1988); Brian Doyle, *English and Englishness* (London: Routledge, 1989); John Lucas, *England and Englishness: Ideas of Nationhood in English Poetry, 1688–1900* (London: Hogarth Press, 1992; James Day, *'Englishness' in Music from Elizabethan Times to Elgar, Tippett and Britten* (London: Thames Publishers, 1999). A word search on the automated catalogue of the British Library in December 1998 failed to come up with any title prior to Pevsner's study that included the word 'Englishness'.

7 For Pevsner's relationship with Pinder see Marlite Halbertsma, 'Nikolaus Pevsner and the end of a tradition. The legacy of Wilhelm Pinder' in *Apollo* (February 1993), 107–9. This contains a full bibliographical note of early studies on Pevsner's intellectual roots.

8 H. Wölfflin, *Kunstgeschichtliche Grundbegriffe. Das Problem der Stilentwickelung in der neueren Kunst* (München, 1915), ix, 255.

9 For example in his celebrated study *Hereditary Genius* (London, 1869). See D.R. Oldroyd, *Darwinian Impacts* (Milton Keynes: Open University Press, 1980), 287–88.

10 Robert B. Joynson, *The Burt Affair* (London: Routledge, 1989), 6.

11 Cyril Burt, 'How the Mind Works — XIII; The Psychology of Social Groups' in *The Listener*, 9 (18 January 1933): 101.

12 *The Burt Affair*, see especially chapter 7.

13 H. Wölfflin, *Principles of Art History*, trans. M.D. Hottinger (London: G. Bell & Sons Ltd., 1932), 6.

14 His precise phrase was 'to the personal style must be added *the style of the school, the country, the race*', *Principles of Art History*, 6.

15 W. Pinder, *Deutsche Barock: die Groflen Baumeister des 18. Jahrhunderts* (Leipzig, 1924). W. Pinder, *Vom Wesen und Werden deutscher Form*, 4 vols. (Leipzig, 1937–51). For Pinder see M. Habertsma, *Wilhelm Pinder und die deutsche Kunstgeschichte* (Worms, 1992).

16 E.H. Gombrich, 'Norm and Form: The Stylistic Categories of Art History and their Origins in Renaissance Ideals' in *Norm and Form: Studies in the Art of the Renaissance 1*, 3rd ed. (London and New York: Phaidon, 1978), 81–98. See especially p. 94.

17 Richard Muther, *Geschichte der Malerei im XIX. Jahrhundert,* 3 Bde. (München, 1893), translated by E. Dowson, G.A. Greene, and A.C. Hillier as *The History of Modern Painting*, 3 vols. (London: Henry & Co., 1895), 96, 80.

18 Hermann Muthesius, *Das englische Haus. Entwicklung, Bedingungen, Anlage, Aufbau, Einrichtung und Innenraum . . .* Zweite durchgesehene Auflage, 3 Bd. (Berlin, 1908–11).

19 Julius Langbehn, *Rembrandt als Erzieher. Von einem Deutschen*, [i.e. J. Langbehn] Zweite Auflage (Leipzig, 1890), vii, 309.

20 Wilhelm Dibelius, *England*, 2 Halbbd (Stuttgart, 1923), 80; *England*, trans. Mary Agnes Hamilton (London: Jonathan Cape, 1930), 569.

21 Martin Esslin, *Brecht: The Man and his Work* (London: Eyre and Spottiswoode, 1971), 34.

22 Dagobert Frey, *Englisches Wesen in der bildenden Kunst* (Stuttgart and Berlin: W. Kohlhammer, 1942).

23 F. Antal, *Hogarth and his Place in European Art* (London: Routledge and Kegan Paul, 1962); F. Klingender, *Art and the Industrial Revolution* (London: N. Carrington, 1947).

24 M. Dvořák, *Kunstgeschichte als Geistesgeschichte* (Munich: R. Piper and Co., 1924). For a recent discussion of the Vienna School see Christopher S. Wood, ed., *The Vienna School Reader* (New York: 2000), especially the introduction, 9–72.

25 *The Englishness of English Art*, 9–10.

26 For an account of Frey's activities in Poland before and during the Second World War see Stefan Muthesius, *Art, Architecture and Design in Poland, 966–1990* (Königstein im Taunus: K.R. Langewiesche Nachfolger H. Köster Verlagsbuchhandlung, 1994).

27 D. Frey, *Grundlegungen zu einer vergleichenden Hoch Kultur* (Innsbruck, Wien: Margarete Rohrer Verlag, 1949), 120. Originally published in 1947.

28 *Englisches Wesen*, ix.

29 J. Beddoe, *The Races of Britain* (London: Trübner and Co., 1870).

30 Literally 'English characteristics'. Although not identical, I think the two terms are sufficiently similar to be understood to be address the same phenomenon.

31 *Englishness of English Art*, 26.

32 E.H. Gombrich, *Norm and Form*, 81–98.

33 *Englishness of English Art*, 181.

34 P. Pevsner, *Pioneers of Modern Design; from William Morris to Walter Gropius* (Harmondsworth: Penguin Books, 1960). The original text was published by Faber in 1936.

35 Such a claim was popularized in the early nineteenth century by Sharon Turner. See for example Sharon Turner, *History of the Anglo Saxons*, 6th ed., 3 vols. (London, 1936), 1:10.

36 *Englishness of English Art*, 15.

37 *Englishness of English Art*, 126.

38 This is specifically discussed in pp. 442–44.

39 *Races of Britain*, 270.

40 *Englishness of English Art*, 185.

41 *Englisches Wesen*, 105.

42 See note 10.

43 *Englishness of English Art*, 184–85.

44 W. Vaughan, 'The Englishness of British Art', *Oxford Art Journal* 13 (1990): 11–23.

45 Mikes, George, *How to be an Alien: a handbook for beginners and more advanced pupils; Nicolas Bentley drew the pictures* (London: A. Deutsch, c.1946).

46 *Englishness of English Art*, 187.

Notes on Contributors

Ramsey Burt is Senior Research Fellow in Dance in the Department of Performing Arts at De Montfort University, Leicester. He is the author of *The Male Dancer: Bodies, Spectacle, Sexualities* (1995) and *Alien Bodies: Representations of Modernity, 'Race', and Gender in Early Modern Dance* (1998).

Andrew Causey is Professor of Modern Art History at Manchester University and is at present working on a book on the visual arts and national identity in Britain in the twentieth century.

David Peters Corbett is Reader in Art History at the University of York. His main publications include, *The Modernity of English Art* (1997), and *English Art 1860–1914: Modern Artists and Identity* (2000), which he co-edited with Lara Perry. He is currently writing a book on the cultural idea of the visual and its impact on English painting between the Pre-Raphaelites and the First World War.

Paul Edwards is Professor of English and History of Art at Bath Spa University College. His study, *Wyndham Lewis: Painter and Writer*, was published by Yale University Press in 2000. He has edited numerous books by Lewis, and has also published articles on James Joyce, Tom Stoppard and Ian McEwan.

Anna Gruetzner Robins is Reader, History of Art Department, University of Reading. Her publications include *Modern Art in Britain* (1997), *Gendering Landscape Art* (co-edited with Steven Adams) (2000), and *Walter Sickert: The Complete Writings on Art* (2000). She is currently completing a book on late nineteenth-century British art.

Ysanne Holt is a Senior Lecturer in Art History at the University of Northumbria and editor of the journal *Visual Culture in Britain*. In addition to articles, conference papers and contributions to a series of exhibition catalogues on British Impressionism, she has published *Philip Wilson Steer* (1992). She is currently writing about the experience of British artists travelling to and painting in the Midi in the period just prior to the First World War.

Nina Lübbren is a Senior Lecturer in Art History at Anglia Polytechnic University in Cambridge. She is the author of *Rural Artists' Colonies in Europe 1870–1910* (2001), and co-editor, with David Crouch, of *Visual Culture and Tourism* (2000).

Kenneth McConkey is Professor of Art History and Dean of the Faculty of Arts at the University of Northumbria. His main publications include *British Impressionism* (2nd ed., 1998), *Impressionism in Britain* (1995), and *Edwardian Portraits: Images of an Age of Opulence* (1987). He is currently writing a book about memory and desire in late nineteenth-century British painting.

Alan Powers is an art historian, critic and writer and author of many books and articles on design in the twentieth century, most recently *Nature in Design* (2001). He is on the Committee of the Twentieth Century Society.

Fiona Russell is a writer and historian. She is currently co-editing books on sculpture and psychoanalysis (with Brandon Taylor) and, with Jane Beckett, on Henry Moore. She was previously Research Coordinator at the Henry Moore Institute.

Sam Smiles is Professor of Art History at the University of Plymouth. He has a special interest in British art since the eighteenth century and its relationship to historical consciousness. His books include *The Image of Antiquity: Ancient Britain and the Romantic Imagination* (Yale 1994).

Chris Stephens is an art historian specialising in twentieth-century British art and Senior Curator at Tate Britain. As well as contributing to various collections of essays, he has published books on Barbara Hepworth (with Matthew Gale), Peter Lanyon, Bryan Wynter, Terry Frost and Hubert Dalwood. He is currently working on a 'critical history' of St Ives.

Brandon Taylor is Professor of Art History at the University of Southampton. His main publications include *Art and Literature Under the Bolsheviks* (2 volumes, 1990 and 1991), *Art of the Soviets* (co-edited with Matthew Cullerne Bown, 1993), *Art of Today* (1995), and *Art for the Nation: Exhibitions and the London Public 1747–2001* (1999). At present he is preparing a new book, *The Politics and Poetics of Collage and Photomontage,* and a co-edited volume (with Fiona Russell) on sculpture and psychoanalysis.

William Vaughan is Professor of Art History at Birkbeck College, London, and has written on Romanticism, on English and German Art of the nineteenth century, and on Humanities computing. His principal publications are *Romanticism and Art* (2nd ed., 1994) and *German Romantic Painting* (2nd ed., 1994). In 1998 he delivered the Paul Mellon Lectures on British Art at the National Gallery, London, on the theme of 'Painting in English: The Making of the British School'.

Index

A page number in italics denotes an illustration